Cⁱᵉ Gⁱᵉ TRANSATLANTIQUE

PAQUEBOT FRANCE

FRANCE

ART MODERNE

LE

PAQUEBOT

PARIS

M. S. "LAFAYETTE"

Commandant Jules CHABOT, ✳✳ ❧

MENU

Petite Marmite Henri IV
—
Turbot de Dieppe Poché Sauce Hollandaise
—
Poularde du Mans à la Vauclusienne
—
Haricots Verts Sautés au Beurre d'Isigny
—
Côte de Bœuf à la Broche
Pommes Nouvelles Persillées
—
Salade
—
Fromages Assortis
—
Bombe Quo Vadis
—
Gâteau Laurencia
—
Corbeille de Fr

DINER

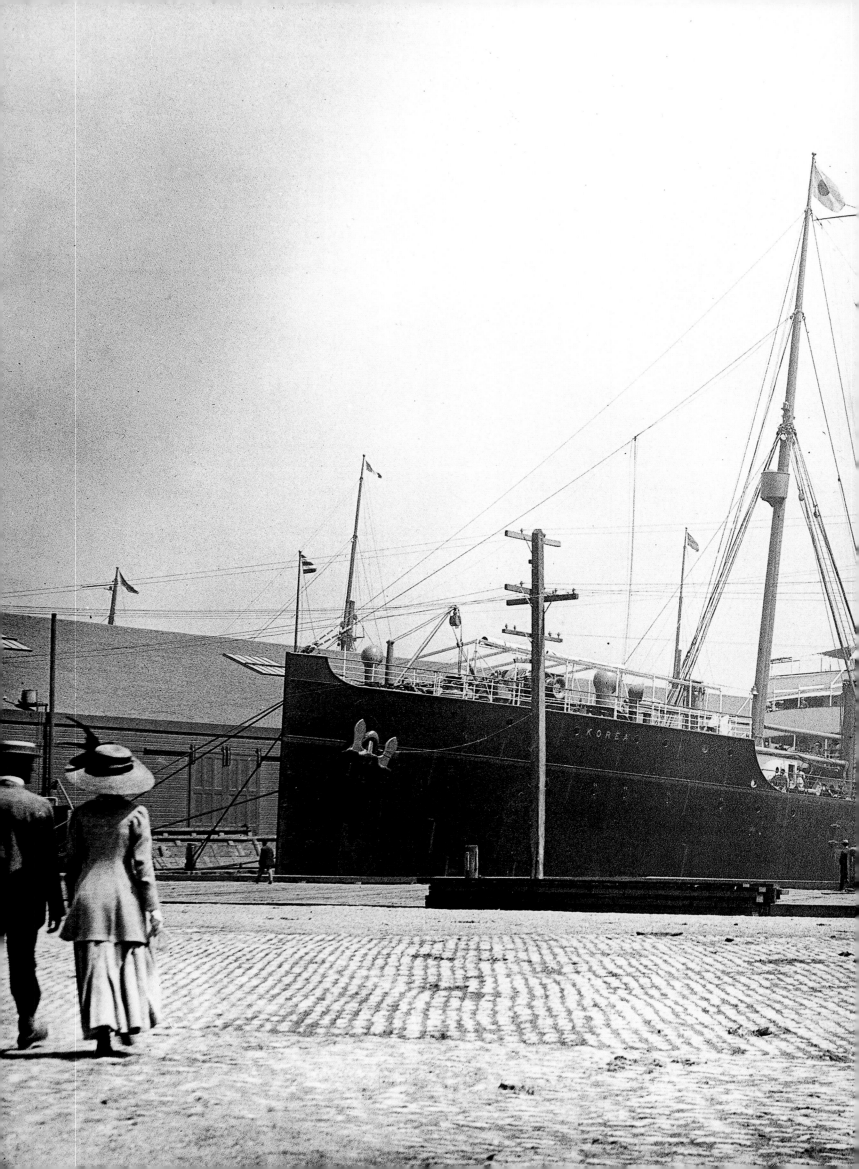

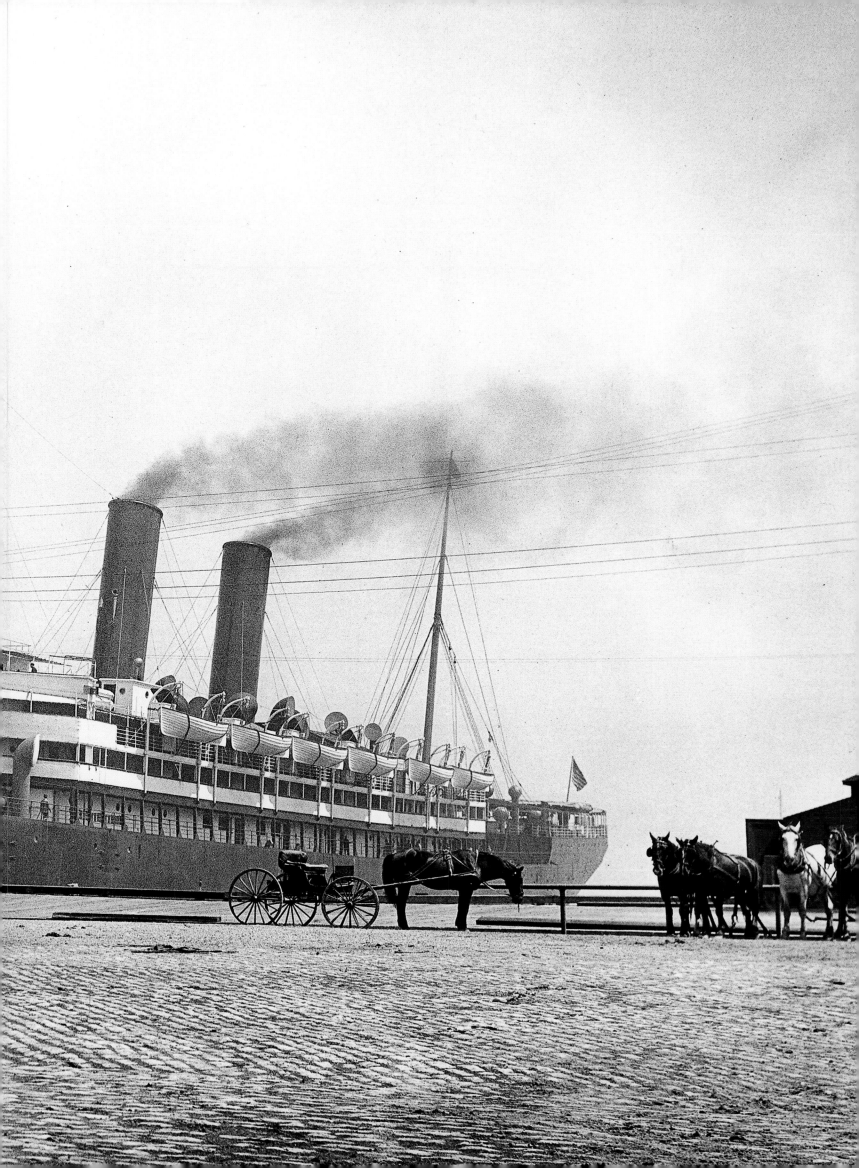

BELOW AND OPPOSITE: Illustrations from the catalogue of Peace Dale, a textile manufacturing company established in New England in the early nineteenth century, noted for its tartan travel rugs.

PAGE 1: Evocative mementos from the archives of four great transatlantic ocean liners of the French Line: a brochure promoting the *Paris*; a booklet from the *France*; a ribbon from the *France* in 1962; and a menu from the inaugural dinner on board the *Lafayette* in 1932.

PRECEDING PAGES AND OVERLEAF: Two liners set sail from different continents: the Pacific Mail fleet's *Korea* (pages 2–3) leaves San Francisco for Australia in 1904; and the *France*, of the Compagnie Générale Transatlantique (French Line), is cheered by crowds on the quayside at Le Havre on her way to New York in 1912 (pages 6–7).

CATHERINE DONZEL

LUXURY LINERS

Life on Board

THE VENDOME PRESS
NEW YORK

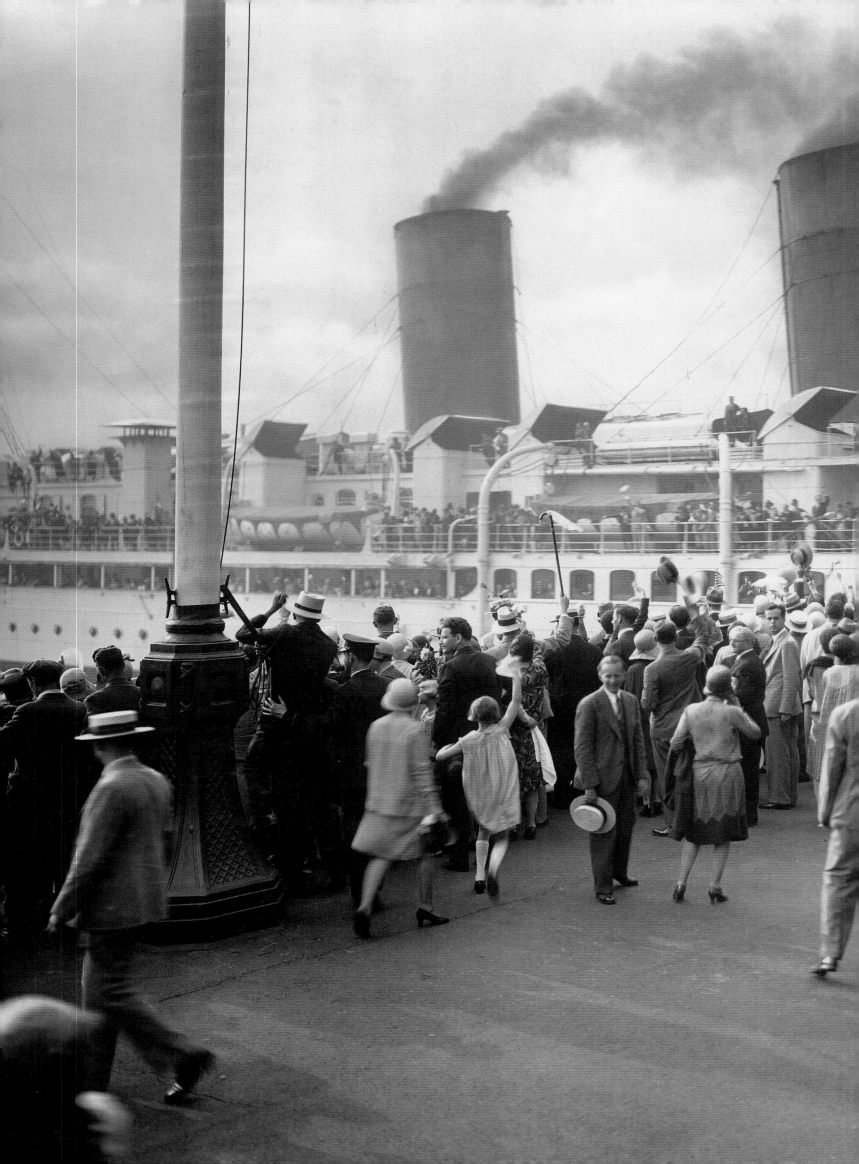

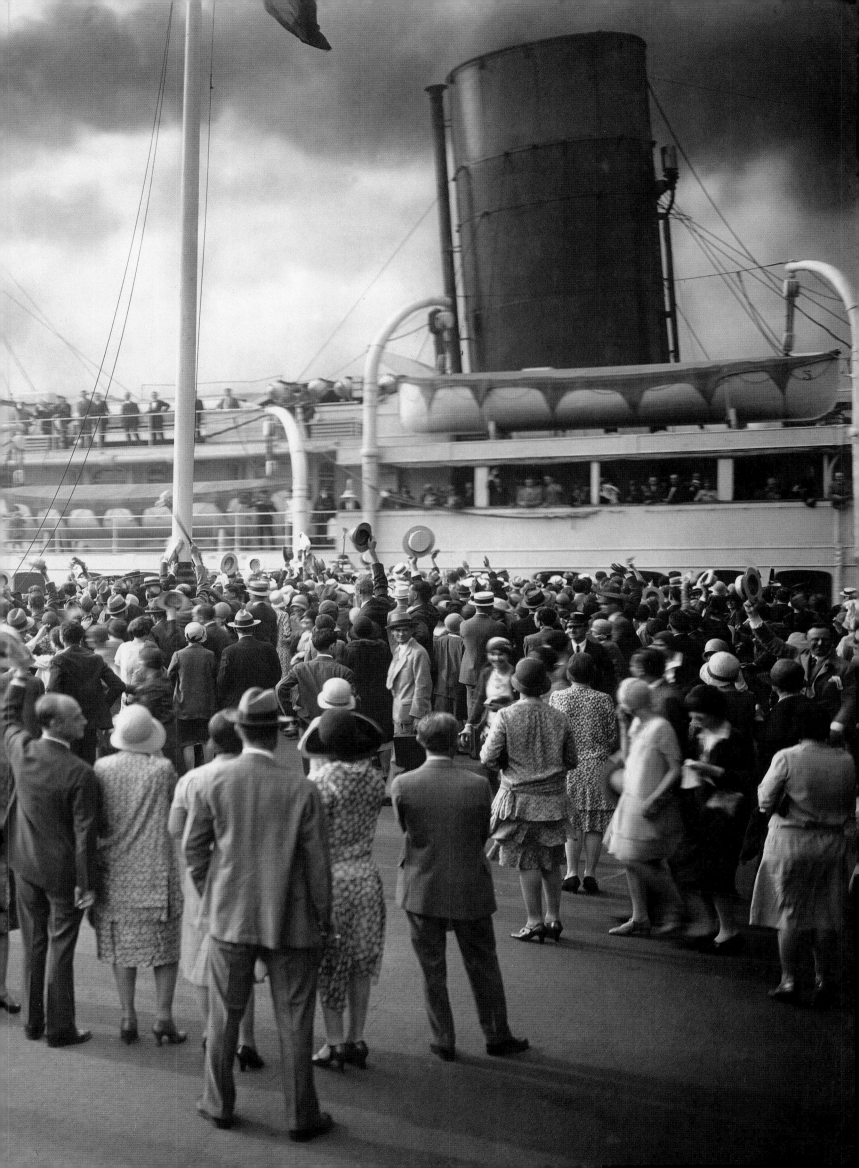

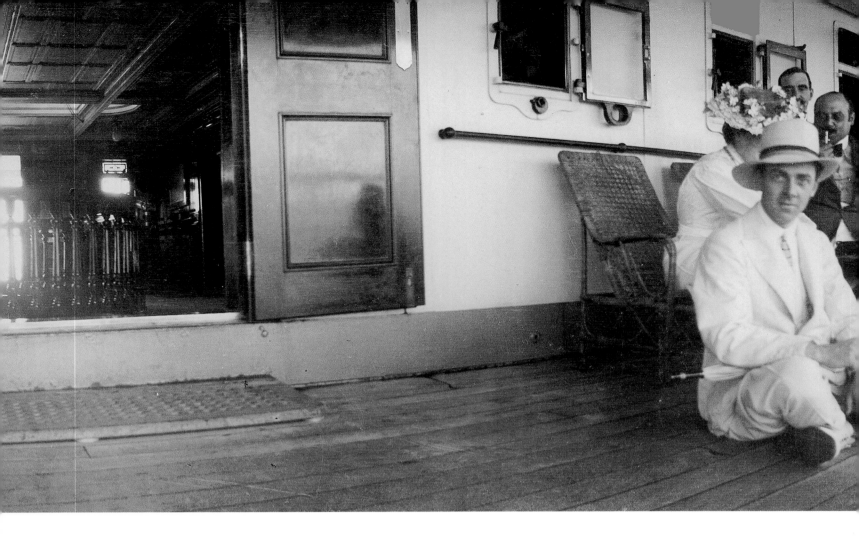

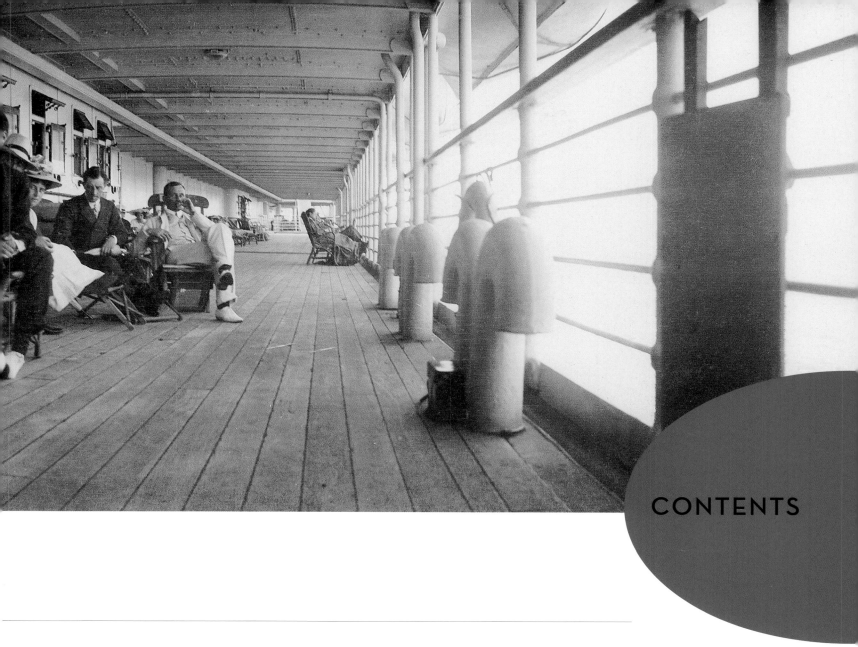

CONTENTS

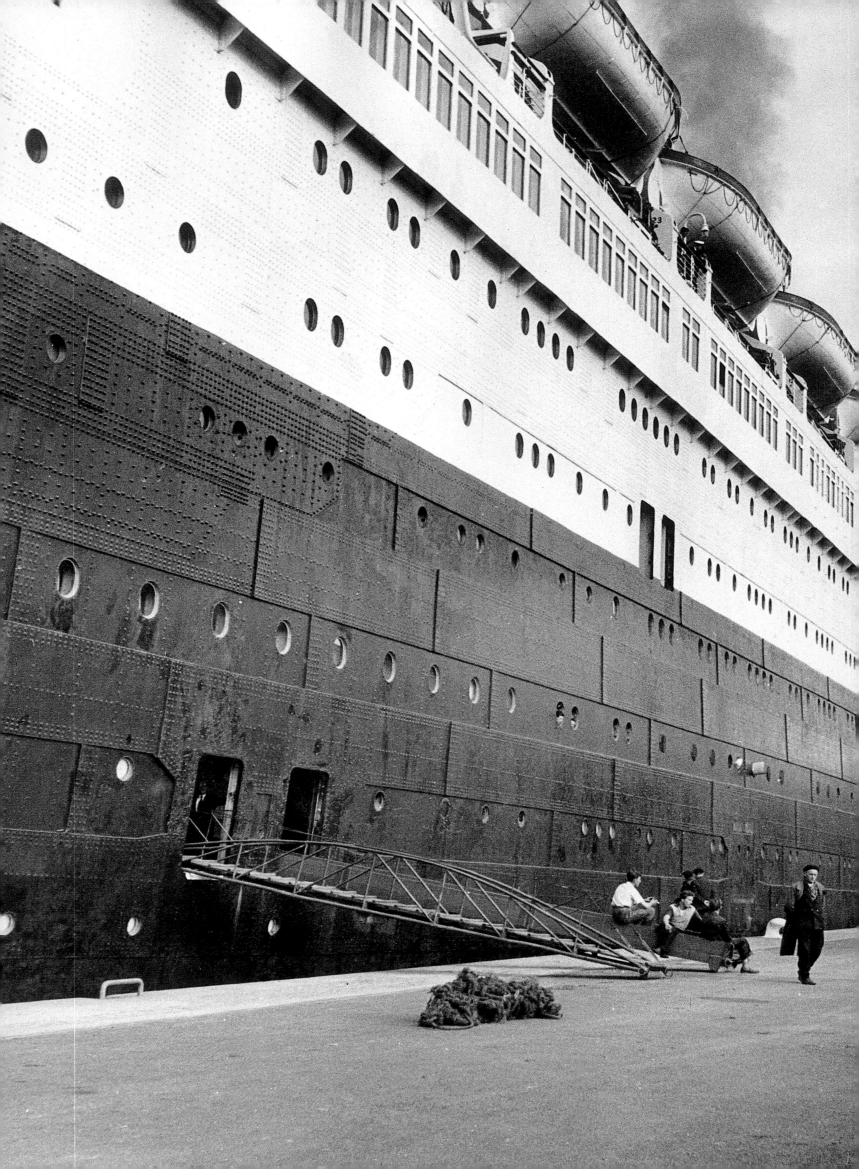

FORGETTING THE SEA

"It seemed to me what it was: tremendous."

Jules Verne, *A Floating City*

TREMENDOUS! What better word could there be to describe these leviathans of the sea, gliding sleekly and virtually noiselessly through the dark waters with all their lights ablaze? Simply tremendous, with a tremendous number of gangways and engines, a tremendous degree of luxury—and above all the tremendous throngs of people, everywhere from the hold to the top deck, dressed in boiler suits, liveries, uniforms, tweed sports jackets, and evening gowns. Also tremendous was the irrepressible thrill of excitement that rippled through the crowds of onlookers and passengers at their first sight of this great ocean liner, those who craned their necks from quaysides and tenders to scan the vertiginous heights of the vessel's steel flanks, like sightseers in the Egyptian desert gazing up at the pyramids. After all, these colossal steamers were hailed as the eighth wonder of the world. The *Imperator*, which was launched in 1913, with its huge imperial eagle figurehead; the *Roma* (1926), "broader than the Rialto and taller than the leaning tower of Pisa"; the *Rex* (1932) with its twelve decks; the *Normandie* (1935), as long as the avenue de l'Opéra in Paris; and the *Queen Mary* (1936) with each of her funnels capable of accommodating three locomotives side by side—all of these ships were built on a quasi mythical scale. They were also all in fierce competition with each other, not only for spectacular looks, but in their prodigious speed. These epic contests were most furiously fought on the formidable Atlantic routes between the European ports and New York, where only these giants could withstand the mountainous seas, the furious winter gales, and the numbing cold, which froze the sea spray that lashed their masts and decks. From the early nineteenth century, the Atlantic routes became the most frequented for both profit and trade, the choice of both for Americans in a hurry—magnates of finance and industry—and the sacks of mail filling the ships' holds. The original vocation of these "packet boats" was carrying letters and packages, and transporting the mail from continent to continent always remained a vital part of business.

By the 1840s, most Western nations had started sending their mail by sea. The age of steam navigation brought with it the creation of regular routes, with arrivals and departures planned according to timetables. The shipping lines that showed themselves capable of meeting these deadlines not only pocketed government subsidies, but also—and better still—stood a chance of carrying off the coveted "Blue Riband." Fluttering from a steamer's

PRECEDING PAGES: Relaxing on deck on the SS *Ortona* of the Orient Line in 1905. The *Ortona* sailed from London to Sydney via Gibraltar, Suez, and Colombo; here she is seen crossing the Indian Ocean.
OPPOSITE: The *Queen Mary*, of the Cunard/White Star Line, making a call in May of 1952 at the port of Cherbourg, recently rebuilt after war damage.
RIGHT: The Cunard liner *Saxonia* depicted on a picture postcard from the 1960s.
TOP: The logo of the French Line, as it appeared on the back of a ship's menu.

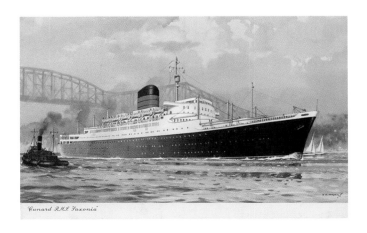

Cunard R.M.S. Saxonia

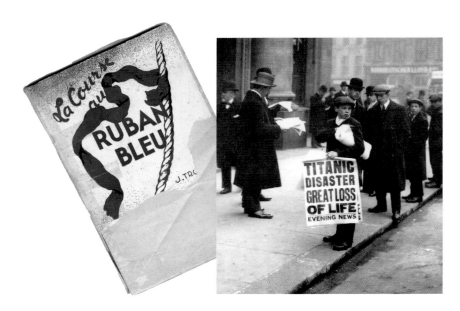

"In all its poignant horror, this is the story of the tragedy of the *Titanic....*" So starts nautical historian Jean Trogoff's account of the calamitous sinking of the "world's safest ship" (according to her owners), in his book *La Course au Ruban bleu*, published in 1945 (far left). Outside the White Star Line offices in London, a newsboy breaks the news that shocked the world (left).
OVERLEAF: On the quayside at Seattle, a crowd watches as SS *President Grant*, of the Dollar Admiral Oriental Line (later to become the Dollar Steamship Line, then the American President Line), sets sail on her maiden voyage to the Far East in 1921. The *President Grant* had formed part of the U.S. Emergency Fleet during the First World War.

masthead, this trophy declared her the proud holder of a new speed record for the Atlantic crossing between Europe and New York. Whenever a vessel carried off this trophy, the line to which she belonged was guaranteed to see its bookings soar—until another ship snatched the title. It was a relentless and cutthroat competition that continued for over a century, with all the major shipping companies entering the fray. These were the British lines, which naturally included the tremendously powerful Cunard, incorporated in 1840, and its rival White Star, established five years later; American lines such as Collins; the French Compagnie Générale Transatlantique (CGT, generally known as the French Line) founded by bankers known as the Pereire brothers; and the Germans, with the splendid vessels of the Hamburg-Amerika line (HAPAG), set up in 1847, and of the Norddeutscher Lloyd line (NDL), created a decade later. Regulations were torn up and caution was thrown to the wind in the race to gain the Blue Riband, with commanders ready to take any risk in all weather. On board the competing ships, meanwhile, millionaires would place bets of jaw-dropping size on the outcome of the race, while in New York, where the wagers were collected, spectators eagerly awaited the arrivals. Concerned passengers lodged numerous complaints and

objections, and with good reason, for as this single-minded recklessness took its inevitable toll, the tragedy of shipwreck became commonplace. Between 1854 and 1856, in pursuit of this goal, two magnificent vessels belonging to the Collins line plunged to the depths of the ocean while steaming at full speed, taking with them hundreds of doomed passengers, among them Mrs. Collins, wife of the founder, and her two children. Its reputation in tatters, the Collins line was forced into liquidation.

Clearly speed was a powerful attraction, but on its own it was not enough to attract the requisite number of passengers. The challenge now was to regain passengers' trust, to allay their fears, and by some means or other to persuade them to enjoy the crossing: in short, to make them forget the brooding presence of the sea. The French took this lesson to heart with characteristic style, creating an atmosphere of jaunty elegance on board their vessels. Launched in 1891, the *Touraine*, a giant of the French merchant fleet, created a delightful first impression and boasted spacious cabins, a charming smoking lounge of Japanese inspiration, mahogany woodwork, and fine cuisine. Equally conscious of the truth that the way to a passenger's heart was through his stomach, the Germans commissioned no lesser a gourmet than Escoffier himself

RIGHT: Emigrants on the deck of the *Kaiser Wilhelm der Grosse*, c. 1900. Inset is a Cunard luggage label.
OPPOSITE ABOVE: A sign of the times: the first-class smoking and games room on *La Touraine* was an exclusively male enclave.
OPPOSITE BELOW: A poster by Dellepiane advertising the mail boats of the Messageries Maritimes (left), and a postcard sent by a passenger on the P&O liner *Persia*, which traveled to Gibraltar between 1910 and 1915.

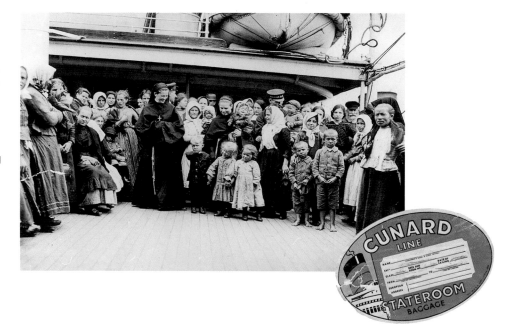

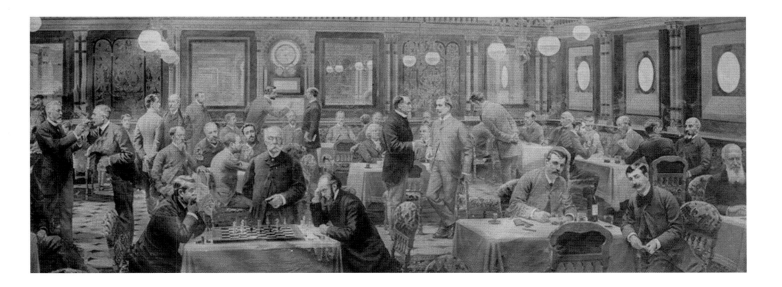

to draw up the menus for the HAPAG liners. Nor did they skimp on the fitting out of their cabins and public rooms: the *Kaiser Wilhelm der Grosse*, flower of the NDL fleet, positively dripped with gilding and extravagant decoration. With its luxury and comfort, its sheer scale and its reassuring impression of solidity, the German approach was a great success with the public. The four funnels of the HAPAG liners came to symbolize safety in the minds of passengers—so much so that the directors of the White Star line decided to give the *Titanic* four funnels, even though its engines only required three, the fourth being purely for show.

This was a ploy intended above all to lure the emigrants who traveled in steerage, and frequently outnumbered first- and second-class passengers put together, and who booked their passage on the basis of examining models of the vessels concerned. The emigrants might have been poor, but they had the power of numbers on their side. Between 1820 and 1920, no fewer than seventy-two million Europeans left their own countries in the hope of making a better life elsewhere—thirty-four million of them bound for the United States. Consequently the price war waged by the different lines for tickets in steerage was ruthless. This trade was a godsend for the shipping lines,

and the British, who had numerous Irish emigrants at their disposal, took full advantage. The German lines were also well placed, filtering emigrants from Central Europe via Hamburg and Bremerhaven. The French Compagnie Générale Transatlantique, meanwhile, though less well placed geographically, enterprisingly dispatched recruiting agents to Austria, Italy, and the Balkans to drum up customers. Entire villages were set up near European ports to receive and process the emigrants.

Although New York was far and away the most popular destination, other companies plied many other routes. The Canadian Pacific Railway Company, for example, with its fleet of steamers all named *Empress*, offered a crossing from Southampton to Quebec, with the possibility of continuing by railway to the Pacific via a transfer at Vancouver. After that, any destination seemed feasible: Australia, perhaps, or Yokohama, or even Hong Kong. And from there it was possible to link up with the great Oriental lines—the territory of the Peninsular & Oriental Steam Navigation Company, which served Britain's vast empire in India and the East.

In reality, however, the Oriental crossings had little in common with those on the transatlantic route. These were long, leisurely cruises of several weeks, punctuated

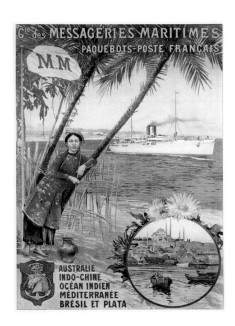

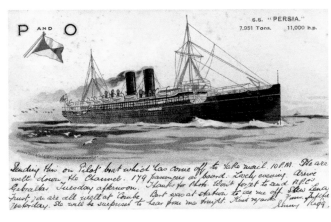

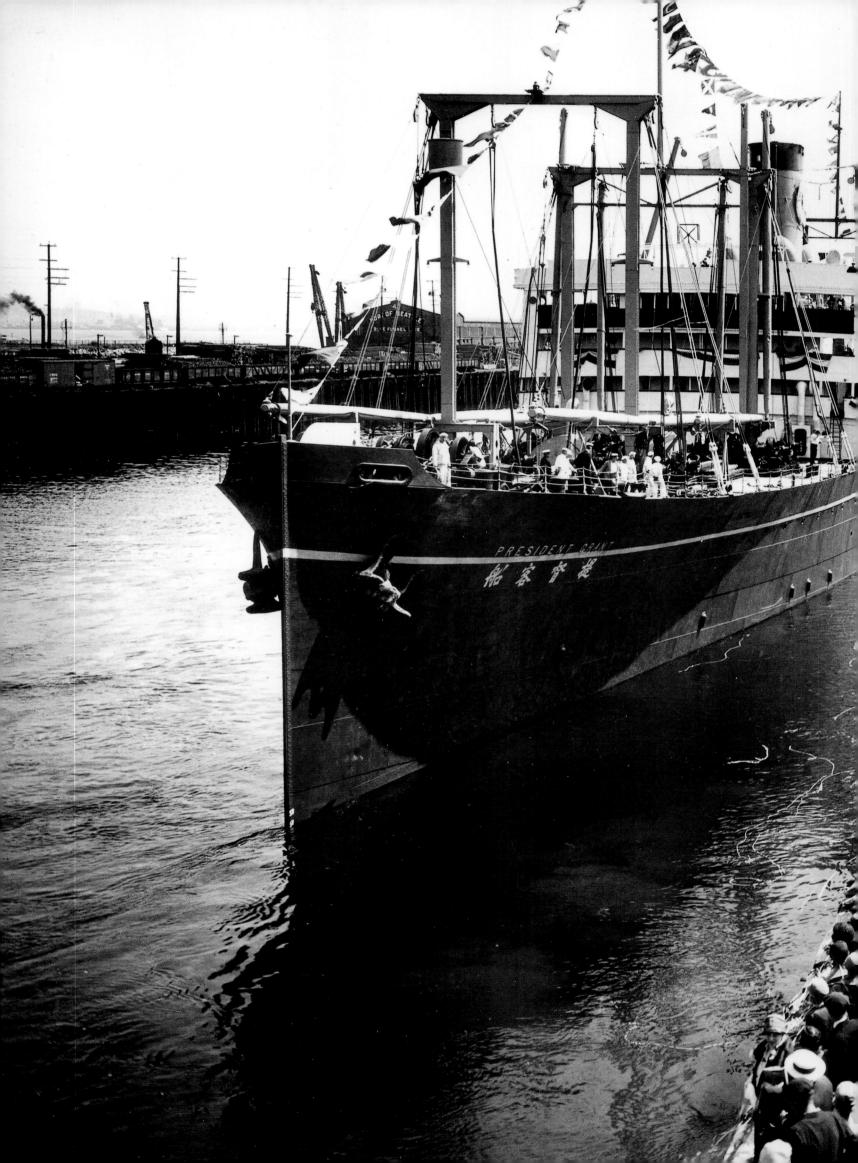

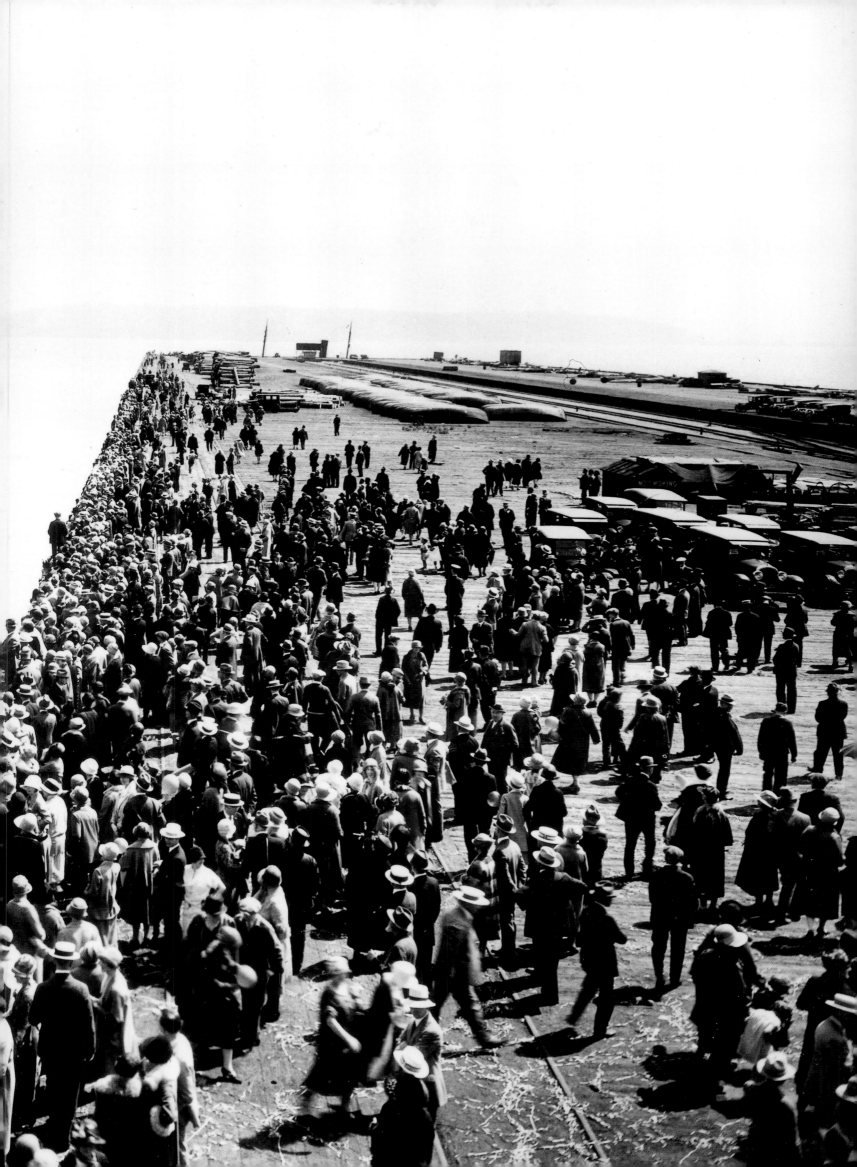

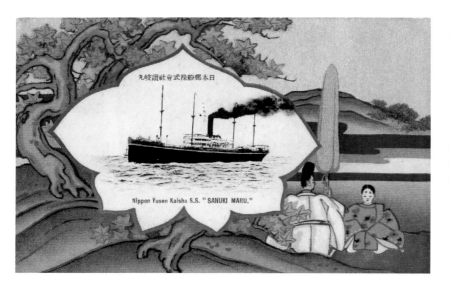

by exotic ports of call, fanned by spice-laden breezes, and occasionally lashed by typhoons and monsoons. Marseille was the port of departure for liners sailing under the French flag. By 1900, those of the Messageries Maritimes line made regular mail deliveries to India, Indochina, and Japan, with a twice-weekly service to Madagascar, Réunion, and Mauritius, and a monthly trip to Australia. The Compagnie Générale Transatlantique, meanwhile, served North Africa, where starting in 1920 it also organized tourist trips based around a considerable network of grand hotels in towns and oases, and even on the fringes of the Sahara. These activities as tour operators were a sign of things to come.

Indeed, the tide was now turning. The first blow came in 1923, when America announced drastic cuts in its immigration quotas. The great ocean liners responded by ripping out steerage accommodation and replacing it with "tourist class" quarters. But although the numbers of tourists grew with the rising standard of living in America, they would never be as numerous—nor as profitable—as the emigrants. With the Wall Street crash of 1929, matters could only get worse. By 1933 the White Star line, which had boasted no fewer than thirty-one liners in 1911, had only four serving New York, and even these frequently sailed virtually empty. Yet it was at this point, when the age of the superliners was drifting inexorably towards its close, that the extravagant glamour and luxury of life afloat reached its most sybaritic heights, from the sleekly glossy *Ile de France*, on which Errol Flynn, in tuxedo and red socks, lived on a diet of caviar and champagne, to the fabulous *Queen Mary* and *Queen Elizabeth*, pearls of the British fleet, and finally the *Normandie*, the "ship of light," and perhaps the loveliest of all, which was to end its days as a burnt-out hulk at the bottom of New York harbor. It all made for a hard act to follow, especially when travelers were starting to wonder whether they might not do better to cross the Atlantic by air at a speed of five hundred knots, rather than by sea at a mere thirty or thirty-five knots. Yet this was the challenge taken up by the *France*, in all her synthetic and Formica glory. In 1972 she made her first round-the-world cruise, making fabulous ports of call at Colombo, Bali, and Easter Island—only to find a special reception committee of tax officials that greeted rich passengers on her return home. Not surprisingly, her second round-the-world cruise in 1974 proved rather less popular. But the tide had definitely turned by now, and the great ocean liners had entered the realm of legend.

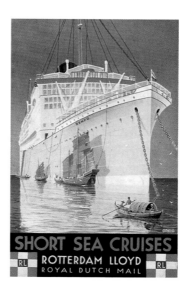

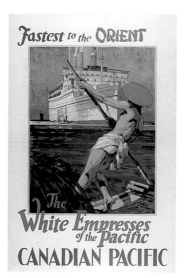

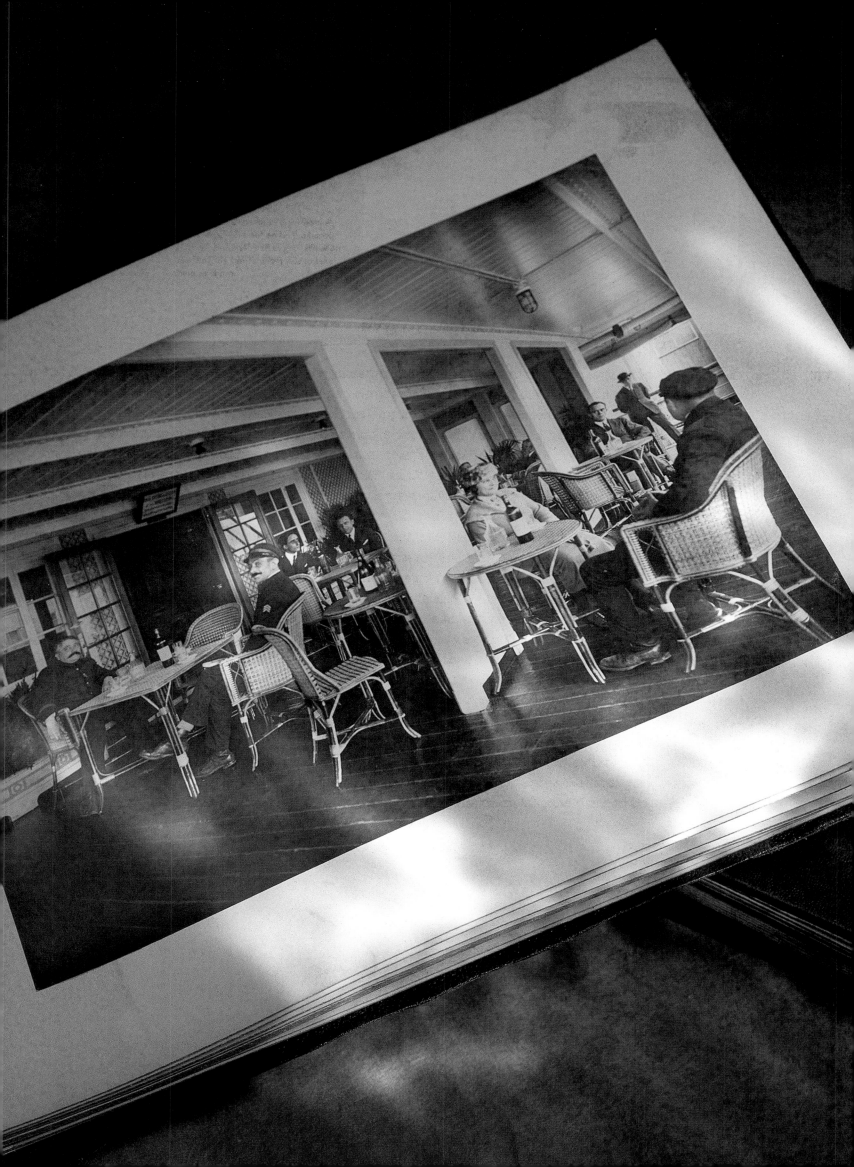

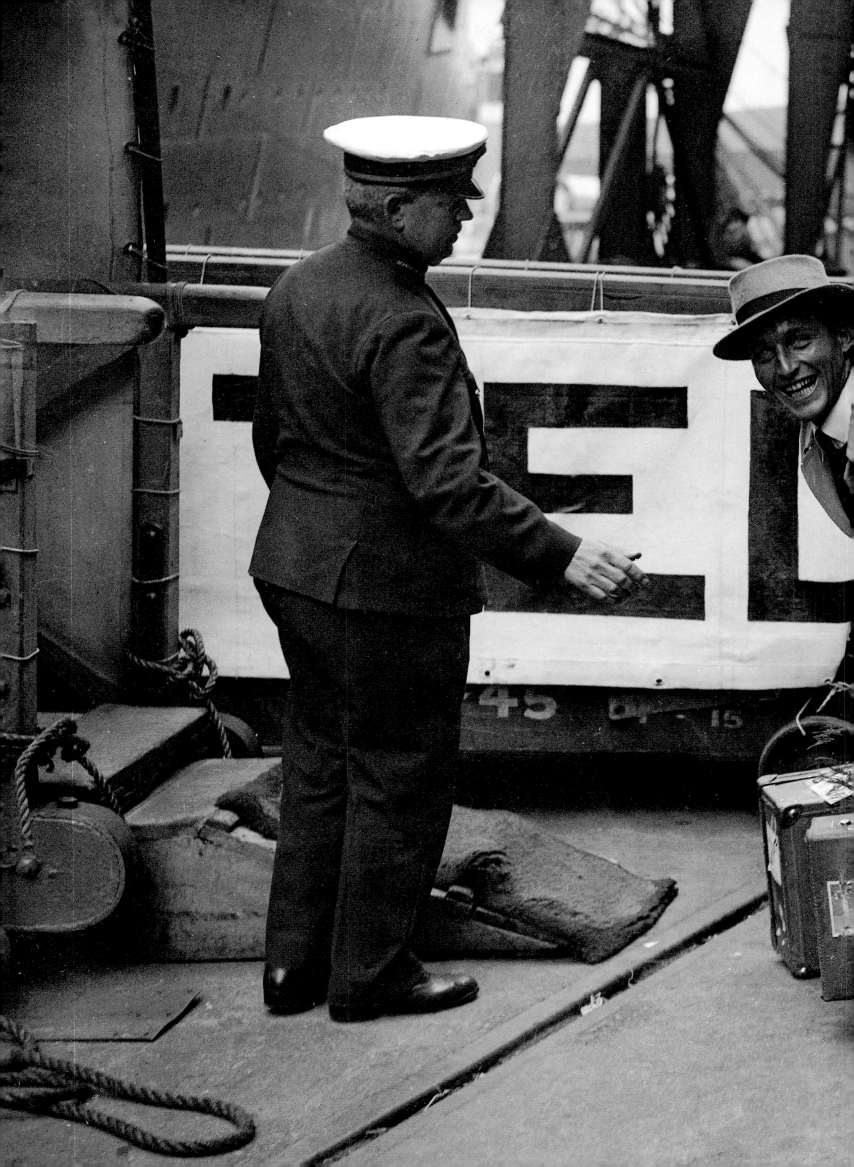

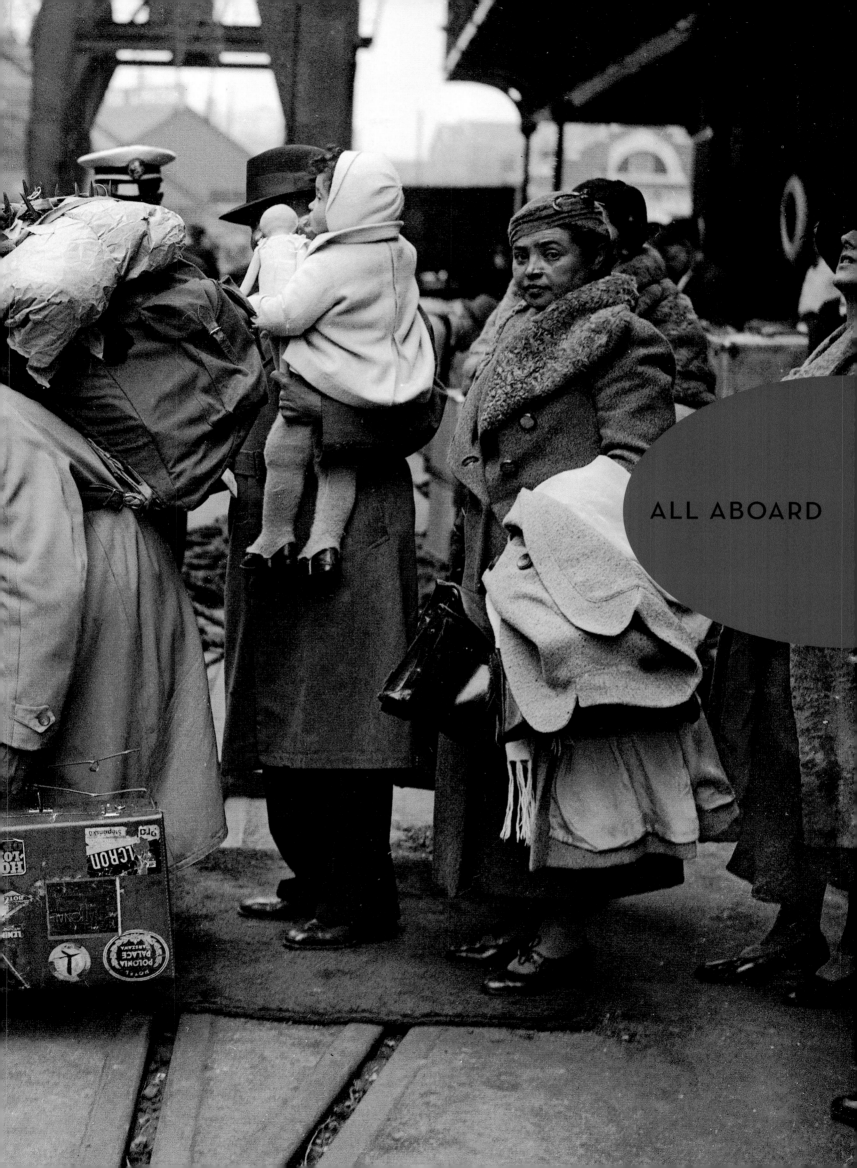

ALL ABOARD

> *"May this ship thus fulfill its destiny: to carry people to people."*
>
> **Charles de Gaulle, on launching the *France***

PARIS, MARCH 1936. Mr. and Mrs. Herbert Carter will not be boarding at Liverpool. The P&O liner that is to carry them to the Dutch East Indies will set sail without them. Instead they will join her at Marseille, so that Carter may treat his young wife to a few romantic days in Paris. There Mrs. Carter will take advantage of the opportunity to visit a number of elegant shops, in order to put the finishing touches to her wardrobe. It is already March, and they will be crossing the Red Sea under torrid skies, so cruise-wear of billowing natural silk and linen, worn with tennis pumps, will be de rigueur—as will a silk evening gown for dining on board, for the Carters are traveling first class. Their stay in Paris ends at the Gare de Lyon, where Herbert has reserved sleeping accommodation for two on the "boat train," which brings them right to the harbor at Marseille Maritime the following morning. There, a mere hundred yards away, the great liner lies at anchor: she has just docked and is preparing to leave at midday. Filled with excited anticipation at the prospect of the voyage and of his posting in the Far East, Herbert sets about hailing porters with enthusiasm. His young wife, meanwhile, shyly follows him as he thrusts his way through the crowd, while the passengers who embarked

at Liverpool hurry to scrutinize the new arrivals from the ship's rail above.

Marseille, September 1901. Joseph Tremble, a young naval officer, writes to his parents, "As I promised, I am writing to you before I go aboard. The steamer, which is called the *Armand Béhic,* sails at four o'clock, and it is now two o'clock. As soon as I have written this letter, I shall go to the post office and wire you a telegram." The *Armand Béhic* is one of the new liners launched by the Messageries Maritimes line, and this is her maiden voyage. As Joseph observes, "This splendid new ship inspires complete confidence [and] is altogether as fine as the Transatlantic steamers that sail from Le Havre," with its white-and-gold salons and its bathtubs "carved from a single block of marble." The jetties and quayside are thronged with a great crowd that has come to see the ship off on her maiden voyage, and it could not get off to a more auspicious start. Better still, the young officer is no longer alone: already he has bumped into his friend and fellow officer Henri Faure, who clapped him on the back as he got out of the express train from Paris at the Gare Saint-Charles.

Like the Carters thirty-five years later, Joseph under-took the journey to Marseille by train, as was standard.

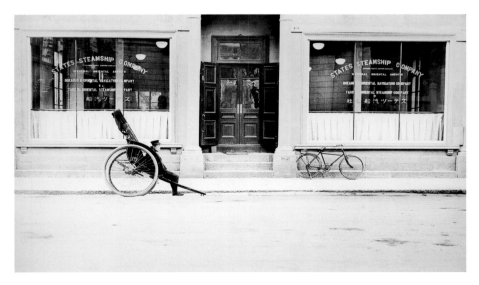

LEFT: The Japanese office of the States Steamship Company in Kobe. In the 1920s, the main shipping lines opened offices in all the world's major ports. **PRECEDING PAGES:** Third-class passengers on the quay at Southampton prepare to board the *Queen Mary* for her maiden voyage, on May 26, 1936. The day before, King Edward VII and Queen Mary had been guests at a sumptuous celebration thrown by Cunard/White Star Line. After the launch the queen noted in her diary: "Launched the world's largest ship today. Too bad it rained."

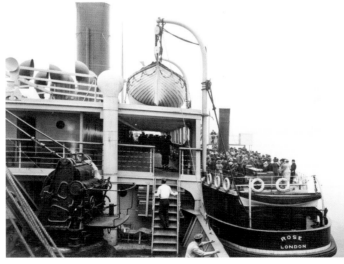

The history of the P&O line is inextricably bound up with that of the former British Empire. Starting in 1840, the company's ships sailed to Alexandria, where passengers crossed Egypt to the Red Sea in order to sail on to Ceylon and Calcutta—P&O's port of registry in India from 1842.

LEFT: An early twentieth-century photograph from the P&O archives showing passengers on a tender in the Port of London.

FAR LEFT: By 1910, P&O had extended its routes as far as the Far East.

ABOVE: Berth 102, the new transatlantic passenger terminal at Southampton, in 1956.

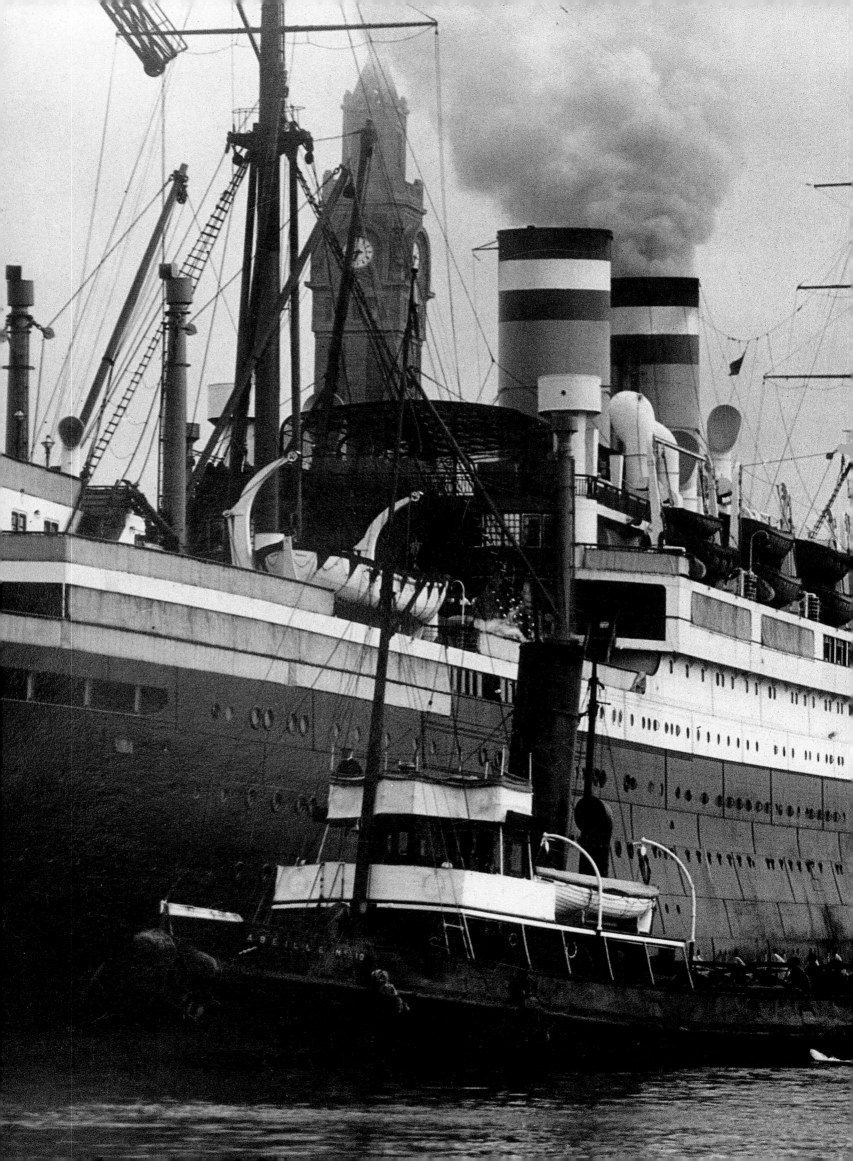

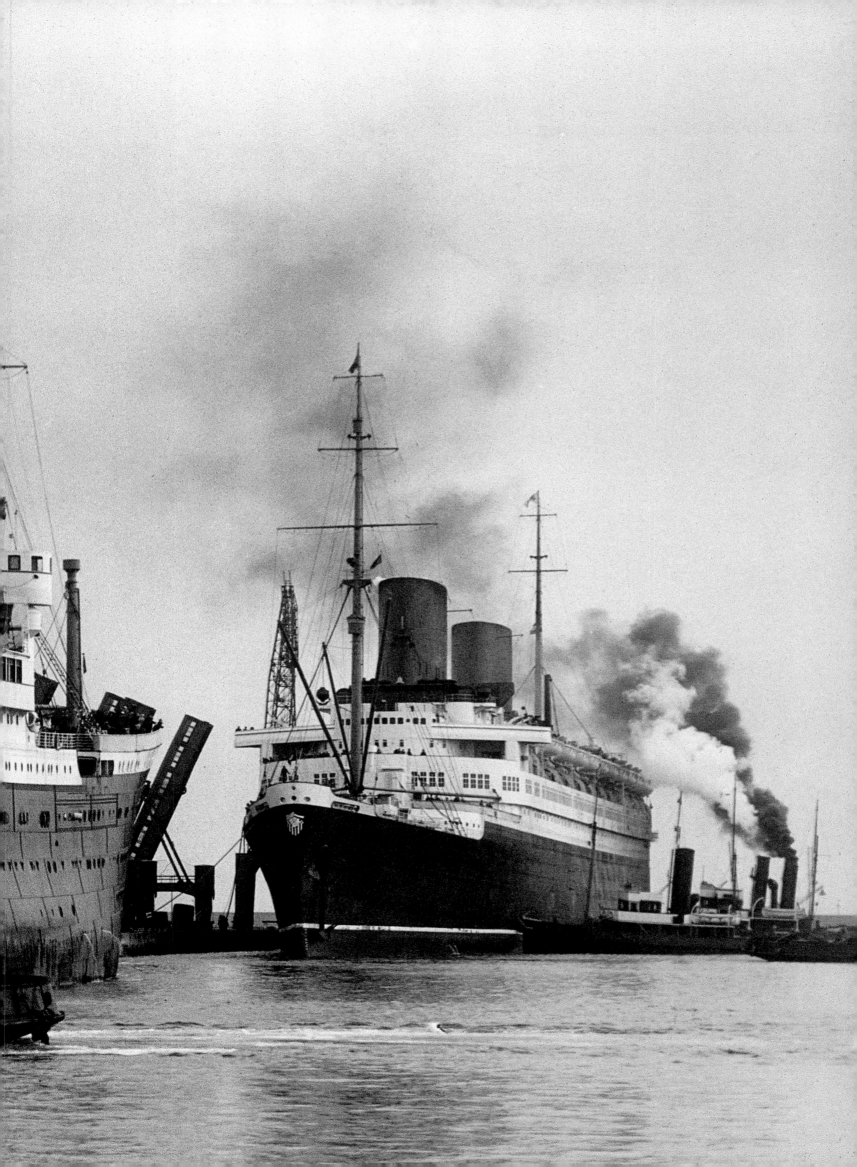

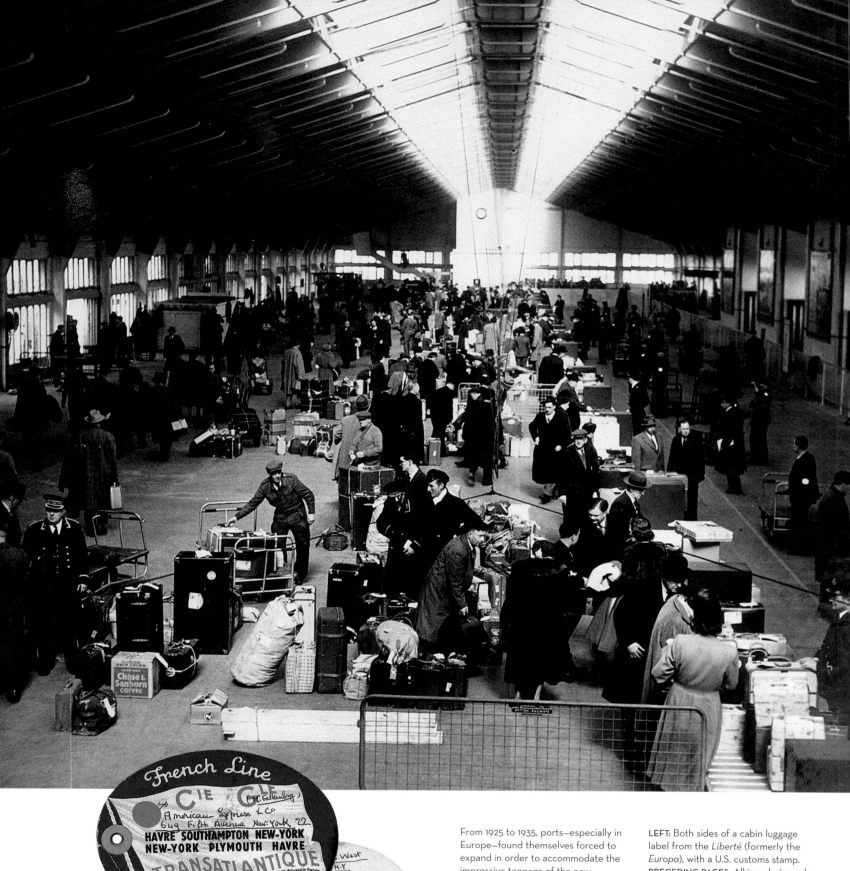

From 1925 to 1935, ports—especially in Europe—found themselves forced to expand in order to accommodate the impressive tonnage of the new superliners, and new harbor railway stations began to appear, as at Le Havre and Cherbourg. Heavily bombed during the Second World War, and in some cases totally destroyed, these ports underwent complete renovation and reconstruction in the 1950s.
ABOVE AND OPPOSITE ABOVE: The harbor station at Southampton in 1959: the first-class customs hall and a view of the Ocean Terminal, known as Berth 102, with the first *Queen Elizabeth* at anchor.

LEFT: Both sides of a cabin luggage label from the *Liberté* (formerly the *Europa*), with a U.S. customs stamp.
PRECEDING PAGES: All in a day's work at the port of Cherbourg in 1935: a brace of German superliners making port of call, the *New York* of the Hamburg Amerika Line, and the *Bremen* of the Norddeutscher Lloyd fleet.

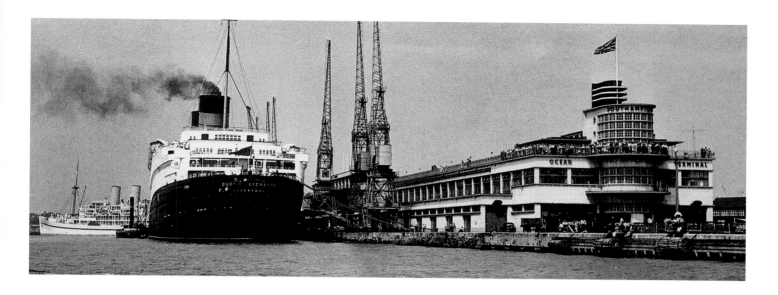

Virtually every sea crossing in the golden age of the ocean liners started in a railway station somewhere, and this close relationship between trains and boats proved of crucial importance to the shipping lines. It was no coincidence that the *Great Western*—the magnificent prototype of the ocean liner, and the winner of the Blue Riband in 1838 with the first transatlantic crossing powered by steam—had been the brainchild of the great railway engineer Isambard Kingdom Brunel. A skeptical member of the board of the Great Western Railway, aghast at the length of the proposed London to Bristol railway, had jokingly asked, "Why not make it longer, and have a steamboat from Bristol to New York and call it the *Great Western?*" And that was just what the unstoppable Brunel promptly set out to do.

So it was that, while the great liners were made ready for another crossing amid the deafening cacophony of clanking cranes and rattling chains and the pungent aroma of fresh paint, solder, and grease, trains by the thousand chugged into the ports of Europe. Trains from all over Central Europe streamed into Hamburg and Bremen; at Marseille and Brindisi, passengers who had just exchanged their buttoned and padded railway compartments for mahogany-lined compartments fancied

that they were already closer to the distant Orient; and in England, Liverpool saw its status as Britain's busiest port usurped by Southampton, now a mere hour and a half away from London via Waterloo Station. It was the railways that put Cherbourg and Le Havre within easy reach of Paris, and thereby linked Paris and New York—passengers who boarded the boat train at the Gare Saint-Lazare found themselves deposited in no time at the foot of the gangway, ready to board.

In due course, railway stations and docks combined to form massive terminals, which echoed with the whistles of steam locomotives and the booming of ships' foghorns. The vast transatlantic terminal at Le Havre, which offered the CGT over half a mile of deep-water docks, was completed in 1935, the year in which the *Normandie* was launched. Two years earlier Cherbourg had opened its new terminal, which was, after the palace of Versailles, one of the largest buildings in France. The massive Quai de France could accommodate two liners at once, making it possible for thousands of passengers to board or disembark in under an hour. The *Mauretania, Bremen, Berengaria,* and *Empress of Britain* were only a few of the magnificent vessels that moored here. Seven train services came and went daily, and the railway terminus was an

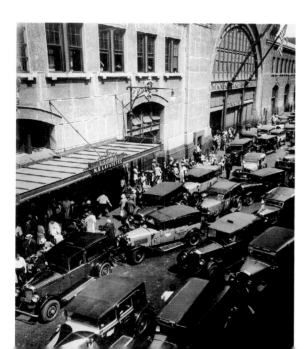

LEFT: A crush of private automobiles and taxis delivering passengers bound for Europe to the New York transatlantic railway terminal in the 1930s.
OVERLEAF: Gangways raised for the Norddeutscher Lloyd liner *Europa,* sister ship of the *Bremen,* as she sails out of the port of Cherbourg in 1935.

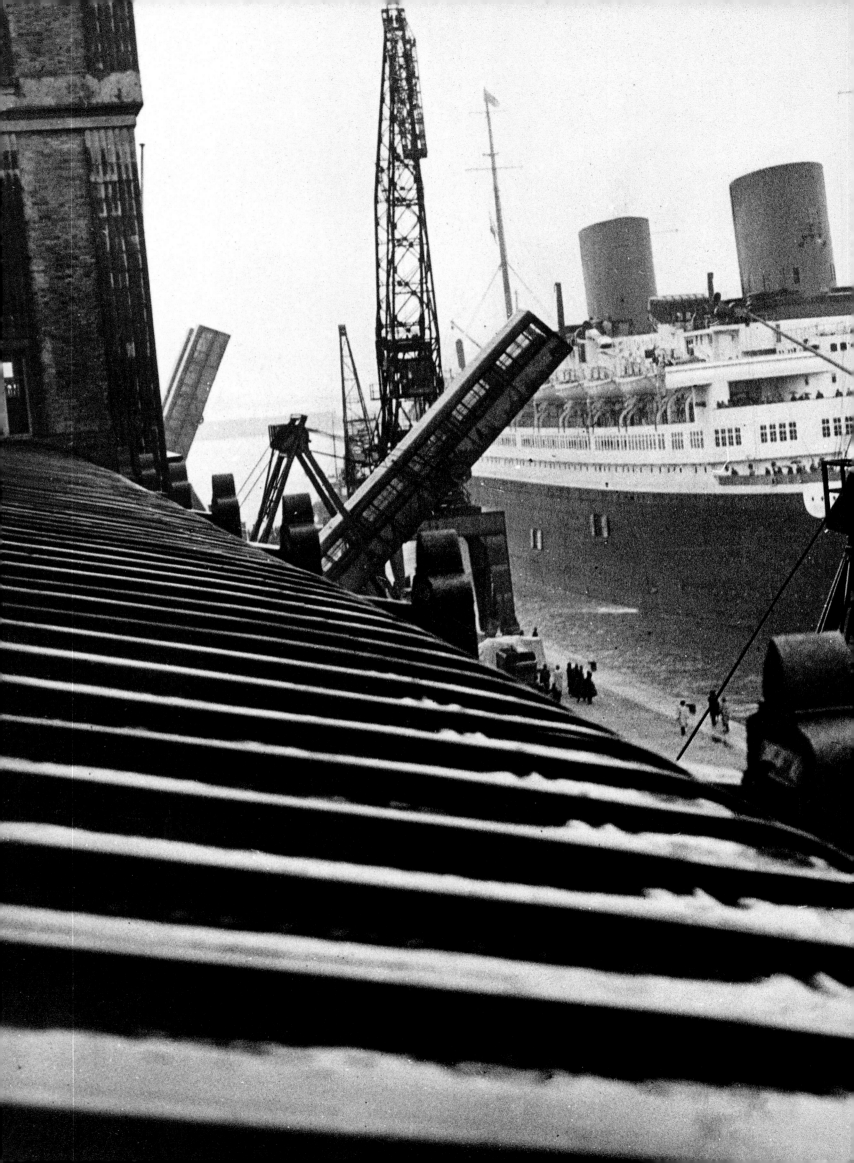

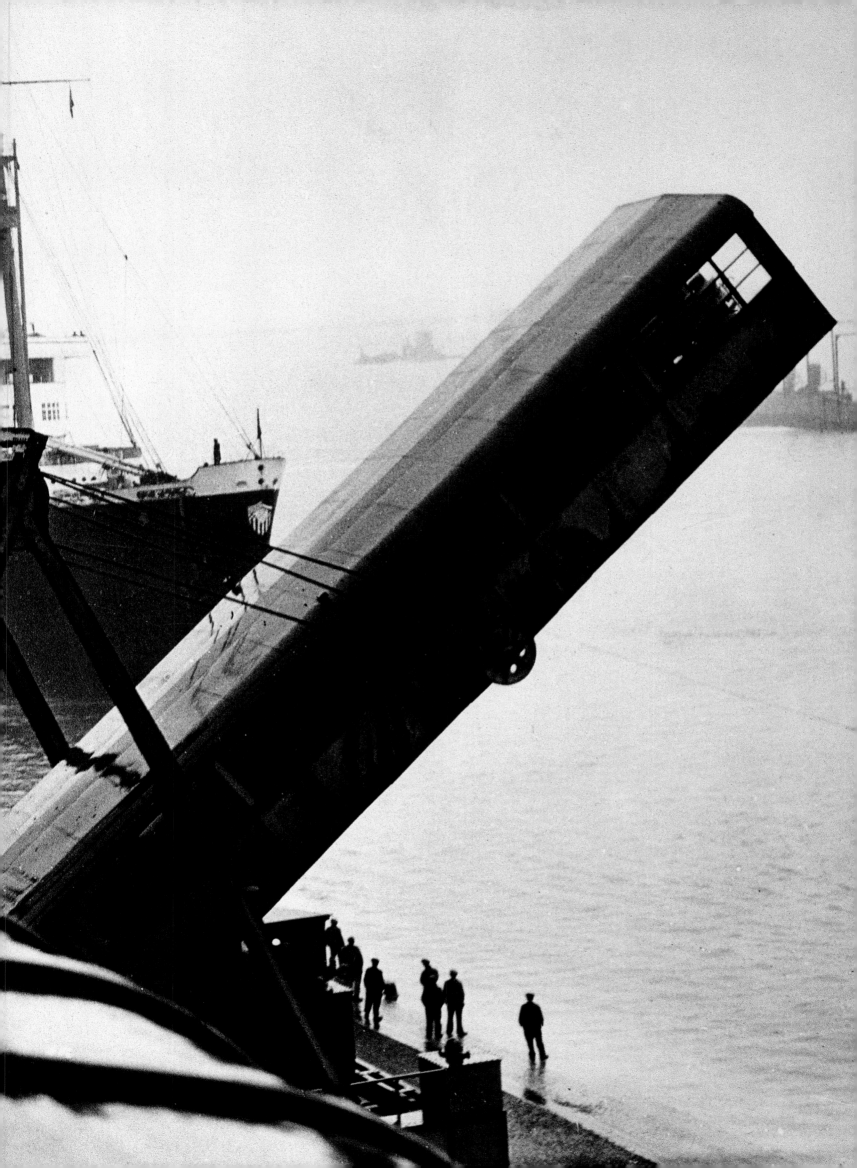

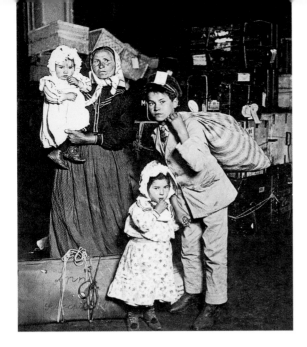

In the years between 1820 and the Wall Street crash in 1929, seventy-two million Europeans emigrated to the Americas (almost half bound for the United States). This exodus continued in the 1930s and '40s for those, mostly Jews, who were forced to flee the rise of National Socialism in Europe.
LEFT: A Central European family with their meager luggage, photographed by Lewis Hine in 1905.
BELOW: Emigrants at Le Havre undergo a medical inspection before embarking for New York, c. 1905.

The CGT or French Line had recruitment agencies in a number of European countries, the largest being in Basle, Switzerland, from which emigrants traveled to Le Havre by train.
OPPOSITE: First-, second-, third-, and fourth-class tickets from 1932 for the *Georges Philippar*, one of the liners of the Messageries Maritimes fleet.

28

equally imposing affair, several stories tall, with nine moveable gangways that gave access to the ships' flanks. In the waiting hall, which had precious wood paneling and mosaic floor, shops offered a tempting range of *Articles de Paris* for last-minute shoppers, and a bureau de change and post office were both at hand, all of which was designed to help passengers pass the time before going aboard.

At customs, officers stood ready behind huge oak and steel tables to carry out baggage checks; and in the offices of the *Police spéciale*, government officials prepared to check the papers of passengers who were intending to emigrate. Generally this was a mere formality, as the shipping lines took particular care to ensure that their passengers were already carrying the necessary paperwork, since they were responsible for repatriating—at their own expense—any passengers refused entry to the United States (the immigration screening station at Ellis Island was notoriously stringent in its decisions). To ensure that emigrants had all their papers in order, and that there were no last-minute surprises, the shipping lines chartered special trains to convey passengers intending to emigrate to the ports, and accommodated them in hotels built for this purpose. The Hôtel Atlantique

in Cherbourg, for instance, which opened in 1926 and could accommodate twenty-five hundred guests, was co-owned by Cunard, White Star, and Red Star. Run by French staff under the supervision of the United States public health department, it subjected passengers to a barrage of medical and customs checks before transferring those deemed to be of a satisfactory standard from the "contaminated area" to the "decontaminated area"—a choice of vocabulary that speaks volumes. Nonetheless, the general verdict seemed to be that the accommodation offered was acceptable, with adequate food and sleeping arrangements.

On land, the countdown to departure started days before the ship set sail: the business of embarking the passengers was a trifle compared with the long list of tasks that had to be gone through before every sailing. The arrival of the colliers "laden to the gunwales," or filled completely, with coal, announced the beginning of the process of taking on fuel. Ton upon ton of coal was stowed in the steamer's bunkers, enough to ensure that the great vessel could reach the next port, and then as much again "to be on the safe side"—double the amount that was strictly necessary was loaded. Until the introduction of oil, every voyage saw mountains of coal disappearing into the ship's

OVERLEAF: Coal being loaded by manpower on the *Shinyo Maru* (of Toyo Kisen Kaisha Lines) in the port of Nagasaki, c. 1915. Very few ports at this time were equipped with machinery for loading coal, or indeed any other goods.

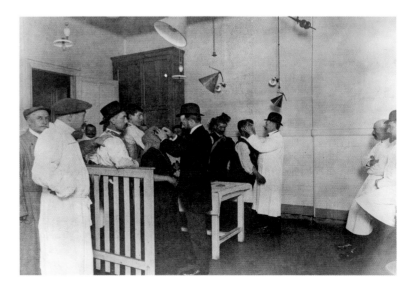

ERVICES CONTRACTUELS des MESSAGERIES MARITIMES
Société anonyme au Capital de 60.000.000 de Francs

Passage de Quatrième Classe كَ.إ.ت.لة

AVEC NOURRITURE — WITH FOOD

Débarqué

à _____

le _____

CF

'ORDRE 145

le Paquebot

art du _deux_

ENTE TROIS

X DU PA

SERVICES CONTRACTUELS DES MESSAGERIES MARITIMES
Société Anonyme au Capital de 60.000.000 de Francs

Reg. du Com.: Seine n° 176.390

EK

Passage de Troisième Classe

CATÉGORIE

N° D'ORDRE 549 Ligne de _Chine_

Voyage N° _11 R_

COUCHETTE

Sur le N/N _Georges Philippar_

Départ du _4 ?? ?? 10h ??_

Marseille

Débarqués

à _Saïgon_

le _21 Avril 1932_

à 21 heures

Rembarqué

à _Saïgo_

sur le

MPAGNIE DES MESSAGERIES MARITIMES
Société Anonyme au Capital de 75.000.000 de Francs

Passage de Seconde Classe

Ligne de _Inoch_

Ge R

COUCHETTE 218 B / 258 B

Capitaine _Baudet_

MPAGNIE DES MESSAGERIES MARITIMES
Société Anonyme au Capital de 75.000.000 de Francs

Passage de Première Classe

555 Ligne de CHINE

Voyage N° 11e Retour

COUCHETTE 77-AB

uebot "GEORGES PHILIPPAR"

23 AVRIL 1932. Capitaine VICQ

et Madame LANG WILLAR (Français) à 11 heures 30

arrête nt DEUX Place s de PREMIÈRE CLASSE

à MARSEILLE

Débarqué

à _____

le _____

Rembarqué

à _____

sur le _____

HANGHAI

ASSAGE (Nourri

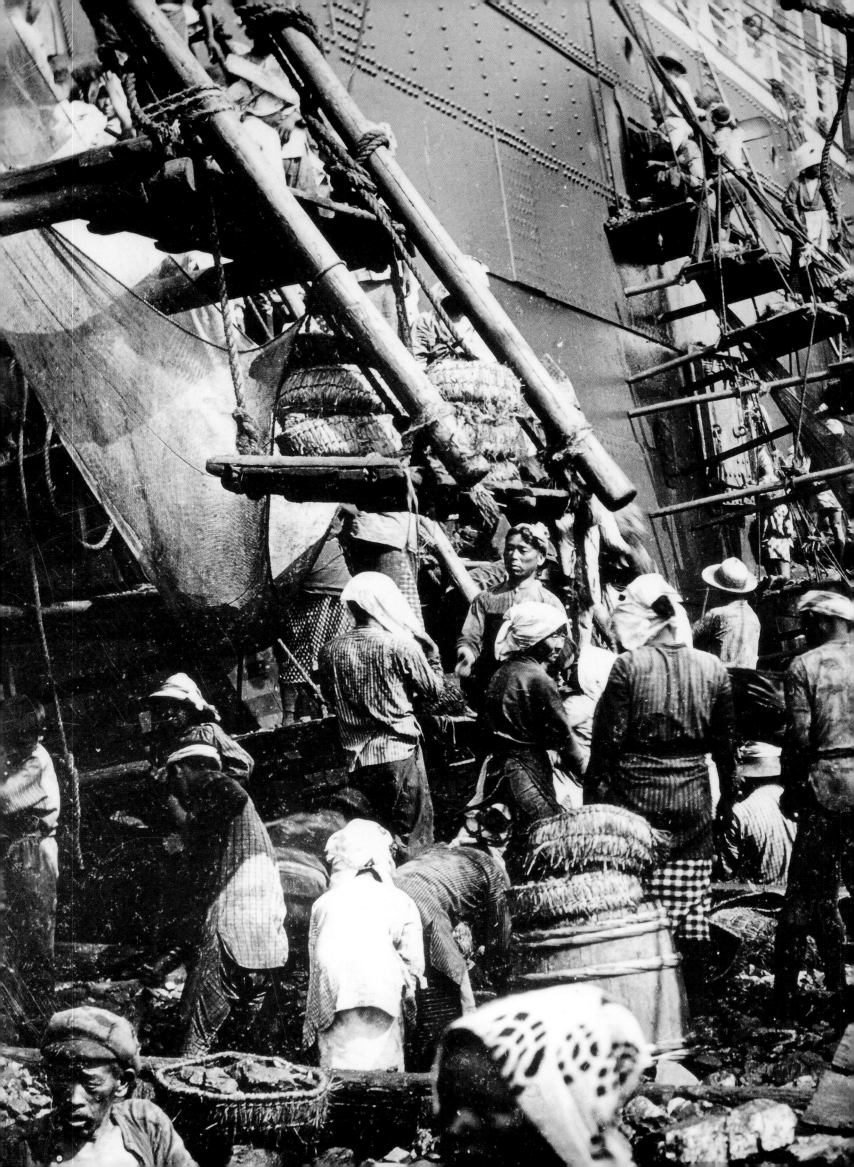

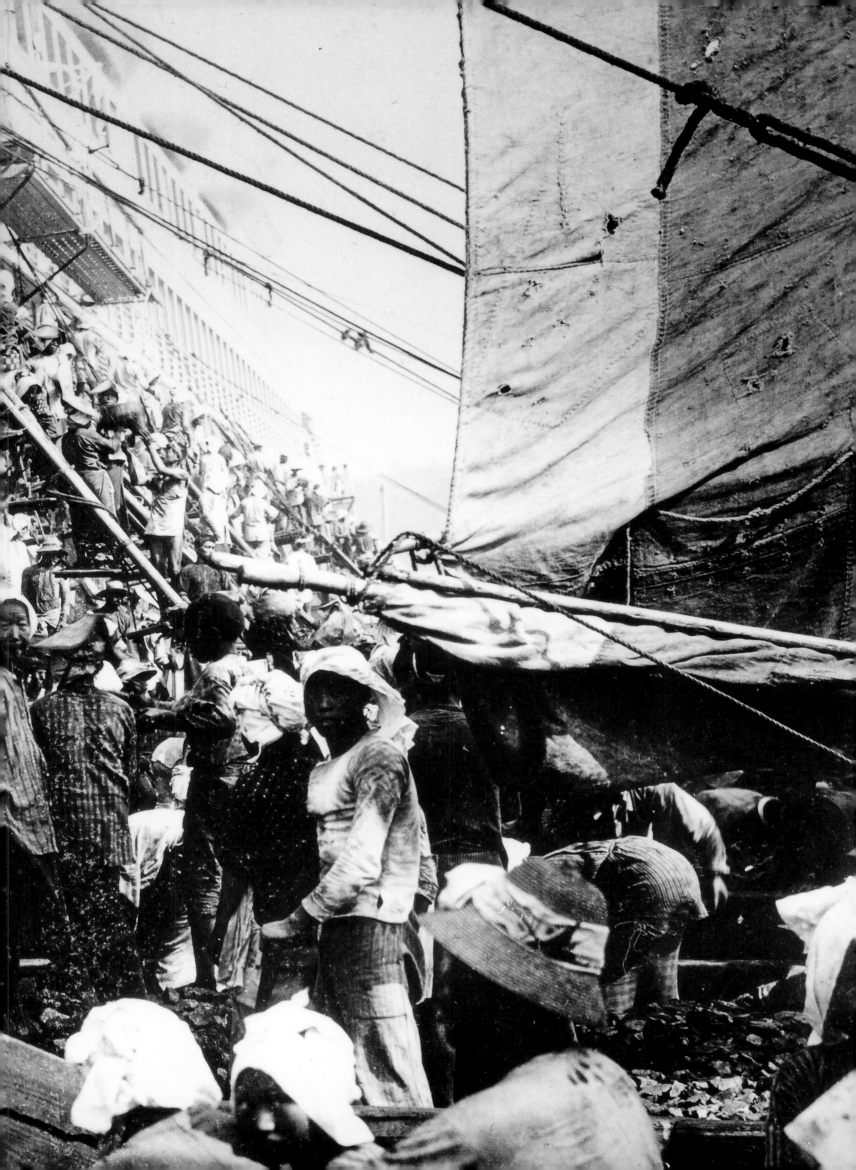

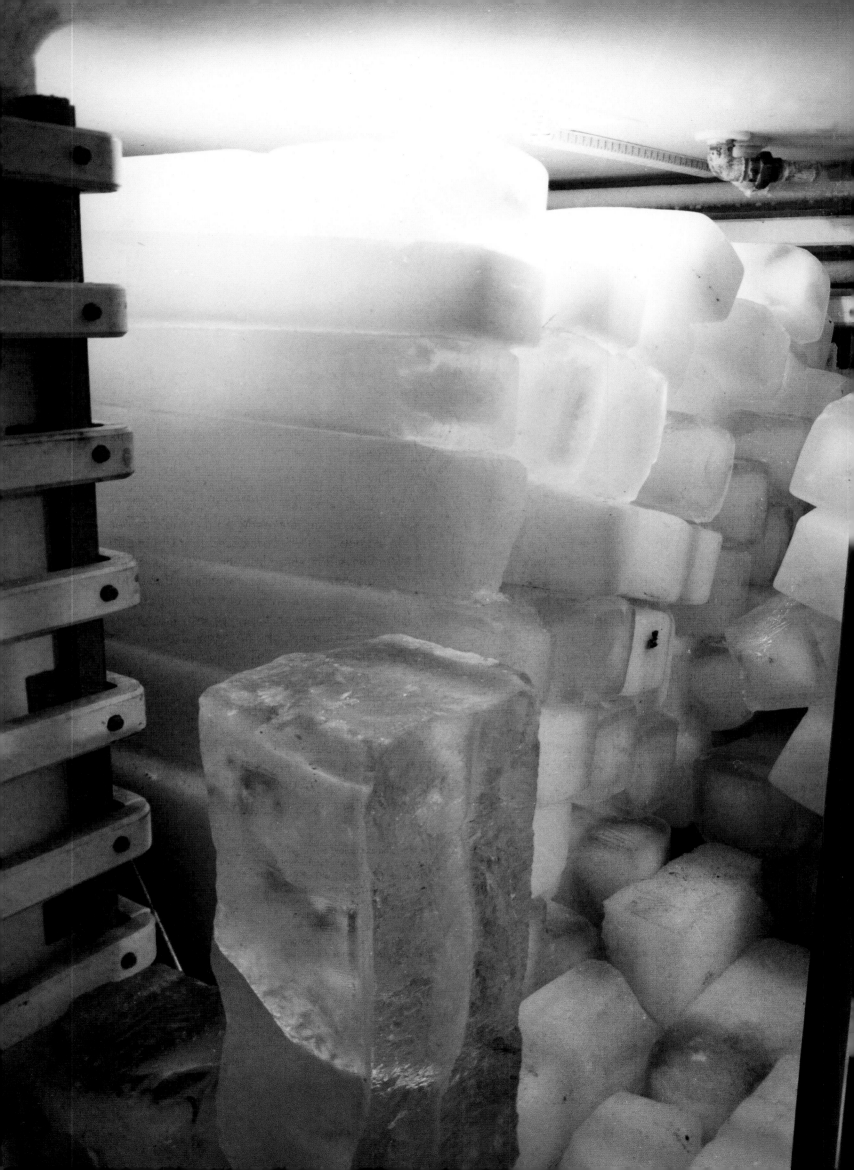

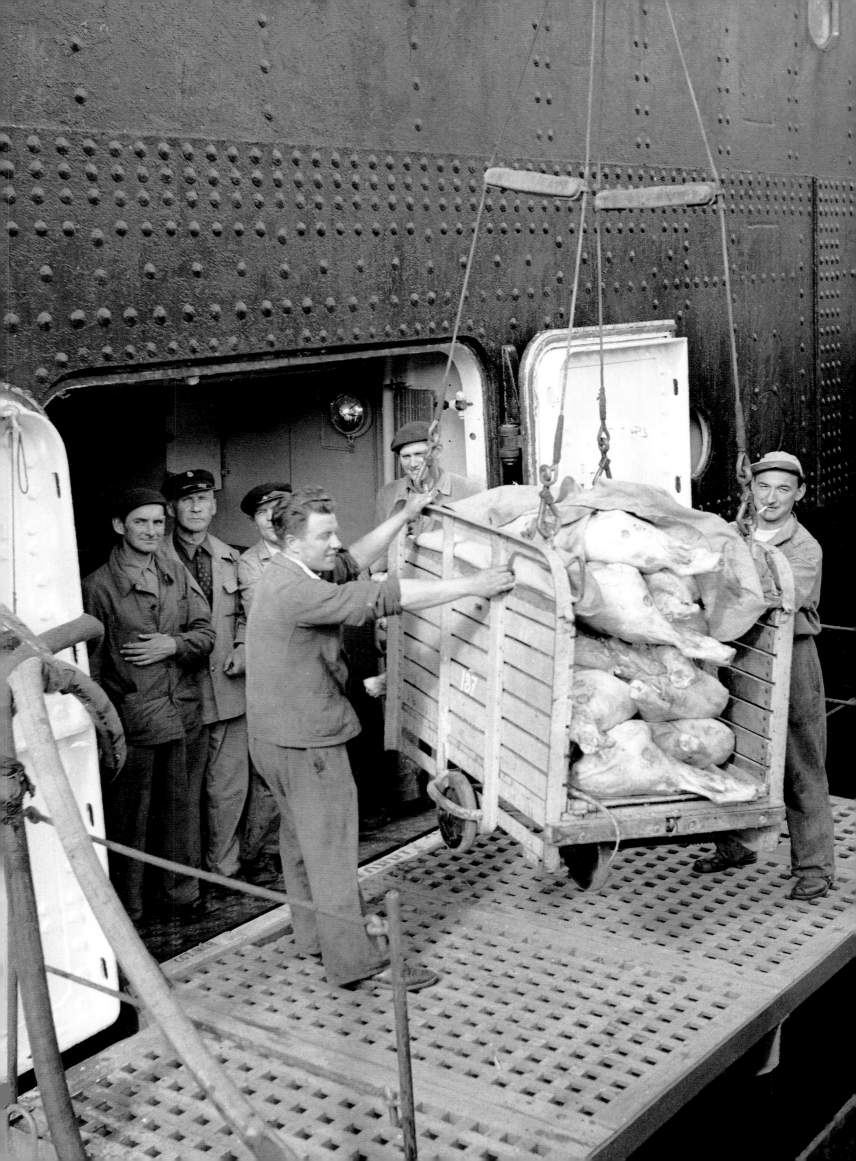

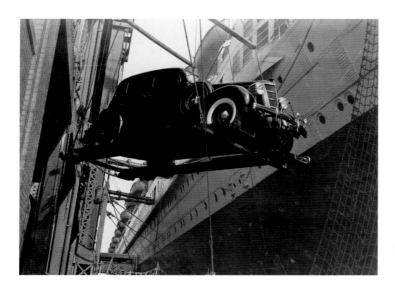

The embarkation of passengers on superliners would take two or three hours. As for the time required to load the necessary provisions for the voyage, the following list, quoted by the historian Michel Mohrt, speaks for itself: "For her maiden voyage in May 1935, the colossal food stores and refrigerated compartments of the *Normandie* bulged with 60,000 eggs, 4,000 chickens, 1,000 *poussins*, 8,000 ducks, 4000 turkeys, 1,200 pigeons, 300 rabbits, 22,000 pounds of beef, 4,400 pounds of veal, and the same weight of mutton and lamb, 1,200 sides of pork, 4,400 pounds of ham, 8,800 pounds of charcuterie . . . , 6,300 gallons of wine, 7,000 bottles of *grand cru* wines and champagne, 2,600 bottles of liqueur, etc."

34

bunkers. Indeed, it was the necessity of stowing these staggering quantities of coal that dictated the gargantuan size of ocean liners. And the problem was complicated further by the constant pressure to set new speed records, the concomitant of which was unprecedented levels of fuel consumption. At nineteen knots, *La Touraine* burned three hundred tons of coal a day; at twenty-two knots, the *Lucania* consumed six hundred tons; and at twenty-five knots, the *Lusitania* consumed a staggering twelve hundred and fifty tons on a daily basis. Loading coal was therefore a time-consuming operation that provided work for a small army of dockers, who were recruited from among the casual laborers who thronged every port in hope of finding work. They came in the thousands: Annamese in Saigon, Chinese in Singapore, and native tribes in Djibouti. In Lisbon, it was Portuguese women who awaited the arrival of steamers on the South Atlantic route, surrounded by their wicker baskets filled with coal. When it came to loading time, they would clamber up to the scuttles with the baskets balanced on their heads, tip the contents into the bunkers, and then scuttle down again to repeat the process as fast as they could. It is hard to imagine the exhaustion and discomfort of this interminable process, which

caused greasy coal dust to fill every pore of the skin. Indeed, coal dust in general became a problem of daunting proportions; the fine black powder coated every surface and infiltrated every crack or fissure, no matter how small. Whenever ships had to take on coal during long voyages, the passengers were requested to disembark, while the decks were covered with tarpaulins, and all doors, windows, and portholes were hermetically sealed. With the introduction of oil in the 1930s the process of taking on fuel became much less arduous, but the quantities remained impressive. In 1936, the *Normandie* consumed no less than thirty tons of oil per hour.

The next item to be loaded was food supplies, another operation of colossal proportions. It was a lively affair, too, since up to about 1875, live provisions were taken on board—a veritable farmyard of animals shared steerage with the emigrants. This practice went some way to offering a solution to the intractable problem of keeping perishable foodstuffs aboard ship, but even the regular sacrifice of poultry and ruminants and the addition of salt meat and fish to the ships' menus failed to lift the generally mediocre standard of the cuisine. Bound for New York on the *Britannia* in 1842, Charles Dickens complained of the unrelieved monotony of the diet of

ABOVE: Loading an automobile at Le Havre, c. 1935.
RIGHT: The wharf at Bordeaux in the late nineteenth century.
OPPOSITE: Section through the *Giulio Cesare*, an Italian superliner of the 1930s.
PRECEDING PAGES: Blocks of ice in the stores of the last *France*, 1962 (left); stowing meat in the holds of the *Liberté* in the 1950s (right).

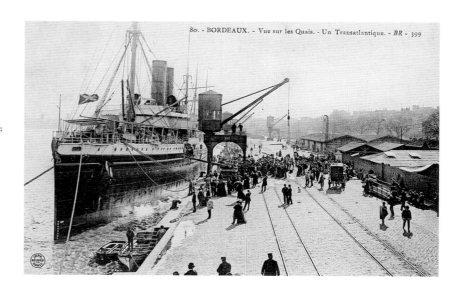

80. - BORDEAUX. - Vue sur les Quais. - Un Transatlantique. - BR - 399

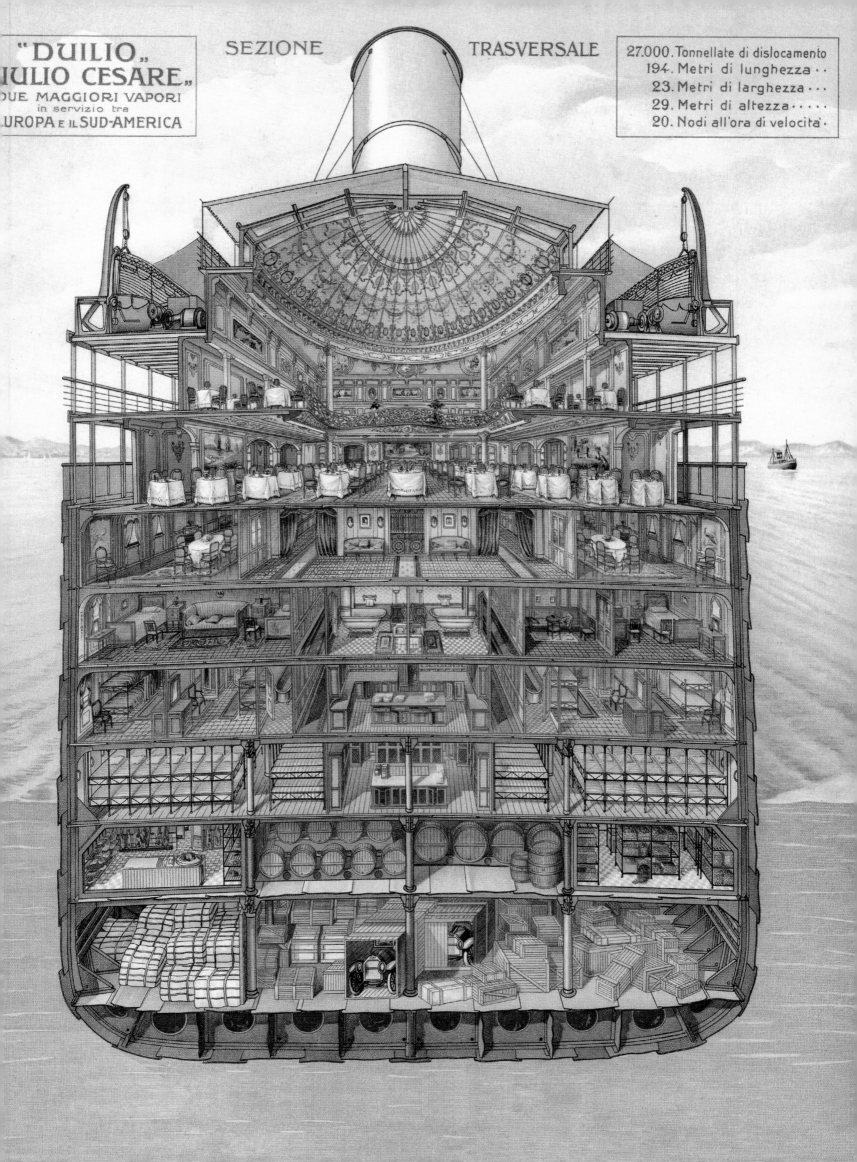

"DUILIO„
GIULIO CESARE„
DUE MAGGIORI VAPORI
in servizio tra
EUROPA E IL SUD-AMERICA

SEZIONE TRASVERSALE

27.000. Tonnellate di dislocamento
194. Metri di lunghezza ..
23. Metri di larghezza ...
29. Metri di altezza
20. Nodi all'ora di velocità .

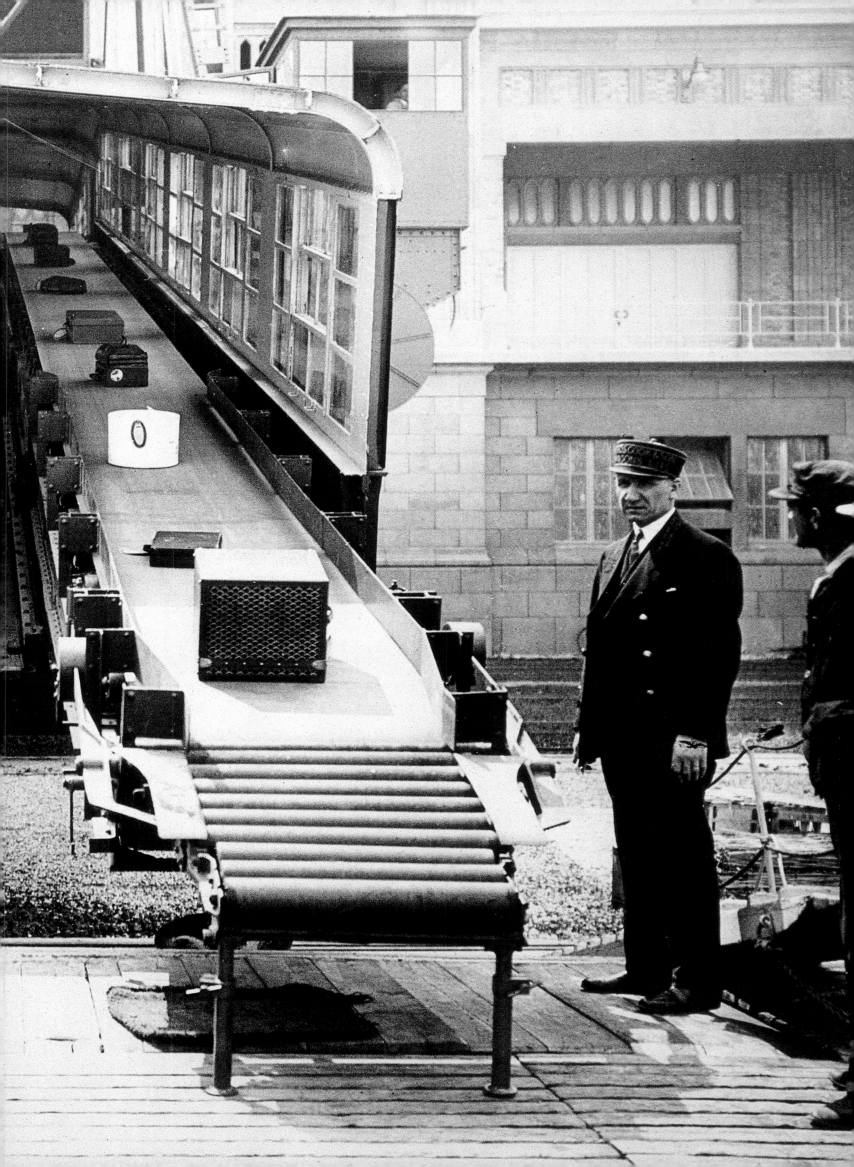

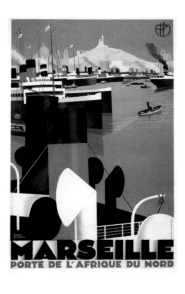

MARSEILLE
PORTE DE L'AFRIQUE DU NORD

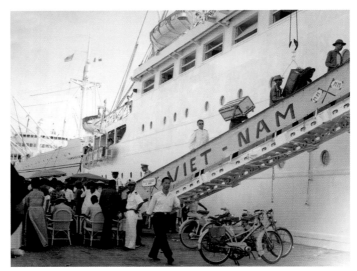

Up to the 1930s, wealthy families sailing from New York to Europe, or from Europe to "the colonies," would often stay away all summer and take some of their servants and staff with them. Thus first-class passengers on the great ocean liners were frequently accompanied by impressive quantities of bags, steamer trunks, hatboxes, cases, and assorted parcels. Some were intended for the cabins, others for the hold, and all were insured—generally by the shipping line itself.

brawn, cold ham, salt beef, and boiled or baked potatoes, with a rather moldy dessert of apples, grapes, and oranges. But all this was to change around 1880, when the introduction of electricity meant that steamers could be equipped with proper ice rooms. Now the great ocean liners could take aboard all the provisions required by any self-respecting chef. The list was a prodigious one, elaborated in meticulous and dizzying detail in the shipping lines' brochures. Before setting off on her transatlantic crossing of April 12, 1912, for example, the *France* stowed away some 9,000 pounds of fresh meat, consisting of 22 whole beef cattle carcasses, 13 sheep, 8 calves, 4 pigs, 350 kidneys, 270 tongues, 550 sides of lamb, 400 legs of lamb, 80 calves' heads, and 64,000 pounds of poultry, game, and charcuterie, including 18 barrels of foie gras. This was followed by 1,000 pounds of fish, 88 pounds of prawns, 250 lobsters and crayfish, and 7,200 oysters. Then came enormous quantities of vegetables; 35,000 pounds of flour along with eggs and milk, for bread, cakes, and pastries; and a profusion of sugared almonds, candied fruit, and cookies—not to mention the wine and spirits cellar, which held more than 60,000 bottles. On top of all this came the mountains of linen required for both the restaurants

and the cabins: a fabulous and snowily laundered trousseau of tablecloths, serviettes, tea towels, pillowcases, sheets, and towels.

Even when all of this was safely stowed in the ship's hold, the business was far from over. Next came countless sacks of mail and the bewildering array of items brought to the port by road or rail to accompany passengers to their destination, from baby carriages to bicycles, phonographs to cameras, harnesses to automobiles, works of art to racehorses, not forgetting—especially on P&O steamers—cases of champagne, a basic necessity of "civilized" living for any self-respecting Englishman, even in the remotest depths of the Malayan jungle. Until the 1920s, the vast majority of passengers, of whatever social class, were by no means tourists. The emigrants in steerage were not the only ones sailing to a new life: many passengers in first and second class—industrialists, soldiers, missionaries, and civil servants—were also intending to make their homes in distant lands. Even if they planned to return at some point, if they were to stay abroad for any length of time they needed to take most of their goods and chattel with them.

Not everything could be stowed in the hold: porters' trolleys groaned under mountains of hat boxes, trunks,

ABOVE LEFT: Poster by Rogers Broders, c. 1935.
ABOVE RIGHT: Passengers embarking on the *Viet-Nam* in Saigon, 1952. The Marseilles–Saigon line was the first to be opened by the Messageries Maritimes under the Second Empire (1852–70), when the company still bore its original name of Messageries Impériales.
RIGHT: Leaflet issued by the French Line giving prices for insurance (1935), and a luggage label from the *Champlain* (1930s).

OPPOSITE: A Louis Vuitton trunk from before 1914 (predating the monogrammed fabric now synonymous with the firm).
PRECEDING PAGES: Luggage being loaded using the earliest example of a carousel, at the new harbor station at Cherbourg, 1933.

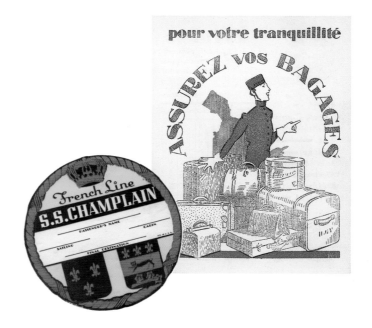

pour votre tranquillité
ASSUREZ VOS BAGAGES

French Line
S.S. CHAMPLAIN

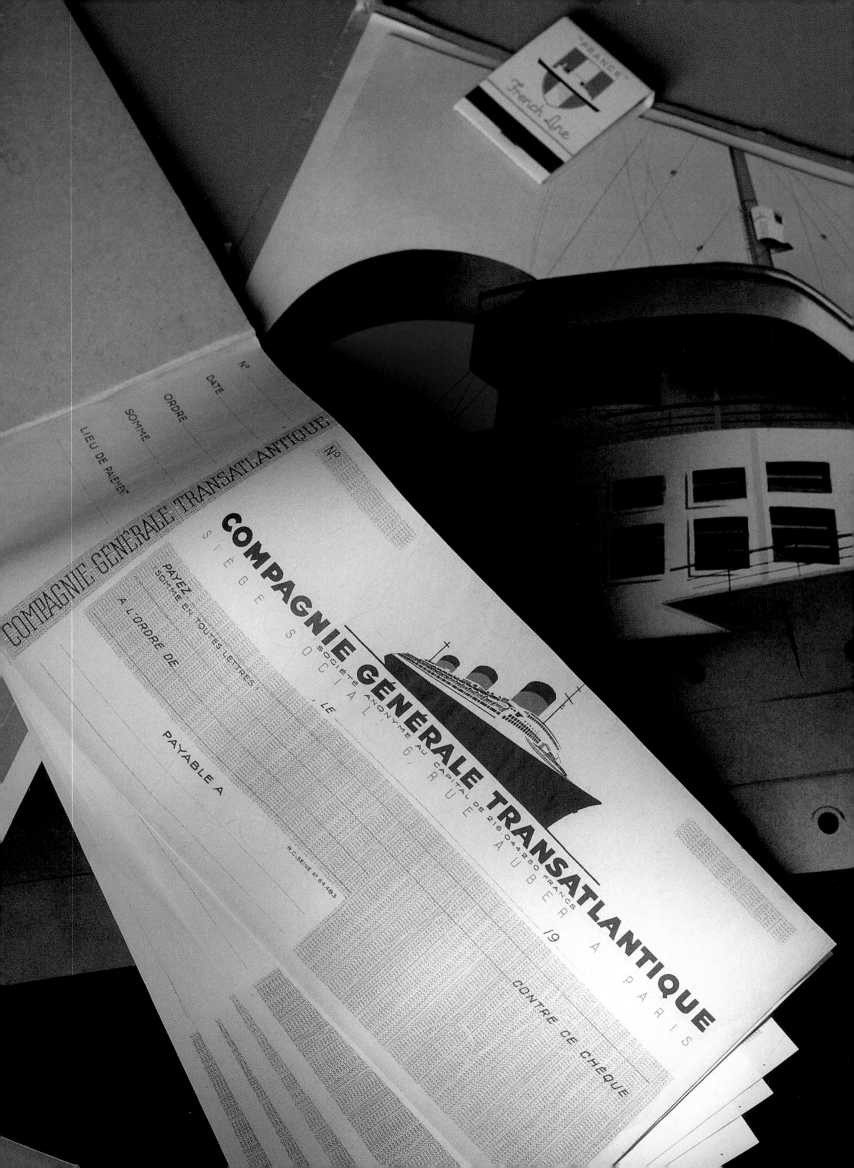

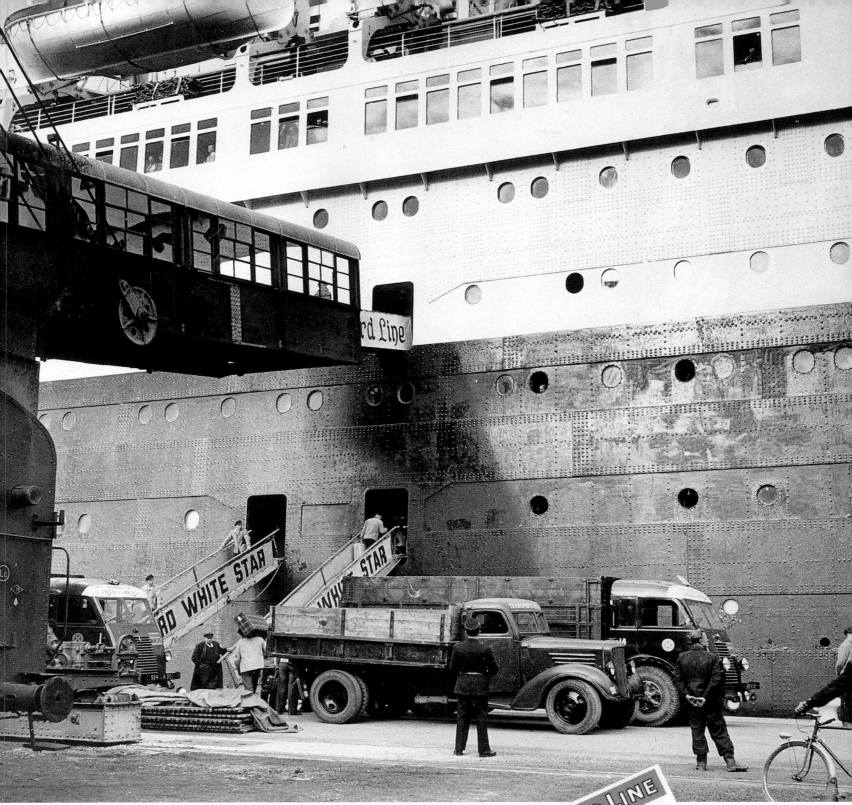

ABOVE: The last of the luggage being stowed aboard the *Queen Mary* on the Quai de France at Cherbourg, during the ship's first port of call there, on May 8, 1952.

INSET: A Cunard Line luggage label.

OPPOSITE: Mementos of the *Normandie* from the French Line archives. Resting on a brochure with a cover lithograph by Jan Auvigne (1936) is a CGT checkbook with which passengers could make payments on board. At the top is a book of matches from the *France* (1962).

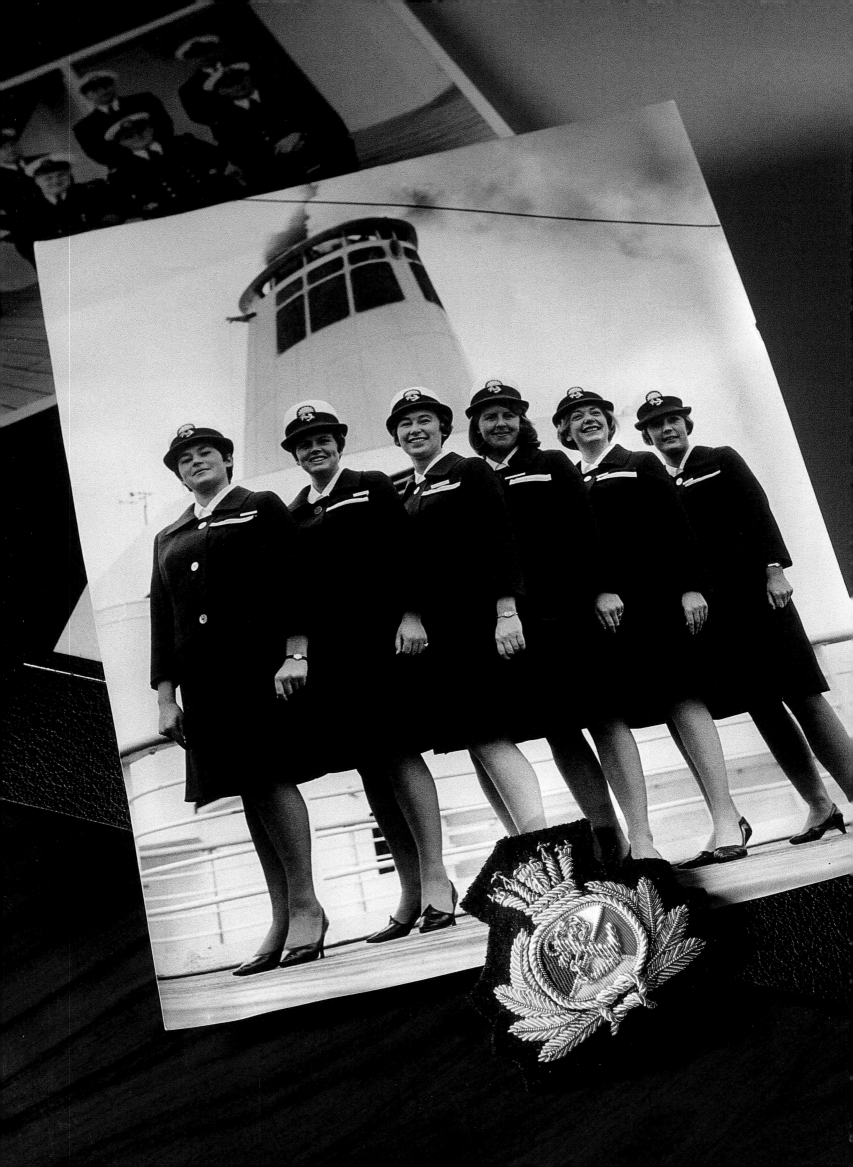

On board a transatlantic ocean liner, as in a luxury hotel, crew members were permanently on call to serve the passengers' requirements. Uniforms were rigorously inspected every day, and everyone from cabin boys to stewards and stewardesses was subject to a quasi military regime of strict discipline.
RIGHT: The bridge of the CGT steamer *Lafayette*, which sailed the Le Havre–New York route—the French Line—from 1930 to 1938.

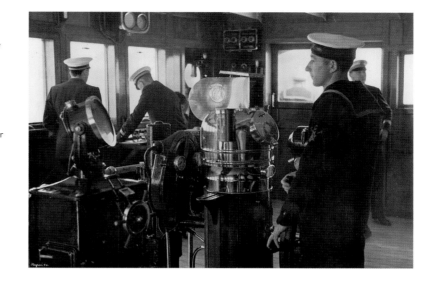

shoe boxes, and other steamer bags, all of which boarded ship with their owners. They were specifically designed to fit the cabin space available: cabin trunks, for instance, measured one by three feet so that they would slide with precision under a bunk bed. The wealthiest passengers traveled with the latest models in cabin luggage, purchased from the celebrated Parisian trunk makers Goyard or Vuitton, or from their American counterpart Oshkosh. A deluxe model in cloth-covered poplar, boasting both drawers and hanging space, went by the appropriate name of Wardrobe, for it was indeed capacious enough to accommodate an entire wardrobe. And nothing less would do for passengers traveling in first class, for whom life onboard consisted of one change of clothes after another, with a different outfit for every occasion as laid down by a strict code of etiquette. Even the gentlemen could not escape the rigorous dress code, wearing a sports jacket and cap in the morning, a double-breasted suit in the afternoon, and a dinner jacket in the evening. On top of all this, passengers bound for the Far East were expected to produce an array of white garments and pith helmets, which were de rigueur once the liner reached the Red Sea. The plethora of trunks and boxes that all this clothing necessitated did

nothing to ease the lives of the cabin boys, whose job was to find places to stow it all.

Once the mountains of cargo, luggage, and provisions were stowed, it was nearly time for the passengers to come onboard. The chief purser double-checked the readiness of the ship and prepared the staff. He and his team were in charge of the ocean liner's battalion of catering and cabin crew, including chief stewards, kitchen staff, chambermaids, and cabin and deck boys. Personally responsible for the well-being of all passengers, and a master of tact and diplomacy, he was constantly available to listen to complaints and sort out problems, from the largest to the most delicate. Such was the prestige and following of an outstanding purser that it could enhance the reputation of a shipping line as a whole. The pride of the French Line, for example, was the remarkable Henri Villar, chief purser on the *Paris, Ile-de-France, Normandie,* and *La Lorraine,* who had such a faithful following that it was said regular passengers would cancel their bookings were he not on duty.

Porters, cabin boys, and all other relevant crew were posted on deck while the gangway officer checked boarding cards, and one by one, the passengers finally came onboard. Sometimes the various classes all

LEFT: A P&O cruise timetable from 1931, with a luggage label from the British India Steam Navigation Company, another shipping giant that merged with P&O in 1914.
OPPOSITE: Unveiling of the "trendy" uniforms—modeled here by stewardesses of the SS *Oriana*—designed for P&O in 1967 by the English fashion designer Hardy Amies.
OVERLEAF: Morning ablutions in the crew's quarters on the *Normandie* (left), and the cotton twill uniform worn by CGT crew when working in parts of the ship to which members of the public were not admitted (right).

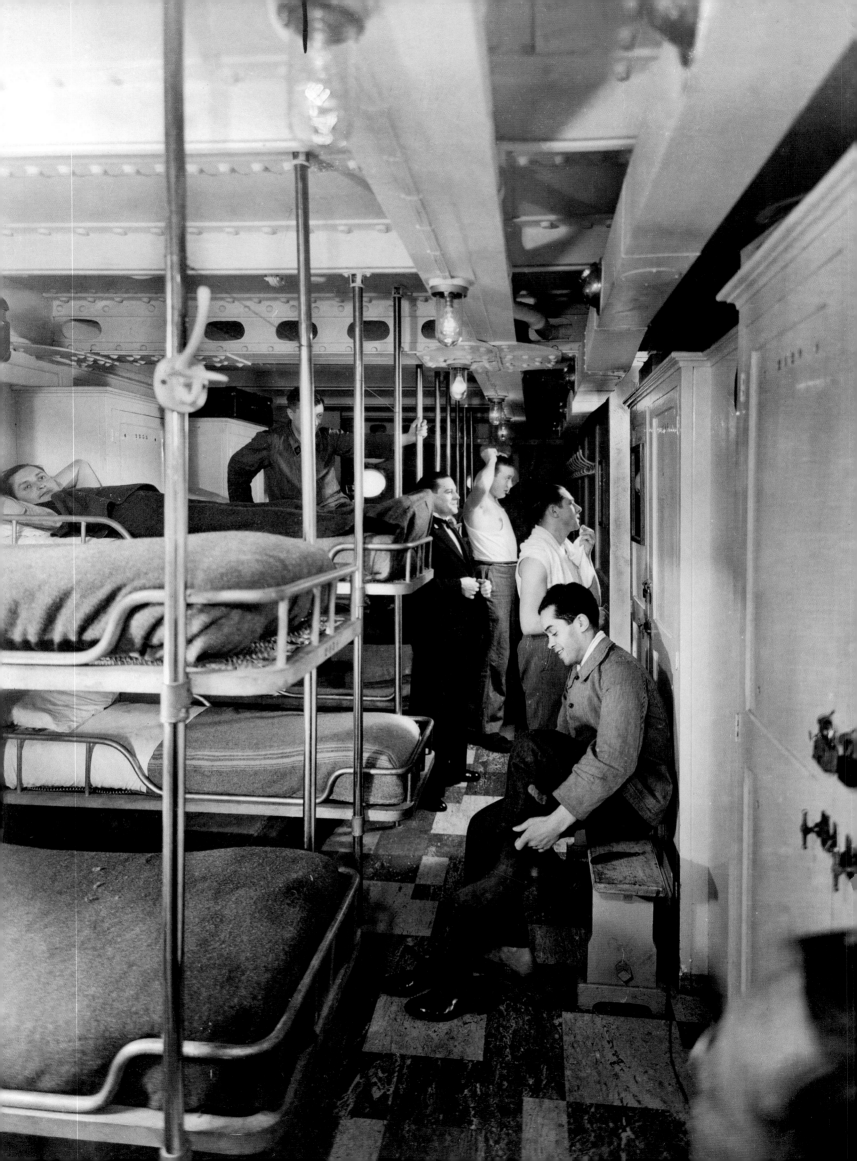

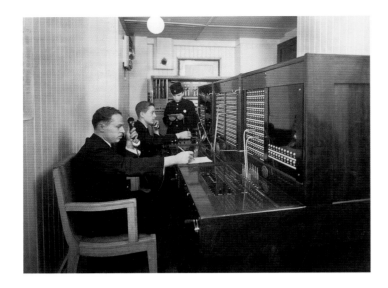

"From the bowels of the ship there rose the muffled throbbing of the engines." (Blaise Cendrars). As well as being floating palaces, ocean liners were first and foremost great mechanical leviathans that swallowed up ton upon ton of coal. Progress in engineering techniques led to the replacement of coal by diesel oil, machinery and instruments on board became increasingly sophisticated, and communications developed from the telegram and telephone to radar and electronics.
LEFT: In the telephone operating room of the *Lafayette*, a bellboy dictates the number that a passenger wants to call.

boarded at the same time, but via different gangways; sometimes they all boarded via the same gangway, but one after the other. Last to embark were the passengers who had paid the highest price, the crème de la crème of shipboard society, who would require the most pampering. For if passengers from different classes might momentarily have rubbed shoulders on the quayside or made eye contact on the gangway, this unfortunate occurrence was quite certain not to be repeated before the ship docked at her destination. Once she had set sail, the boundaries between the different classes were set in stone, although the young constantly looked for a way to sneak into first class. But for the moment, amid the hectic excitement of boarding, convention was less rigidly observed and attitudes were more open. Porters swarmed up and down the accommodation ladder, those going down with empty hands and those going up laden with the last of the trunks to be added to the growing mountain of luggage on the deck in first-class quarters. Here the luggage handlers took over, delivering every trunk and box to the cabin number indicated on its label. At the same time the chief steward, after a few brief words of welcome, shepherded passengers from cabin to cabin along passageways that were far too narrow to

accommodate the throng of people rushing in all directions: chambermaids running to get their work done, post boys bearing telegrams, and bellboys laden with bouquets of flowers and boxes of chocolates—gifts from those who were staying to those who were leaving. Above the din of shouted greetings, farewells, and barking of orders, the ship's orchestra played something jaunty and uplifting. Passengers embarking on ships of the White Star line were traditionally serenaded by the strains of the "White Star March," while elsewhere brass bands playing traditional airs on the quayside made up in local color for what they lacked in sophistication—in Brindisi and Naples the anthem for arrivals and departures was invariably "O sole mio."

Meanwhile, the chief purser was besieged with protests and complaints—to nobody's great surprise. Cabins were ridiculously small, it was protested, so that there was no room for all the luggage, and one trunk had needed to go in the contingency hold, which was simply maddening and excessively inconvenient. Other cabins were too noisy, too hot, too cold, too dark, and so on. To all these complaints the unflappable chief purser replied imperturbably that it would be seen to the next day, knowing from long experience that after a good night's sleep

RIGHT: The wheelhouse of the *Normandie*, showing the ship's impressive control panel to the right.
OPPOSITE: The engine room of the CGT liner *Ile de France*, with a crew member observing the maneuver from the navigation bridge.

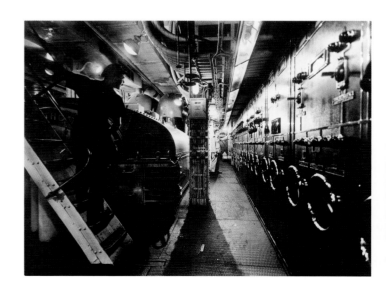

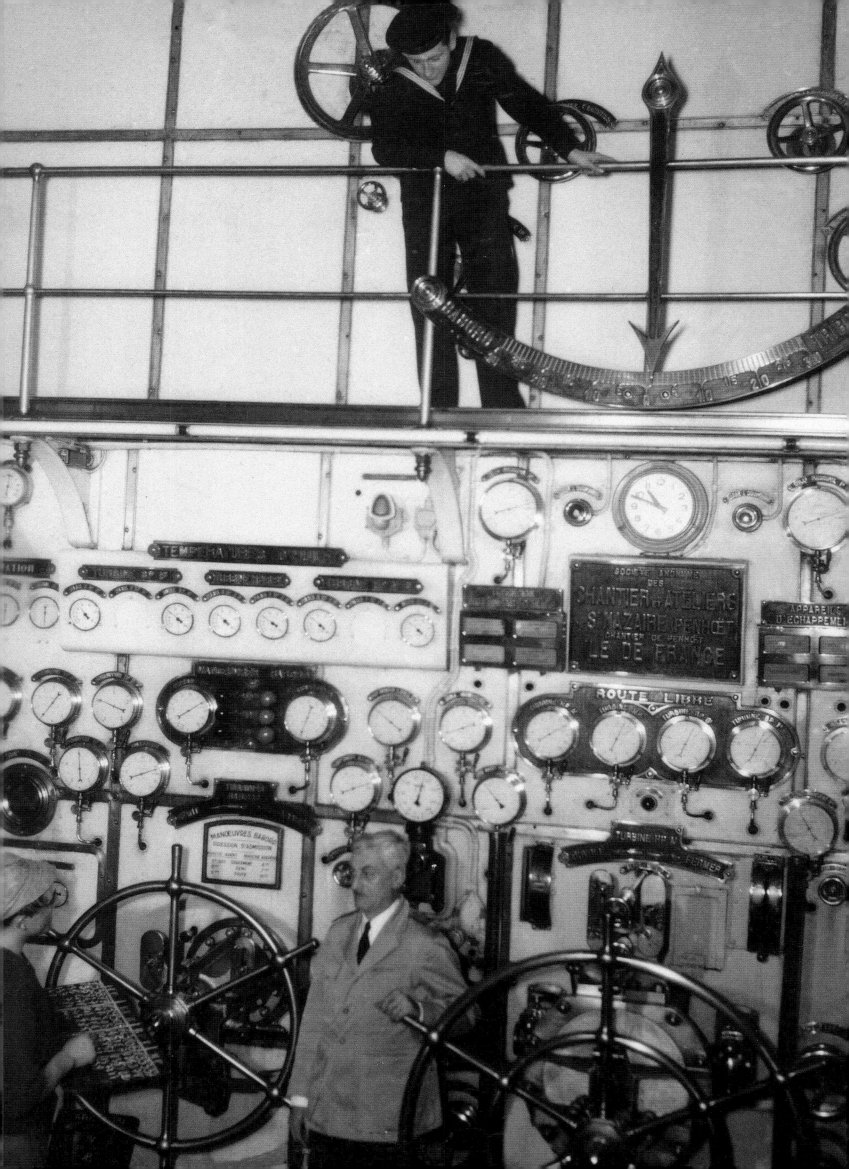

Writing in *New York* in 1930, Paul Morand observed: "There still exists a nocturnal activity that is exceedingly characteristic of New York, taking place after the theater and before supper: the farewell party on board ship. The transatlantic liners set sail at midnight, and it is customary to accompany one's friends to their cabins." This period saw the heyday of the farewell party, events of sumptuous extravagance thrown by wealthy first-class passengers, whether advertising executives, press magnates, or stars of show business.

PRECEDING PAGES: Jayne Mansfield and Tony Randall creating a farewell party on screen for Frank Tashin's 1957 comedy *The Blonde Bombshell*.

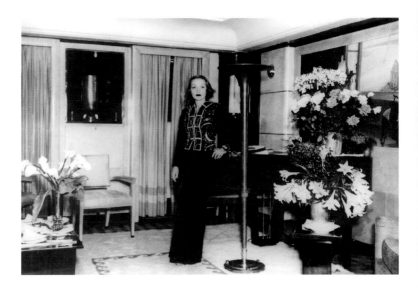

most of the aggrieved parties would find themselves perfectly well satisfied with their accommodation. While all this was going on, regular passengers wasted no time on such petty disputes, and instead set about the serious business of staking out their territory. First and foremost came the reservation of a table in the dining room, always a matter of pressing urgency on cruise liners. Snagging a table in a good position was essential, for the sake of convenience and the establishment of the correct order of precedence. Drawing inspiration from his crossing aboard the *Great Eastern* in 1867, in *A Floating City* (1871) Jules Verne described how, as soon as the passengers set foot onboard, there would be a mad dash for the dining saloons, where they would claim their places by leaving their calling card or writing their name on a scrap of paper. Earlier, in the 1830s, rather than marking territory, passengers would besiege the chief steward, who, ever unflappable, would patiently set about drawing up yet another revised seating plan. Another essential matter was reserving a deckchair, complete with tartan rug. A banknote slipped into the deck steward's palm ensured one of the most desirable ones, for which there was invariably keen competition. Once this urgent business was accomplished, passengers could be found leisurely chatting with well-wishers on deck, or they

were starting to unpack in their cabins, and in the bar carousers drank noisy toasts on deck, young men eagerly checked out potential lady companions for the voyage, and the young ladies of fashion clamored elegantly for the presence of the commander.

The commander, the most prominent and sought-after man onboard and the linchpin of shipboard society, would return to the bridge a few hours before the ship got under way. His social mode would give way to that of the skilled seaman, helmsman, and wielder of ultimate power onboard. A pilot would join him at the helm and would help steer a passage for the gigantic liner pulled out of the harbor by tugs. The helmsman would be at his post, while in the map room a lieutenant pored over the charts. An atmosphere of quiet efficiency reigned, with officers posted at all the vessel's strategic points.

All that remained now was to give the orders, by telephone or acoustic tube, to the engineers working dozens of meters below, deep in the bowels of the ship. Far beneath the passengers lay another world, dangerous, intriguing, magnificent, and formidable. This was the world beloved of novelists and journalists in search of the sensational. During the maiden voyage of the *Normandie*, Blaise Cendrars, special reporter for *Paris Soir*, plunged

Trunks, cases, and other bags were carefully labeled before being taken on board, where they were dispatched to the appropriate cabin or placed in the hold.
LEFT: Luggage tickets from the CGT steamers *Paris* and *Liberté*.
ABOVE: Marlene Dietrich on board the *Normandie*, in the deluxe suite called Rouen, which the ship's purser has taken care to fill with lavish floral arrangements.

OPPOSITE: Perspective view of cabin 477 on the *Ile de France* (1927), with the luggage store in the foreground.

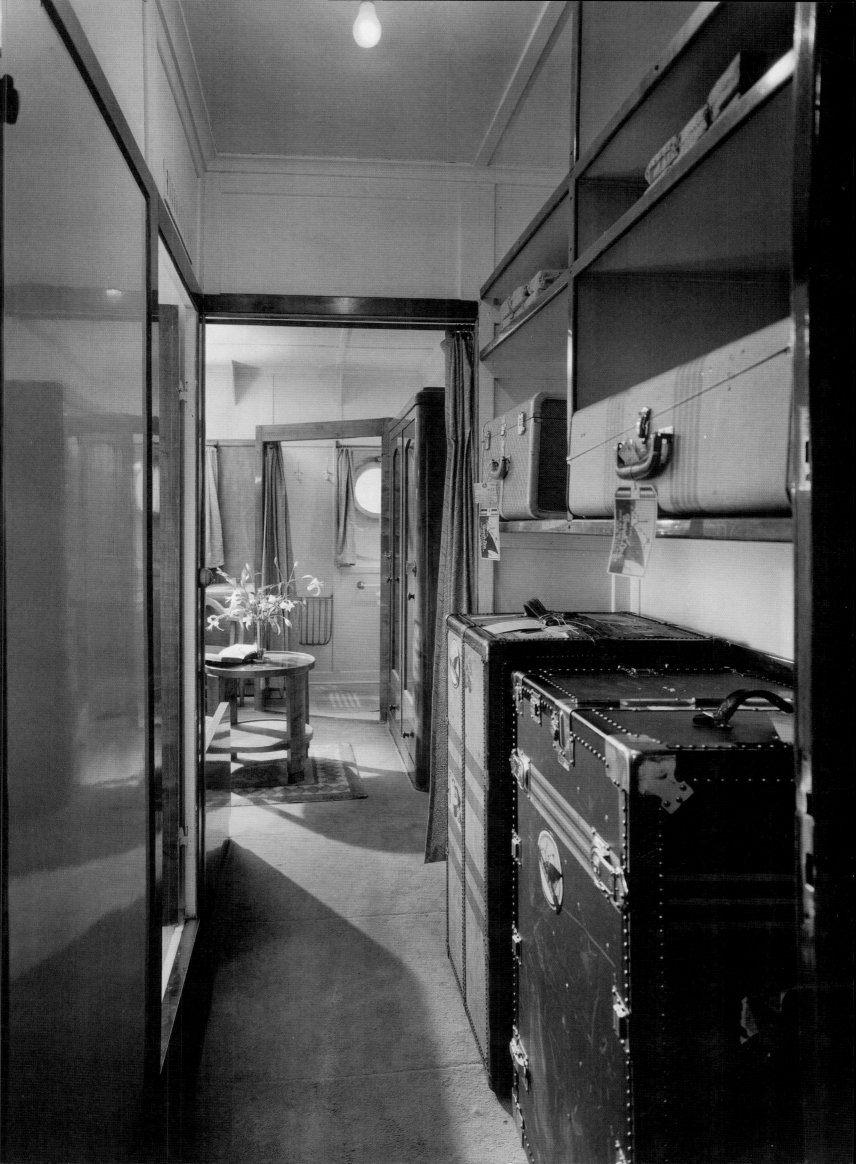

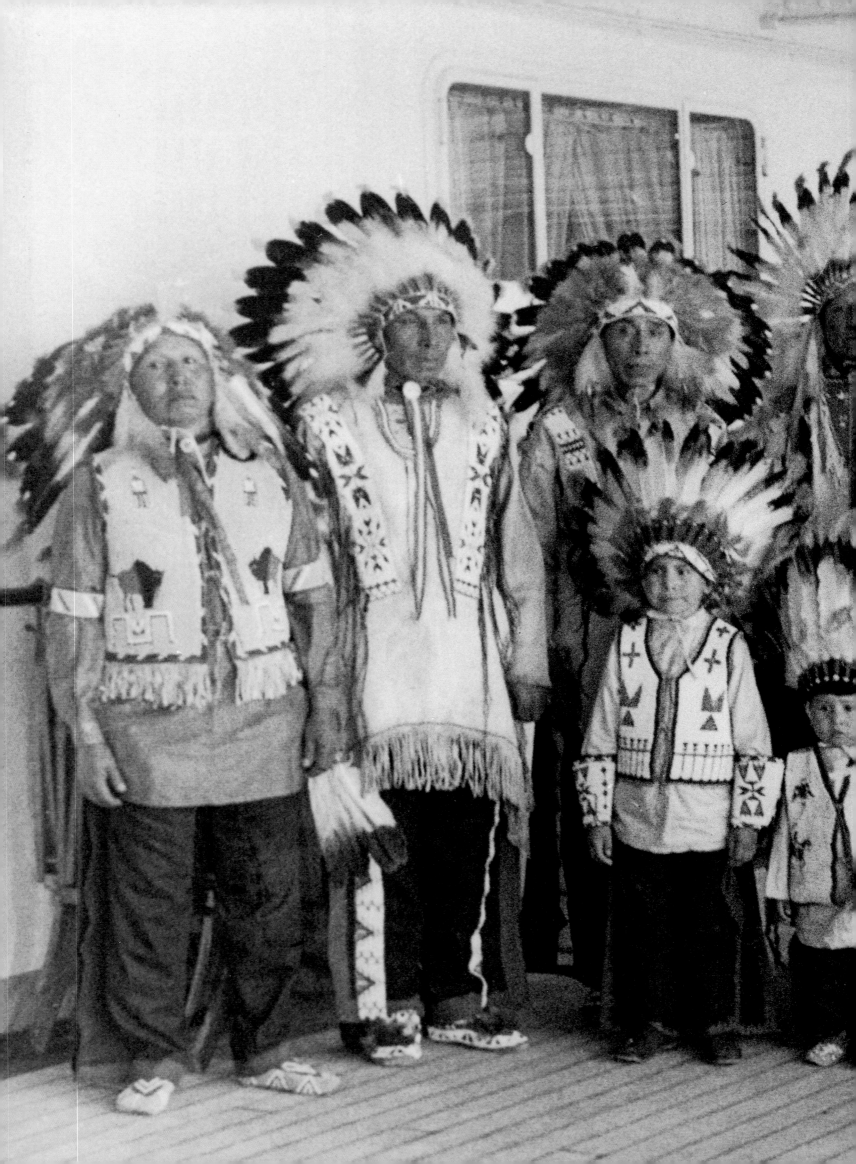

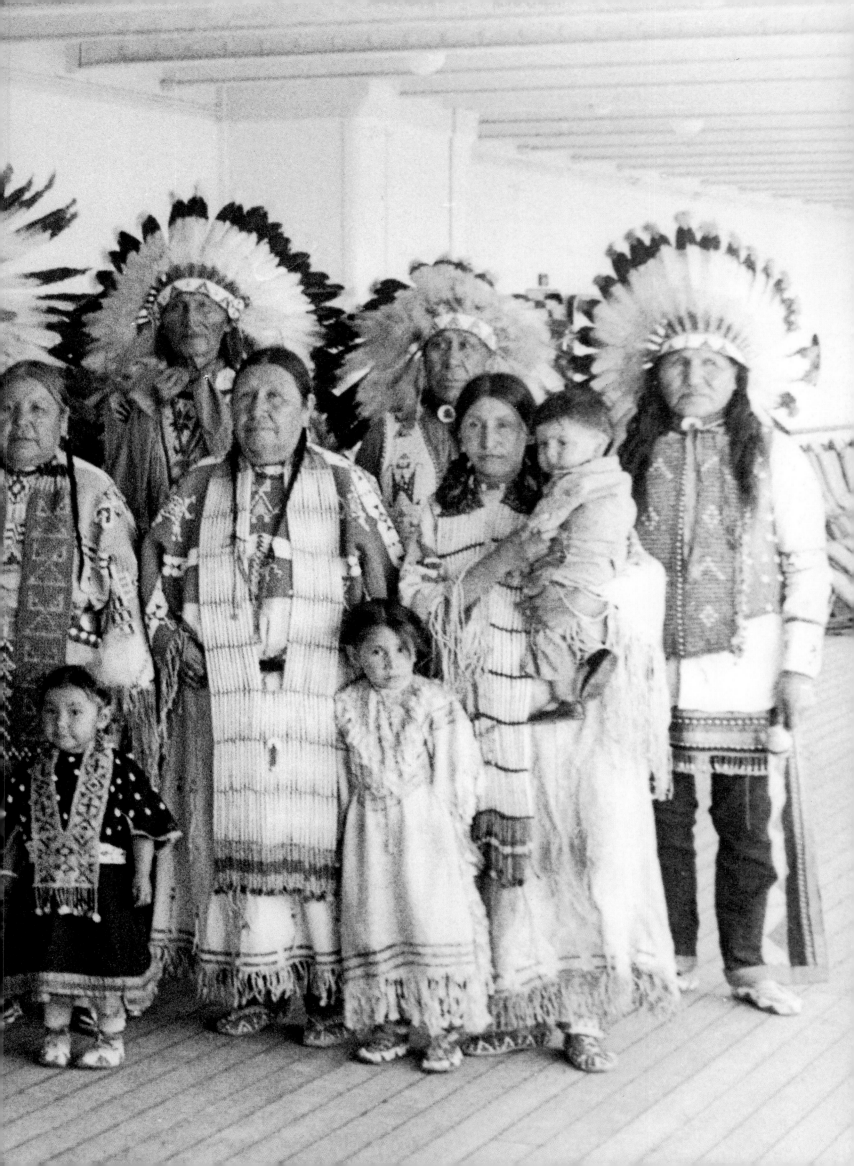

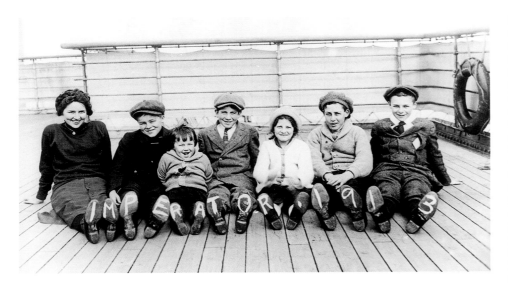

People of all nationalities and every social class could be found on board the passenger liners—subject to strict segregation by class. The internal arrangements of the great steamers were designed to make it impossible for passengers to move between the different classes during the voyage. **LEFT:** Young third-class emigrants photographed in 1913 on board the *Imperator* of the HAPAG line, then the world's largest ship. So dramatically did the great liner pitch and roll, however, that she was dubbed the Limperator. **PRECEDING PAGES:** Taken in April 1935 on board the *Bremen*, one of the largest of the Norddeutscher Lloyd fleet, this press photograph shows a troupe of performing Sioux Indians from Ohio, bound for the theaters and music halls of Europe.

with his readers "more than thirty meters, below the sun-deck, to depths never penetrated by the strains of the jazz bands," where he witnessed the "mysterious work of the lubricators, standing before the blue, white, and red eyes of the boilers."

Aboard the *André Lebon* in 1924, it was Roland Dorgelès's turn to venture down into the bowels of the ship, where he was quite overcome. "Through another door, and we stop, transfixed. . . . A great void lies beneath us, like a church viewed from the organ loft. . . . Suddenly I had a view of the entire hull, down to its depths, and I was nothing more than a speck, an atom, pressed against the dome of this immense factory." And at the foot of a steep companionway, he came upon the stokehold, a scorching 155° Fahrenheit, and white with the blinding glow of the furnaces and doors opening to throw heat "like shovelfuls of burning coals" in the faces of the firemen who stoked the furnaces. The extraordinary game of illusion that underpinned the world of the ocean liners was demonstrated by the inferno of the engine rooms on one hand, and the paradise of the first-class salons on the other, neither place existing without the other.

It was at this point, at the very last minute and often in highly ostentatious fashion, that stars of stage and screen preferred to embark. Josephine Baker, for example, was granted special permission by the French Line to drive right onto the quay in her Bugatti before making her way to a deluxe suite accompanied by her maid, several dogs, a cat, and at least sixty trunks and cases. Others adopted a more whimsical approach, like Charlie Chaplin's arrival at the departure of the *Yokohama*. Jean Cocteau, who observed the whole performance from the deck of the *Coolidge*, recounted, "A crowd had been waiting on his arrival for some time, fluttering handkerchiefs as the streamers tossed from the vessel to the landing stage stretched and began to shred, and "the sirens boomed their deep-throated call. . . . Six o'clock. To the left a small automobile opened a path through a crowd, and from it we saw the small figures of Charlie Chaplin and Paulette Godard emerging." His fedora "worn in Napoleonic style, one hand in his waistcoat and the other in the small of his back," Chaplin got on just in time, executing a pirouette and leaping up the gangway just as the ship started to move away from the quayside. But the very special passenger who boarded the *France* on December 14, 1962 arrived in a nondescript van, completely incognito: this was the *Mona Lisa*, making her maiden voyage at the age of five hundred in an attempt

RIGHT: Just arrived in port at Göteborg (Gothenborg) from America in 1932, Greta Garbo, then at the height of her fame, poses for the press on board the SS *Gripsholm* before disembarking. **INSET:** An Orient Line luggage label. **OPPOSITE:** Salvador Dalí and his wife, Gala, on board the *Normandie* in New York harbor, December 1936.

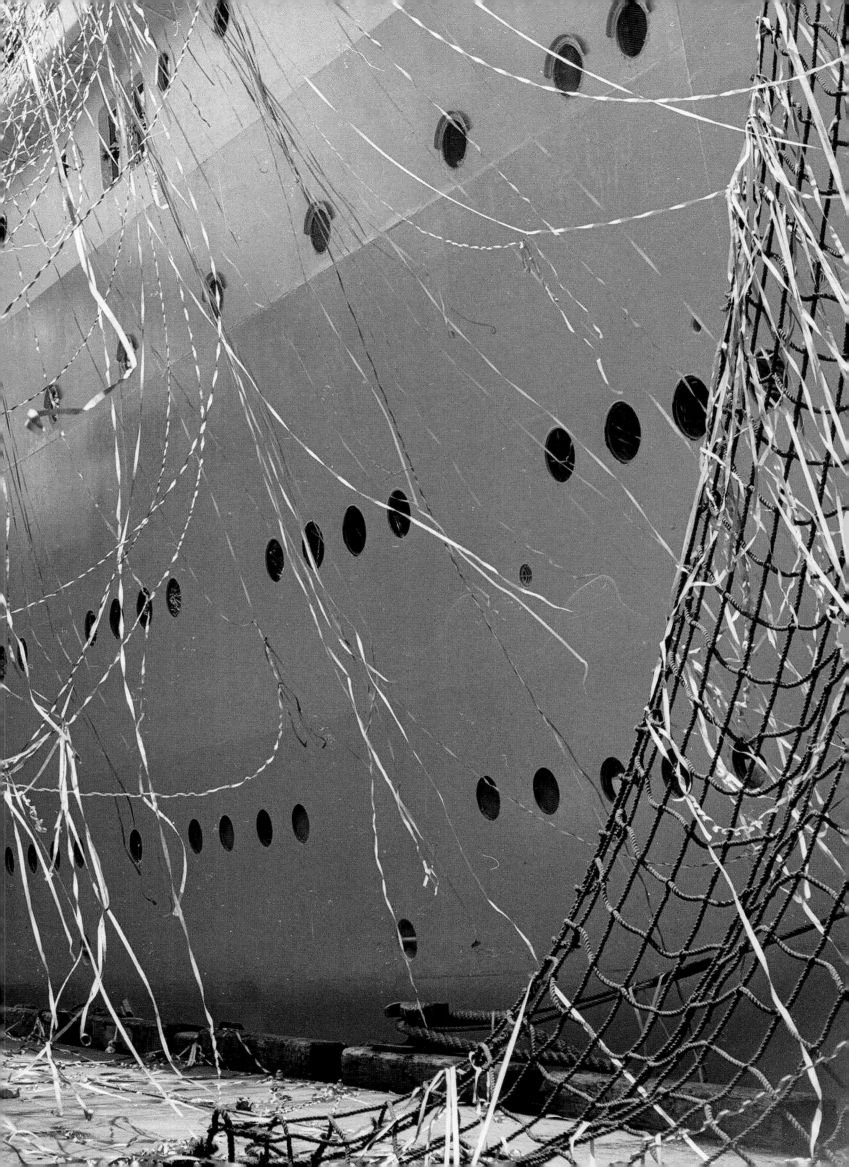

Accompanied as it was by celebrations that varied from one port to another, from one country of origin to another, and from one century to the next, the setting sail of an ocean liner was always a great event. The custom according to which passengers on board tossed multicolored streamers to friends and family on the quayside, the streamers tearing as the vessel moved off to symbolize their parting, was most widespread on lines bound for the Far East.
LEFT: Exotic images advertising cruises to the Far East in the 1930s: a camel and drummer on the cover of a supplement in the monthly *Blue Peter*, sold on board P&O liners, and (far left) an elephant complete with howdah on a Messageries Maritimes poster.
PRECEDING PAGES: The *Orsova*, of the Orient Line, setting sail for Australia in 1955.

by French Minister of Culture André Malraux to mollify American public opinion at a time when diplomatic tension was at its height. She was to spend the crossing in the deluxe Artois suite, accompanied by her phalanx of six bodyguards, one of whom revealed to the press that in the event of fire or shipwreck their orders were to throw her overboard, as her container was unsinkable and would float. But, added the guard, who had clearly read up on maritime law, he was determined to throw himself after her and hang on, come what may. Flotsam worth a cool fifty million francs could not be allowed get away without a struggle.

But it was time for the ship to leave, and the subject of shipwrecks was taboo. The engines started to throb, and the whole ship began to shudder. The siren boomed, and cabin boys and bellboys ran along the passageways ringing their bells: it was time for all visitors to go ashore. The subterranean throbbing that rose from the bowels of the ship increased, coming more sharply into focus. Making their final farewells, passengers and visitors pressed to the gangway, which was soon raised. On the quayside below,

the crowd grew denser, while above them, passengers jostled each other at the ship's rail, attempting to shout a few last words to someone down below. But it was impossible to hear above the din. The siren boomed again, and the anchor was raised. Passengers who had taken refuge in their cabins, too overcome by emotion to stay on deck, knew that the ship had set sail from the great cheer that suddenly rose from the quayside.

At Le Havre on May 29, 1935, all the harbor buildings and even the locomotives in the station joined forces to open their whistles and sirens in a formidable cacophony to salute the departure of the *Normandie* on her maiden voyage. And off the coast of Marseille, Joseph Tremble watched the distinctive silhouette of the basilica of Notre-Dame de la Garde vanishing into the distance. A year far away from France was a long time, but at his age feelings of homesickness were rapidly quelled by a sense of adventure. The sea was calm, the weather glorious; the only jarring note was struck by the deck steward's breezy warning: "Once she's crossed the bar you'll know all about it!"

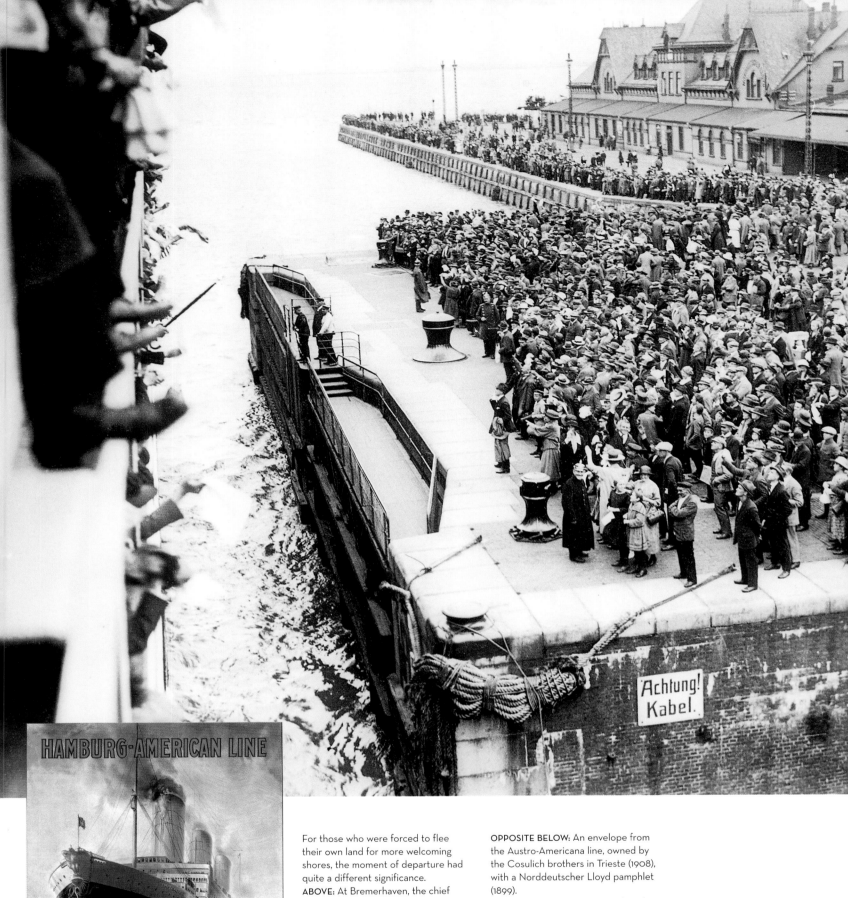

Achtung!
Kabel.

HAMBURG-AMERICAN LINE

S·S·IMPERATOR
WORLDS LARGEST SHIP
919 FEET LONG 50,000 TONS 98 FEET BEAM

For those who were forced to flee their own land for more welcoming shores, the moment of departure had quite a different significance.

ABOVE: At Bremerhaven, the chief German port of Norddeutscher Lloyd, departing passengers wave handkerchiefs as they sail away from their native land.

LEFT: A 1913 poster for the Hamburg-American Line (HAPAG), based in Hamburg.

OPPOSITE BELOW: An envelope from the Austro-Americana line, owned by the Cosulich brothers in Trieste (1908), with a Norddeutscher Lloyd pamphlet (1899).

OVERLEAF: An anonymous and quirky photograph from the 1920s capturing the departure of the *Leviathan*, with clouds of smoke pouring from her two working funnels (the third was a dummy). The *Leviathan* was formerly the HAPAG liner *Vaterland*, handed over to the United States Line after the First World War as reparations under the Treaty of Versailles. Other German liners, such as the *Bismarck* (renamed the *Majestic*), went to the White Star Line.

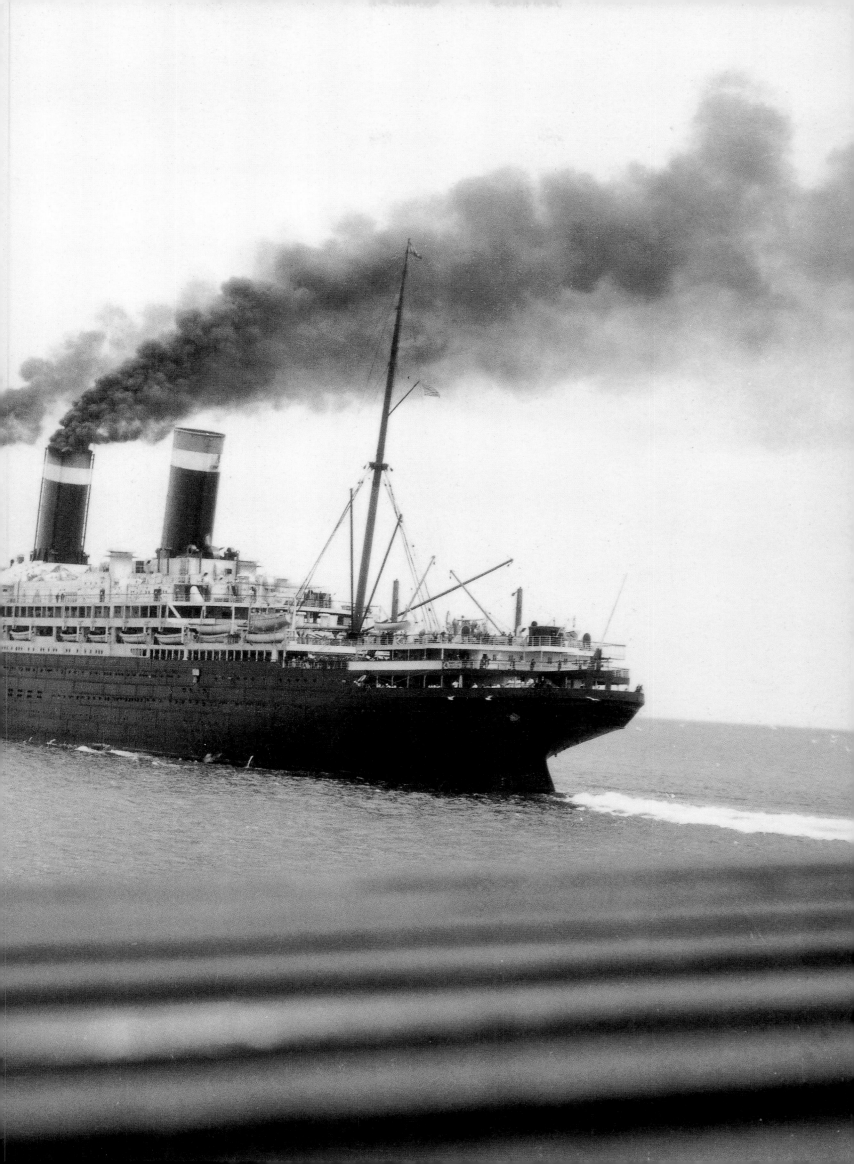

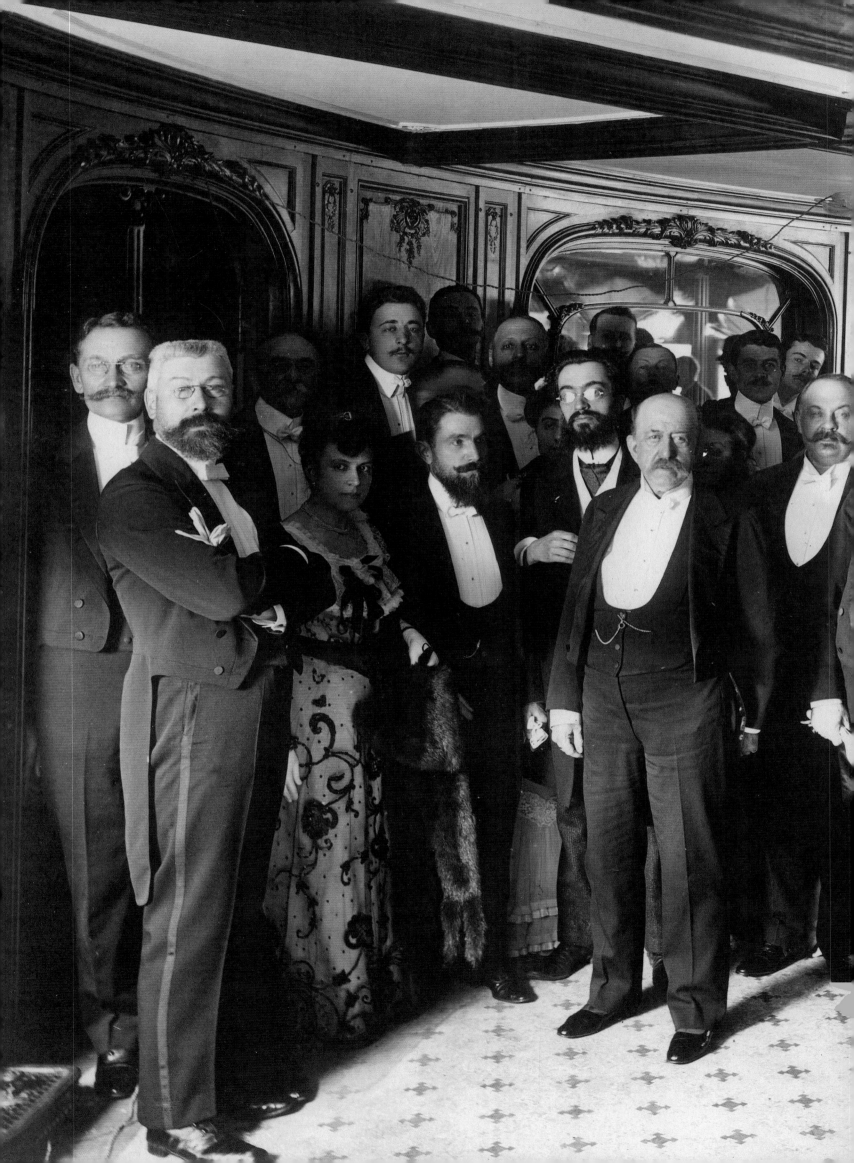

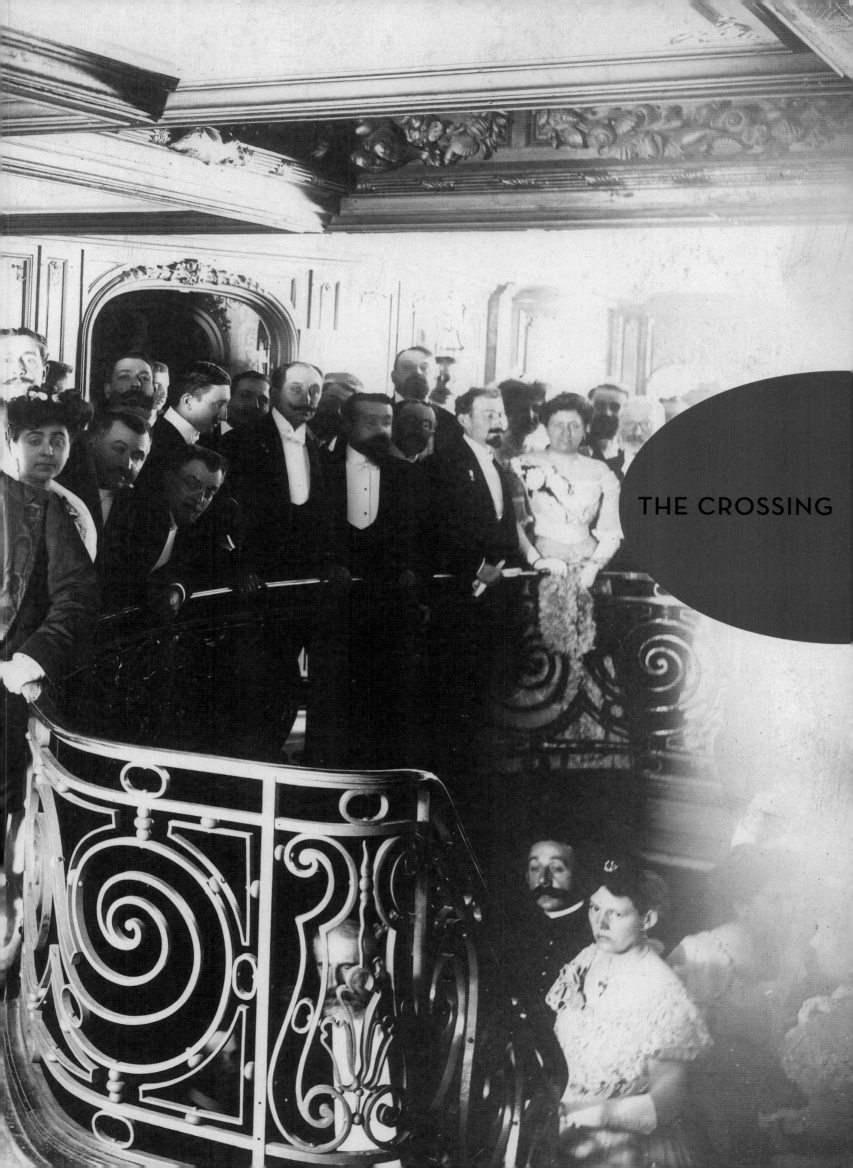

THE CROSSING

> *"While the great ships of the Pacific & Orient*
> *Slumber beneath the finery of their glittering lights . . ."*

Valéry Larbaud, *Europe*

THE DECK STEWARD WAS NOT WRONG: the crossing promised to be a choppy one. The lights of Marseille were still in sight when the swell began to grow. The Mediterranean held many such surprises up its sleeve, and for ships of the South Atlantic line the fearsome Gulf of Gascony was a far-from-welcoming start to their voyage. The English Channel, meanwhile, with its impenetrable fogs and buffeting winds gave passengers a rough ride for nine months of the year. Barely had the ship set sail before passengers on most crossings would begin to feel the deck dip and heave beneath them. Stalwart souls took it in their stride quite literally, pacing the decks in order to get their bearings on the enormous vessel: an ambitious aim, and one in which they were more or less bound to be thwarted. Even on cruise liners bound for Asia or the Pacific, where the voyage might take four weeks or more, passengers rarely managed to find their way around. Passengers on the *Europa, Bremen, Queen Mary,* and other great leviathans of the 1930s, by contrast, were only on board for five days during a transatlantic crossing, so what chance did they have to find their way? Nearly one thousand feet long, with flanks rising ten stories from keel to top deck, ocean liners contained a labyrinth of streets, avenues, and squares populated by two or three thousand souls. Not surprisingly, there were myriad tales of passengers losing their bearings day after day. The ingenious "movable" map devised for first-class passengers on the *Normandie* thus proved a welcome innovation: a system of cardboard tabs that enabled them to know where they were in any part of the ship, sparing novice travelers the indignity of getting lost in the maze of passageways.

Less seasoned travelers such as these—those who endured the evening breeze for a brief interlude before clinging to the copper handrail as they tottered back inside, chilled to the bone—might also find other useful information in their cabins. First and foremost, naturally, came the list of passengers, with surnames and titles, drawn up for passengers in first and second class by the purser. This sacrosanct document was distributed immediately after the vessel set sail, hot off the ship's presses. It was the indispensable key to a socially successful crossing, and it went without saying that receiving it was a matter of the utmost urgency. With due consultation of this list—scanning its columns for familiar names of those with whom they were not yet acquainted, for

In the early part of the twentieth century, shipping lines stressed their luxury, speed, and elegance in order to attract a wealthy clientele. The French Line particularly suffered from the lack of French emigrants, compared with the huge numbers leaving the countries of Northern and Eastern Europe, from whom other lines, especially the German ones, made a fortune. Luxury liners such as *La Provence*, launched in 1906 on the Le Havre–New York crossing, enabled the French Line to substantially increase its quota of first-class passengers.
PRECEDING PAGES: *La Provence* boasted a magnificent Art Nouveau grand staircase.
LEFT: A first-class cabin on the *France* (1962).

OPPOSITE: Under the impassive gaze of her maid, a passenger on the *Ile de France* puts the finishing touches to her coiffure.
ABOVE: A souvenir powder compact from the SS *Orford*, which was part of the P&O fleet in the 1930s.
OVERLEAF: Cabin service on board the *France* (1962). The uncompromisingly modern décor of the last *France*, "à la Jacques Tati," attracted a good deal of criticism. The bellboy is wearing the brilliant scarlet uniform (right) of the CGT.

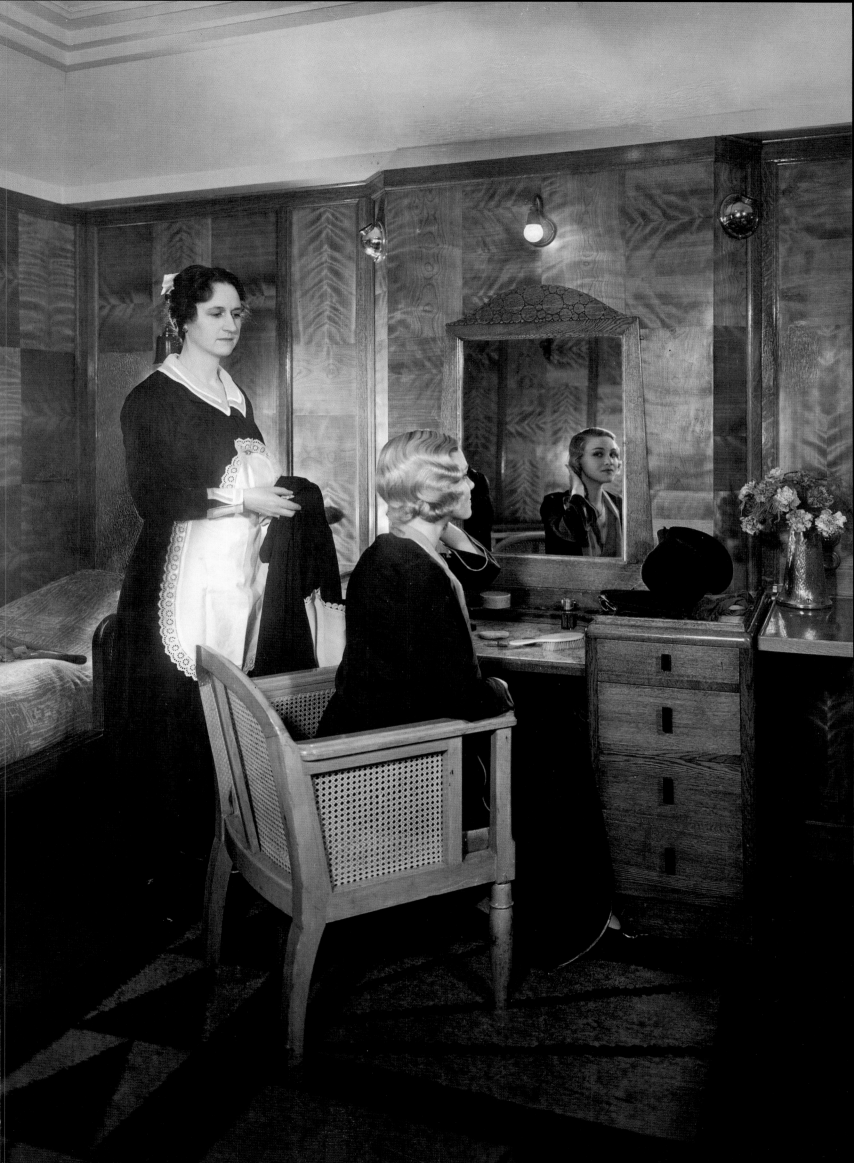

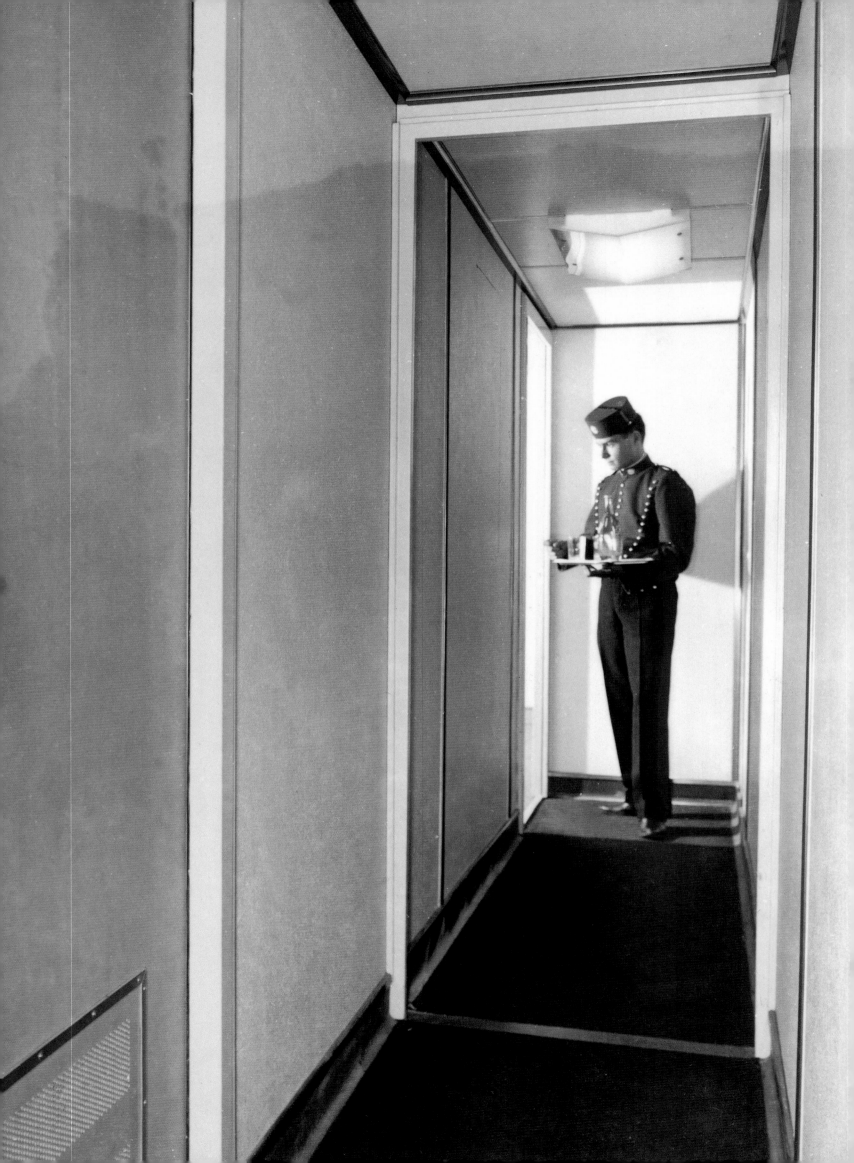

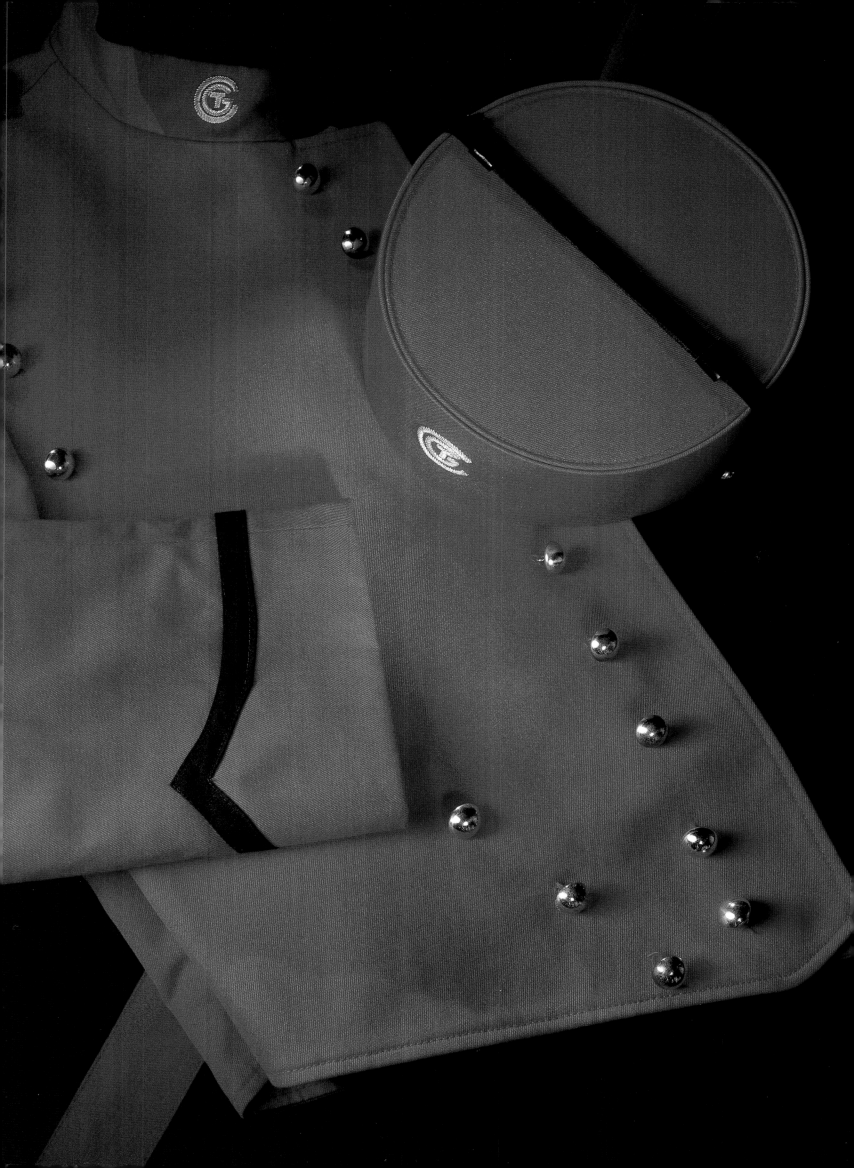

The list of passengers was the reading of choice for first-class passengers. Slipped under the cabin door at the moment of departure, it was an invaluable *Who's Who* of their fellow passengers, from which they could decide who was to be avoided and who was worth cultivating. It was not unknown for passengers to ask to change their cabin in order to avoid a fellow passenger they deemed undesirable, while others did everything possible to procure a seat at the same table as a celebrity they were determined to meet. Sorting out all these questions of high diplomacy was the unenviable role of the purser.

68

names of those with whom they were acquainted but wished to avoid, and for social and business acquaintances for whom it was worth (as it were) pushing the boat out—passengers could work out a strategy and draw up a social diary for the days to come. This was the ideal opportunity for ambitious mothers to sniff out the perfect son-in-law among all the young bachelors with promising futures, and to devise a means of ensuring that their daughters were seated beside the desirable young man at dinner. Marginally less pressing reading was the passengers' vade mecum, a handbook prepared by the shipping lines in order to guide them through the potential pitfalls and social solecisms of life on board. In the Edwardian period, the White Star Line produced a twenty-page booklet covering every aspect of life on its cruise liners, from mealtimes and shoe-cleaning to currency exchange and sporting activities—not forgetting the strict prohibition on moving from one class to another without invitation.

By this time the excitement of the day would be starting to take its toll, with the pitching and rolling of the ship adding its own piquancy to the general air of weariness now descending on the passengers. Fortunately, and for the first night only, first-class passengers were not required to dress for dinner. It was generally understood that clothes just unpacked from trunks would be in no fit state to be seen in public, and therefore it was the custom for no dinner jackets or evening gowns to be worn on the first evening. On the evening of such an exhausting day, this was an indulgence that came as a huge relief to all concerned. The first dinner was never a terribly lively affair anyway, and even less so when a heavy swell confined three-quarters of the passengers to their cabins. Those who sat at the tables laid with white linen and vases of fresh flowers, stoically surveying the *mousse de foie gras au xérès* before them, with wine tipping at a hectic angle in the crystal glasses as the tables dipped and heaved and the floor slid away from under them, felt duty bound to keep up a jaunty front and put on a brave face.

But when a diner suddenly dashed out of the saloon, everyone knew that the battle was lost, and with it all attempts at decorum or keeping up appearances. The beaded brow and exquisite agony could mean only one thing: seasickness, that eternal bane of the ship's surgeon,

LIST OF PASSENGERS

BY THE

P. & O. s.s. "Strathmore"

23,500 Tons Gross.

Commander - R. HARRISON, D.S.O., R.N.R.

Commander - L. J. EDWARDS, R.N.R.

Officer.	Chief Engineer.
C. ABLEWHITE.	D. GOODSIR.
ROBERTS.	Purser. G. K. HIGHLEY.

CRUISE 12

on 25th July, 1936

QUIS SEPARABIT

P & O

LIST OF
PASSENGERS

P & O

CABIN BAGGAGE

Berth No. 620

S.S. "STRATHMORE"

To SOUTHAMPTON

Name Mr. R. L. MOORE

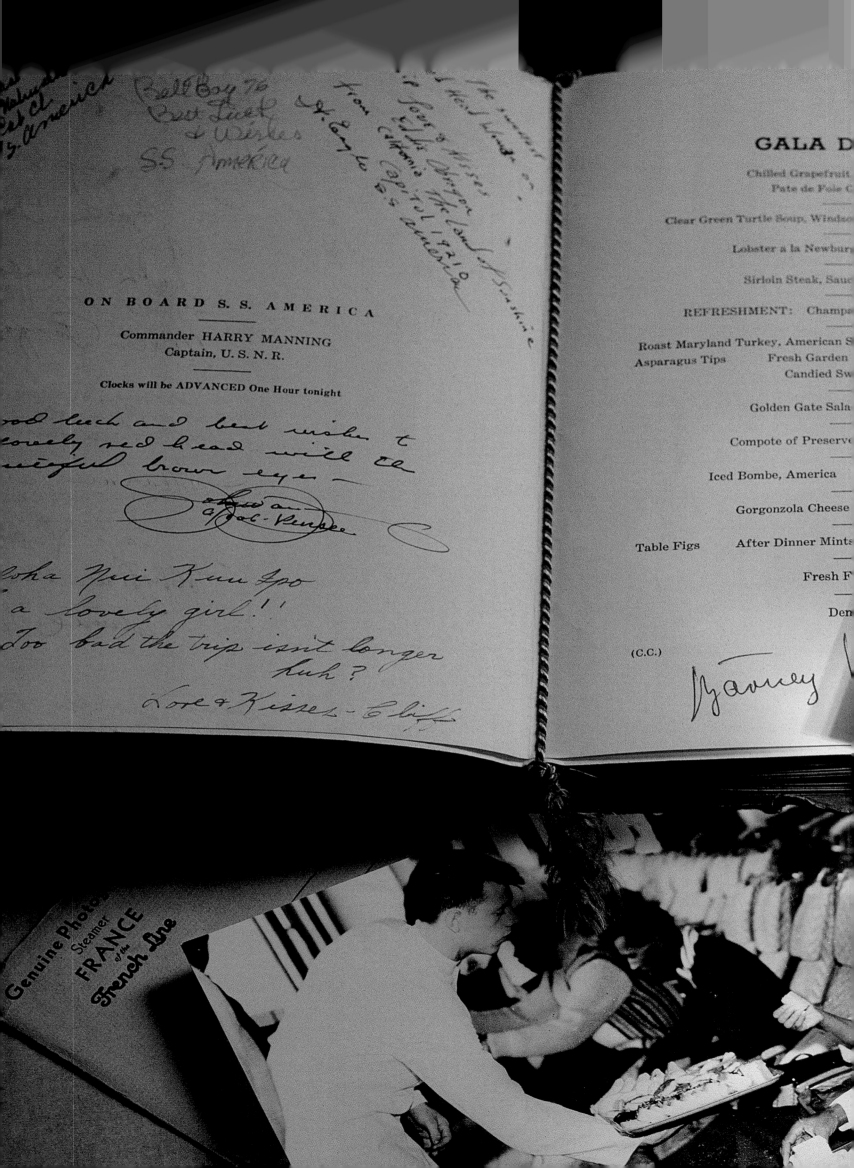

Bell Boy 76
Best Luck
& Wishes
S.S. America

ON BOARD S. S. AMERICA

Commander HARRY MANNING
Captain, U. S. N. R.

Clocks will be ADVANCED One Hour tonight

GALA D

Chilled Grapefruit
Pate de Fois G

Clear Green Turtle Soup, Windso

Lobster a la Newbur

Sirloin Steak, Sauc

REFRESHMENT: Champa

Roast Maryland Turkey, American S
Asparagus Tips Fresh Garden
Candied Sw

Golden Gate Sala

Compote of Preserve

Iced Bombe, America

Gorgonzola Cheese

Table Figs After Dinner Mints

Fresh F

Den

(C.C.)

Souvenir PASSENGER LIST

S. S. MONTEREY
Voyage No. 13
Sailing from Honolulu, May 14, 1934, at 4:00 P. M.
For Los Angeles Harbor and San Francisco

OFFICERS

CAPTAIN A. G. TOWNSEND, Commander
R. J. MELANPHY, U.S.N.R., Chief Officer
H. T. KEENE, U.S.N.R., Chief Engineer

WM. LINDBLOM, Asst. Chief Steward
LOUIS MAGION, Chief Steward
WM. LINN, Cabin Class Steward
H. SHURTZ, Executive Chef

R. JOSE, Purser
H. D. CARL, Asst. Purser
D. T. MEHIGAN, Cabin Class Purser
Dr. S. B. DEGNAN, Surgeon

FIRST CLASS PASSENGERS

A

Albert, Mr. M. Frank
Albert, Mrs. M. Frank
Adrews, Mr. L. R.
Archoold, Mr. Richard
Archer, Mr. C. H.
Ault, Mrs. Ralph
Ault, Miss Susan

B

Bardsley, Mr. W.
Booth, Miss Alice
Bowthorpe, Miss Doreen Phoebe
Brearley, Major Norman
Brearley, Mrs. Norman
Brooks, Mr. J. H. J.

Brooksbank, Mr. J. S.
Brooksbank, Mrs. E. M.
Brown, Mr. Leslie J.
Brown, Mrs. Leslie J.
Brown, Miss Marion N.
Brown, Mrs. W. Clezy
Bruce, Rt. Hon. S. M.
Bruce, Mrs. S. M.
Brunton, Mr. J. Spencer
Brunton, Mrs. J. Spencer
Blair, Mr. F. R.
Blair, Miss Jean F.
Bragg, Mr. Thomas
Bragg, Mrs. Thomas
Brooks, Miss Polly
Brooks, Mr. Harry L.
Brooks, Mrs. Harry L.
Burnaby, Mr. Frank H.
Burnaby, Mrs. Frank H.

C

Carlson, Mr. C. H.
Carr, Mrs. G. W.
Carson, Lieut. H. R.
Carson, Mrs. H. R.
Carson, Miss Mary Alice
Chapman, Mr. John M.
Chapman, Mrs. John M.
Clayton, Mr. Charles
Clayton, Mrs. Charles
Clubb, Mr. George
Clubb, Mrs. George
Clubb, Miss Betty
Clendinnen, Mr. S. C.
Cohen, Mr. Frank
Coles, Mr. George J.
Cox, Mrs. Beulah
Cranston, Miss Claudia
Chapman, Mr. R. B. Hay
Clarke, Mrs. John K.
Cooper, Mr. T. A.
Cooper, Miss Effie E.

D

de Monchaux, Dr. C. F.
Dexter, Mr. W. J.
Dexter, Mrs. W. J.
Doyle, Dr. Leo
Doyle, Mrs. Leo
Doyle, Mr. Ralph R.
Dreifuss, Mr. L. G.
Dunn, Miss M. A.
Dunn, Miss L. M.
Davis, Mr. L. A.
Defoix, Mr. Gilbert
Duerr, Miss Helen V.
Durrieu, Baroness Antoinette

F

Farwell, Mr. Walten
Farwell, Mrs. Walten
Felts, Mrs. G. E.
Ferris, Miss Amy
Foote, Mr. Henry F.
Foote, Mrs. Henry F.
Fulton, Mr. James V.
Fulton, Mr. R. W.

G

Ganney, Mr. W. E.
Ganney, Mrs. W. E.
Gillman, Mr. W. N.

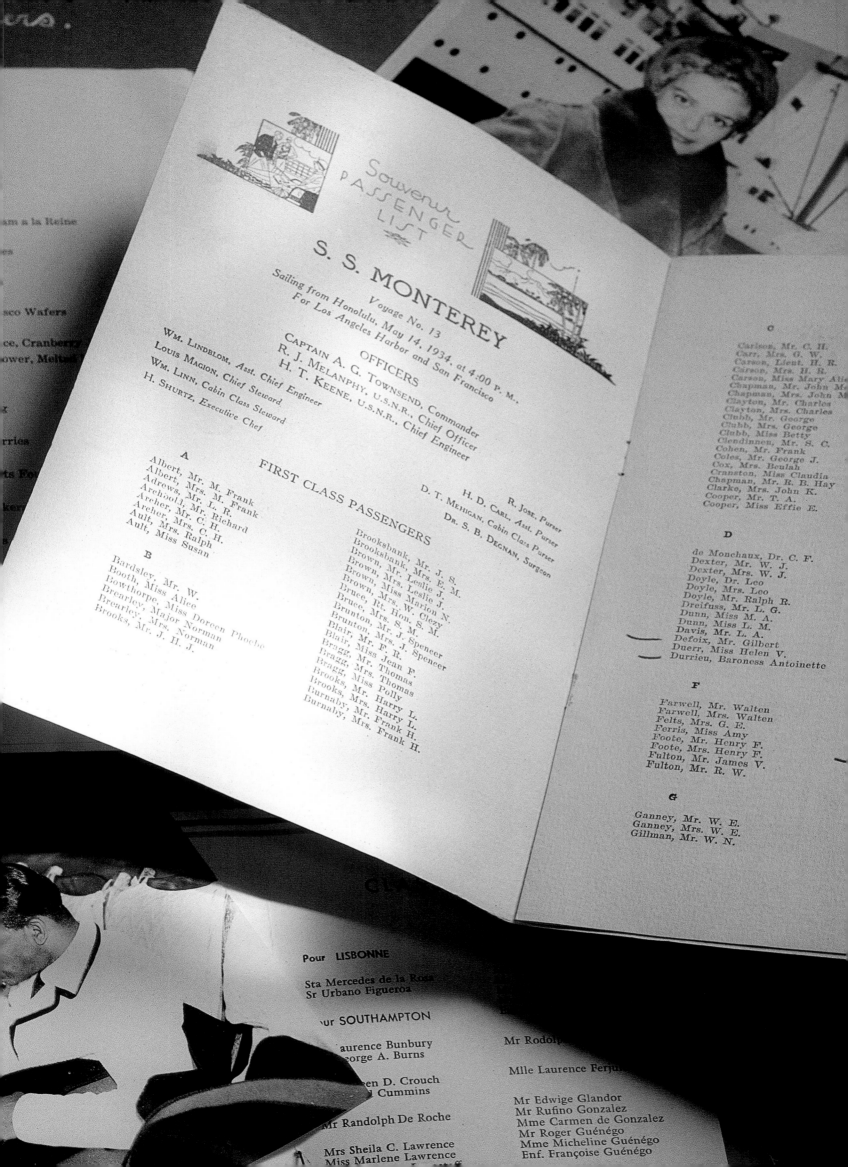

Paquebot "Paris"

en Mer

Le Commandant P. de Malglaive prie
Monsieur & Madame J. Heilbronn
de vouloir bien lui faire l'honneur de Dîner
avec lui le Dimanche 19 Mars 1933
et d'accepter le cocktail au Salon Mixte
à 19 heures 30.

Mr & Mme J. Heilbronn

Cab. 46.

who was doomed to spend his time distributing bicarbonate of soda and attempting to undo the worst effects of fashionable quack remedies, which were at best useless and at worst downright dangerous. These ranged from the treatment perfected by one Dr. Madeuf, who at the turn of the century urged the use of dumbbells to "block the intestines," to the recommendations of his colleague Dr. Legrand, who suggested that one tightly bind the stomach from groin to sternum with a strip of flannel fifty feet long, via a whole range of mutually contradictory old wives' tales, which required the sufferer to remain in bed or engage in vigorous activity, fast or feast, and so on. Then came over-the-counter remedies such as Mothersill's Seasick Remedy, opium, ether, or cocaine, which was a favourite with the ladies, particularly on voyages to the Far East. Cartoonists and satirists of the period took delight in lampooning the snobbery that developed in the emerging world of transatlantic liners by poking fun at seasickness and all its attendant indignities, but the shipping lines did not take the matter lightly at all. For them it represented a real threat to their continued commercial expansion, and it is true to say that the technical, architectural, and decorative development of ocean liners was dictated in part by the need to find solutions to this disagreeable scourge.

The owners of the earliest steamships had used seasickness as an argument for poaching passengers from sailing ships, promising them a clear head and an end to seasickness. Those who believed them had reason to regret it, which can be judged by the fury of the passengers on the *Great Eastern,* who according to Jules Verne came to curse the charter company's claim that seasickness was "unknown on board." We need only imagine the *Great Eastern, Great Western*, and their ilk, plowing through the Atlantic swell for thirty years or more, their heavy hulls groaning and creaking, and their gigantic paddlewheels tearing into the waves and hurling showers of black foam up among their forests of masts and funnels. Lurching from side to side and pitching in terrifying fashion, the bows plunging into the depths of a watery abyss while the stern pointed skyward at an angle of ninety degrees, they could hardly have been better designed to produce the most acute cases of seasickness. It is not hard to imagine just how delightful the experience must have been for passengers, at a time when a transatlantic crossing took over ten days—or in other words an eternity.

OPPOSITE: On the *Ile de France* in 1932, two celebrities of the period, Maurice Chevalier and Buster Keaton, honor the table of Commander Blancart with their presence.
INSET: An invitation from M. de Malglaive, commander of the *Paris*, to M. and Mme J. Heilbronn, first-class passengers. As was traditional on French liners, dinner at the captain's table was to be preceded by cocktails in the lounge.

ABOVE: "The first dinner: not quite so hungry as he thought he was. . . . Mr Jones is never seasick, but explains that he is slightly upset by his early breakfast in town. . . . Mr Smith feels he might possibly survive another ten minutes if his charming companion and the attentive stewards would leave him alone." A choppy mealtime on board a P&O steamer in the 1890s, as described in W. W. Lloyd's *P&O Pencillings*, c. 1891.
INSET: Reservation ticket for the last dinner service on a HAPAG steamer.

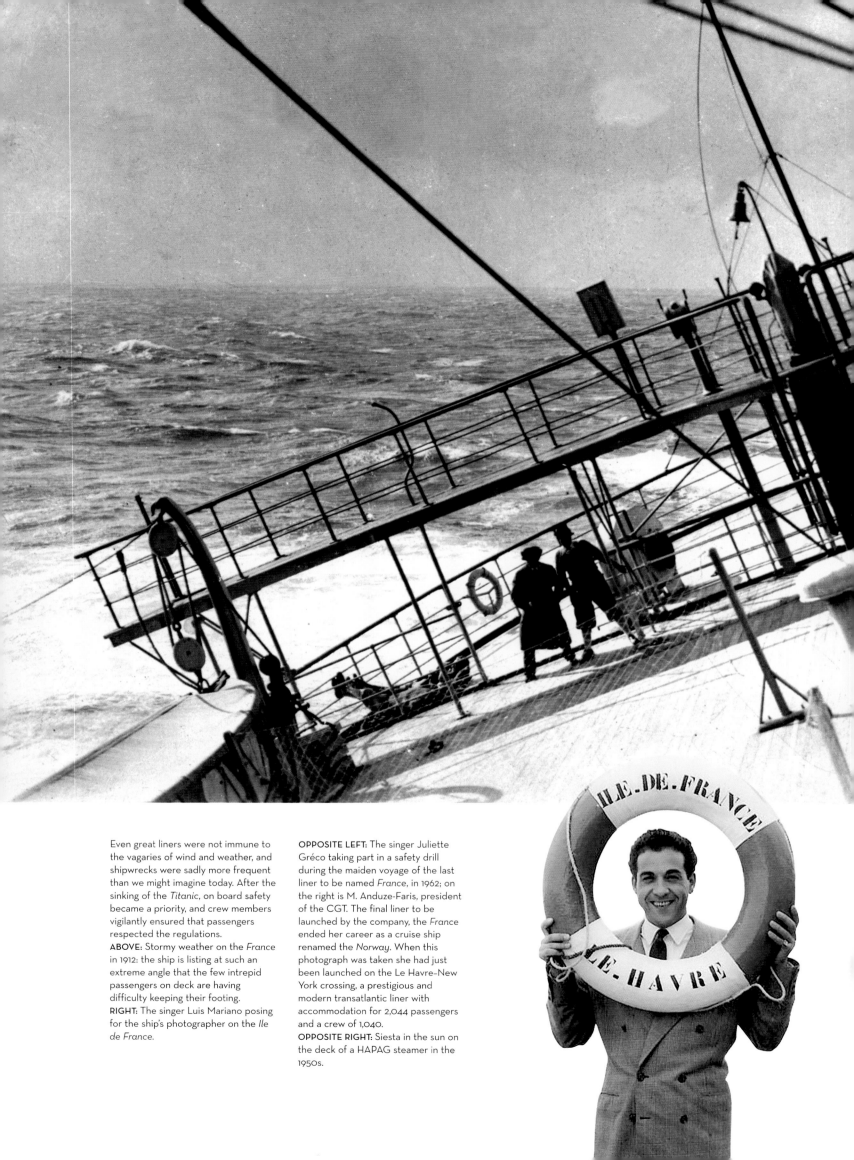

Even great liners were not immune to the vagaries of wind and weather, and shipwrecks were sadly more frequent than we might imagine today. After the sinking of the *Titanic*, on board safety became a priority, and crew members vigilantly ensured that passengers respected the regulations.

ABOVE: Stormy weather on the *France* in 1912: the ship is listing at such an extreme angle that the few intrepid passengers on deck are having difficulty keeping their footing.

RIGHT: The singer Luis Mariano posing for the ship's photographer on the *Ile de France*.

OPPOSITE LEFT: The singer Juliette Gréco taking part in a safety drill during the maiden voyage of the last liner to be named *France*, in 1962; on the right is M. Anduze-Faris, president of the CGT. The final liner to be launched by the company, the *France* ended her career as a cruise ship renamed the *Norway*. When this photograph was taken she had just been launched on the Le Havre–New York crossing, a prestigious and modern transatlantic liner with accommodation for 2,044 passengers and a crew of 1,040.

OPPOSITE RIGHT: Siesta in the sun on the deck of a HAPAG steamer in the 1950s.

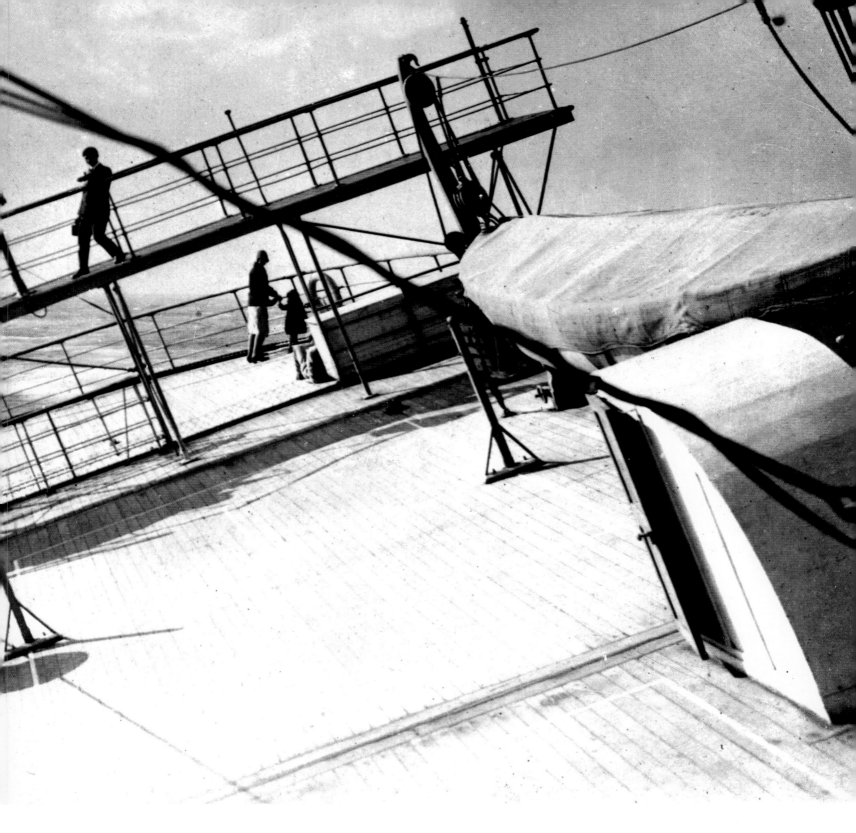

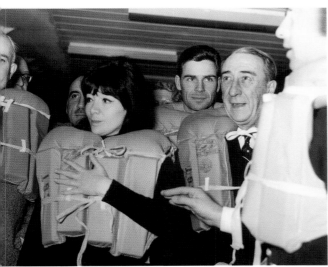

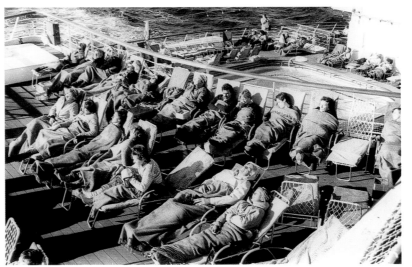

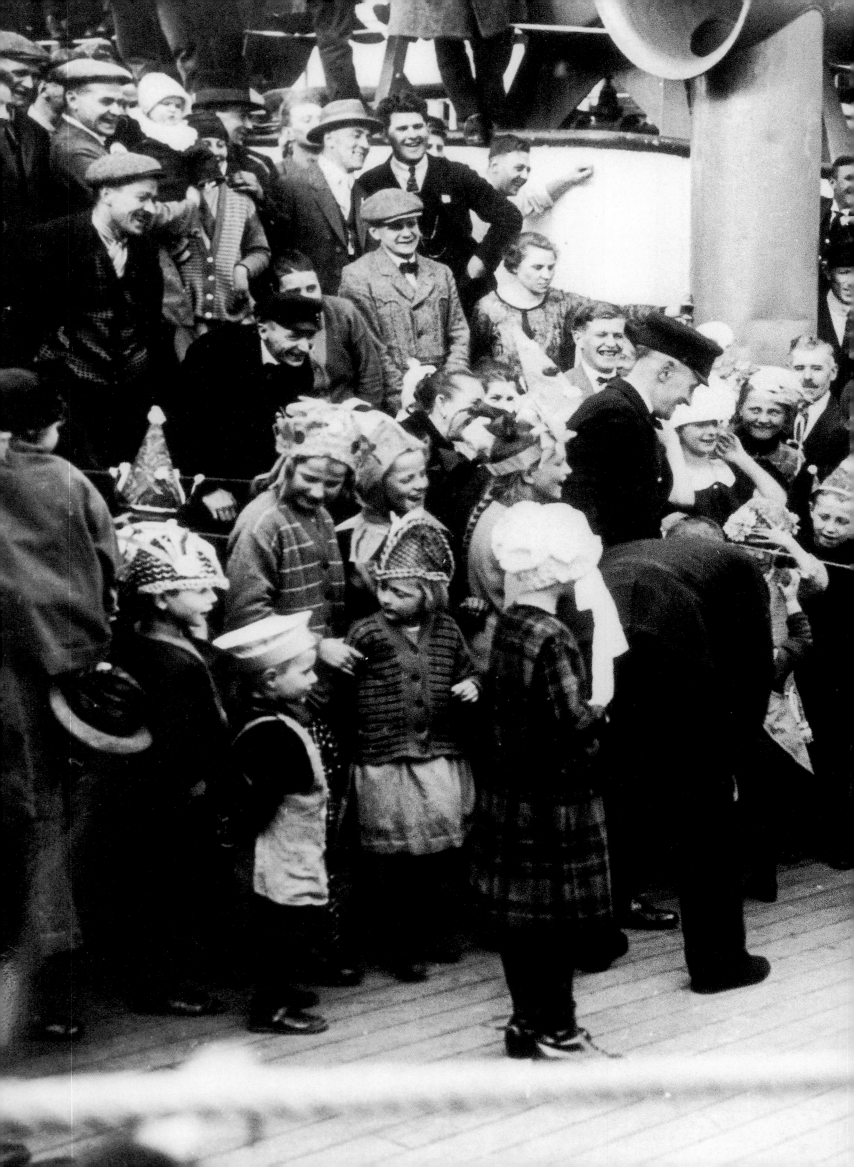

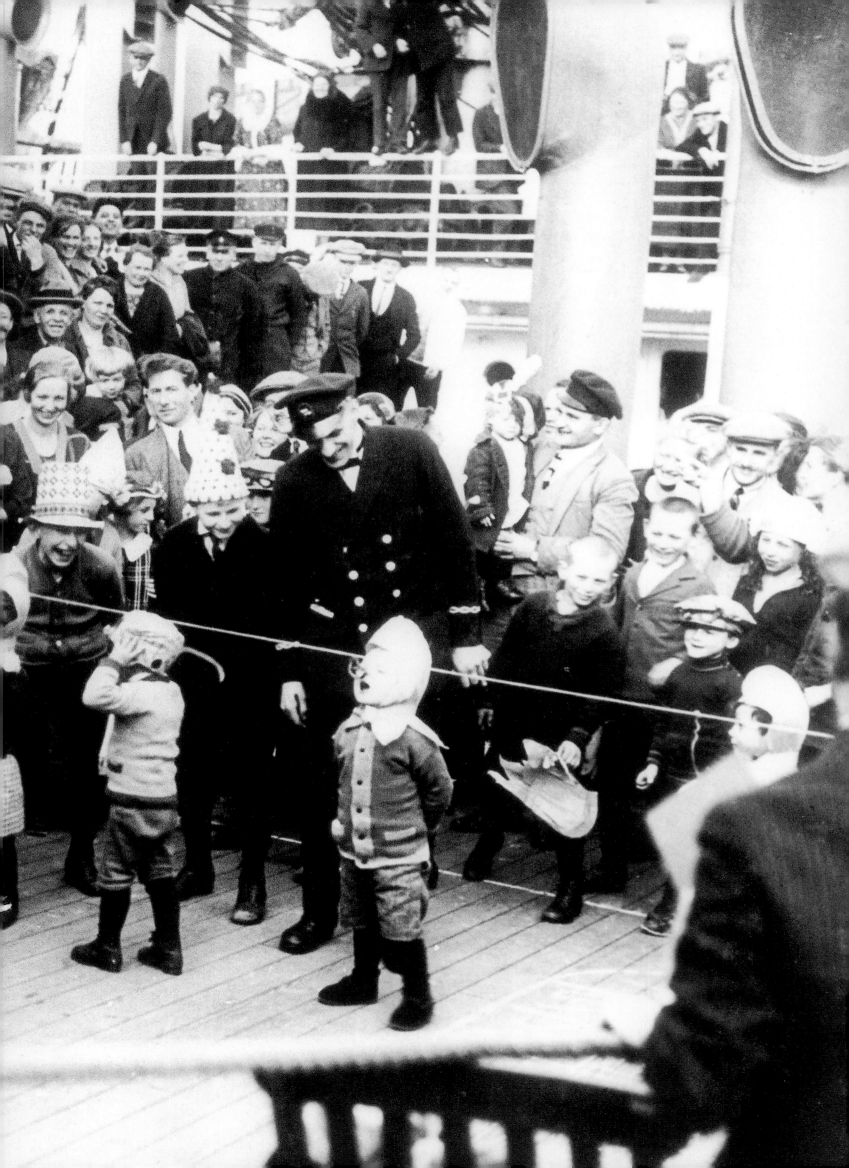

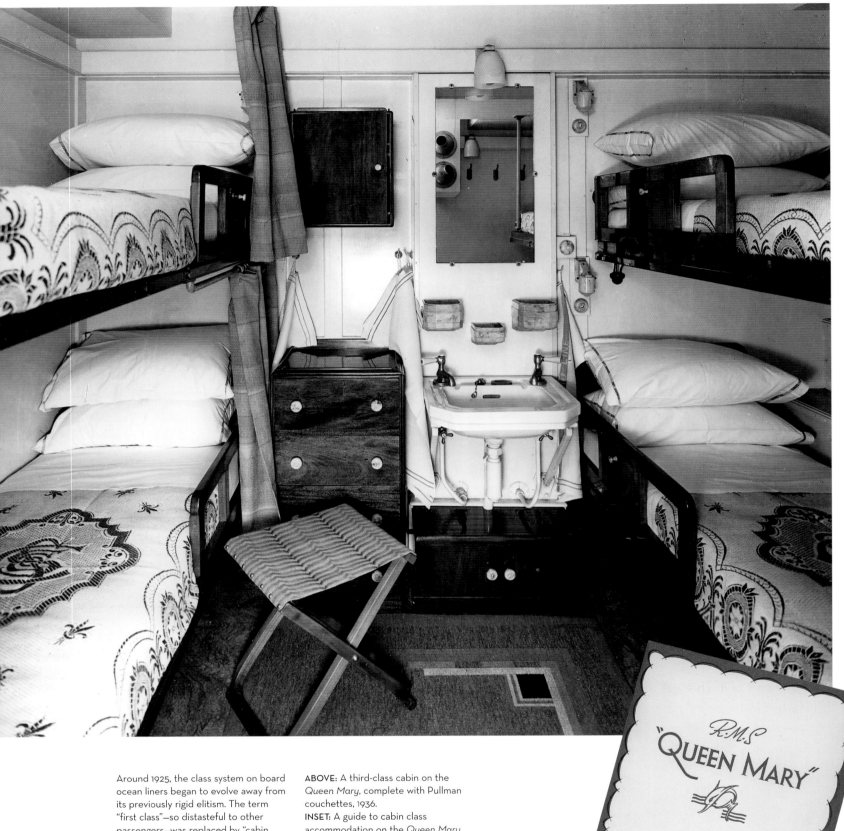

Around 1925, the class system on board ocean liners began to evolve away from its previously rigid elitism. The term "first class"—so distasteful to other passengers—was replaced by "cabin class," while second class became "tourist class." In 1930, the CGT went so far as to launch two "cabin ships," with only one class of accommodation, the *Lafayette* and the *Champlain*. As for third class, this level of accommodation on the *Queen Mary*, so Cunard claimed, was the equal of first class on any other line.

ABOVE: A third-class cabin on the *Queen Mary*, complete with Pullman couchettes, 1936.
INSET: A guide to cabin class accommodation on the *Queen Mary*, distributed to passengers by Cunard in the 1950s.
PRECEDING PAGES: Children letting off steam in a fancy-dress parade on board a HAPAG steamer, to the great amusement of several members of the crew, c. 1930.

R.M.S
"QUEEN MARY"

GUIDE TO
ACCOMMODATION

CABIN

Cunard White Star

In heavy seas, performing one's toilette could become something of an adventure. In about 1891 P&O commissioned the artist W. W. Lloyd to produce *P&O Pencillings*, a collection of entertaining watercolors and sketches documenting the vicissitudes of life as he experienced it on the voyage from Southampton to India on the SS *Himalaya*. Here a gentleman passenger is shown attempting to extract a clean shirt and collar from his case and put them on for dinner. The perils involved in shaving—merely hinted at here—were perhaps best left to the imagination.

To add to their "comfort," the two monumental paddle-wheels took up the whole of the amidships area, relegating passengers to the stern, beneath the poop deck. Nowhere was the pitching and rolling of the vessel felt more keenly than in this cramped space that served as both dining saloon and lounge, hemmed in by cabins and too confined to be laid out with any regard to comfort. Dimly lit by tiny portholes, which were usually kept firmly closed, it reeked of cooking smells, engine fumes, and the contents of chamberpots, which with every shudder of the boat, slopped onto the floor of neighboring cabins. An effort was made with the decorations, nevertheless, and there was a profusion of mahogany and velvet, with the inevitable piano for evening entertainments under the gloomy light of oil lamps.

The solution to all this was discovered in the form of the screw propeller. Thus relieved of its enormous paddlewheels, the steamship was now able to rearrange its accommodations and organize them into classes: henceforth all passengers would share the same boat, but never the same part of it. This was the system—launched by the British Inman Line in around 1870—that was to become the norm. It was reflected in the new structure of steamships, with a "central castle" between the forecastle and aftcastle, a city or "ship within a ship" in which everyone knew his or her place. First-class passengers occupied the central, most stable section. Those in second class were placed towards the stern, where they would be more subject to rolling and shuddering, but would enjoy the benefits of space and fresh air. There remained the steerage accommodation, occupied by third-class passengers, who were mostly emigrants from whom a profit was gained in quantity. These accommodations were little better than the wind-driven "coffin ships" in which emigrants were treated like cattle. Serried ranks of bunk beds, with headroom of a mere six feet, were the only furniture, the portholes were permanently shut and pounded by the waves, and the lurching and plunging of the ship were horrendous. Only after the navigation companies had been called to order on numerous occasions, notably by the American government, and farsighted individuals such as Albert Ballin, director of the HAPAG, had exerted their considerable influence, could it be said that the conditions in which emigrants were transported were no longer a disgrace to the shipping lines.

Where the safety of passengers and crew was concerned, the great ocean liners inhabited a different world from the early paddle steamers of the nineteenth century, which pitched and tossed so violently that on occasion, according to Michel Mohrt, "one or other of the paddle wheels would be lifted right out of the water and be left churning the air," and which moreover could send no SOS messages, as the telegraph had yet to be invented. **RIGHT:** One of the booklets issued to passengers on the *Ile de France* (1927), containing safety instructions "in case of emergency."

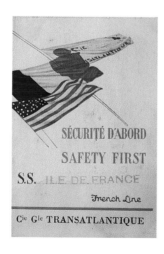

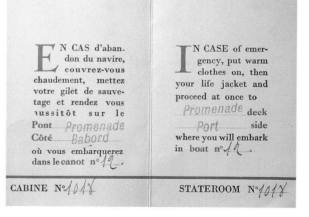

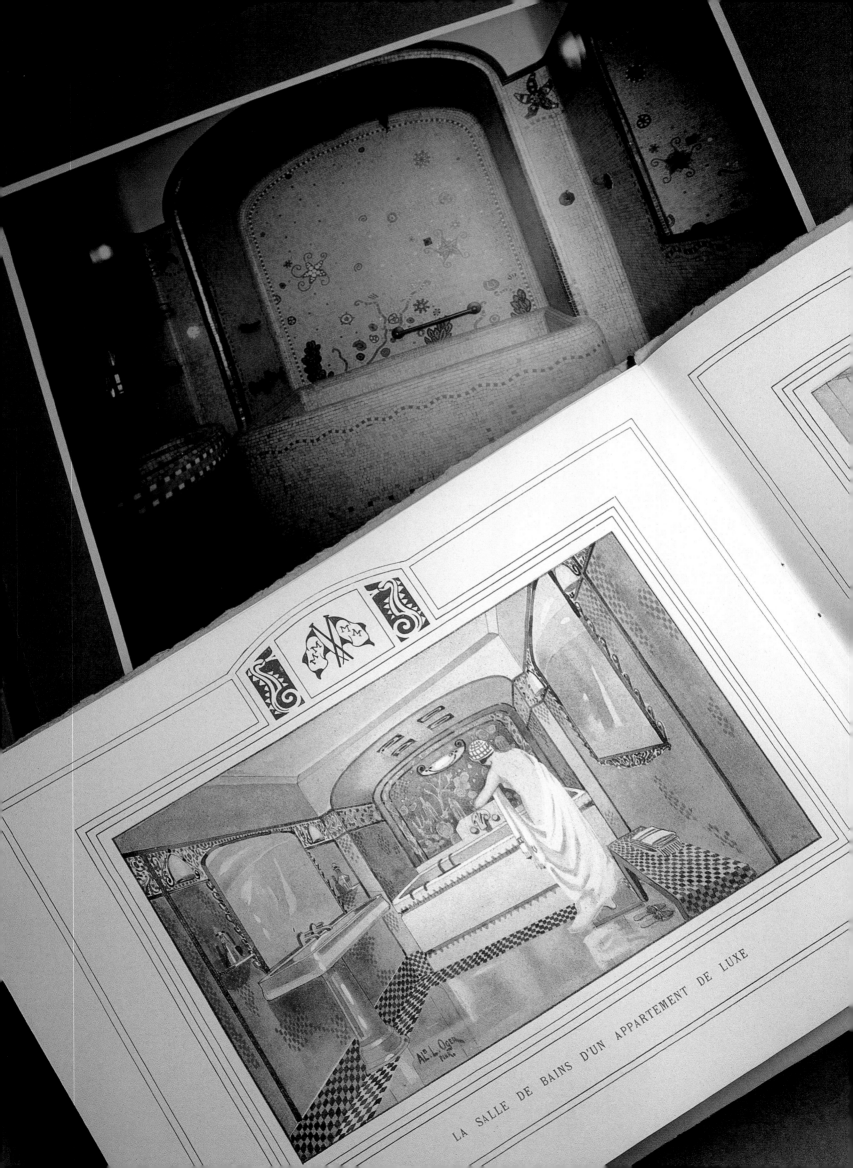

LA SALLE DE BAINS D'UN APPARTEMENT DE LUXE

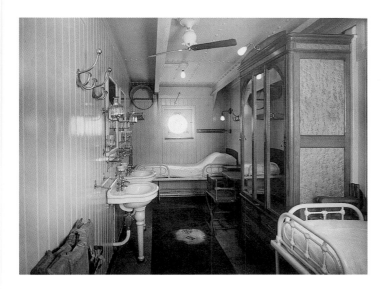

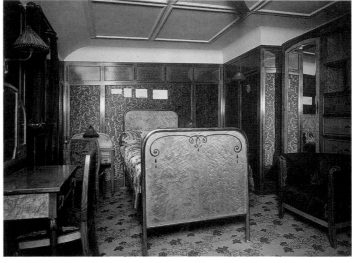

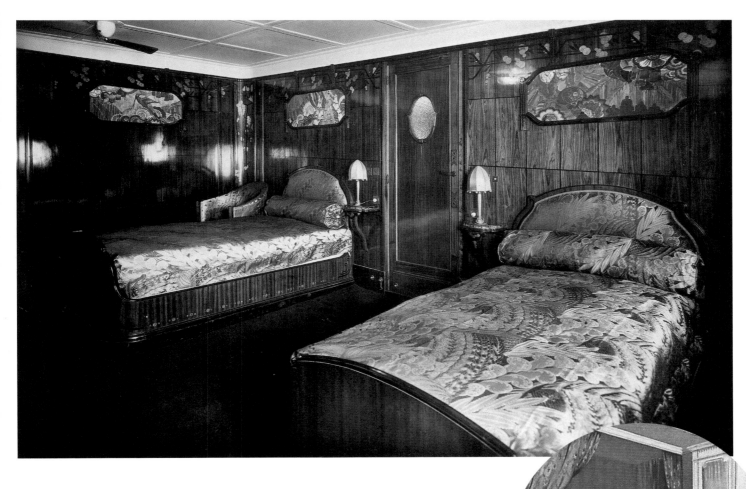

The *Champollion*, launched in 1925 on the Messageries Maritimes' Egypt–Syria route, was one of the most prestigious ships of the company's fleet, to be joined in service a year later by her sister ship, the *Mariette Pacha*. The last word in luxury and distinguished ship design, the two liners were elegant exponents of the neo-Egyptian style, infused with a strong Art Deco influence. Their sumptuous décor featured paneling and marquetry in precious woods, friezes depicting scenes from antiquity, and stylized floral motifs, painted metal, and lacquer inlay, combined with Empire-style furniture, gondola chairs, and columns in the form of lemon trees. The effect was stylish, sophisticated, and surprisingly restrained.

ABOVE AND TOP RIGHT: "Semiluxury" cabins on the *Champollion*, showing the *tapissier*, or upholstered, style typical of Art Deco in its early years.
TOP LEFT: A less plush, more austere style prevailed in this first-class cabin with twin beds. Note the life jacket in the foreground.
INSET: A deluxe cabin on *La Provence*, 1906–16 .
OPPOSITE: Photograph and lithograph (by L. Oger Pina) of bathrooms in deluxe suites on the *Champollion*. With their bathtubs of colorful mosaic tiles set in alcoves strewn with starfish and other aquatic flora and fauna, these enchanting rooms were the stuff of dreams. The little album of colored lithographs bears the colophon of the Messageries Maritimes, flanked by a pair of seahorses, emblem of the company from its foundation in 1851.

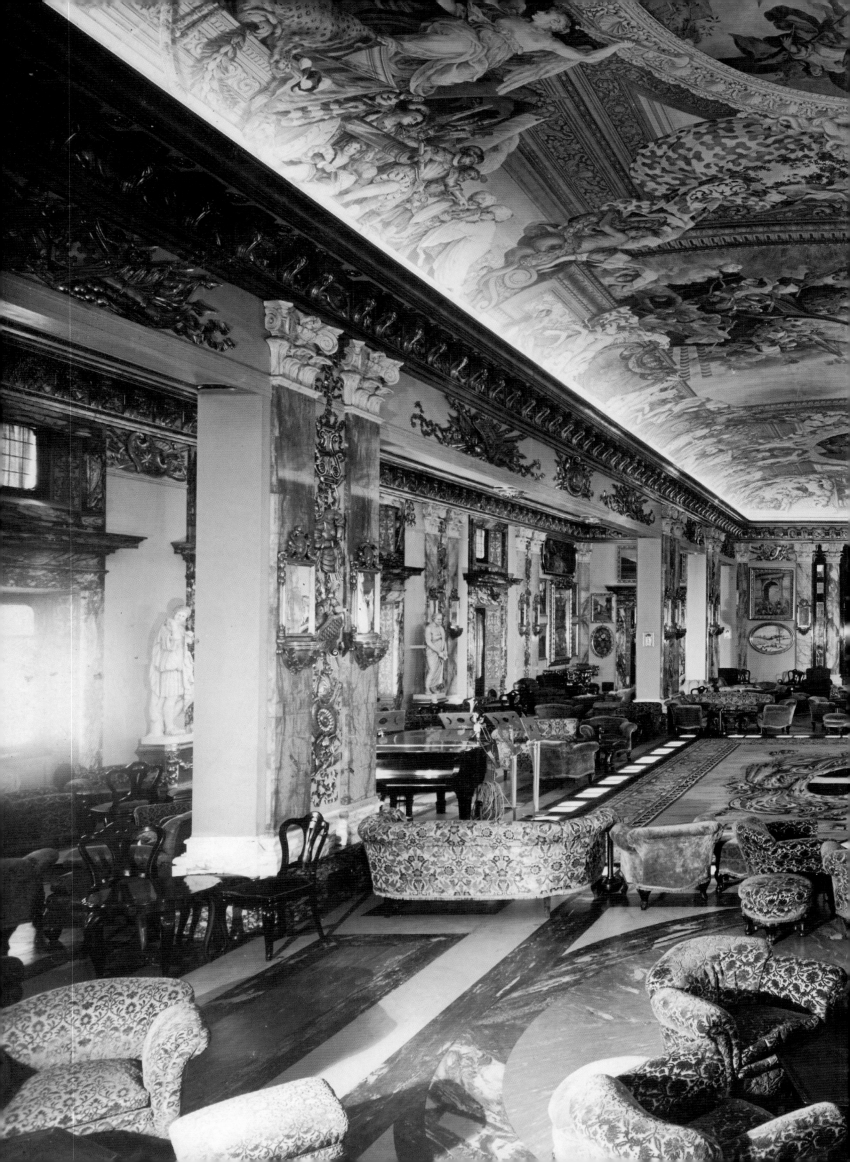

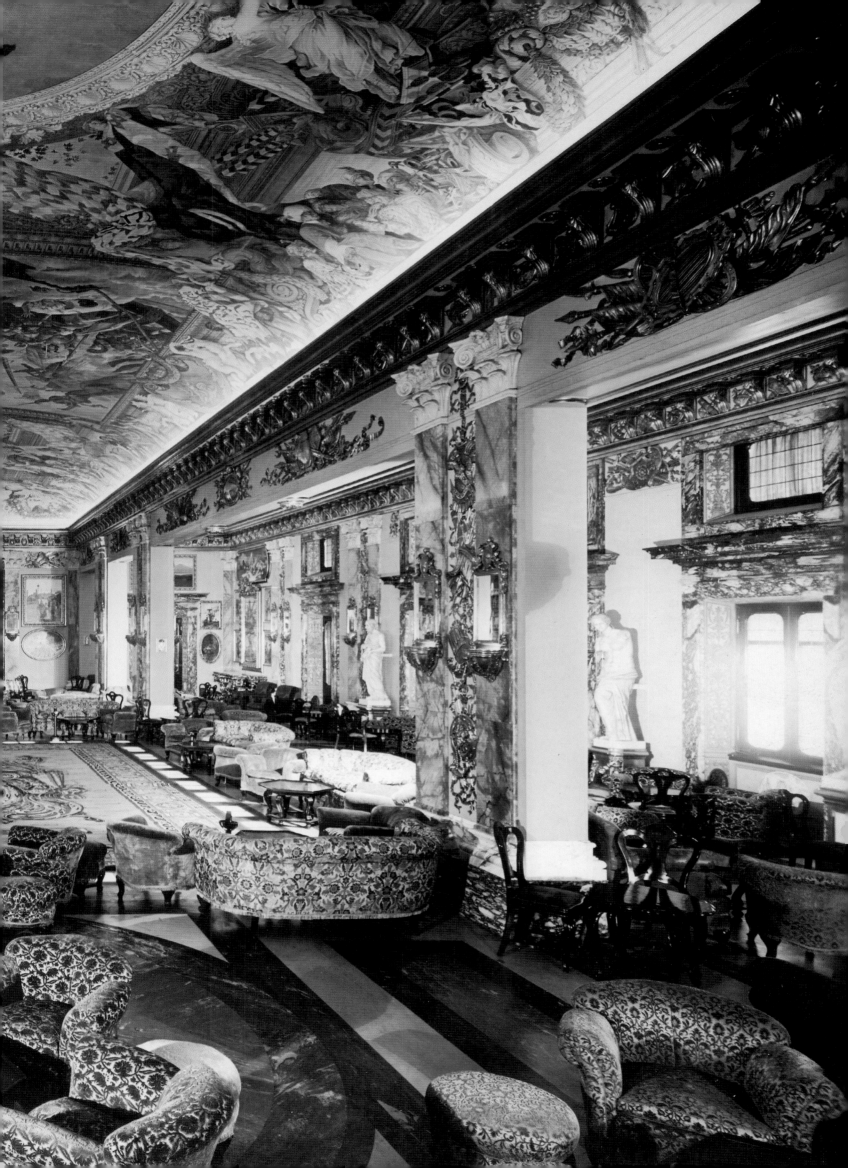

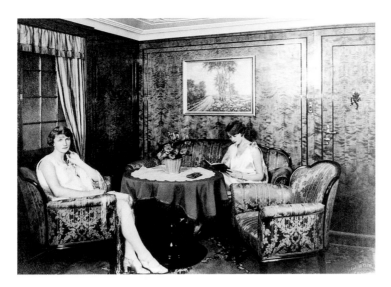

The décor of the public and state rooms on the great liners was designed to impress. In order to flatter the tastes of as many passengers as possible, it had to marry harmonious classicism with a contemporary approach, and luxuriousness with modernism. This combination of styles was most apparent in the decade from 1925 to 1935.
LEFT: Velvet upholstery and lacquer panels in the sitting area of a deluxe cabin on the *Cap Arcona*, owned by the Hamburg-based company HSDG, 1925.
OPPOSITE ABOVE: The grand salon of the *Normandie*, with columns by Jean Dunand, murals painted on glass by Jean Dupas, and light "fountains" by Labouret (illustration by Bouwens de Boijen and Expert, 1935).

84

New improvements in first-class accommodation, by contrast, transformed the crossings made by the fortunate few once and for all. First-class cabins were placed beneath the main deck, amidships and close to sea level, in an area of relative calm. The passage was made all the more agreeable by the transformation of these cabins—as on *La Touraine* in the 1890s—into proper bedrooms, with over seven feet of headroom, beds made of precious woods or copper, marble bathrooms with running hot and cold water, bells to call the cabin boy or chambermaid, generous portholes, and attractive electric lights. The architectural plans for the dining saloons, where more than anywhere else, passengers needed to be pampered and cosseted, were simply spectacular. Breathtaking heights could be reached by constructing ceilings that were several decks high. These saloons were sometimes covered in with a fragile glass dome—so fragile that the dome of the *City of New York* could not withstand the frozen nights of the North Atlantic. The occasions on which the whole edifice shattered, causing the diners below to make a hurried retreat, became too numerous to count.

Yet it was preferable for passengers to gaze up at these fragile creations than to look through the portholes at the horizon as it rose and fell. Everything was contrived, indeed, to distract their attention from this unfortunate fact of life, and it was no coincidence that on *La Lorraine* and *La Savoie*, both launched in 1900, the portholes were veiled or opaque. On the *Imperator*, meanwhile, the windows of the winter garden—itself an elaborate illusion, with trompe l'oeil topiary and water features—looked out only onto the sky, as the room was suspended more than ten stories above the waves. Another approach was simply to do away with all openings, and by extension with all allusions to the vessel's watery surroundings. Thus on the *Normandie*, passengers entered a lavishly decorated and hermetically sealed dining saloon, flooded with light beneath its gilded stucco ceilings. Here the passenger was completely cut off from any upsetting contact with the outside world, and was plunged instead into a different and altogether happier dimension. Passengers' feelings about being able to "see the sea" from the ship's lounges shifted, interestingly, from one era to the next, and it became perceived in a completely different manner. In 1938, for instance, the brochure for the *Nieuw Amsterdam*—the flagship of the Dutch-owned Holland-Amerika Line boasted, among other merits of its restaurant

PRECEDING PAGES: Adolfo Coppedè's famous Galleria Colonna on the *Conte di Savoia*—a faithful reproduction of a Roman Renaissance palazzo—was a stylistic anachronism amid the otherwise avant-garde world of this great Italian steamer designed in 1932 by Gustavo Pulitzer Finali. This reference to a vanished world was a last concession from the designer to the owners.

OPPOSITE BELOW: The legendary grand salon, or main lounge, of the *Ile de France*, decorated by Süe et Mare in the Art Deco style made popular by the Exposition des Arts Décoratifs in Paris in 1925. The columns are in deep red lacquer, the chairs upholstered in velvet with a design of foliage, and light pours in through the glazed caisson ceiling.
RIGHT: A chair from the grand salon of the *Normandie*, with upholstery by Gaudissart.
OVERLEAF: The Cambodian-inspired music room on the *Félix Roussel*, 1930.

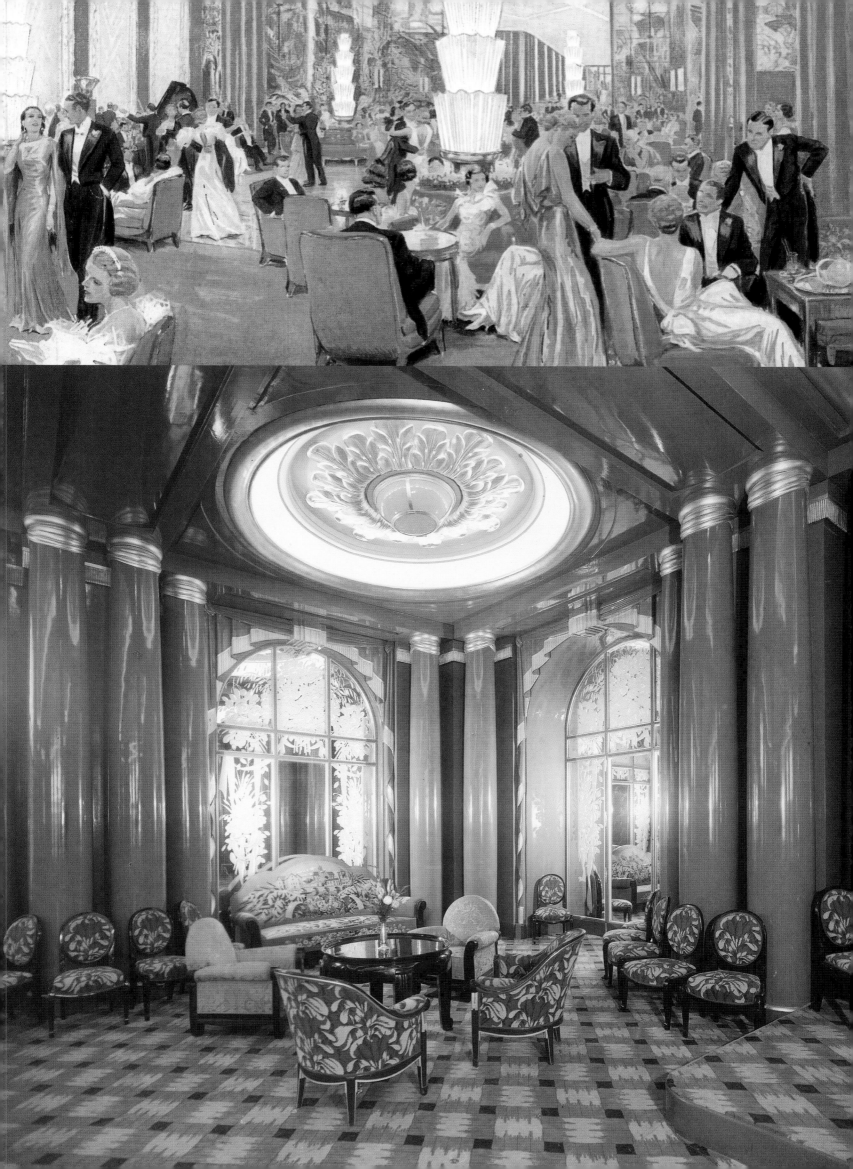

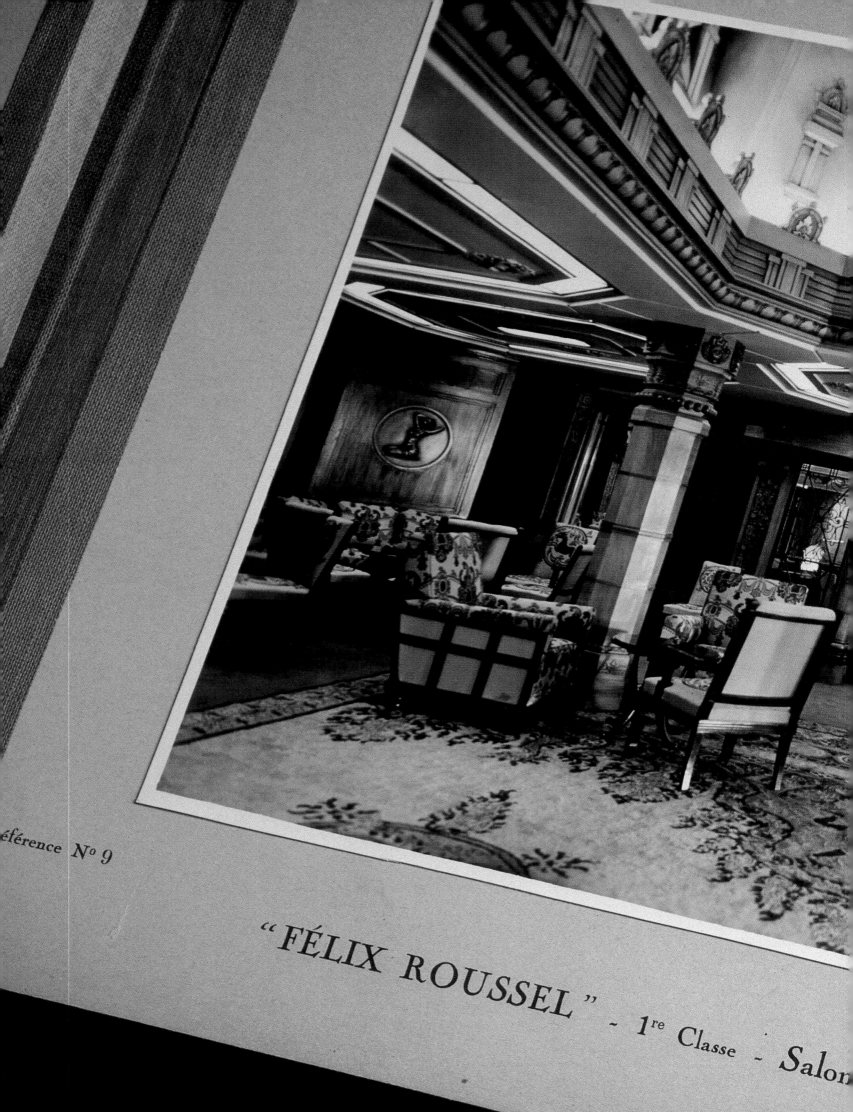

"FÉLIX ROUSSEL" - 1ʳᵉ Classe - Salon

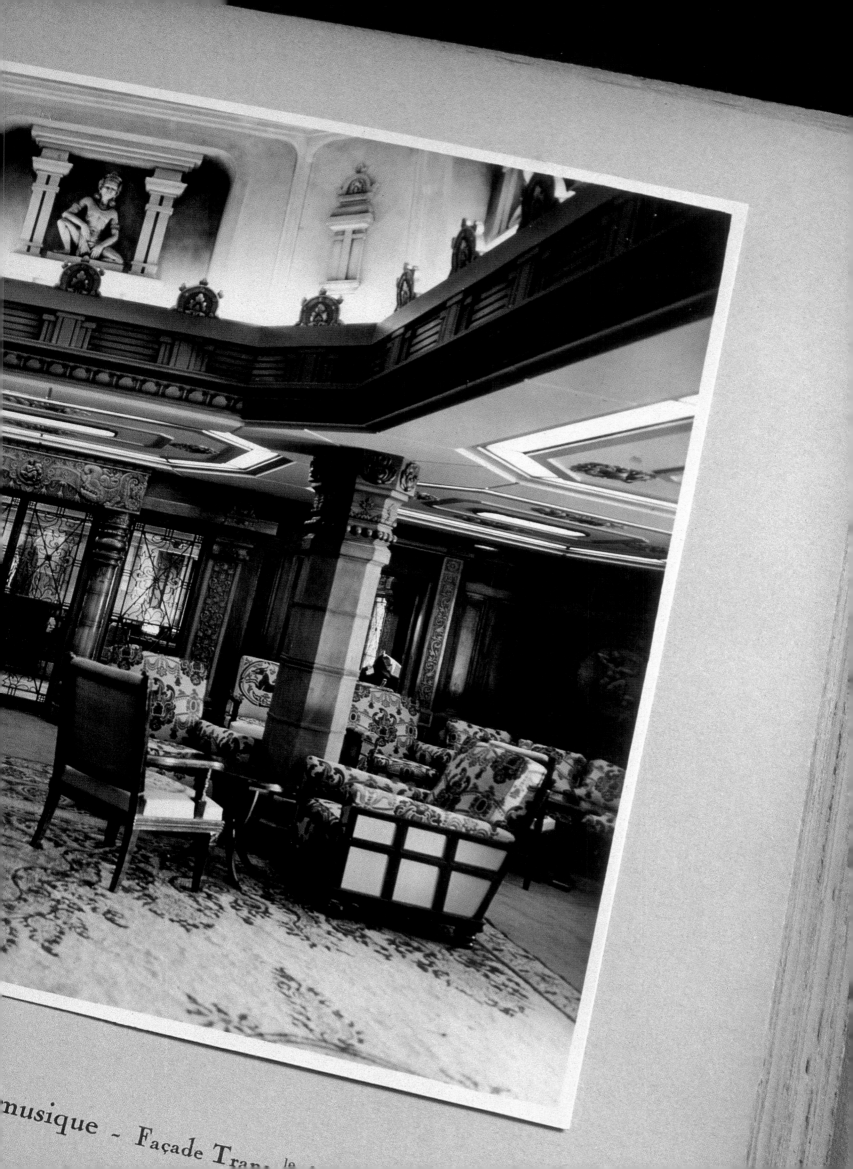

musique - Façade Tra...

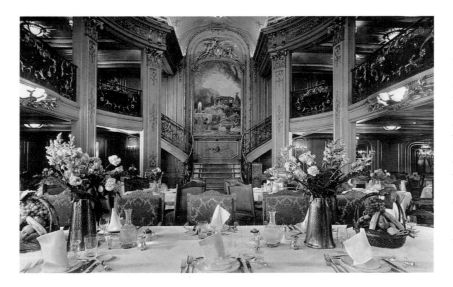

"Imagine a vast hall occupying three decks of the ship and eight meters in height. The hall is laid out on two floors, and can seat 350 passengers at mealtimes. The center is topped with a dome supported by pilasters, and the two floors are linked by a magnificent staircase." This description of the first-class dining saloon on the *France* in 1912 (left) is taken from an elegant brochure produced by the CGT at the time, in which it was further explained that "the decorative scheme is inspired by the *hôtel particulier* of the Comte de Toulouse," and that the painted panel above the staircase "represents *La Grâce française* and is the work of the eminent artist La Touche".

on A deck, that it had "neither windows nor portholes looking out to sea." This, perhaps even more than the beautiful decorations—ivory walls, pale gold ceiling, columns gilded with gold leaf, and satinwood furniture—was the decisive factor in its favor. Yet thirty years later, during the building of the *Queen Elizabeth 2*, the prospective clientele was enticed with glowing descriptions of the restaurants on the upper decks, with their unparalleled views of the breathtaking spectacle of the high seas.

But in the end there could be no denying the fact of the matter, and nothing could change the fact that a ship would always be a ship. There would always be breakages in the galleys (no fewer than a couple thousand glasses and fifteen hundred plates, cups, and saucers perished per crossing on the *Etruria* in the 1890s); and in heavy swells, flower vases and anything else that might slide, tumble, or overflow would always have to be secured or lashed down. And there would always be the need for precautions of every possible kind: ropes around the dance floor that could be used instantly to block it off, the "violin" that could be used at a table to hold a full glass of wine and a dish of scalding hot consommé. It all depended on the ship. Some were

solid as a rock, while others were tossed about like matchsticks. Some were notorious for being "rollers," and on these a passage would be far from smooth sailing. The *Kaiser Wilhelm der Grosse* (1897), for instance, was renowned not only for her unsurpassed combination of opulence, comfort, spaciousness, and elegance, but also for her unfortunate tendency to roll when there was a swell—to the point where her American passengers dubbed her Rolling Billy. And not only did she roll, but she also vibrated. Few passengers present would ever forget the evening in 1906 when the Italian composer Ruggero Leoncavallo gave a gala concert. Sitting through the cacophony produced by the orchestra, which was in competition with the throbbing of the engines, the clanging of the lifts, and above all the unbearable shuddering, was torture beyond all endurance. The *Lusitania* also suffered from an appalling vibration problem, to the extent that when she was steaming at full speed her second-class cabins were unusable. The graceful *Deutschland*, meanwhile, a multiple winner of the Blue Riband, suffered from bad vibrations from the outset, and at full throttle passengers could not hear themselves speak in the grand bar, where

RIGHT: Dinner sometimes resembled a game of skittles, with bottles, glasses, jugs, and plates toppling in all directions, as may be judged from this scene from W. W. Lloyd's *P&O Pencillings*, c. 1891.
OPPOSITE: The dining saloon of the Messageries Maritimes steamer *Angkor* (1922). The swivel chairs, tables, and other furniture are firmly bolted to the floor: an essential precaution at sea during this period.
OVERLEAF: The magnificent Art Nouveau dining saloon and gallery of the *Amazone*, of the CGT fleet, viewed from the grand staircase.

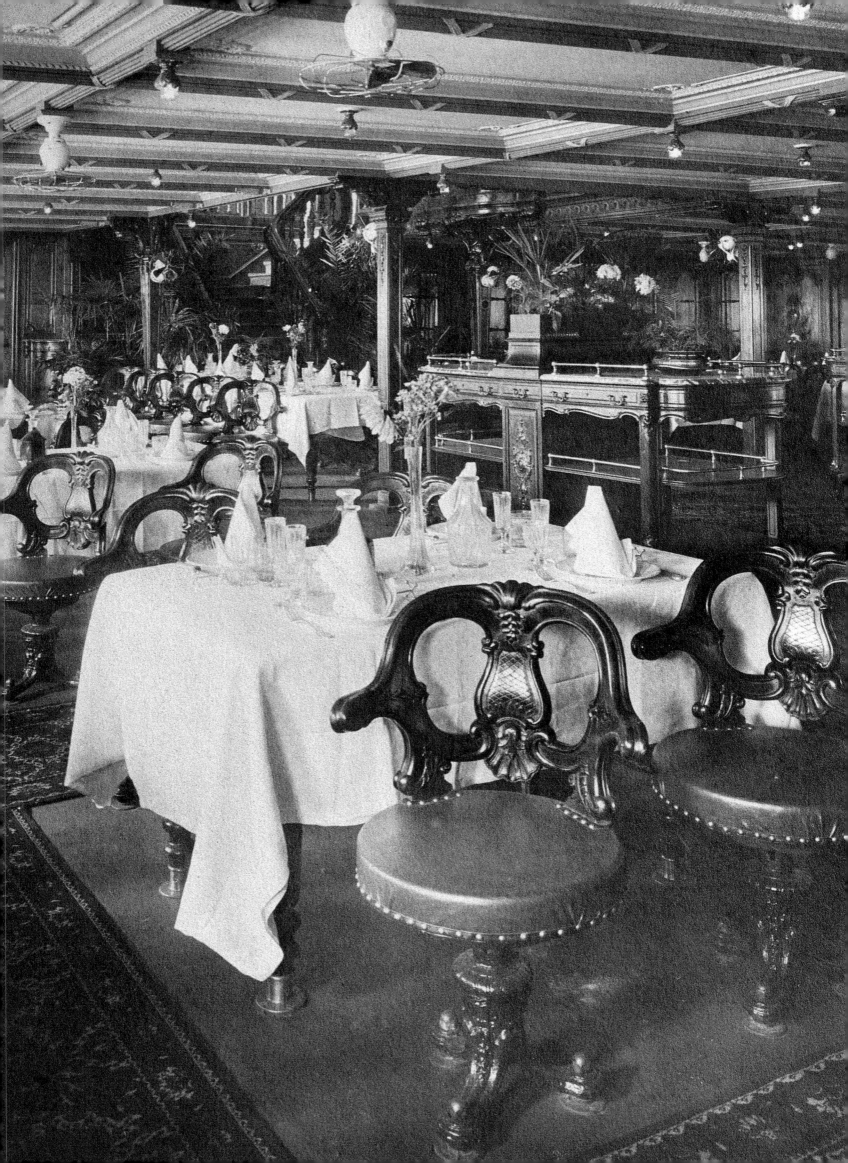

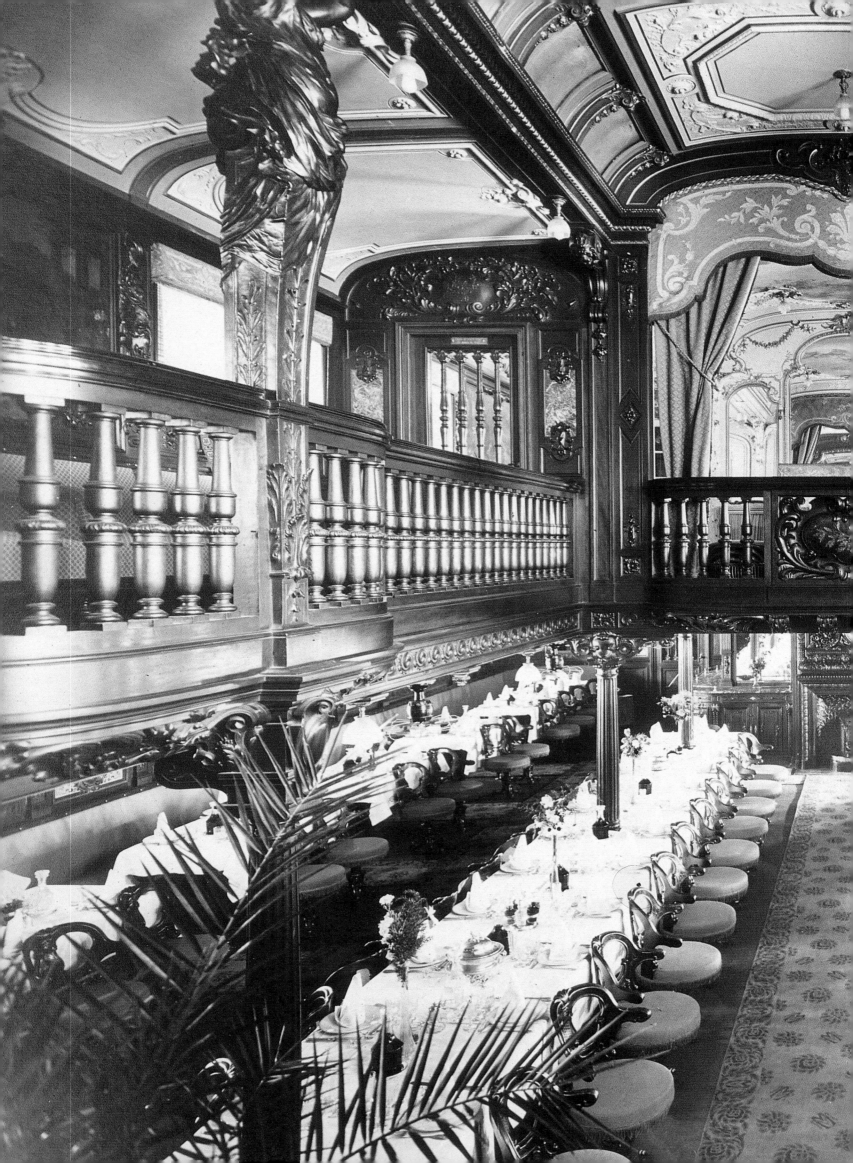

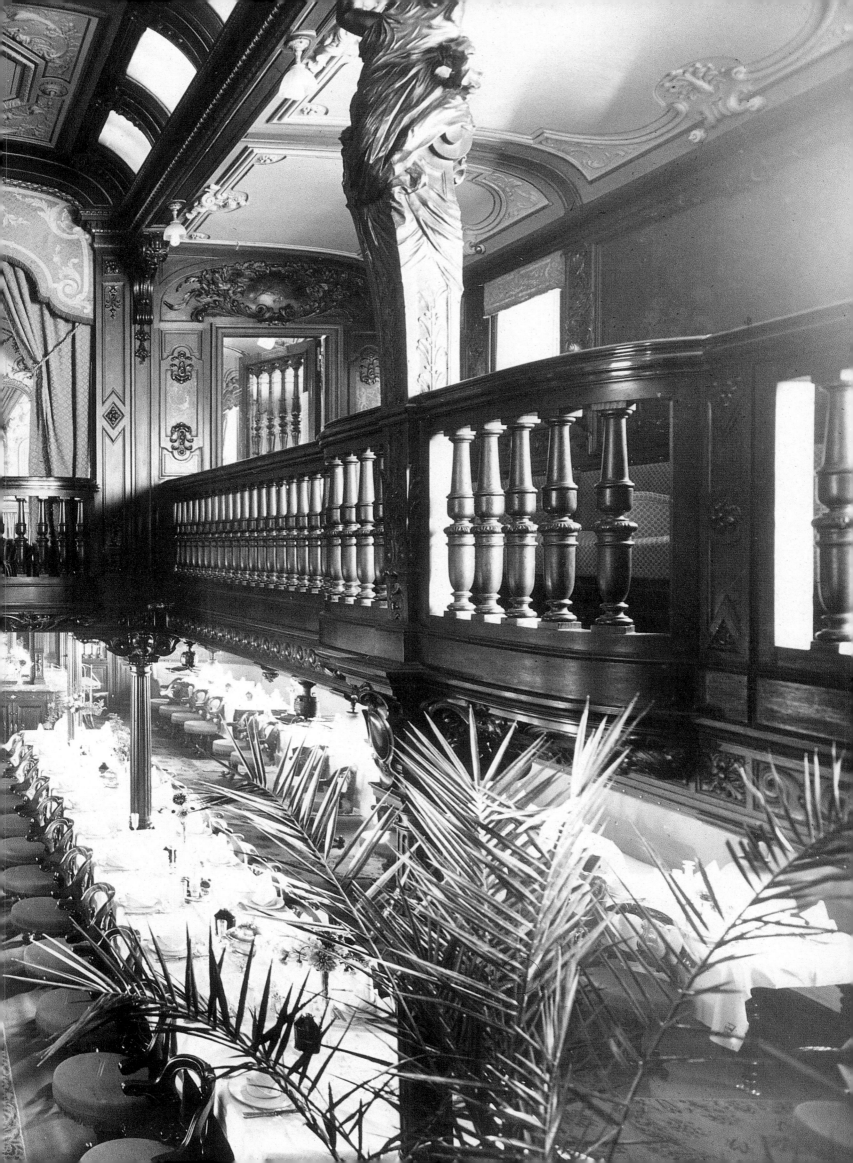

Developments in telecommunications meant that a "transatlantic gazette" could be printed aboard ship, providing passengers with news, and above all keeping them up to date with the timetable of activities on board.
RIGHT: The printing shop at work on the *Normandie*.
INSET: The program of sports and amusements on the *Rajputana* of the P&O fleet (1925), also printed at sea.
OVERLEAF LEFT: Reading *l'Atlantique*, the newspaper of the CGT steamers.
OVERLEAF RIGHT: The edition of *l'Atlantique* of August 23, 1923, with a list of cabin passengers of *La Bretagne* (March 1887), a CGT mail boat.

the thousands of crystal droplets making up the enormous chandelier jangled furiously. For similar reasons, the *France* of 1912 was obliged to return to the naval dockyard. Even the largest were not immune: the *Queen Mary* shuddered from keel to crow's nest at speeds over thirty knots. As for the *Normandie*, the tremendous shudders that ran through the third of the ship that was towards the stern threatened to ruin her maiden voyage. Madeleine Jacob of *Vu* magazine reported: "There is a slight trembling in the first-class dining saloon, but so very slight! Really nothing at all, just like the shaking of a bus as it passes by. It is perfectly bearable. Where it is not is in tourist class. The cabin that I have just visited, belonging to our photographer, was executing a convulsive jig to a tumultuous din on an operatic scale!"

The iron leviathans were in fact as delicate as fob watches, with teams of engineers and mechanics toiling ceaselessly to reduce vibrations and other unfortunate side effects. In March 1937, the *Normandie*, fitted with new screw propellers, at last managed an almost noiseless crossing. Eliminating unwanted noises was not enough, however. Risks also had to be eliminated, and additionally, the passengers required assurances, certainties even—but not too much detail. Where safety was concerned, there existed a sort of unspoken understanding between the navigation companies and their clientele, founded on a superstitious dread of naming dangers. Disasters at sea, which were shouted by newspaper headlines, inflicted a collective trauma that had the companies rushing to reassure their passengers. Fire, for example, was a constant fear, and with cause: a number of steamers launched between 1900 and 1910 suffered a succession of fires. The *Imperator*, in particular, racked them up at a rate that was truly terrifying. Little did Cunard suspect, when it received this great HAPAG liner after the First World War as damages for the loss of the *Lusitania*, what a liability it was in fact taking on. Renamed the *Berengaria*, she continued to go up in flames at the slightest provocation. The American government refused to let her carry U.S. citizens, and in 1938 Cunard sent her to the breaker's yard. The "ocean-liner style" launched by the *Ile de France* was a decorative response to this curse: out went the chandeliers, padded plush upholstery, and hangings, and in came pure, simple light and empty space, softened by the incombustible beauty of stone and marble, molded glass, metal, ceramics, engraved glass, lacquer, and fire-

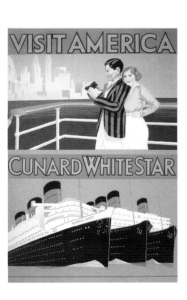

Among the pleasures of being at sea, the simplest were often those least spoken of, no doubt for fear of being exposed to the mockery of more "serious" travelers, "regulars" who were no longer interested in anything other than their own comfort or beating the speed record. Yet there were many passengers who would spend hours strolling or loafing around on the promenade deck, happy simply to breathe the sea air, feel the salt spray on their face, daydream as the white spume of the ship's wake disappeared into the distance, or contemplate the seabirds soaring and swooping through the air.

LEFT: A Cunard poster of the late 1930s advertising the line's three giants, the *Queen Mary*, the *Berengaria*, and the *Aquitania*.
OPPOSITE: Photographs from the maiden voyage of the SS *Colombie*, launched by the CGT on the West Indian route in 1931.

FRESH AIR FACTS

Most people know that through the
consumption of food and muscular exer-
cise our bodies are constantly produc-
ing heat, while the sweatlands are just
as constantly losing heat and moisture
by evaporation. The healthy nervous
system has a miraculous way of keep-
ing the temperature normal by striking
an exact balance between income and
expenditure of heat.

What is not so generally known is
that the respiratory passages also
"sweat," a great deal of moisture and
heat being got rid of in this way.

When the air is hot and dry the natu-
ral adaptations of the body can increase
the amount of moisture present, just
as they can raise the temperature when
it is cold. But in the moist, hot atmos-
phere that one finds in so many rooms
neither the sweat-glands nor the lungs
can act properly.

The result is an increase in body-heat,
retention of waste products, and an
unhealthy congestion of blood in the
skin and respiratory passages.

In the light of modern conceptions it
is easy to see why such conditions
favour the spread of "spring colds" and
other ailments.

Daily Mail.

MILK TOO DEAR

Margin Between Producer and Consumer

MILK is too dear to the consumer,
and the producer is underpaid.

In London and in several towns
there is a margin of 1s. per gallon bet-
ween these two prices.

This is the main fact which a Depart-
mental Committee has brought to light
in an interim report.

The committee comes to the conclu-
sion that the nominal margin of 4d. a
gallon for the wholesaler and 8d. a
gallon for the retailer in large towns is
too much.

The retail costs are largely due to the
wages of roundsmen, which are fully 100
per cent. above pre-war rates.

Door to door delivery of small quanti-
ties of milk is an expensive luxury. The
number of shops in the towns is in ex-
cess of requirements.

The combine (United Dairies, Ltd.)
handles onetwelfth of all the milk pro-
duced in Great Britain, but that does
not measure its influence on the industry
as a whole.

Its distributive operations are centred
mainly in London, where it controls by
far the larger part of the wholesale
trade and one-third of the retail trade.

The methods followed by this huge
organisation are interesting. It has
proved the methods of distribution.

It could have retailed milk at a some-
what cheaper average rate in 1922.

"We recommend," says the committee,
"the Government to consider the intro-
duction of legislation to require com-
panies such as the United Dairies to file
at Somerset House a co-ordinated balance
sheet, showing how much of their
capital is represented by (a) goodwill
and other intangible assets, (b) fixed assets
(c) floating assets, and also the aggre-
gate amounts of their liabilities, reserves
and profits."

On the producers' side the committee
recommends the extension of co-opera-
tion.

Lower rail charges would also be a
great advantage, and the method of
transport should be brought up-to-date.

(Daily Sketch)

A LIBERTÉ A NEW-YORK

...et la vaste baie de New-York a reçu son nom de Liberty-Island, depuis l'érection de la colossale statue de la Li-
...français Bartholdi. Une ligne de bateaux-mouches relie cette île à la Battery, qui forme la pointe extrême de New-York

Ch. Underwood

3ᵉ jour aller

On ocean liners, all equipment and amenities, whether technical or sporting, were constantly kept up to date. This was also true of the services offered. Even apparently trivial matters such as the care of pets on board received dedicated attention from the crew. On the *Ile de France*, for example, passengers' dogs were not only walked each morning by a crew member (left), but were also offered a special canine menu featuring a range of five different treats.

proofed wood. The *United States* (1952), so dear to American hearts and a favorite with Cary Grant and the Duke and Duchess of Windsor, went even further, using no wood but only aluminum, even for furniture. Her architect, William Francis Gibbs, went so far as to make inquiries with Steinway to the possibility of making a piano entirely of aluminum, a request that was emphatically refused.

And last but not least came the most powerful taboo of all—shipwreck. Until the catastrophe of the *Titanic*, one word sufficed to settle all doubts on this score: "Unsinkable!" But after the sinking of the *Titanic*, that word was heard no more. A new and more circumspect attitude was spread abroad by the press, and six weeks after the tragedy, *Le Petit Journal* opined: "We should not set out to alarm passengers, but it is more dangerous to conceal danger from them than to arm them against it. They are well aware that, however sophisticated ships may be, they are always at risk of collision . . . and at the mercy of storms. . . . It is therefore better to prepare passengers to act intelligently." In London in 1914, sixteen nations took part in the first International Conference on the Safety of Life at Sea, where they laid down safety measures and drills to which all passengers and crew should adhere. However, it must be said that the presence in every cabin of life jackets, bearing the number of the lifeboat to join in case of accident, sent a momentary shiver down the spine. But the safety drills rapidly became part of nautical life, and in fine weather were even viewed as healthy outdoor exercise. In 1927, Father Joseph Bulteau, a missionary heading for Korea on board the *Sphinx*, showed no hesitation in taking part in the safety drill, and sported his life jacket like all the other passengers—with the exception, as he breezily explained, of the nuns, who had chosen not follow his example, "probably because their headdresses would keep them afloat."

The degree to which passengers proved themselves capable of forgetting their fears, even—or perhaps especially—when they were most justified, is certainly surprising. At seven o'clock in the evening on February 5, 1962, when the *France* reached the northernmost point on her maiden voyage, a severe gale blew up. As an officer of the watch recalled, "The bows shot up as if we had hit an iceberg, before plunging down again into the waves. The construction engineer appeared on the bridge, distraught and moaning, 'My ship's going to break up!' " In order to avoid

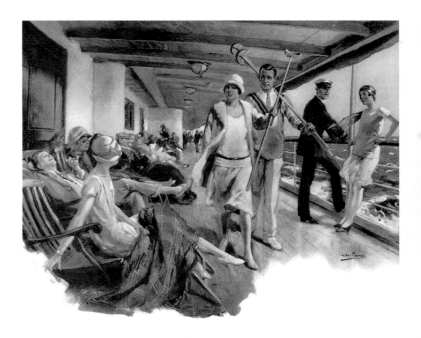

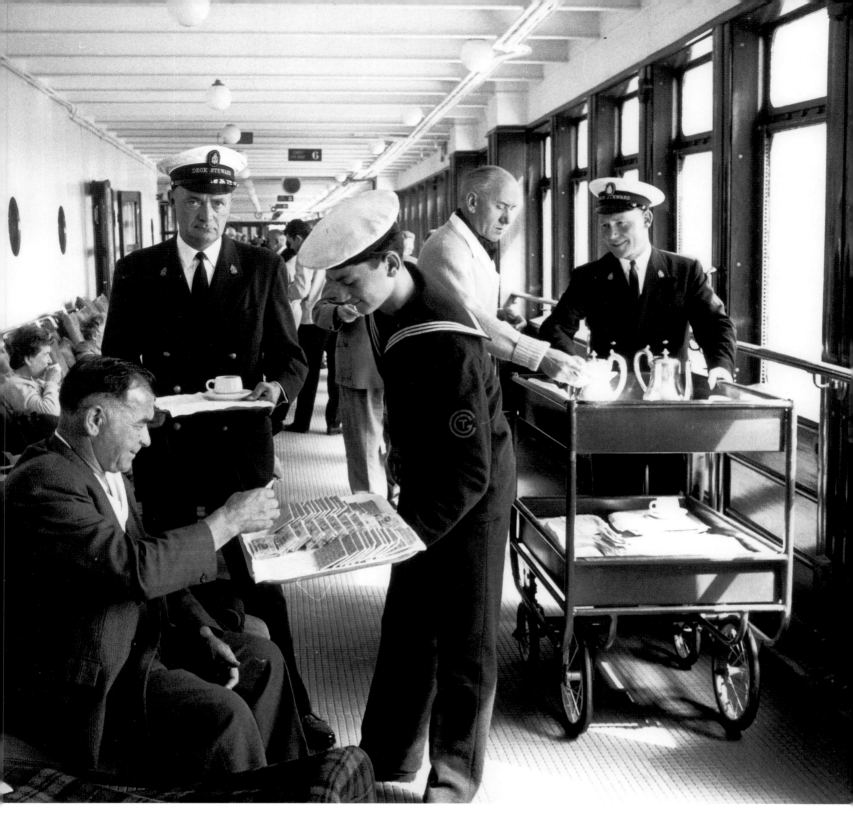

ABOVE: Teatime on the *Liberté*. In 1950
the former *Europa*—newly refitted
throughout *à la française*—returned to
the transatlantic route as part of the
CGT fleet. Interior decorators of the
stature of Leleu, Marc Simon, and
Camille Hilaire redesigned the interiors
of the new *Liberté*, whose suites bore
the names of French provinces and
ports that had suffered extensively
during the war.

OPPOSITE BELOW: Rest and recreation
on the promenade deck of the
Normandie, a typical 1930s scene from
a series of illustrations by Léon Fauret.
OVERLEAF: Tea is served on the
Victoria, a modern-style Italian steamer
of the SAN fleet, a second-generation
company that enjoyed its heyday in the
years before the Second World War.
The ship's interior decoration was by
the Trieste-born architect Gustavo
Pulitzer Finali, famous for his dashing
interpretation of the International style.

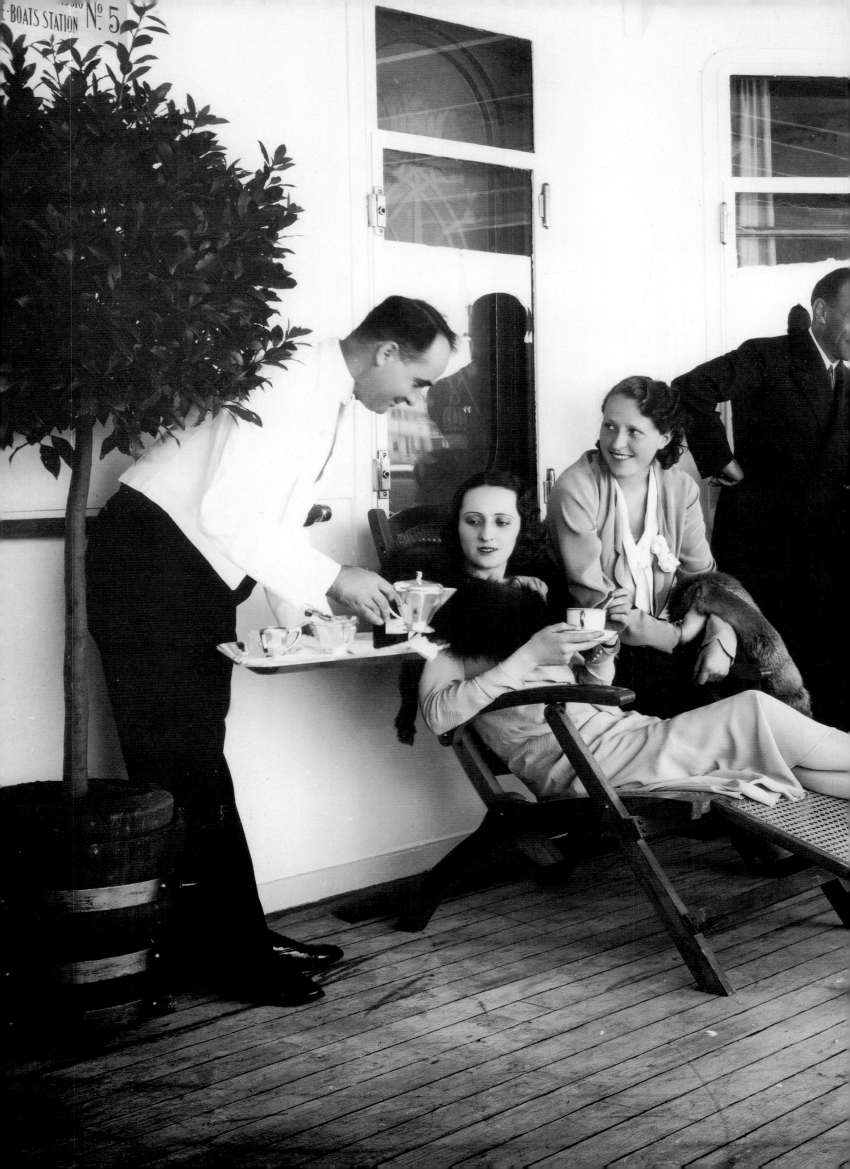

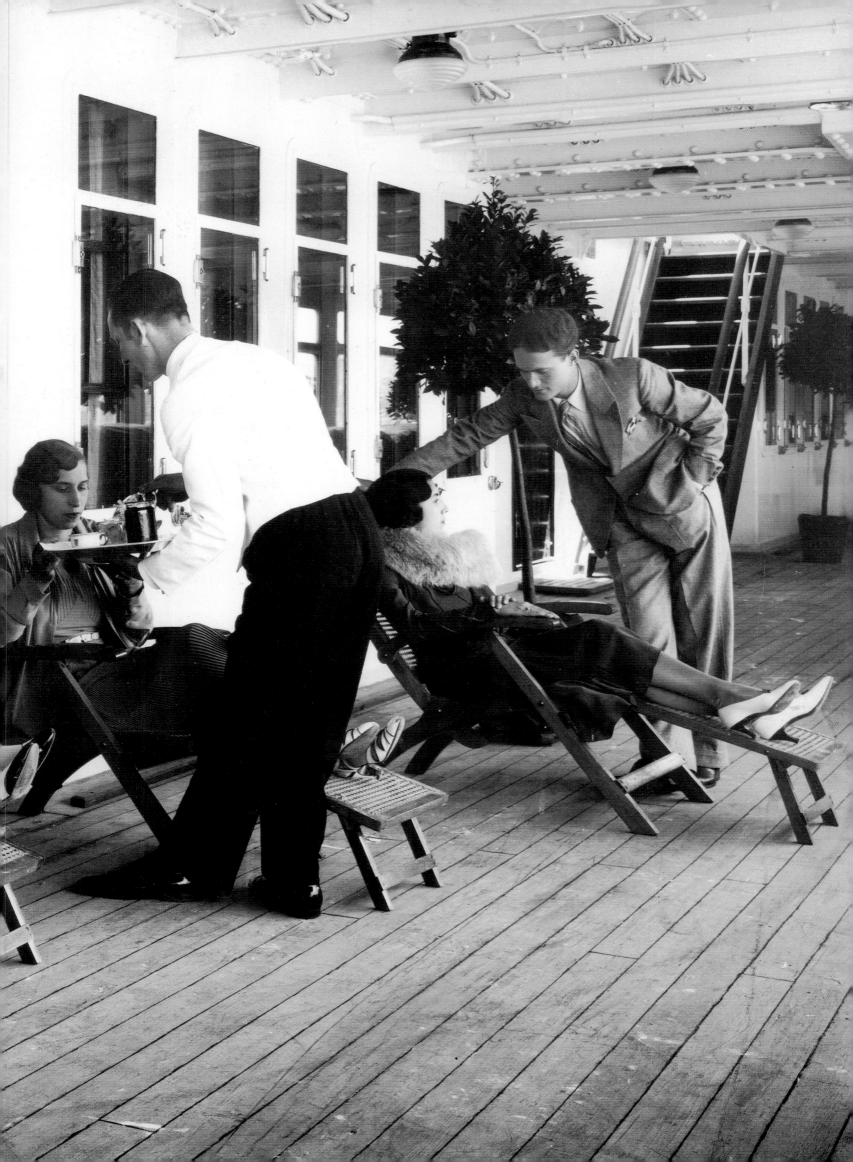

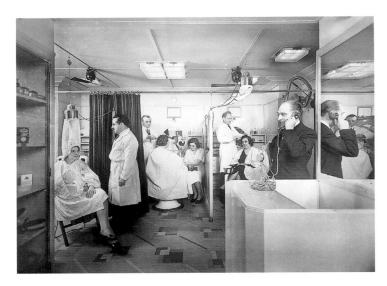

Launched in 1930 in the wake of the *Ile de France*, the more modest *Lafayette* nevertheless received careful attention in all its details from the CGT. The interior decorations, entrusted to René Prou, were distinguished by their stylish restraint.
LEFT: The clinical appeal of the beauty parlor was aimed at the ship's American clientele. With its discreetly barbaric-looking contraptions, this was a supremely fashionable and quint-essentially 1930s salon, offering a team of hairdressers and manicurists eager to cater to their clients' every whim.

attracting the attentions of the press, the crew decided to keep quiet about this alarming squall. As for the passengers, it can only be assumed that they failed to notice anything untoward. There were a few complaints that evening about the noise of the propellers, and of the bowls in the bowling club; and the "excessive fragility of the Saint-Louis crystal" also caused some consternation, as did the mediocre quality of the andouillette sausages served at dinner—and that was about all. But what was there to complain about, after all? Life on board was most agreeable and sybaritic. There was one member of crew for every two passengers, so a wish had barely to be expressed before it was fulfilled. Come raging winds or mountainous waves, the ship would sail on!

Meanwhile, life afloat had its unspoken rules to be observed. There was the unquestioning acceptance of the delicious state of languid ennui that descended on every crossing, and the savoring of every moment of those endless, glorious days of idleness. The done thing was also to look no further ahead than to the next cup of tea; and to admit to only the vaguest notion of the time of day, except at noon, when the captains of nineteenth-century steam packets would check the time according to the sextant and

everybody would set their watches. Or if they preferred, passengers could observe the distorted time displayed by the clocks on board ocean liners, which lengthened days to twenty-five hours or shortened them to twenty-three in order to make up for the time difference. Even the temperature displayed on board could not be believed: when temperatures soared on steamers plying routes in the Far East and passenger morale was in danger of plummeting, the thermometers were judiciously adjusted to display a more bearable temperature.

In fact on board ship there was no necessity to think at all: the crew would take care of everything. From the moment of waking, all the important issues of the day were sorted. Outside the cabin door polished shoes gleamed beside a copy of the shipboard newspaper, which contained not only the program of the day's events on board, but also the latest news on politics, the arts, stock-market prices, and social events in the world at large. For since 1893, when the *Lucania* and *Campania* first offered their passengers the use of the wireless telegraph, liners were able to remain in contact with terra firma. This bulletin would be perused in bed, to the accompaniment of early morning tea, an

Life onboard ship was regimented virtually hour by hour, with teatime at four o'clock being an inviolable fixture (it was also held to be beyond dispute that the best tea was served on Cunard steamers). Passengers could however choose where they preferred it to be served: in their cabin, in the lounge to the accompaniment of a string quartet, or on deck in their deckchair. And so that mothers could enjoy this sacred moment undisturbed, a kindergarten was on hand to entertain their offspring.

RIGHT: A children's nurse with her charge on the *München* of the Norddeutscher Lloyd fleet, 1923.
OPPOSITE: A tea service sporting the CGT monogram, set on a brochure for the *Normandie*. Headed *Cabines*, the illustration shows the boudoir of one of the four deluxe suites, the Deauville, decorated by Louis Süe.
OVERLEAF: A tea dance on the deck of the *Ile de France*. Only on still, calm days could this type of entertainment be contemplated in mid-Atlantic.

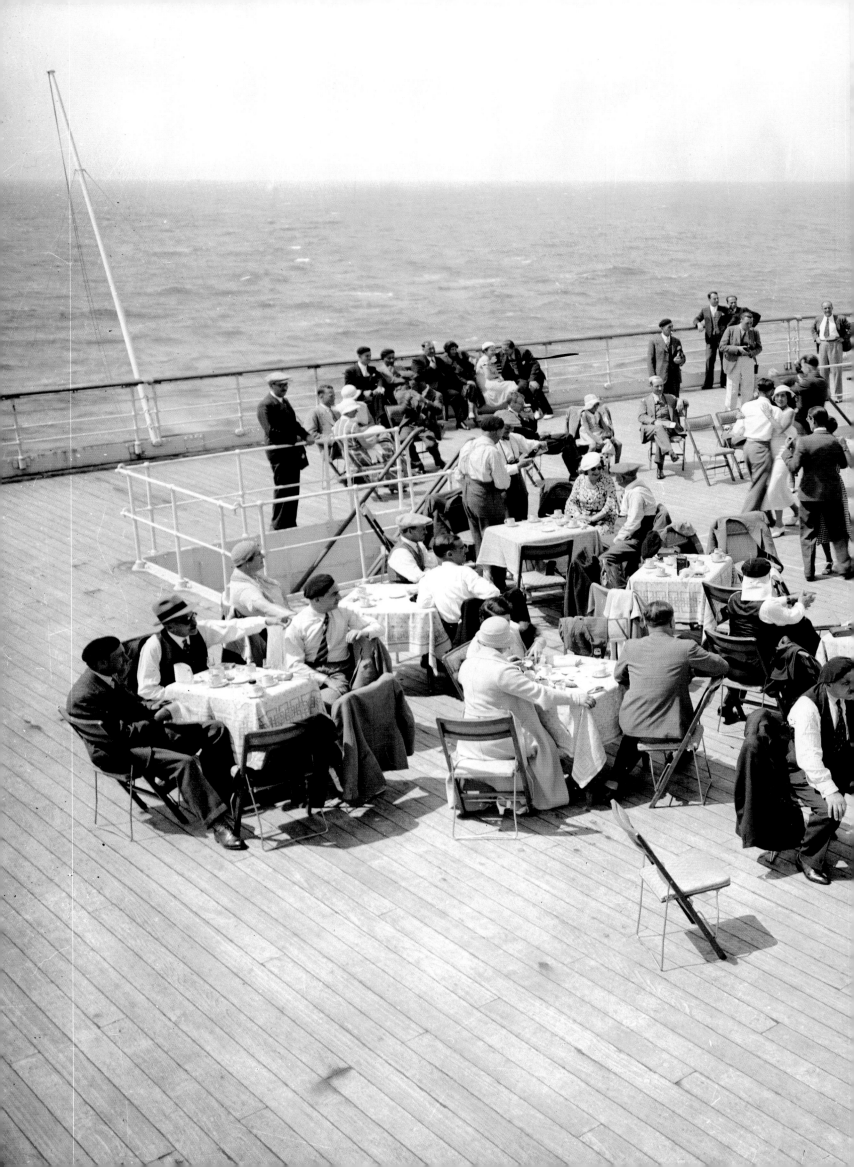

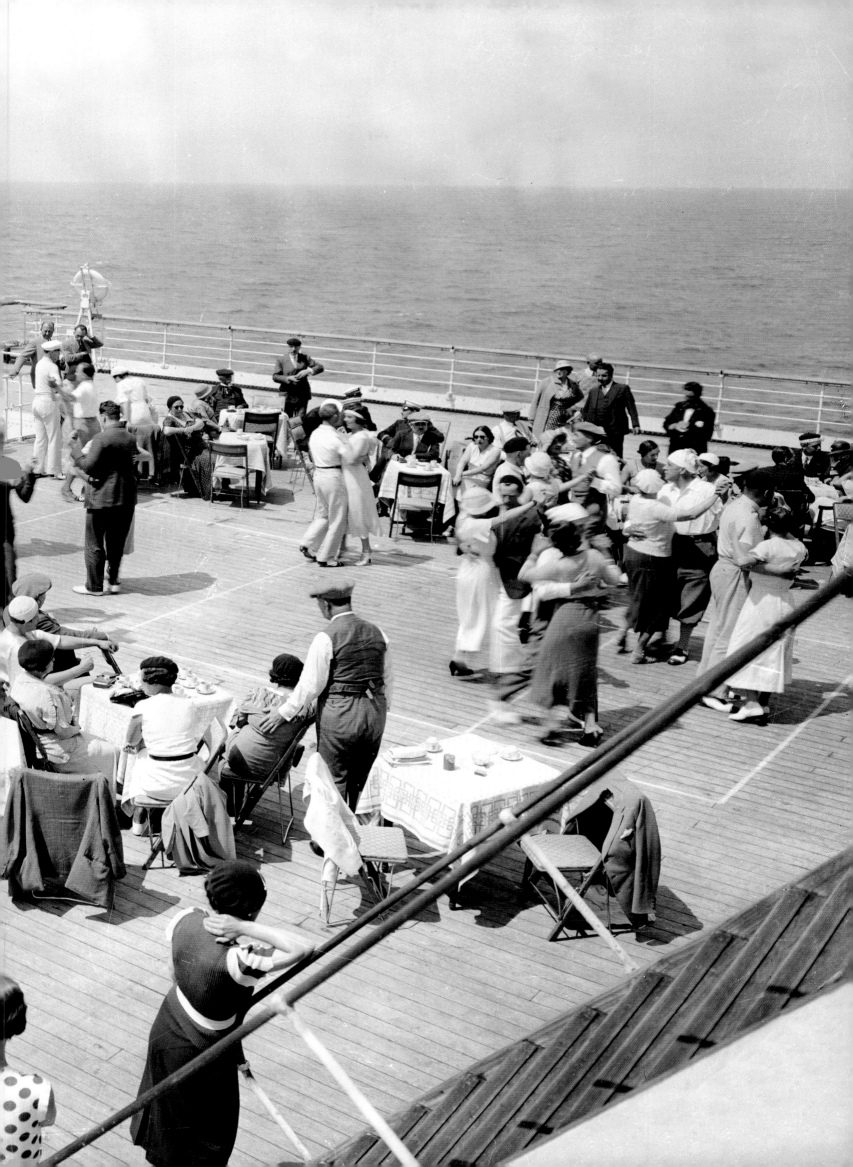

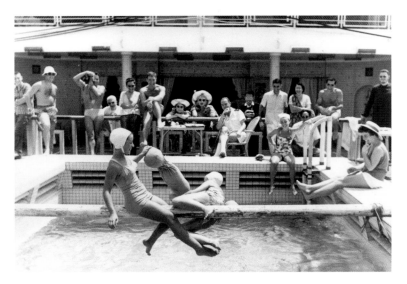

Every ocean liner had its swimming pool, but no two were the same. Their character and atmosphere varied hugely according to both the fleet and the destination, as well as the period.
LEFT: Fun and games in the pool of the Messageries Maritimes steamer *Cambodge*, in the late 1950s.
OPPOSITE: The Pompeian baths on board the *Imperator*, with their marble décor inspired by the exclusive Royal Automobile Club in London, dictated the adoption of stiffly military poses (and no slacking) for the benefit of the HAPAG photographer. The gallery proved a popular spot for clusters of admiring spectators.
OVERLEAF: Relaxing in the swimming pool bar of the first *De Grasse*, in the 1940s.

indulgence dear to British hearts and generally made much of in the brochures of companies of all nationalities.

And whatever else they might have been, mornings on board were certainly early, for from first light the superliners were teeming hives of activity. Light sleepers would find their nights were short, especially if they were fortunate enough to have secured one of the cabins opening onto the deck, which were far more coveted than those opening onto the passageways. Barely had the ship's bell struck four o'clock than a cohort of ship's boys, giggling and jostling, swarmed onto the decks, swabbing them down, dragging the deck chairs about and piling up the rattan chairs, while the quartermaster barked their orders. Then they vanished as quickly as they had appeared, like a flock of sparrows, to be replaced by cleaners who vigorously polished the portholes and their copper surrounds. By the time you had managed to get back to sleep, the people in the neighboring cabins would be stirring, and there would be a volley of bells. People in the passageways would be shouting to each other while maids bustled about. On deck, early risers were already starting their brisk morning constitutional, and it would not be long before the children came to join them. You might as well give

in and join them, especially as from eight o'clock, according to the ship's rules, it was forbidden to appear in night attire.

After this the day unfolded according to a fixed and unchanging routine, punctuated by regular meals and a plethora of refreshments. In his letters, Joseph Tremble, who left Marseille on the *Armand Béhic*, offers a glimpse of the regime on board a steamer of the Messageries Maritimes: from seven in the morning, sugar, lemons, water, and ice were laid out in the dining saloon, where—drinking sufficient water being of the utmost importance in tropical climes—they remained in constant supply until eleven o'clock at night. Breakfast, meanwhile, was served in first-class cabins between seven and nine. Luncheon was served between eleven and one, and at four o'clock came afternoon tea, with warm brioche, sponge cake, and jam accompanied by pots of tea. At six the ladies changed into evening gowns, the gentlemen into dinner jackets, and the crew (including Joseph) into frock coats for dinner, which was served at six-thirty. At nine o'clock in the evening, coffee and tea were served with a light snack, followed by lights out at eleven o'clock. Clearly there was little danger of passengers on the *Armand Béhic* in 1901 going hungry. But this pales into insignificance beside

In their constant efforts to find new distractions for their passengers, pursers on passenger liners were only too happy to organize friendly sports contests. Sometimes these would take advantage of the presence onboard of a champion athlete, who was willing to take on a member of the crew or a volunteer from among the passengers. Thus some famous boxers and fencers, for example, took part in these events— the sports equivalent of the singers and other entertainers who gave performances on liners such as the *Ile de France* and the *Normandie*.
RIGHT: On the *Conte Verde* of the Lloyd Sabaudo fleet, passengers watch a match featuring Erminio Spalla, a famous Italian boxer of the 1920s.

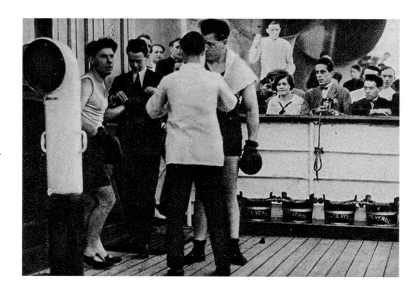

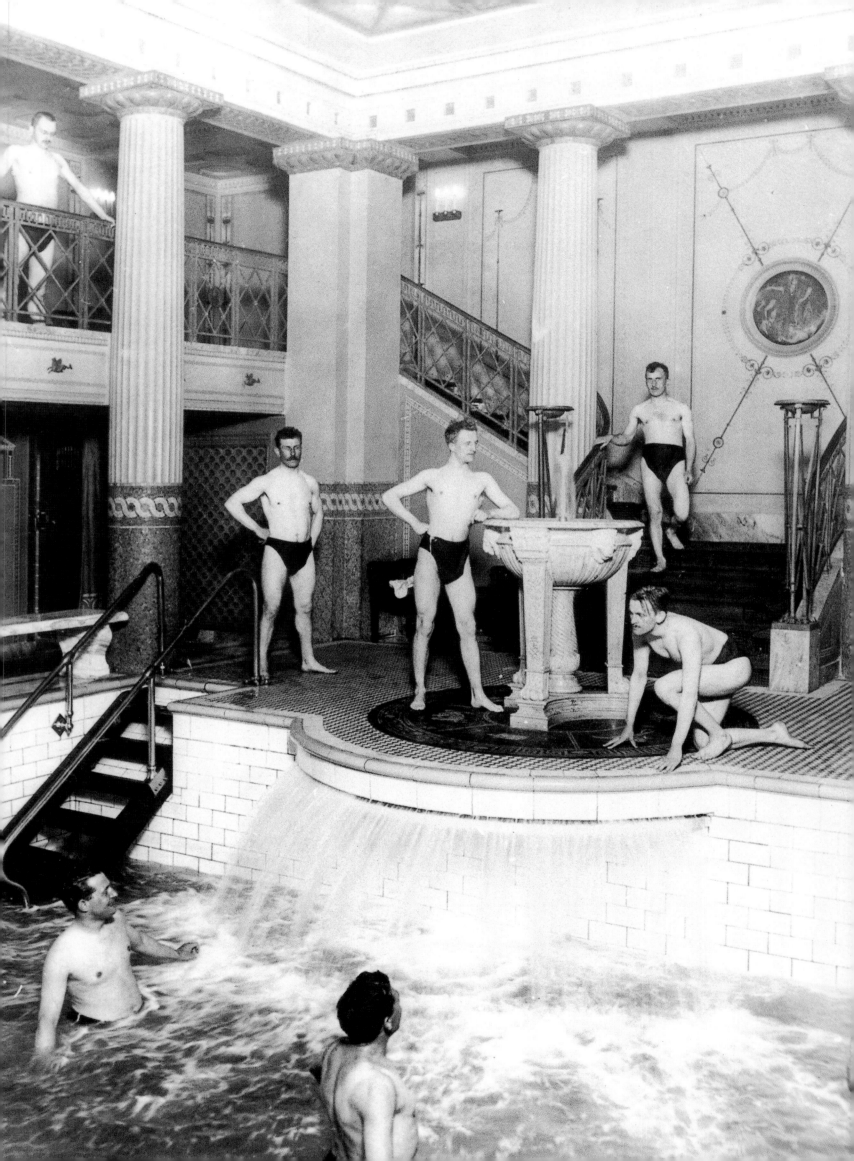

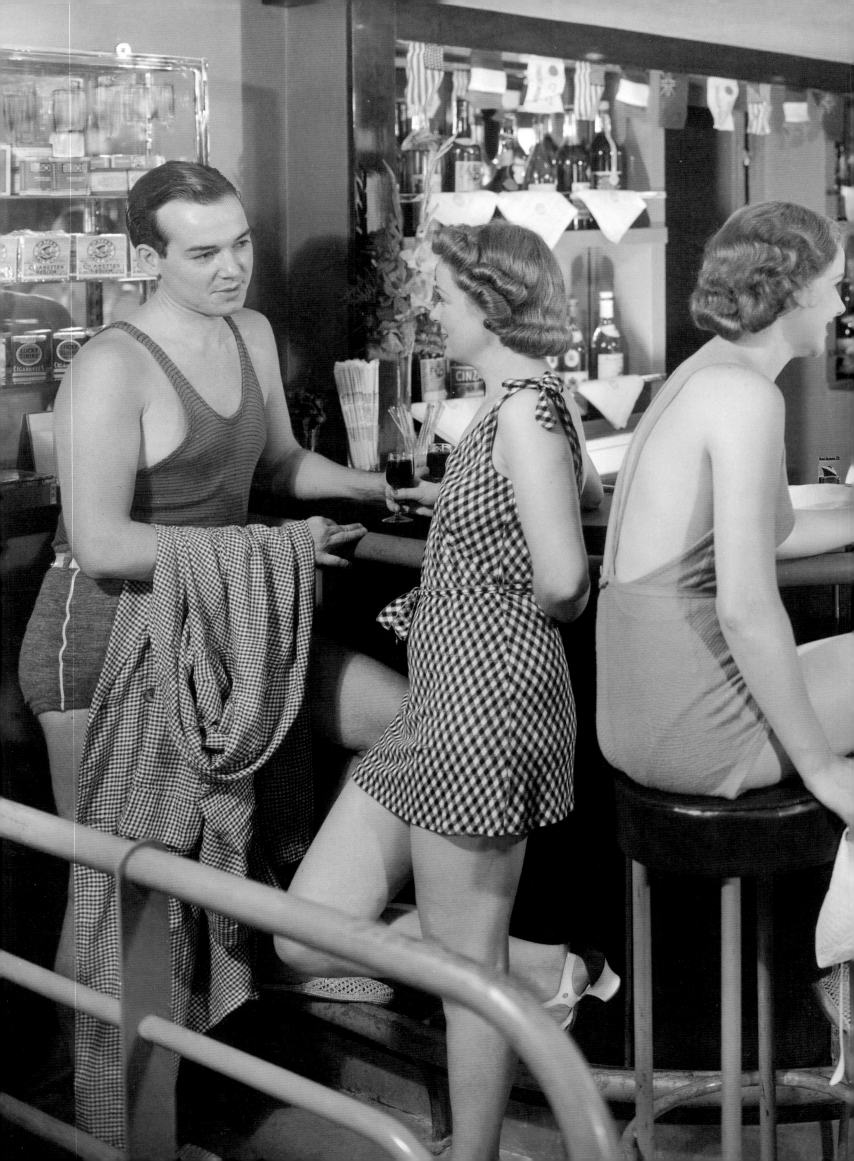

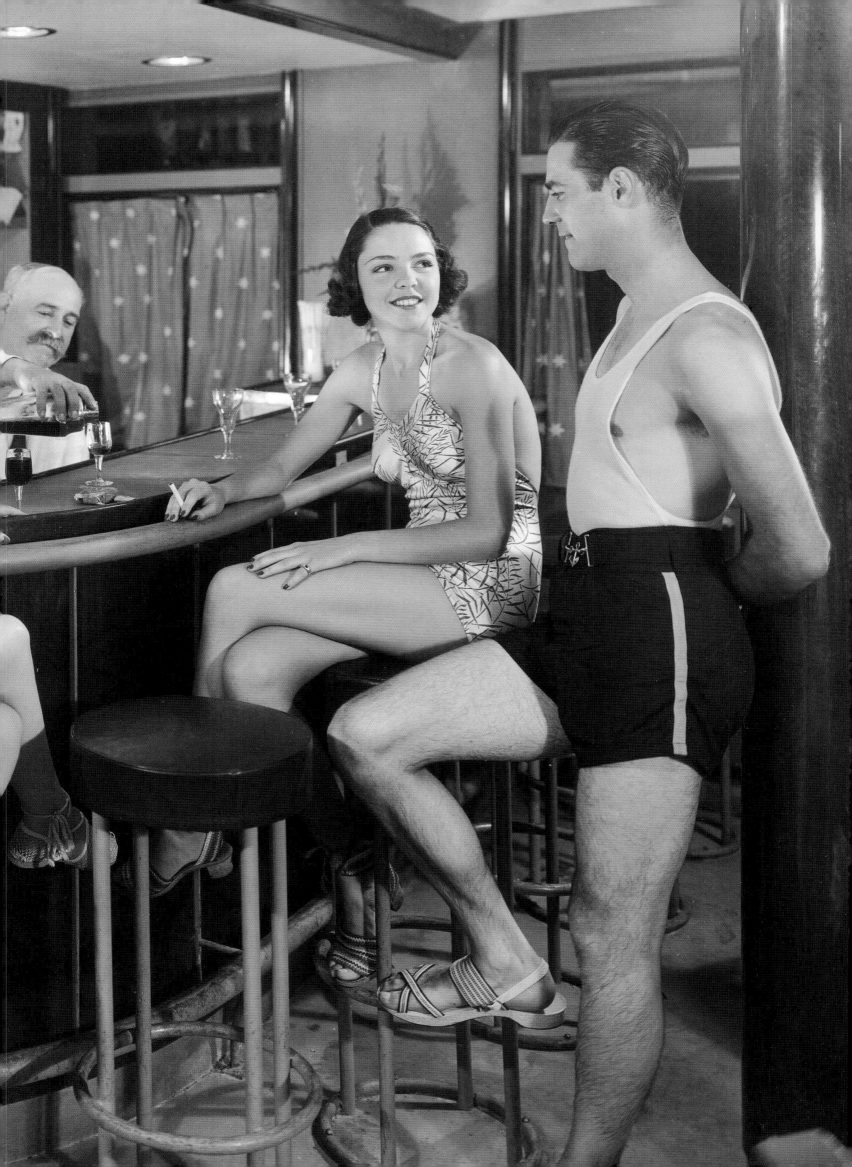

the frequency and quantity of refreshments offered on the White Star Line a decade later. The day started with breakfast in bed, followed between eight and ten o'clock by a second breakfast in the dining saloon. At eleven o'clock, passengers were served in their deck chairs with cups of steaming hot bouillon, followed an hour later by plates of sandwiches as an aperitif. Luncheon was at one, followed two hours later by a selection of sorbets and pastries. At four o'clock it was teatime, with cucumber sandwiches and a selection of cakes, followed an hour later by fruit compote. At six-thirty, a bugle call to the tune of "The Roast Beef of Old England" alerted passengers that it was time to dress for dinner, which was served at seven. Tea, coffee, liqueurs, fresh fruit, and ice cream came at nine, and at midnight it was lights out. Some maintain that the British steam companies attempted to make up in quantity for what the French companies offered in quality; whether or not this was true, during rough weather in particular, this impressive rate of consumption must have kept the ship's surgeon occupied.

Looking at this demanding timetable, it becomes clear that the serious business of eating took up a considerable part of the day, leaving only the brief periods in between meals and

snacks for other activities. And to judge from the tenacity with which passengers hauled deckchairs from sunny spots to shady spots throughout the day, most of this leisure time was spent on deck: languorous afternoons spent gazing out to sea, wreathed in cigarette smoke. The promenade deck—under cover and usually glazed, and so usable in all weather—was quite a different affair from the upper decks, which were open to the elements. The German lines had been the first to promote the therapeutic qualities of sea travel, encouraging their passengers to pace the windswept upper decks, cluttered as they were with lifeboats, ventilation shafts, pipes, crates, and other nautical paraphernalia. There was just enough space left for the classic deck games such as skittles, shuffleboard, and quoits. To this were sometimes added, according to the inclination of those present, tugs of war, hopping races, and other hearty amusements.

It had to be admitted, however, that the transatlantic crossing, being frequently cold, foggy, or worse, was not terribly conducive to outdoor activities. For this reason the upper decks remained largely unchanged in their arrangement, at least until the 1920s, and the steamer companies were forced to rethink their commercial strategy, limiting the

Deck games, or deck sports, were so many and various that it would be almost impossible to list them all. British steamers were the pioneers in this area, offering their passengers proper shuffleboard courts worthy of this noble sport.

RIGHT: Bowling on the *France*, 1912.
ABOVE LEFT: A game of quoits on the *Lafayette*, c. 1935.
ABOVE RIGHT: A breezy game of shuffleboard on the deck of the *Berlin* in the late 1920s. This liner of the Norddeutscher Lloyd fleet sailed for sixty years before sinking in 1986 after a tragic collision in the Black Sea, with the loss of 483 lives.

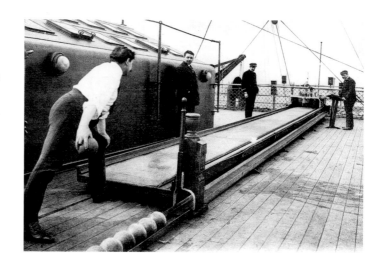

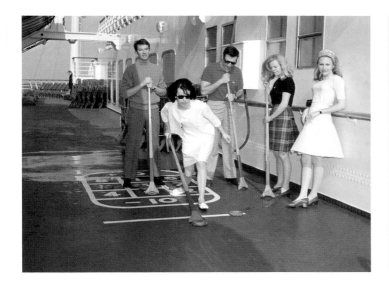

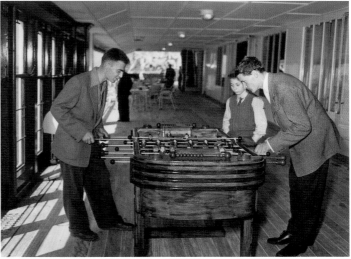

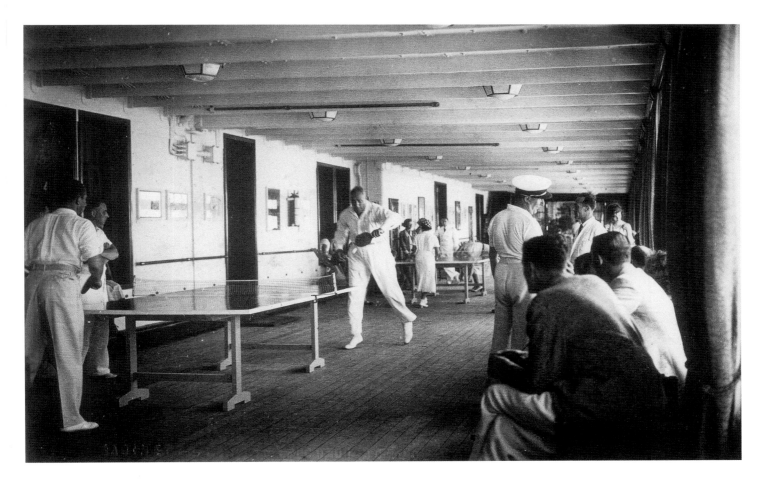

Launched in 1931 by Queen Elena, the *Rex* was the largest and fastest of the great Italian liners, holder of the Blue Riband from 1933 to 1935, when the honor was claimed by the *Normandie*. The *Rex*'s distinguished career came to an end in 1944, when it was bombed by the RAF off Trieste. In order to attract American tourists, Italia Line steamers bound for New York, such as the *Rex* and the *Conte di Savoia*, followed a more southerly route after Gibraltar than the other transatlantic companies— the "sunny southern route" according to the Italia advertising slogan. Outdoor spaces on the Italian liners were consequently more generous, with large windows to take full advantage of even the feeblest ray of sunshine.

ABOVE: A game of table tennis on the deck of the *Rex*.

ABOVE LEFT: Shuffleboard on the *France*, 1962.

ABOVE RIGHT: On the Messageries Maritimes steamer *Laos*, two members of the Franco-Swiss Himalayan Expedition, Messrs Guinot and Gendre, play table football, August 1955.

OVERLEAF: A game of tennis on board the *Normandie*, the only ocean liner with an expanse of deck sufficiently large to accommodate a regulation-size tennis court.

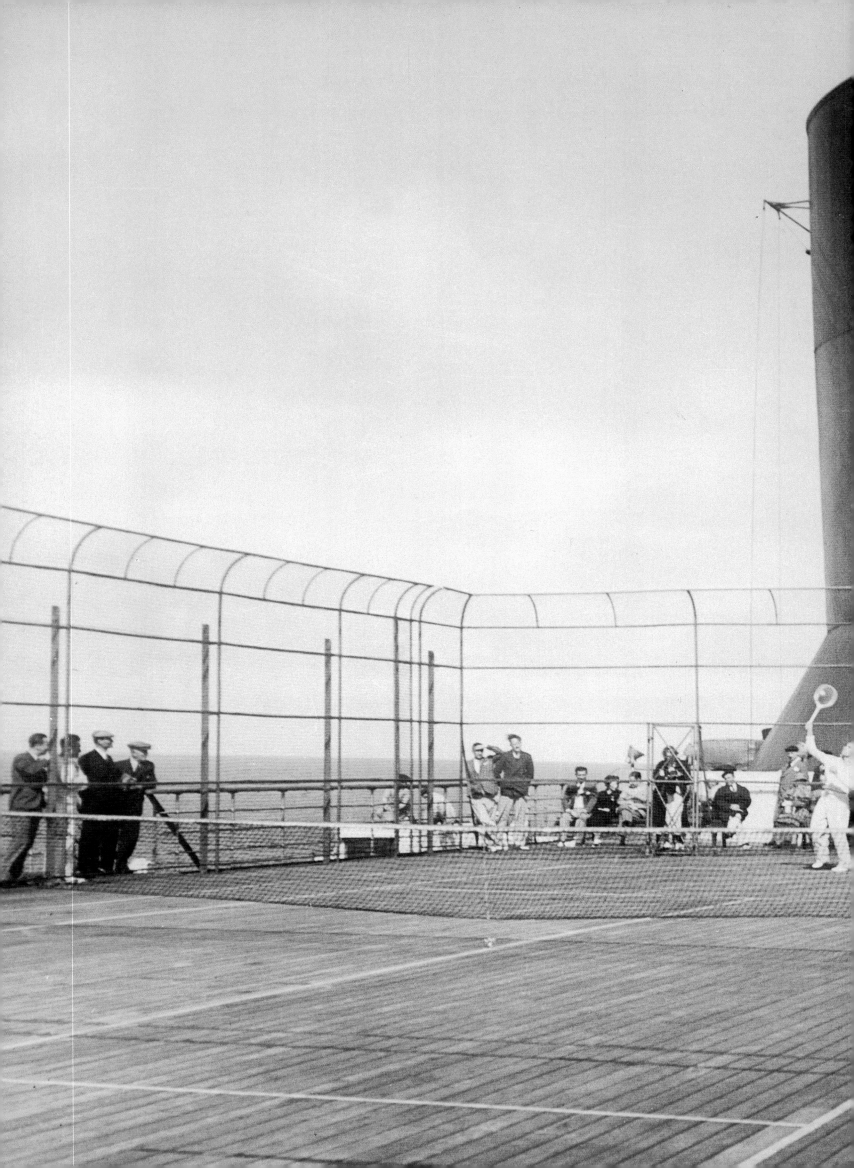

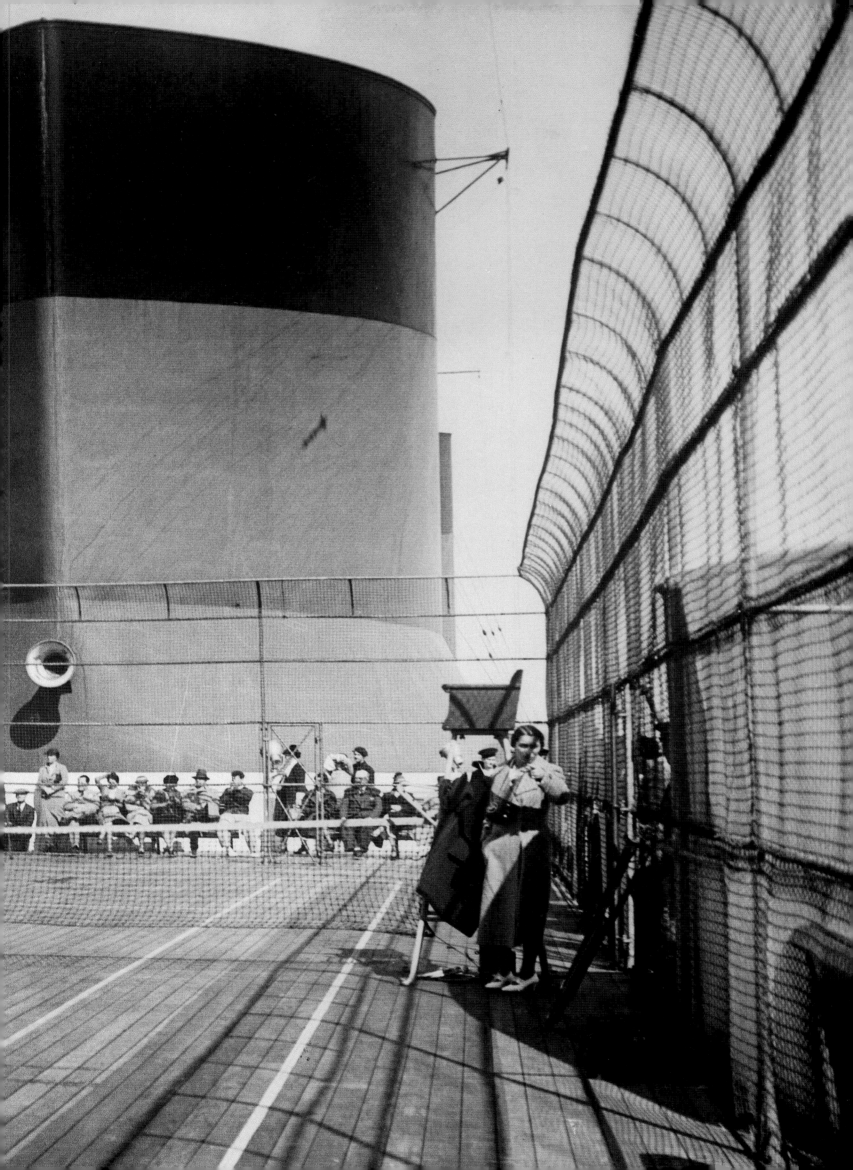

Being cooped up in the relatively confined space of a passenger liner rendered physical exercise all the more necessary. It was in addition believed to be an effective antidote to seasickness: small wonder, then, that so many of the surviving photos of life on board feature passengers engaged in some kind of sport.

LEFT: Mixed gymnastics on the deck of the *Berlin*, 1930.

BELOW: Skipping on the second-class deck of the *Bremen*, c. 1930.

RIGHT: The *France* of 1962 boasted two swimming pools. The tourist-class pool, situated on the aft sundeck, enjoyed unrivaled views out to sea. The water level was deliberately kept very low, both as a precaution against being swept overboard in choppy waters, and to protect the bathers stretched out around it from splashes.

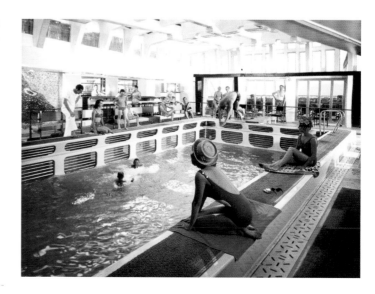

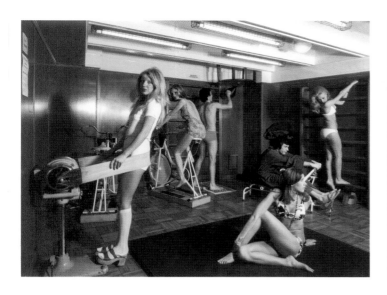

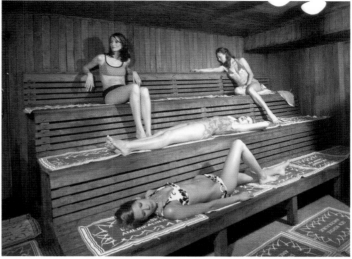

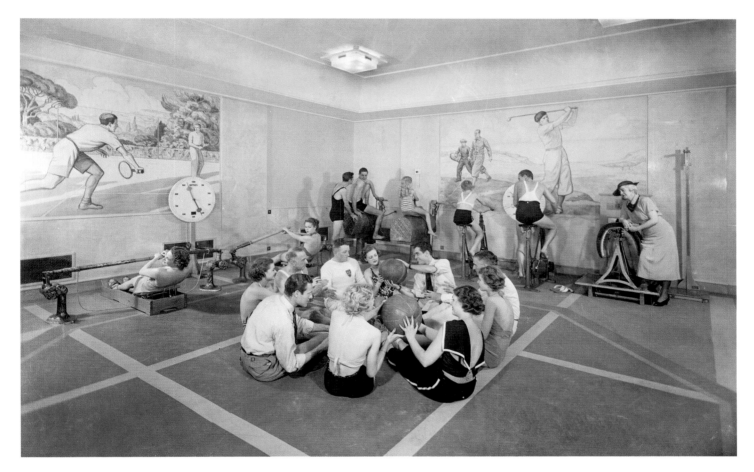

From the early 1930s, traditional gymnastics were complemented by "mechanotherapy," a new type of gymnastics using machines to simulate horseback riding, rowing, and cycling—the forerunners of the equipment found in modern gymnasiums.
ABOVE: A gymnastics session in the mechanotherapy room of the *Ile de France.*
TOP: The gymnasium and sauna on board the *De Grasse II,* 1971.

"From the foyer, sparkling with light, roads containing shops run in every direction. . . . This is the heart of the ship, the central square of this floating city, the meeting place from which routes fan out to all its different areas." Pierre Kjellberg's description of the central foyer of the *Ile de France* (in an article entitled "Le décor des paquebots" in *Art deco*) was equally applicable to all the other great ocean liners, on which franchise outlets selling souvenirs and postcards rubbed shoulders with luxury shops.
LEFT: Shop window of Au Bon Marché, the French chain store, on the *Normandie*.
BELOW: A Messageries Maritimes souvenir calendar.
OPPOSITE: A fine leather-bound ship's folder of 1893 bearing the gold-tooled monogram of the CGT, with a fan embellished with an image by Camoz (c. 1910–15); together they evoke the era of lengthy transatlantic crossings.

transatlantic crossing to the summer months, and in winter sending their ocean liners off on more profitable cruises in warmer seas. This saw the apotheosis of the aft sundeck or lido deck, which was flat, uncluttered, and large enough to accommodate a tennis court—and in the case of the *Normandie* much more besides. Swimming pools, which since the vogue for them started with the *Adriatic* in 1872, had always been elaborate indoor confections of marble and mosaic, matching the gymnasium and Turkish baths, now started to appear outside. In 1932 the Italian Line took the lead with the *Rex* and *Conte di Savoia*, which boasted lido decks complete with swimming pools, multicolored parasols, and even beaches of real sand, rather like a complete floating Riviera off the American coast. But despite all these attractions, the most exclusive and evocative spot, the place where cosseted passengers might sit for hours, tucked up in their tartan rugs, chatting, daydreaming, watching beautiful strangers or their dining companions for that evening stroll by, still remained the first-class promenade deck (not to be confused with its equivalents in second class or—heaven forbid—third class). It was rather like a seaborne equivalent of the Via Veneto, a privileged, exclusive, and ultrachic space in

which the wealthy and fashionable could be among themselves with no risk of intruders. It gave direct access to the first-class smoking rooms, lounges, and libraries by way of elegant shops purveying every conceivable type of luxury item. It was said that on the promenade deck of the *Queen Mary* passengers might obtain anything from flowers, French perfumes, and cigars to an evening waistcoat or a souvenir cravat printed with the name *Queen Mary*.

Even on more modest liners and in second-class accommodation, passengers were united in their attachment to the promenade deck and its rituals. The disappointment in an indignant letter written by a passenger by the name of Edmond Garnier is palpable. Garnier had embarked on a second-class passage to Argentina on the *Chili* in 1909, when he found, to his chagrin, that the view of the ocean from the second-class promenade deck was completely obscured by the lifeboats, and to make matters worse, even the passengers in third class seemed to be better off: "For their promenade deck, first-class passengers have the whole of the aft and part of amidships: ten times more space than they need. The emigrants have the whole of the fore part of the ship, from where they have a magnificent view. As for the

Every great liner had its library, "hushed and meditative, a secluded spot greatly appreciated by those who like to reflect in the company of books," as described by M. A. Pawlowski in his evocation of the *France* in 1912. Their catalogues listed works by classic and contemporary authors in a range of languages.

OVERLEAF LEFT: Reading in the writing room of the *De Grasse* (1940s).
OVERLEAF RIGHT: Jean-Paul Sartre, Françoise Sagan, and Antoine de Saint-Exupéry appear alongside Shakespeare, Salinger, Scott Fitzgerald, and Shaw in the catalogue of titles in English in the tourist-class library of the *France* of 1962. The beautifully decorated edition of Pierre Loti is in Spanish, and formed part of the library of the *Paris*. Behind it is the catalogue of works in French in the Paris library with, in the top left-hand corner, a cabin key from the last *France*.

ALBUM

ANTIQUE

Cⁱᵉ Gᵉⁿˡᵉ TRANSATLANTIQUE
French Line

PIERRE LOTI

LA TERCERA
JUVENTUD
DE MADAMA
ENE...INA

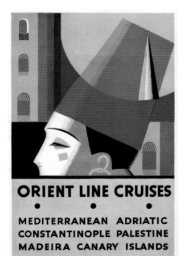

LEFT: Advertising poster for P&O/Orient Line (1932) promoting their cruises in the Mediterranean and the Adriatic, and to sunny spots such as Madeira and the Canary Islands. The opening up of the Suez Canal in 1869 enabled ships to reach India, Ceylon, Malaysia, and the Far East without having to sail round Africa and navigate the Cape of Good Hope in order to reach the Indian Ocean. For passengers this meant the end of the journey by train across the Egyptian desert and transfer to a ship on the Red Sea. Henceforth P&O and Messageries Maritimes ships made port of call at Port Said, the busy trading center at the start of the canal.

BELOW RIGHT: A view of Port Said around 1930, with (inset) passengers going ashore by boat before 1914. Ocean liners were far too large to moor at the quayside of most ports at this time, so at Port Said, as in many other places, small boats provided the only means of getting ashore.
OPPOSITE: The Suez Canal in 1899, in a photograph by Arnoux taken from the French Line archives (top); a view of the dining saloon on the *Champollion* in about 1925 (center); and menus for passengers of all three classes of "lines east of Suez," proposed by the Messageries Maritimes.

wretched second-class passengers stuck in the middle, who admittedly pay less than first class but considerably more than third class, we are cooped up between a metal partition and the lifeboats … It feels very much as though we are being tossed crumbs from the rich man's table. . . ." It has to be said that, on passages to the South Atlantic and the Far East, the stifling heat meant that passengers virtually lived on deck. Despite canvas awnings and regular sprinklings with water, in the heat of the midday sun even the deck became intolerable, and passengers retreated to the library or the music room, where English maidens pounded the floor to the fashionable rhythm of the foxtrot. There they sat out the heat of the day, engaging in dilatory conversation in the sticky heat, churned up by an electric fan or cooled by a cloth fan or punkah, attached to a series of ropes and pulleys and operated by the punkah wallah, an Annamese, Indian, or Chinese boy who would invariably fall into a trance and then doze off. But as soon as the sun went down, the deck was the place to be, either to stretch one's legs or to sink into a deckchair. This is also where many passengers chose to spend the night, complete with pajamas and pillows, anything being better than the unendurable heat of the cabins.

Lengthy passages, such as those to China, Japan, Australia, Indochina, or New Caledonia, had little in common with the transatlantic crossing. Though less prestigious, they made up for this by being more adventurous and exotic, and were served by fabulous creations such as the *Mariette Pacha,* decorated in ancient Egyptian style; the *Félix Roussel,* with its ceiling carved with celestial Indian nymphs; the *Angkor,* on which the visionary Jesuit philosopher and scientist Teilhard de Chardin met Henry de Monfried; and the *Georges-Philippar,* which was where the distinguished journalist Albert Londres died. On these journeys, it was the sea that provided excitement and entertainment. In the Red Sea there were porpoises to spot, and occasionally the curious atmospheric phenomenon known as the "emerald flash." Passengers in the Indian Ocean would rush from port to starboard a dozen times a day after sightings of sharks and flying fish. In the Straits of Malacca there was always the hope of seeing one of the two tropical storms that circled Sumatra in the spring. And then there were the ports of call that added such pungent interest and turned these passages into cruises. At Port Said local boats would swarm round the great liners, offering their services to passengers

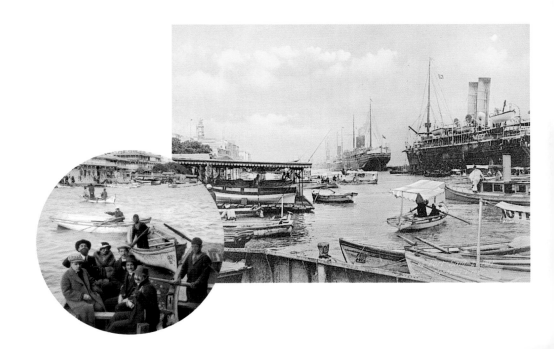

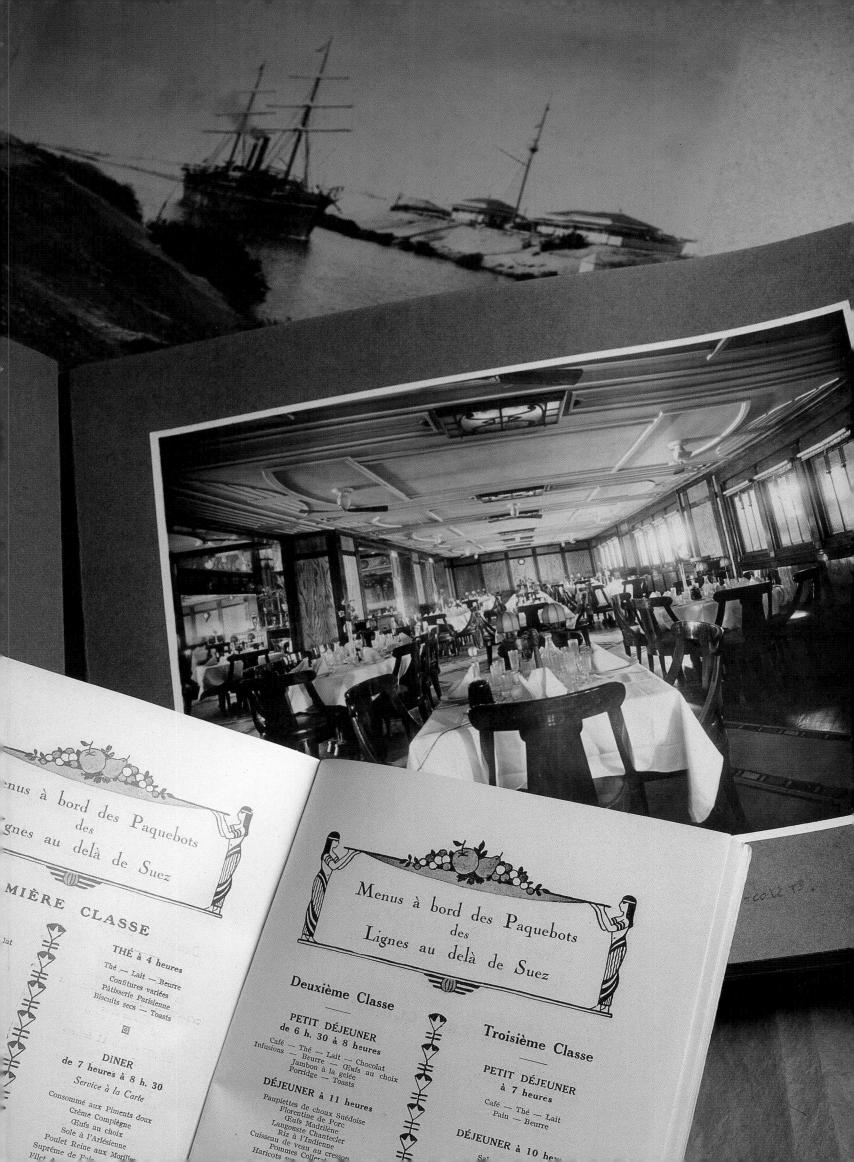

Menus à bord des Paquebots
des
Lignes au delà de Suez

MIÈRE CLASSE

THÉ à 4 heures

Thé — Lait — Beurre
Confitures variées
Pâtisserie Parisienne
Biscuits secs — Toasts

DINER

de 7 heures à 8 h. 30

Service à la Carte

Consommé aux Piments doux
Crème Compiègne
Œufs au choix
Sole à l'Arlésienne
Poulet Reine aux Morilles
Suprême de Foie
Filet de

Menus à bord des Paquebots
des
Lignes au delà de Suez

Deuxième Classe

PETIT DÉJEUNER
de 6 h. 30 à 8 heures

Café — Thé — Lait — Chocolat
Infusions — Beurre — Œufs au choix
Jambon à la gelée
Porridge — Toasts

DÉJEUNER à 11 heures

Paupiettes de choux Suédoise
Florentine de Porc
Œufs Madrilène
Langouste Chantecler
Riz à l'Indienne
Cuisseau de veau au cresson
Pommes Collerel
Haricots ve

Troisième Classe

PETIT DÉJEUNER
à 7 heures

Café — Thé — Lait
Pain — Beurre

DÉJEUNER à 10 heu

Sa

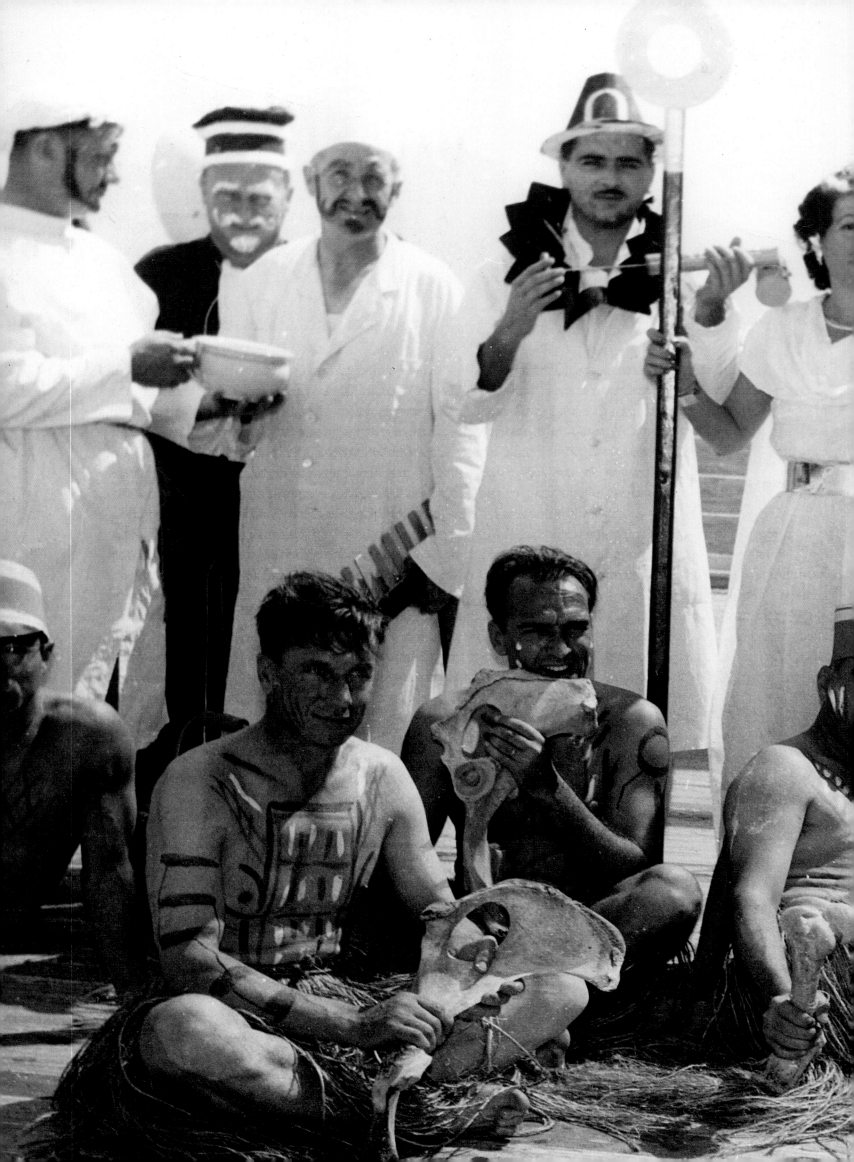

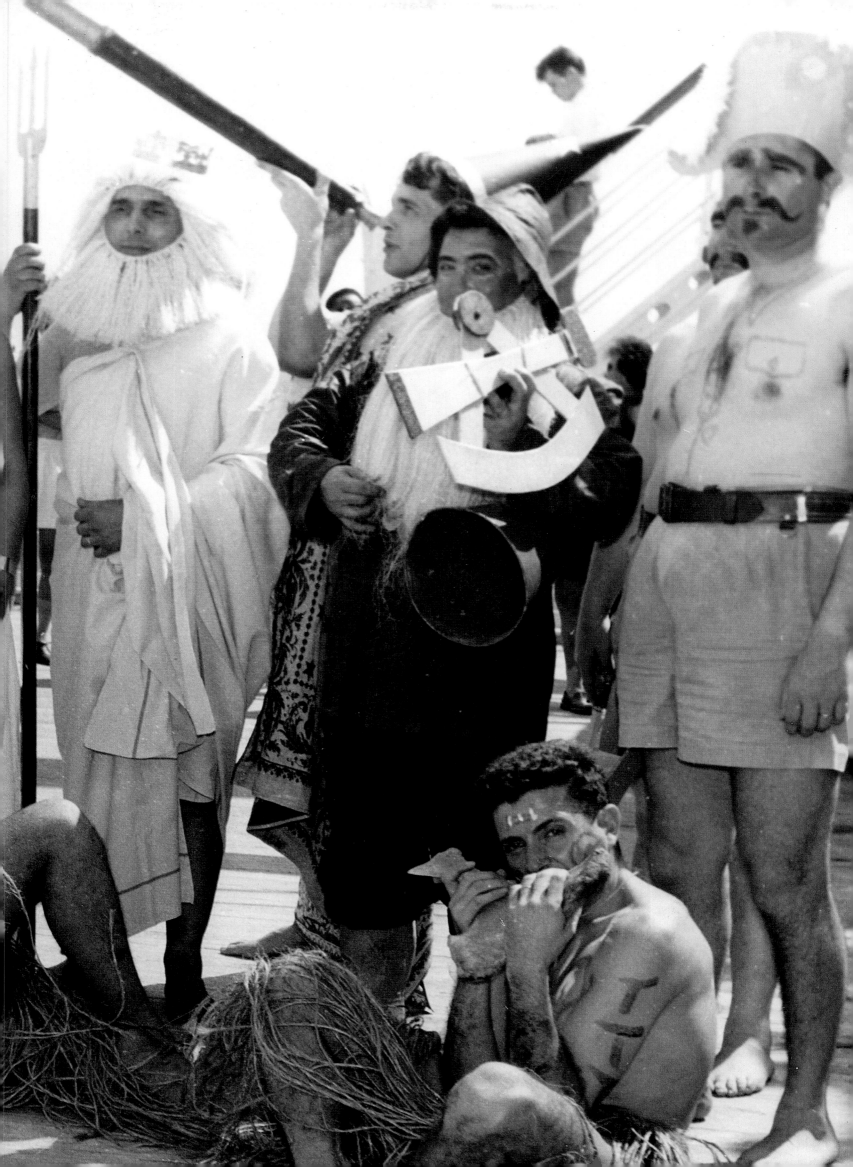

Maiden voyages always provided an opportunity for a company to promote its fleet. Well-known figures and journalists were only too happy to accept an invitation to one of these events, at which they would be given VIP treatment. Photographs and stories of maiden voyages were collected together in souvenir albums.
LEFT AND OPPOSITE: Pages from the album of the maiden voyage in 1931 of the SS *Colombie* of the CGT fleet, with (opposite) a CGT luggage label and (left) a certificate of polar circumnavigation.
OVERLEAF: The stifling heat of the last few hours of a voyage by the SS *Colombie* is palpable in this photograph; the ship is about to berth at Colón, one of Panama's largest ports. Resting on it is a box of matches bearing the crossed flags of the P&O emblem.

122

who wished to go ashore. During technical halts on one of the lakes along the Suez Canal passengers might spot pelican and sacred ibis. At Djibouti fearless small boys would jump from the handrail after small change tossed into the sea. And the approach of Ceylon (now Sri Lanka) could be divined before the island was visible by the spice-laden breezes that wafted over the ship. And everywhere there were local vendors who came aboard to spread out their glittering array of trinkets and knick-knacks on the deck. But in truth, these could barely compete with the souvenir shops run—notably on P&O liners—by the ship's hairdresser: chaotic, overflowing Aladdin's caves of framed portraits of the prince of Wales, enamel sporting trophies, Oriental slippers, boiled sweets, fly swats, gramophones, tennis shoes, sponges, children's toys, picture postcards, and a bewildering array of costumes for the traditional fancy-dress ball or the famous ceremony of the Crossing of the Line. The *Chili*, with the disgruntled Edmond Garnier on board, crossed the equator at seven-forty-five in the evening on January 26, 1909, and he noted with relief that the customary showers and tub duckings were not inflicted on those crossing it for the first time. In contrast, he was quite happy to take part in

a number of inoffensive pranks, and raised his glass in the traditional pair of toasts, the first to "the fair sex of the two hemispheres," and the second to "the two hemispheres of the fair sex." The humor was perhaps rather dubious, but on these long voyages anything that raised a smile made a welcome diversion.

Living on top of one another for such lengthy periods, even in such an extravagantly gilded cage, inevitably took its toll. Francis de Croisset, writer of light comedies, who took a passage to India in 1925, described the petty irritations of daily life. "That's three times that I've had to move my deckchair! . . . I like only the sunny side, but I'm not allowed there. Everyone else has gone there: how can it be that the boat doesn't tilt? There is still some room on the shady side, but it is raked by a vicious wind which makes my eyes water and whips the pages of my book out of my hand before I have finished reading them. Never in my life have I seen such quantities of children. There are three little tots who cry just for me. Every time I move, there they are again! There are two pretty women on board, I'm told, but both of them are indisposed. I go on deck to have a game of quoits. The quoits are taken. The tennis court, meanwhile, has been monopo-

Among the notable events that enlivened sea voyages was the ceremony of Crossing the Line (otherwise known as the Equator, or the Arctic or Antarctic Circle): a welcome opportunity to break the monotony of life on board and an excuse for general high spirits.
OPPOSITE: Tourist class passengers on the *Normandie* celebrate Crossing the Line on a cruise to Rio in 1937.
INSET: Luggage label from the CGT liner *Antilles*.
PREVIOUS PAGES: The tradition was still very much alive in the 1950s, on the Messageries Maritimes liner *La Marseillaise*.

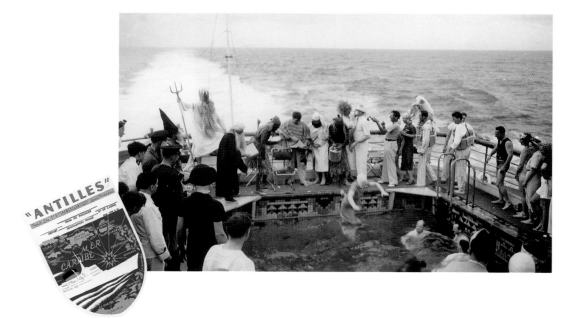

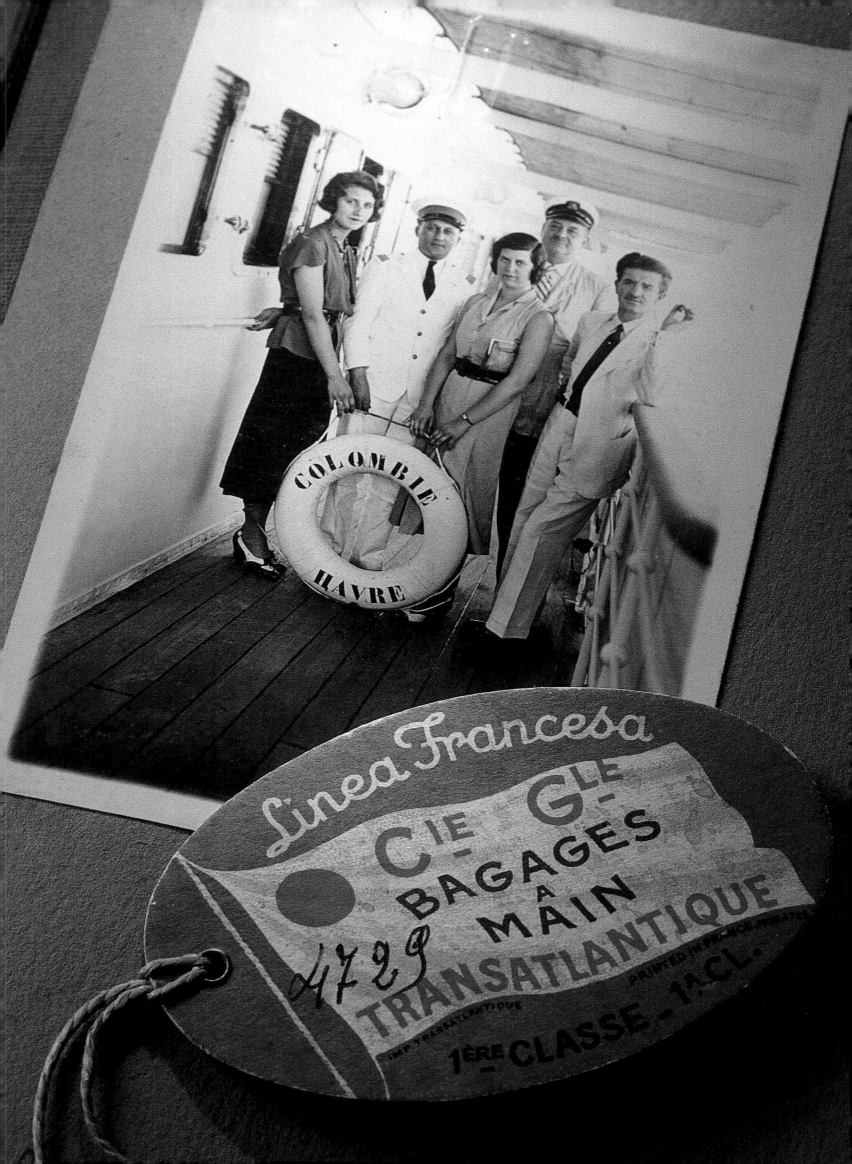

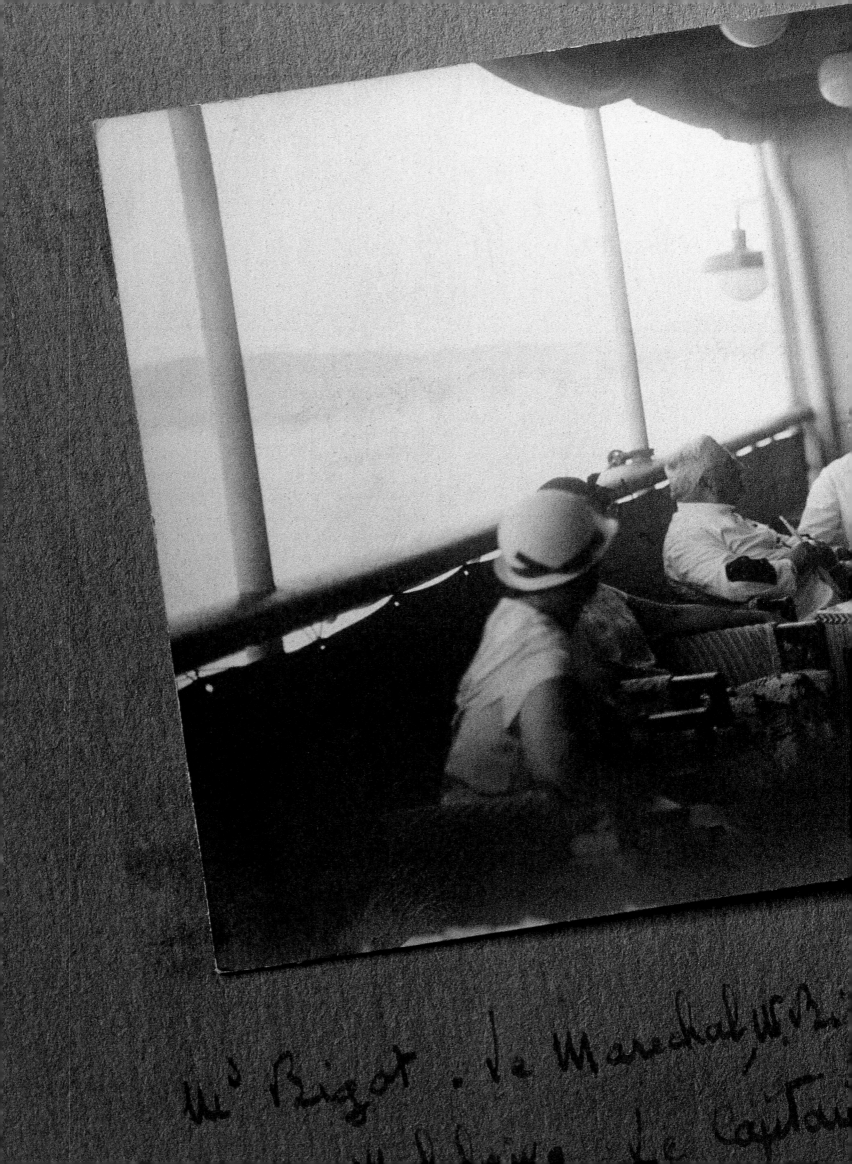

M' Bigot . Je Mareschal W.B...
...l faire le Capitai...

Consommation de charbon par...

...GE............ { Vitesse mo...

KILOS	1166	—
NŒUDS	14	55
...OURS	67	31

...VATIONS A CONSULTER

...cice d'abandon doit être fait au point
...a ligne et non en cours de traversée.

Marseille le 10 Octobre 1911

RAPPORT Général du Voyage N° 23
de *Marseille* à *Yokohama* et Retour

MONSIEUR LE DIRECTEUR,

J'ai l'honneur de vous adresser le rapport général du voyage N° 23 que vient d'effectuer le *Polynésien*.

Sommaire du Voyage.

	Aller.	Arrivées
Départs		
Marseille	16 Juillet 11ʰ matin	
Port-Saïd	21 Juillet 5ʰ matin	Port-Saïd 20 Juillet 10ʰ soir
Aden	26 Juillet 7ʰ m...	Aden 25 Juillet 4ʰ soir
Colombo	2 Août 6ʰ...	Colombo 1 Août 5ʰ matin
Singapore	7 Août 8ʰ...	...apore 6 Août 6ʰ soir
Saïgon	11 Août	9 Août 5ʰ matin
Hong-Kong	14 Août	14 Août 6ʰ matin
Shanghaï	18 A...	...Août 7ʰ matin
Kobé		...11ʰ soir ...matin
Yokohama	4 S... 1911	
Kobé		

Directeur de l'Exploi...

285. — Groupe de Japonaise - Sur le...

The gateway to North Africa, Algiers developed as an important tourist center from the early twentieth century. "Crossing the sea from Marseille to Algiers is child's play today," proclaimed a CGT brochure in 1908, "and it's a game full of attractions, a delightful excursion thanks to the sophisticated luxury and great rapidity of our steamers, which put Algiers a mere thirty hours from Paris." A tempting prospect indeed—especially for those who had never experienced a Mediterranean storm!
RIGHT: Passengers disembarking from a steamer in the port of Algiers, c. 1910, with (inset) a label from the CGT liner *Ville d'Alger*, 1935.

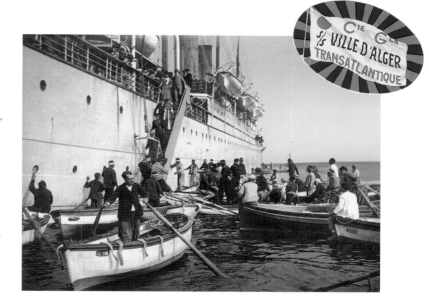

lized by the same players since we left Tilbury. And to think that I have to endure a fortnight of this!" Others complained of the inevitable tedium of life on board, which drove them to find comfort in their fellow travelers. Julien Green, in his short story "Leviathan," lamented that, "For a person of nervous temperament, the monotony of the scene is a trial, almost a torture. And so it is that people on board ship turn, as if toward their salvation, to the company of their fellows, even if they have contempt for them, even if they hate them. For they have to live, they have to escape from the consuming boredom of the days, from the sea, and from the Leviathan, ever lying in wait, which silently accompanies them."

In general, however, things usually did not go too badly, at least on the outbound journey, when fresh-faced passengers in the pink of health looked forward eagerly to a voyage to an unknown land of promise, with all its new sights and ambitions, dreams and hopes. The return journey on these colonial routes was quite a different matter. Ravaged by the effects of heat, alcohol, mosquitoes, and dysentery, some worn down by crushed expectations and broken hearts, these jaded souls could work up little enthusiasm for visiting ports of call, and now voices tended to become raised and

tempers began to fray. The number of deaths also rose, for people can die at sea as they can on land, and every steamer had a quota of coffins among its cargo. Indeed, a complaint addressed to the directors of the Messageries Maritime, the captain of one of these liners objected that "the number of coffins is inadequate if they are to cater for both passengers and crew." Occasionally, by some happy fluke, the reverse was true. The insurers of the *France* on her two world tours predicted that given the average age of the passengers, there would be ten deaths on each voyage, when in the event there were only four on the cruise of 1972, and none at all on the cruise of 1974.

On board ship anything might happen. The ship's surgeon was prepared for any eventuality, up to and including surgery, sometimes performing several operations in a single voyage. White Star liners of the Edwardian era boasted a small infirmary, an operating theater, and two doctors. It was better to be on the safe side, since there were also deliveries to be anticipated. Given the number of passengers, each voyage was bound to see some babies born on board. Some couples were rumored to have planned a birth at sea deliberately, so that their newborn would automatically benefit

However sumptuous and swift the great ocean liners of the 1930s were, passengers embarking at the ports of Europe for India, South Africa, South America, China, Japan, and points east, or boarding ships at Seattle or San Francisco bound for Australia or New Zealand still had a long journey ahead of them. Vast distances were vast distances, and not for nothing were these exotic lands called the Far East.

LEFT: A P&O advertisement for cruises to India, the company's favorite destination.
OPPOSITE: Commander Bruno's report on a voyage by the Messageries Maritimes steamer *Polynésien* from Marseille to Yokohama in July and August of 1911. With it is a contemporary postcard showing a group of Japanese people posing for the ship's photographer.

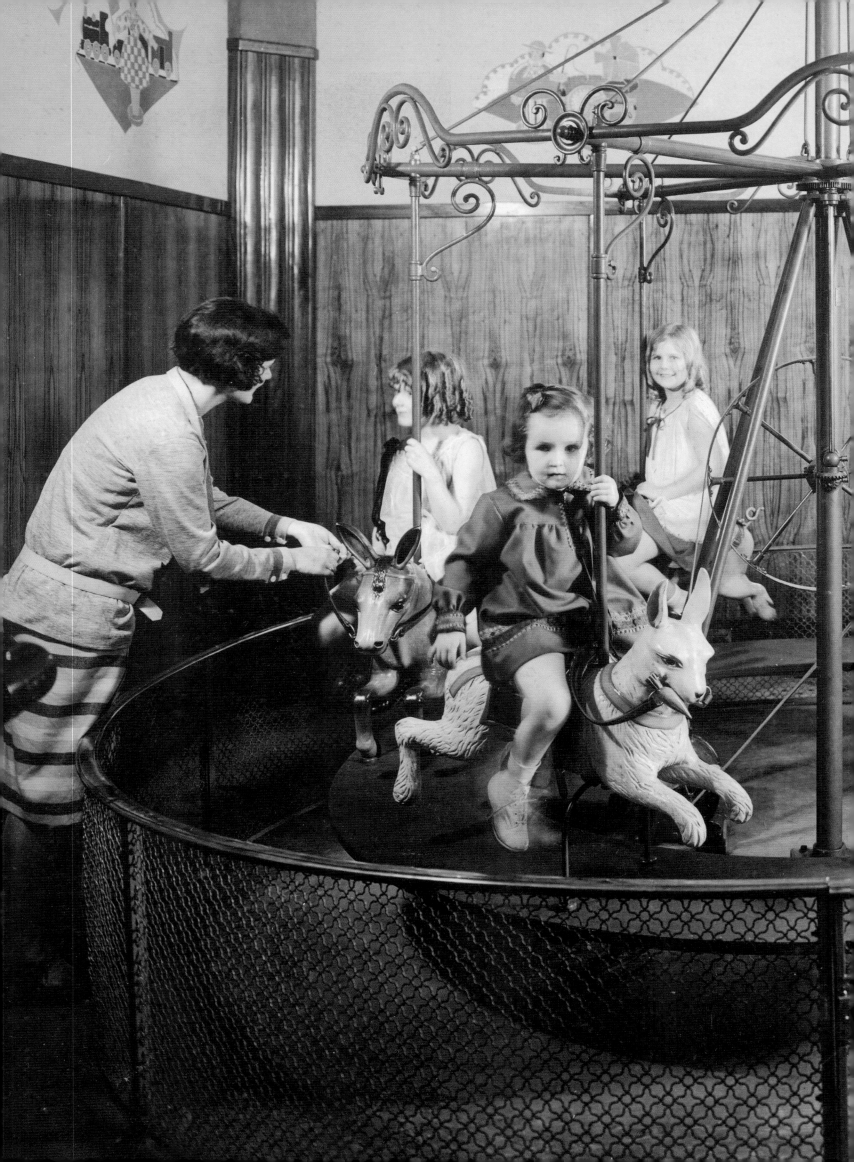

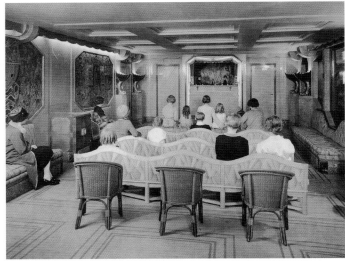

from dual nationality: that of the parents and that of the ship on which the birth took place. It was the commander's responsibility to carry out the due formalities, entering births and deaths in the ship's logbook, which became a register of births, deaths, and marriages. He was also responsible for celebrating marriages, performing the duties of a registrar in a registry office on board ship.

Religious ceremonies were also possible, provided a celebrant of the appropriate faith was available, and the great liners even had their own chapels. The chapel on the *Ile de France* was the first of its kind on the French Line, and its counterpart on the *Normandie*, which had a floral painted ceiling, was ecumenical in spirit and decoration: during Protestant services, the Catholic altar disappeared behind sliding panels, and shutters engraved with simple crosses folded over the face of Christ. And at five o'clock every morning on the *Sphinx*, Father Joseph Bulteau had to make more ad hoc arrangements when he celebrated mass for the seven monks who were traveling with him: in the first-class music room he would unfold a small portable altar "that looked like a piece of furniture," and after the service had finished, he would have to put it away in the exhausting

heat. "I will never forget those masses in the Red Sea," he later recalled. "From six o'clock it was already hot, and throughout mass I had to have a handkerchief at the ready to mop up the perspiration!" On French boats especially, captains tended to be reluctant to allow public spaces to be used for religious services, and especially for Sunday mass. Thus a group of missionaries sailing to Shanghai on the *Tourane* were refused permission to celebrate mass on deck, with the stated rationale being that it might offend the large numbers of Protestants on board. But it would not be surprising if it would have caused more offense to the French government officials on board on their way to Indochina: this was 1907, only two years since the law separating church and state had been passed in France—a subject civil servants were understandably sensitive about.

On British ships, by contrast, Sunday was the Lord's day through and through, from the holds to the upper decks. On the *Titanic*, Sunday service was held at ten-thirty on April 14 in the first-class dining saloon, with the ship's orchestra providing the musical accompaniment. Conducting religious services was another of the captain's duties; Captain E. J. Smith gave a Bible reading and

Keeping children occupied during a voyage at sea required the right equipment, amenities, and impeccable organization. Fortunately, the relevant crew members on the big liners were old hands where this was concerned, and there was stiff competition between the various lines to think up the most creative solutions and imaginative distractions for their youthful passengers.
Nothing was left to chance on the *Ile de France*, where the children of first-class passengers were inevitably the most spoiled in surroundings that rivaled the ship's other public rooms in their wealth of decoration.

RIGHT: A mealtime in the children's dining room, decorated with scenes from Perrault's fairytales.
ABOVE LEFT: Dressing up on the *Conte Verde* (1923).
ABOVE RIGHT: A puppet show, with the children's-duty nurse sitting discreetly to one side.
OPPOSITE: Santa Claus on board the *Cambodge*, 1955.
PREVIOUS PAGES: In the sycamore-paneled playroom, children in their party-best play demurely on the merry-go-round, under watchful adult eyes.

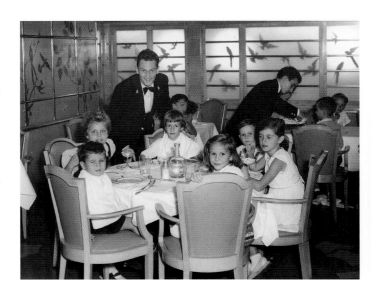

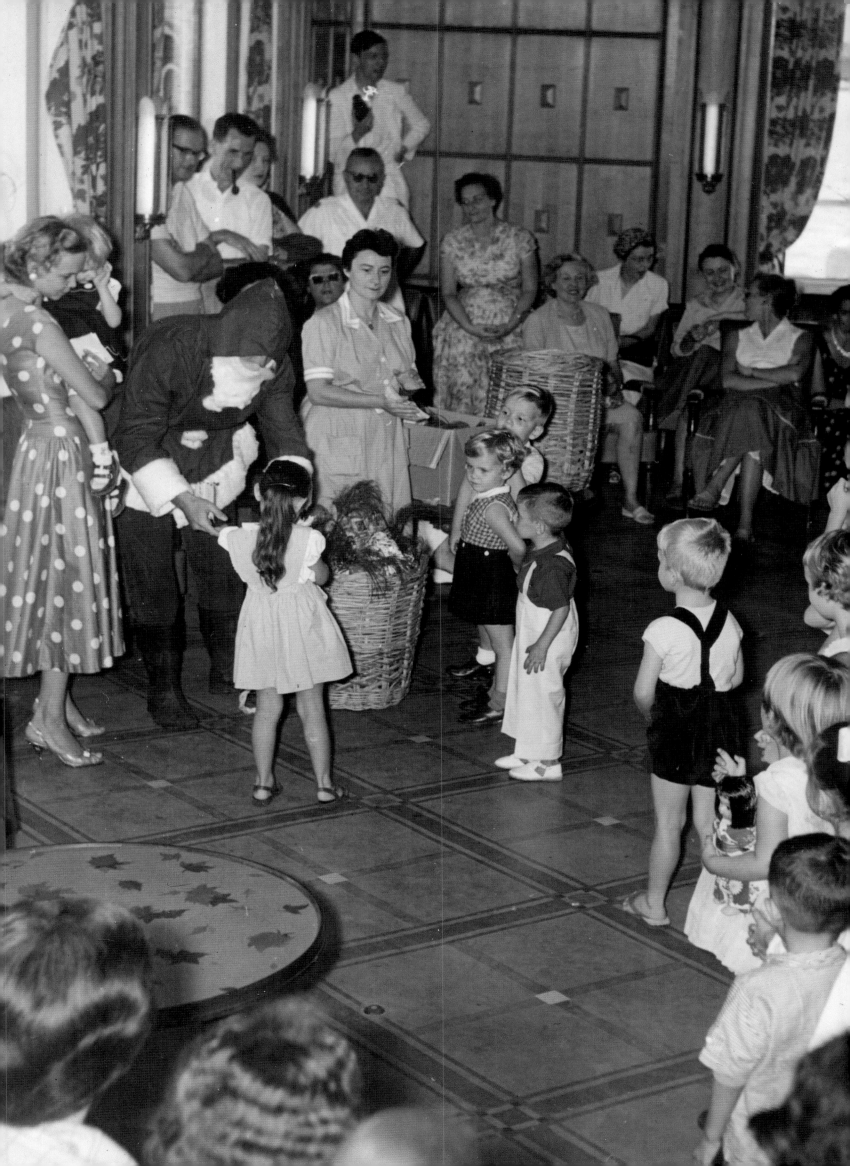

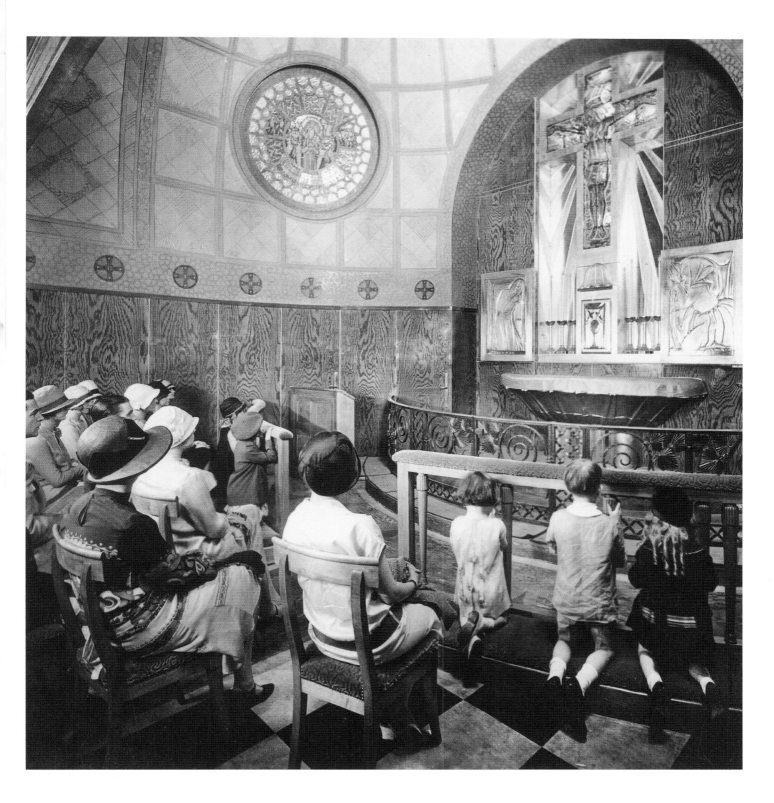

Religious life continued at sea, where there was always a priest or minister, even if there was not a consecrated place of worship. Anything might happen during a voyage, most notably deaths and births. Babies born on board could take the nationality of the ship and were sometimes even given its name.

ABOVE: The first-class chapel on the *Ile de France*. Around the altar is a wrought-iron grill by Raymond Subes, and above it a figure of Christ in luminous glass by Henri Navarre.
RIGHT: A simple service on a P&O steamer in c. 1891, from W. W. Lloyd's *P&O Pencillings*.
OPPOSITE: A mahogany chest from the 1940s containing altar vessels and other accoutrements, now in the French Line collections.

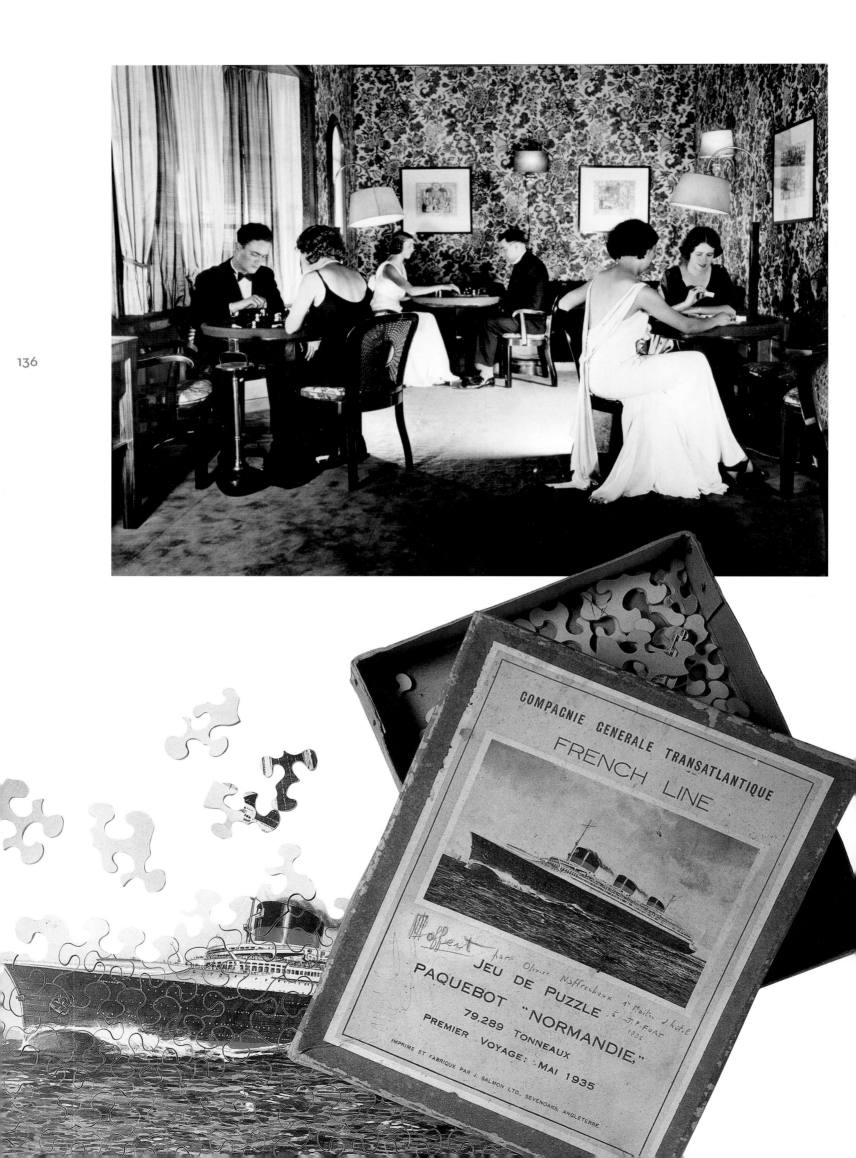

Gambling was a favorite activity on ocean liners—sometimes to excess, as many an unsuspecting wealthy passenger learned to his cost, having been "fleeced" by one of the professional cardsharps who frequented the smoking rooms. But passengers spent a good deal of time engaged in perfectly innocuous games and pastimes, such as doing jigsaw puzzles and playing dominoes, snakes and ladders, checkers, backgammon, and chess.

OPPOSITE ABOVE: An atmosphere of hushed concentration in the first-class games room of the *Victoria*, part of the Italia fleet, 1932–33.
OPPOSITE BELOW: A jigsaw puzzle produced for the maiden voyage of the *Normandie* in May of 1935.
RIGHT: Playing cards in the small salon of the *France*, 1962–65.
PRECEDING PAGES: A game of steeplechase in the lounge of the *Lafayette* in the 1930s, with bellboys moving the horses at the players' request.

recited prayers. A kind of holy truce was declared for the service, and the barriers between the classes were temporarily abolished so that all three classes could worship together. Father Thomas Byles, the Catholic priest, had his own service and celebrated mass in English and French in the second-class lounge, before heading down to third class to give a sermon. On British liners these services generally set the tone for the rest of the day, with no dancing, no noisy parties, and—in theory at least—no low-cut gowns for the ladies, or dinner jackets for the gentlemen, in the evening. The Protestant matrons who had so exasperated Jules Verne aboard the *Great Eastern* were to be found in latterday incarnations on all British liners, where they proceeded to impose by their own rigid example a chaste and wholesome moderation.

In short, it became common for French passengers to complain that nothing on earth could be drearier than a Sunday on a British liner. To make matters worse, all gambling and games of chance were banned on Sundays. At this time, ocean liners of all nationalities were floating gaming dens, with passengers devoting themselves to bridge, whist, poker, backgammon, and steeplechase from morning to night. All these pastimes naturally involved the placing of bets, sometimes of colossal sums, since those playing in the first-class smoking room were often magnates of industry and banking, with considerable fortunes—whether of "new" or "old" money—at their disposal. Even without cards, dice, or any other paraphernalia of the gaming table, these men were gamblers. At the dinner table, fashionable young men would bet on the issue numbers of banknotes chosen at random, using bottles of champagne as stakes. Nothing was safe from having a wager placed on it, from the outcome of flirtations to the captain's age, or what would be on the dinner menu. The arrival of the pilot who, as the ship neared land, came aboard to act as second in command to the captain, provided a golden opportunity. Would he be fair or dark? Married or single? And so the stakes were raised. But above all it was the ship itself that triggered the gamblers' passion. Every evening they would place large bets on the vessel's likely position at noon the following day, when they would congregate impatiently before the chart on which the spot would be marked, champing at the bit, shouting out their predictions in miles and knots and hurling abuse at each other as though they were on the floor of the Stock Exchange.

LEFT: Cards and a score marker for bezique, a game much in vogue on P&O steamers in the 1920s.

OVERLEAF LEFT: The neo-classical decorative scheme of the main lounge of the *Viceroy of India* was inspired by the Adam brothers' free interpretation of Palladianism. Behind is a photograph of the veranda café, with its Moorish-inspired windows and cane furniture. The playing cards are from a deck issued for the Orient Line. Described by one P&O officer as "the perfect ship," the *Viceroy of India* was the jewel in the company's Indian fleet, marrying luxury, comfort, and elegance with such flair that it proved a huge success with passengers and crew alike.
OVERLEAF RIGHT: The first-class lounge on *La Provence* of the CGT fleet, c. 1910.

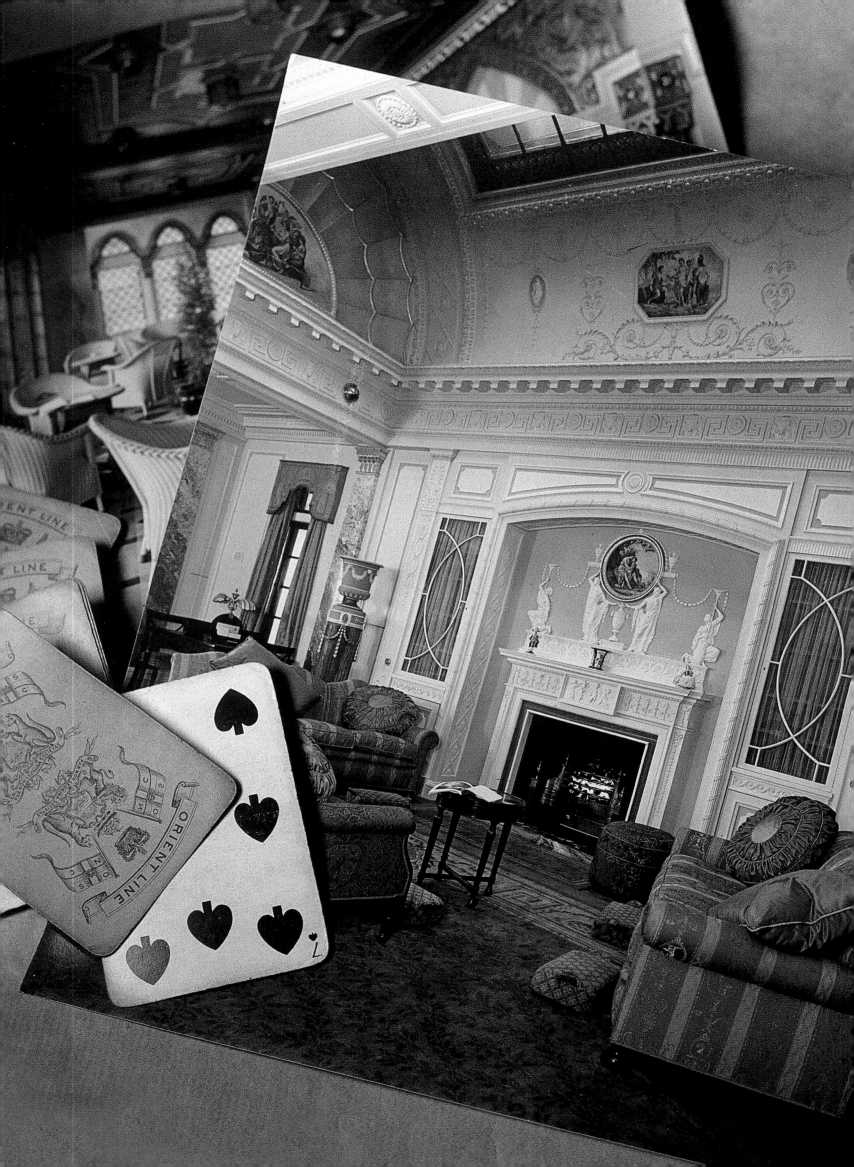

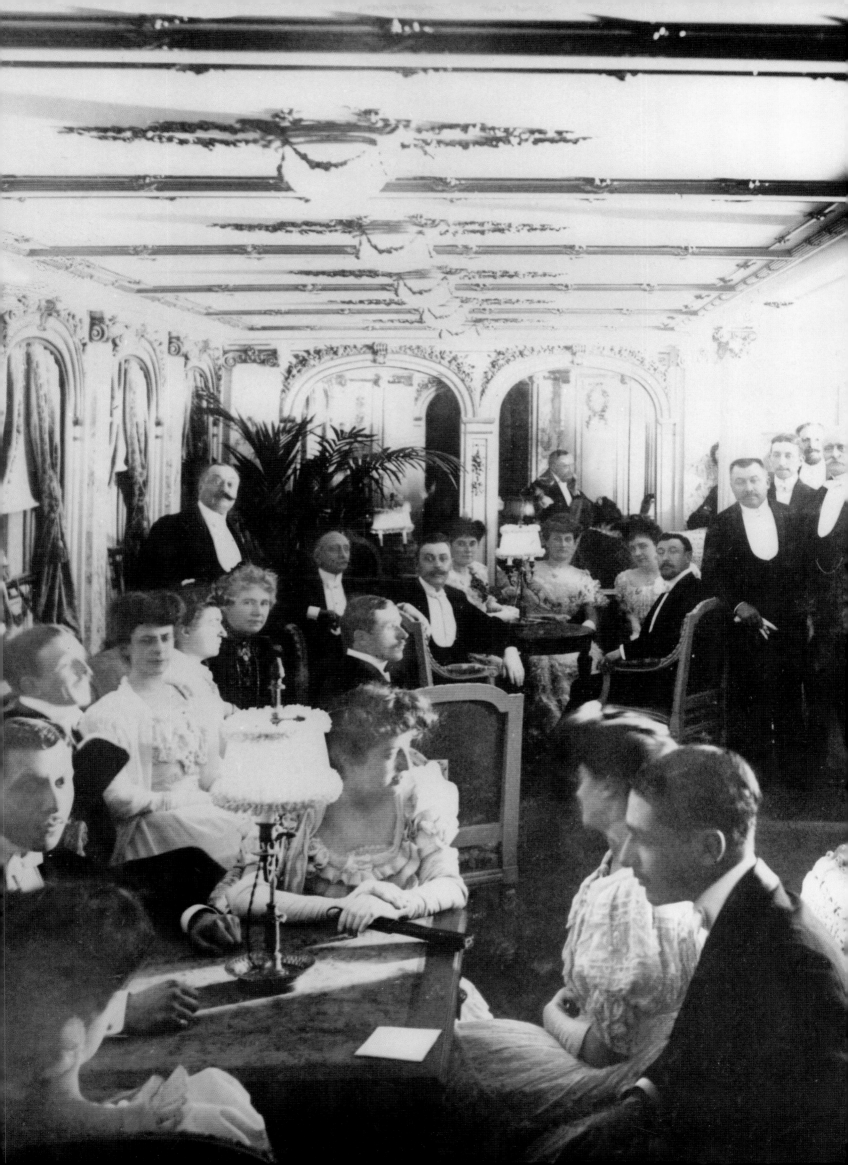

This atmosphere of frantic gaming inevitably attracted more than its fair share of professional gamblers, unscrupulous individuals who, once they had infiltrated the first-class smoking room, lost no time in selecting an ultrawealthy victim. The crew were well aware of the presence of these cardsharps, and the purser and stewards were even acquainted personally with some of the more familiar faces. Nevertheless, a blind eye was turned, possibly aided by a few well-placed backhanders. But the companies' chief fear was that they would become implicated in these activities, and so find themselves held legally responsible for the losses—sometimes considerable—suffered by their passengers. By way of disclaimer, they occasionally printed a small framed warning on the passenger list—a futile gesture that had no effect whatsoever. On her tragic maiden voyage, the *Titanic* had no fewer than four professional cheats on board, all traveling under assumed names. Even as the ship went down, one of them, George Andrew Brereton, was busily engaged in the first-class smoking room, where he was fleecing one Howard Case, director general of the Vacuum Oil Company Ltd. He was even able to make his time spent in the lifeboat and on board the *Carpathia* (which took the survivors to New York) profitable, finding a stooge, whom he managed to implicate in some murky business dealings a few weeks later.

Ladies also played, and sometimes placed bets, but they were protected from the worst excesses of the smoking room, which was to remain an exclusively male bastion on board ocean liners until the 1920s. While the gentlemen were gambling away their fortunes, the ladies enjoyed the use of the rest of the public rooms. Especially popular was the winter garden, a charming and exotic lounge that reached its apotheosis on the *Normandie* in a fairy-tale confection of flower-filled parterres, pergolas, aviaries, and babbling fountains. Although ladies were for many years excluded from the ships' male enclaves, gentlemen were, by contrast, always welcome in the rooms where the fair sex tended to congregate—partly for their amusing company and gossip, but not entirely. On these long sea journeys a little harmless banter helped to pass the time, and after gambling, flirting was a universally popular shipboard activity. The savvy Armand Béhic, president of the Messageries Maritimes, anticipated the havoc this might wreak among susceptible young officers and specified in the company

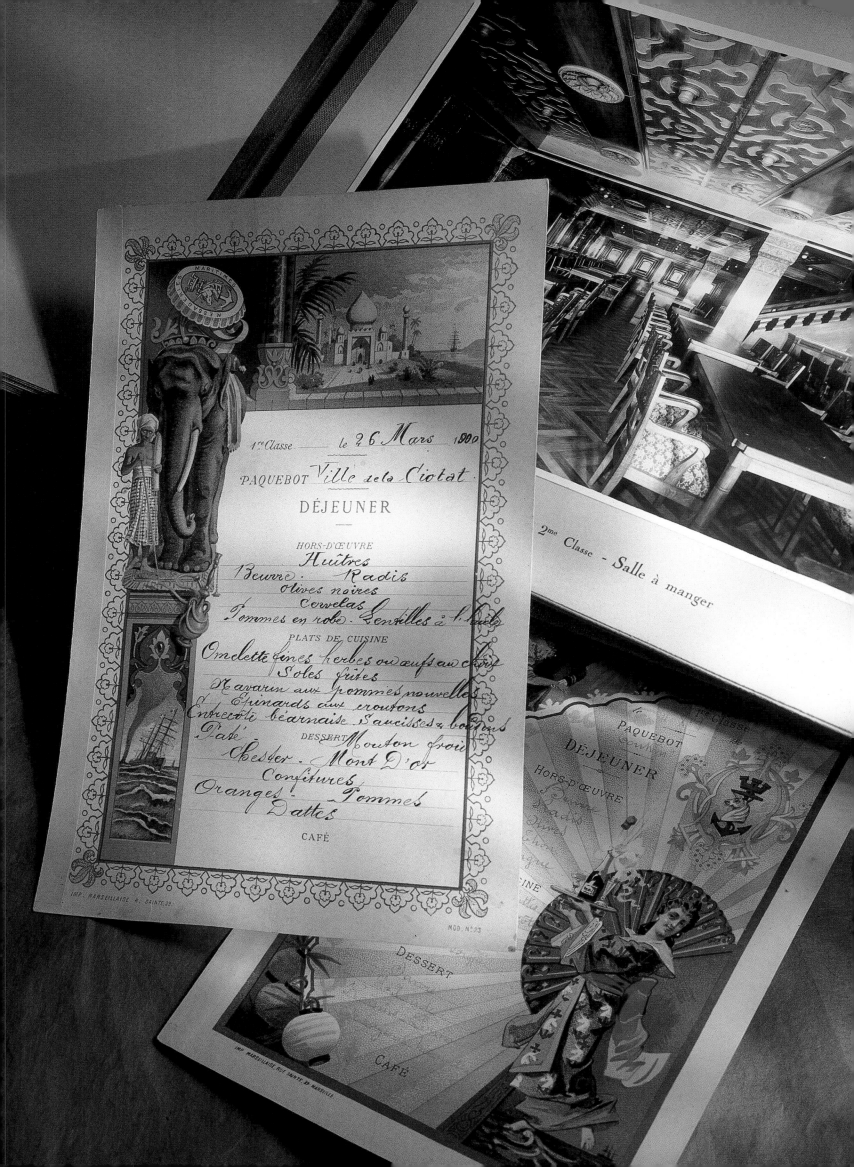

1re Classe le 26 Mars 1900

PAQUEBOT *Ville de la Ciotat*

DÉJEUNER

HORS-D'ŒUVRE
Huîtres
Beurre Radis
Olives noires
Cornelas
Pommes en robe Lentilles à l'huile

PLATS DE CUISINE
Omelette fines herbes ou œufs au choix
Soles frites
Navarin aux pommes nouvelles
Épinards aux croutons
Entrecôte béarnaise Saucisses à boutons
Paté DESSERT Mouton froid
Chester Mont D'or
Confitures
Oranges Pommes
Dattes

CAFÉ

2me Classe - Salle à manger

PAQUEBOT
DÉJEUNER
HORS-D'ŒUVRE

DESSERT

CAFÉ

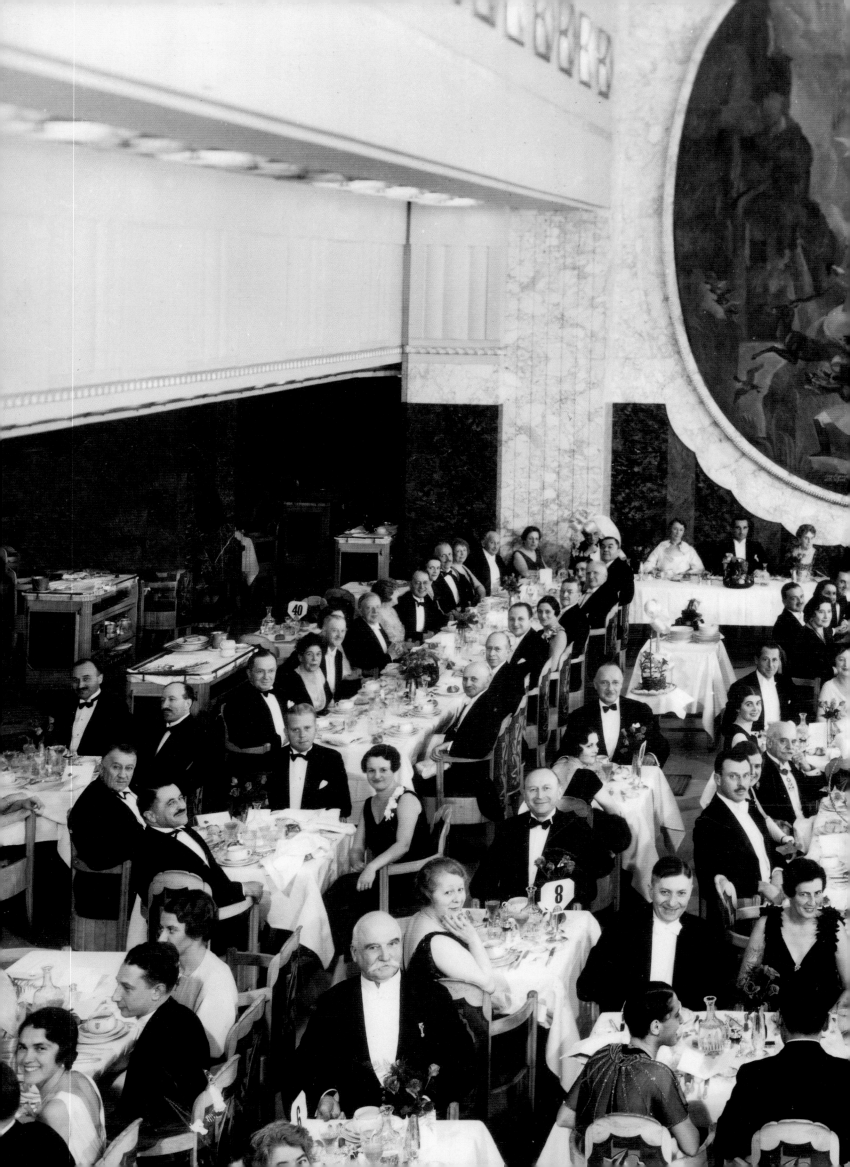

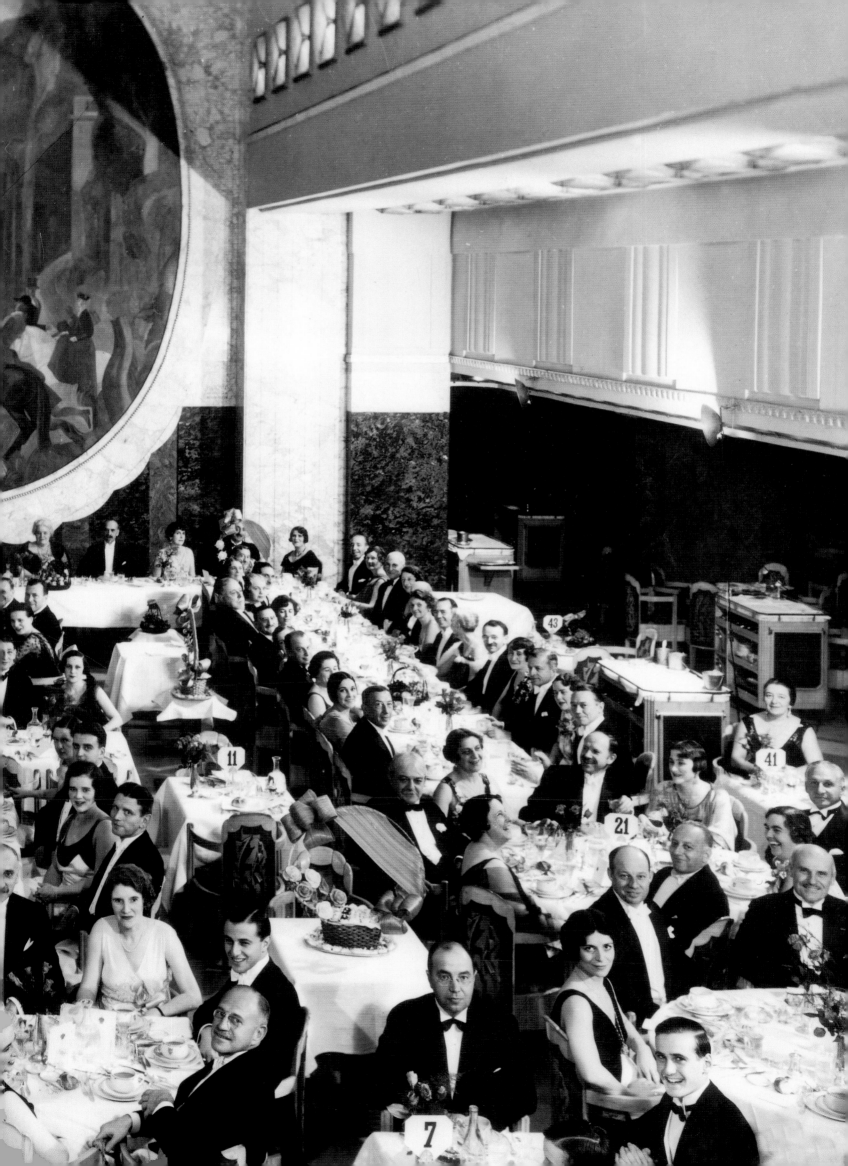

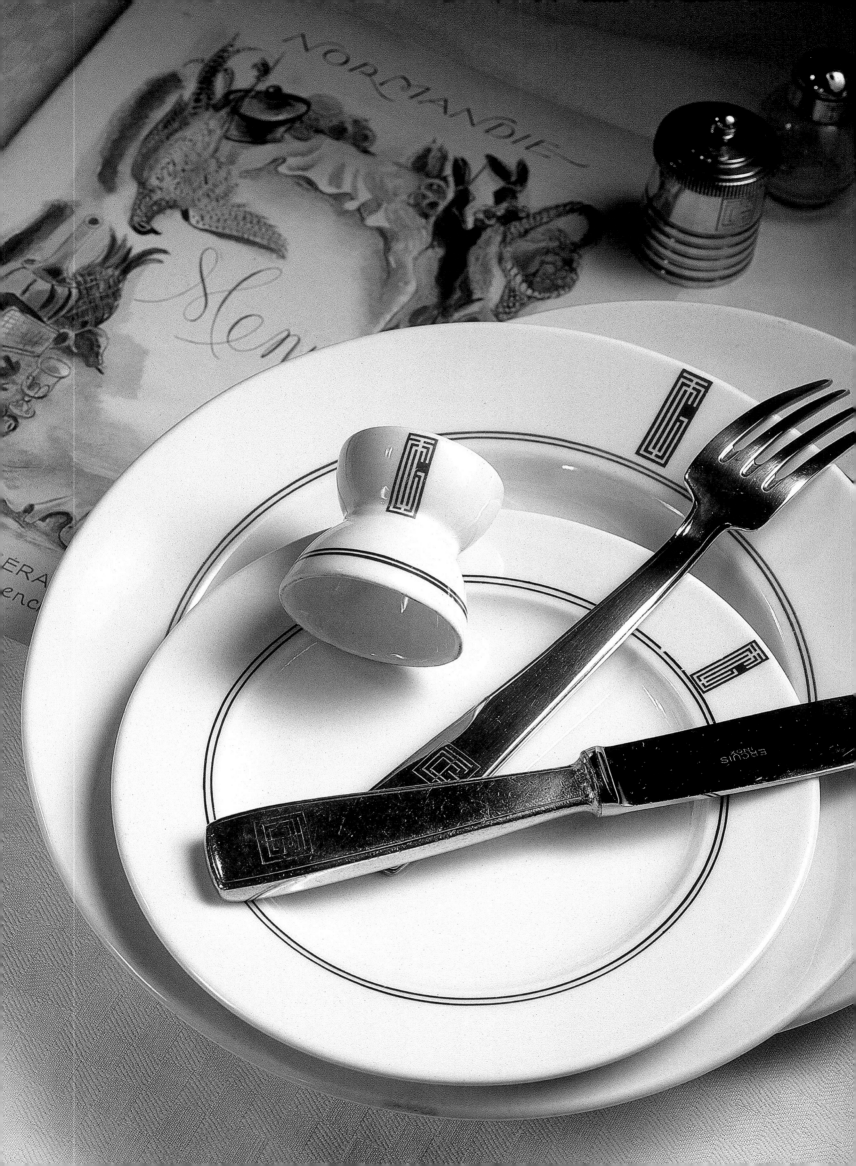

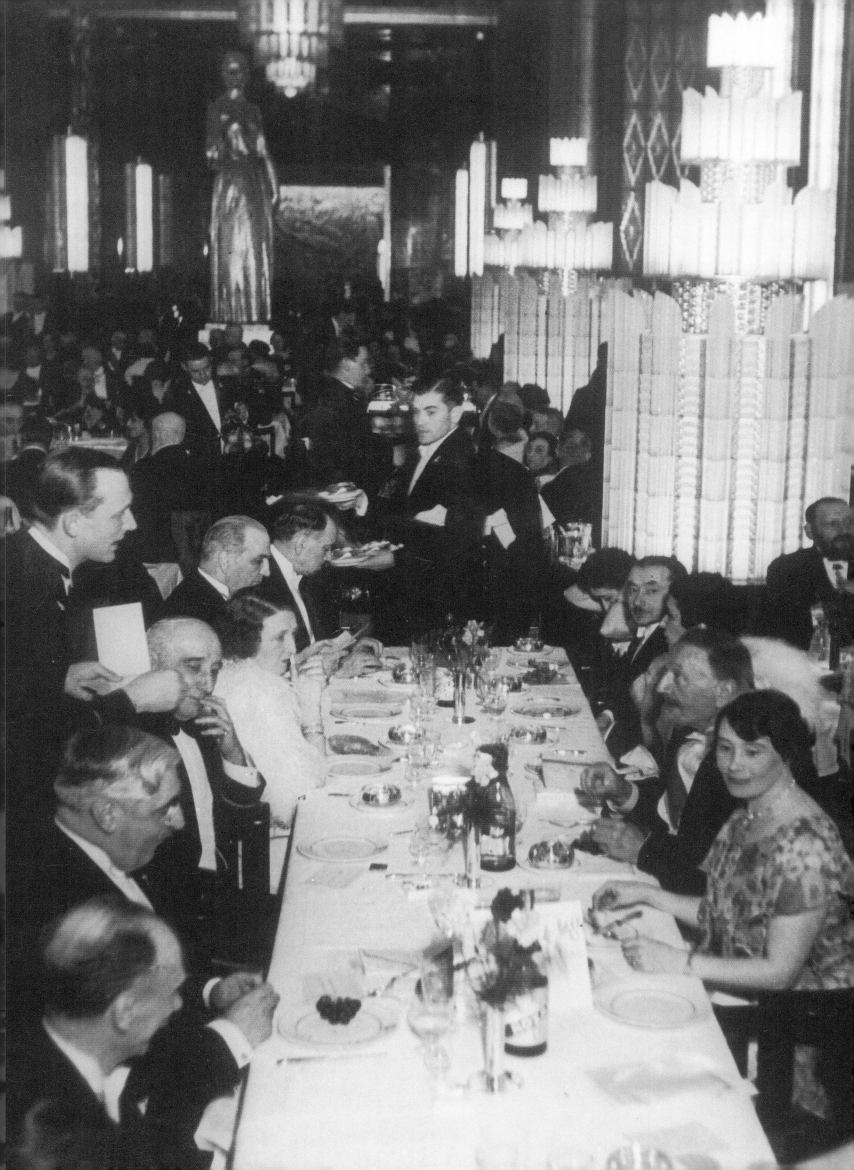

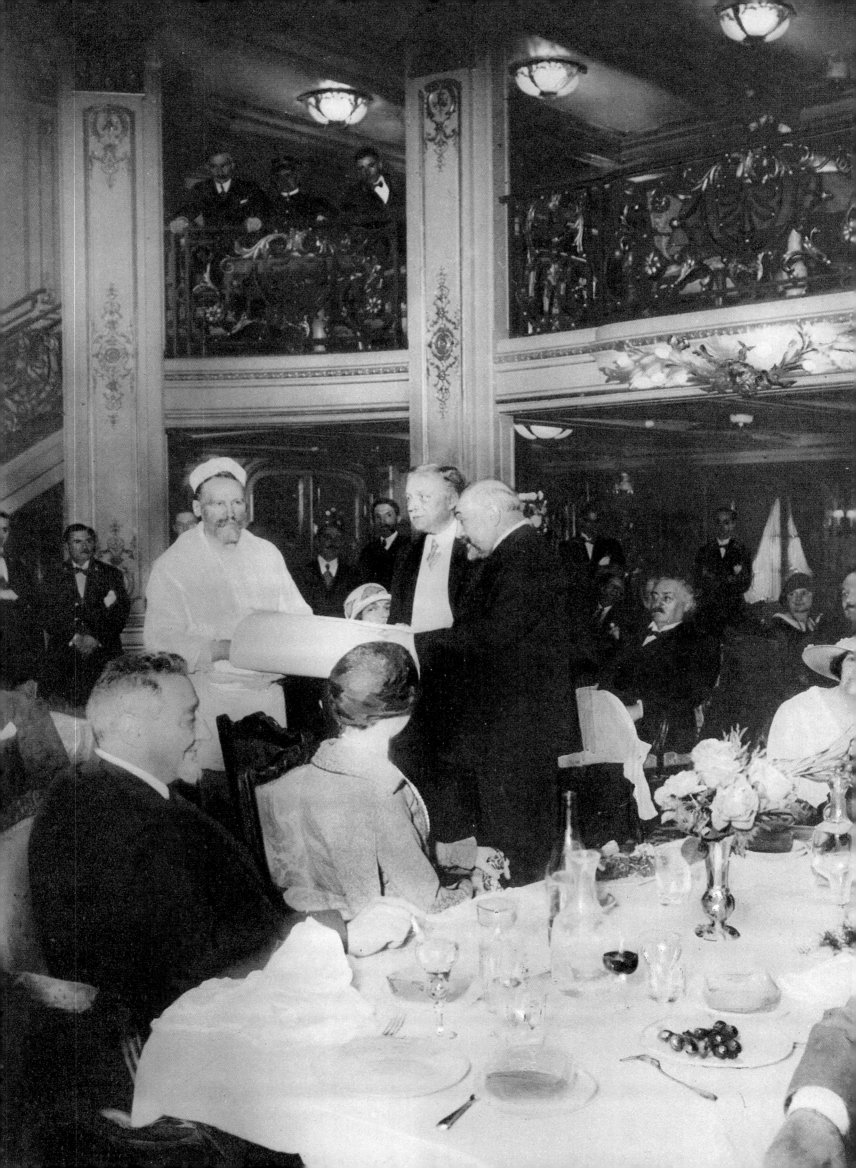

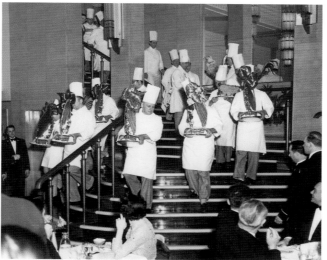

Daum crystal, Haviland porcelain, Christofle silverware, Lalique glass, and French master chefs: the incomparable ingredients of the gastronomic CGT dining experience. Aware of the importance of fine cuisine at sea, Norddeutscher Lloyd recruited the legendary Auguste Escoffier himself (FAR LEFT) to mastermind the menus for the *Kaiser Wilhelm der Grosse*, launched in 1897.
LEFT: A cavalcade of pastry chefs sweeps down the grand staircase leading to the first-class dining saloon on the *Ile de France*.

rules that "female passengers should be spoken to only when absolutely necessary, and as briefly as possible." But, this sage advice notwithstanding, romance remained the spice of life on board ship, especially when the passenger list invariably included many women traveling alone. On routes to the colonies, there were the wives of British officials posted abroad, going home for the annual holidays, accompanied by children and nurse, or returning afterwards. On the outward trip, there would also be young ladies sailing out to marry their fiancés, who had gone ahead to take up their duties as civil servants, officers, or planters in Bombay, Penang, or Batavia. It was not unknown, unfortunately for their intended, for these maidens to change their minds during the voyage out, and to marry a seductive fellow passenger at a port of call. In an effort to preempt these unfortunately timed shipboard romances, the Dutch lines hit upon a solution: all prospective brides on Dutch ships would be required to marry by proxy before embarking, so that they might feel restrained by their marriage vows.

Not all women traveling alone were either innocent or guileless, however. There were also seasoned temptresses who were keenly aware of exactly when and where their charms would be displayed to best advantage: at dinner time, at the top of the grand staircase leading down into the first-class dining saloon, where all social and physical assets were shamelessly put on display. Every evening on board the *Normandie*, the journalist Ludwig Bemelmans observed the entrance of a devastating vamp, a "merry widow" who exercised her powers of fascination over the assembled company: "As the orchestra struck up the opening bars of Ravel's *Boléro* she would make her appearance, trailing clouds of expensive perfume, moving in a studied manner that revealed the rippling of every muscle like the constriction of a python. As she reached the top step she would lean forward, and everyone held their breath; having successfully caught hold of her train . . . she would then, with tiny, careful steps, descend the stairs to the restaurant."

This sweeping descent was governed by the strictest protocol. The first to carry out this ritual were the "ordinary" passengers, each of the ladies nonchalantly allowing her gown to be admired as she passed. When all the other passengers were seated at table, the moment came for the entrance of those who would create a ripple of excitement as they descended the stairs in similarly studied fashion:

The first of the French superliners, the *France* (1912) was breathtaking not only in sheer scale, but also in the glamorous opulence of her internal appointments. The magnificence of the first-class dining saloon and its sensational staircase soon became legendary—as did the quality of the cuisine produced by her kitchens, which was reputed to match the best restaurants in Paris. Not surprisingly, many commentators believed that it was this gastronomic excellence above all that earned French steamers their international prestige and reputation.
OPPOSITE: This prestige was on full show at a gala dinner given by M. Dal Piaz, president of the CGT, for members of M. Louis Forest's Club

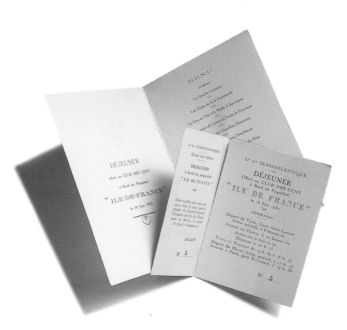

des Cent on board the *France* in port at Le Havre in July 1924. The photograph shows the ship's chef, M. Jean Leer, being presented by M. Forest with a medal and diploma for his excellent cuisine.
LEFT: Railway ticket and menu for a dinner given by the CGT for members of the Club des Cent on board the *Ile de France* on June 16, 1930.
OVERLEAF: The wine cellar on the *Normandie* (left) and wine being served in the first-class dining saloon. For each of her crossings, the famous liner took on board 6,300 gallons of table wine, 7,000 bottles of vintage wine and champagne, and 2,600 bottles of various liquors.

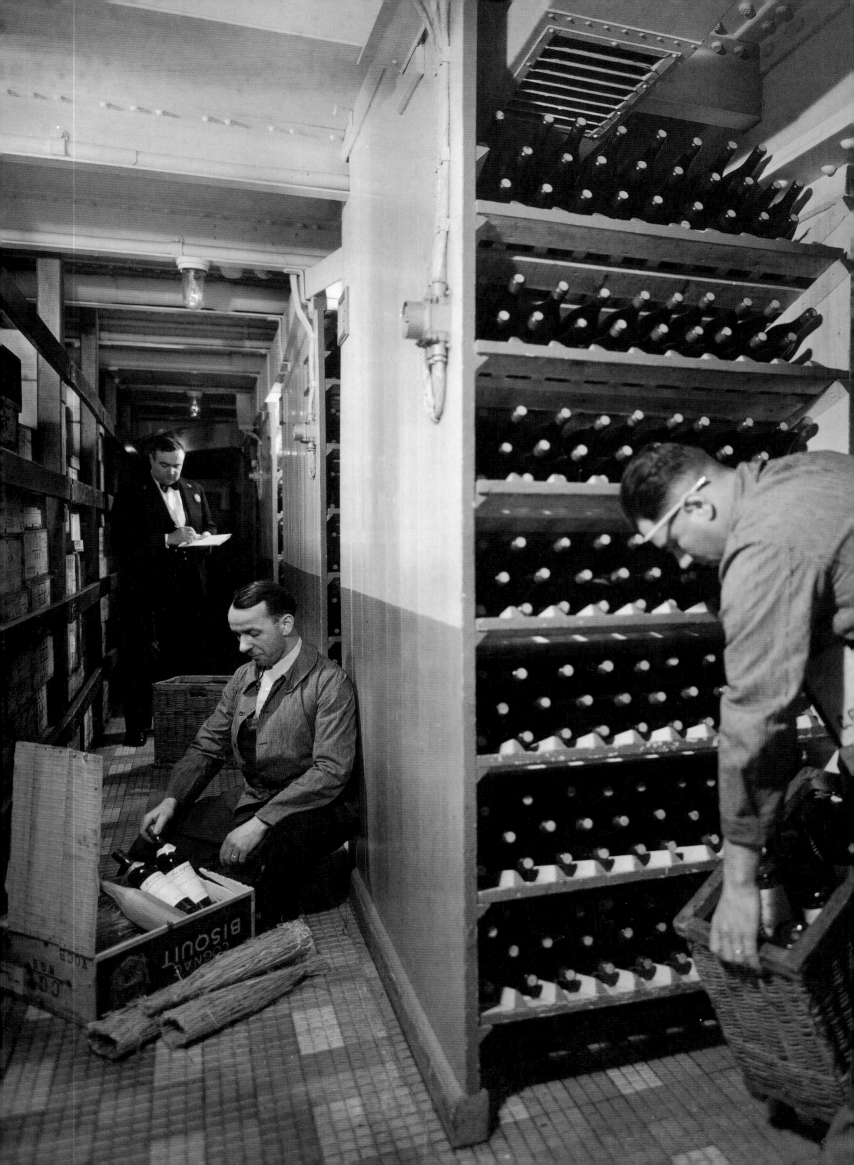

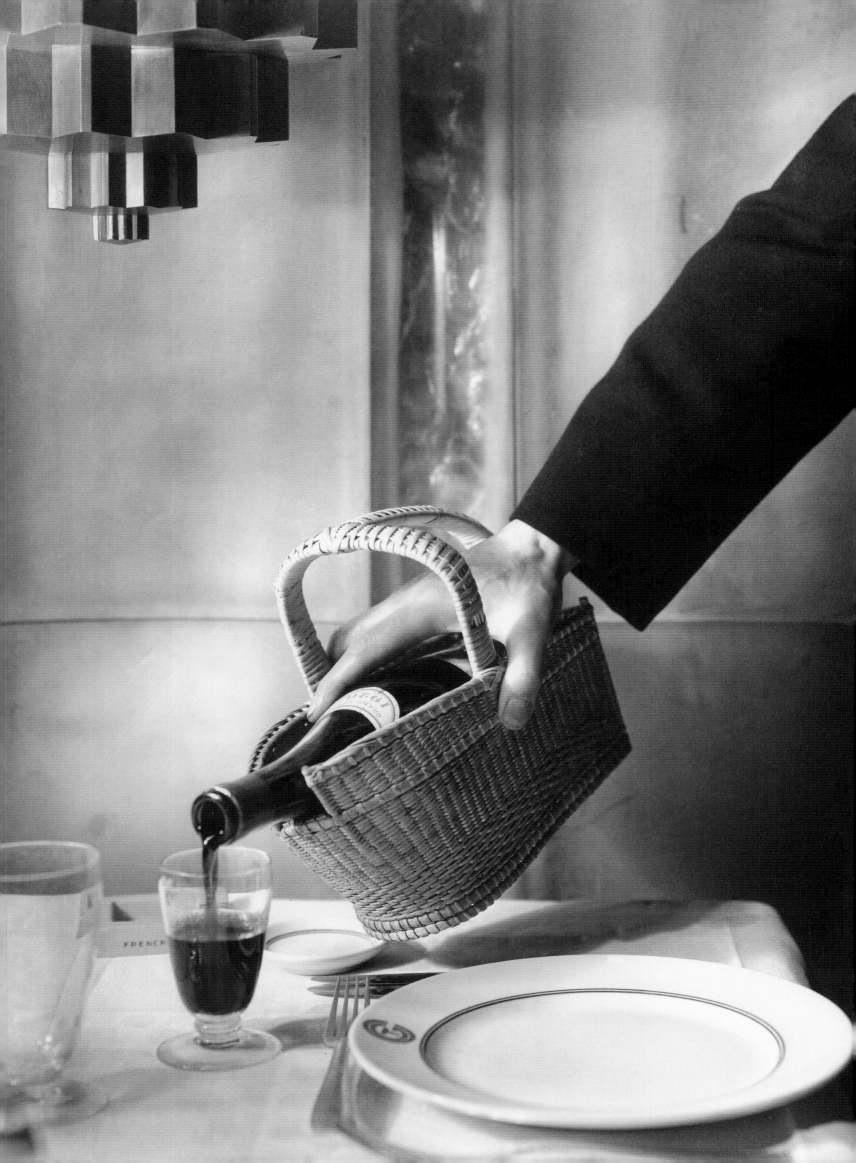

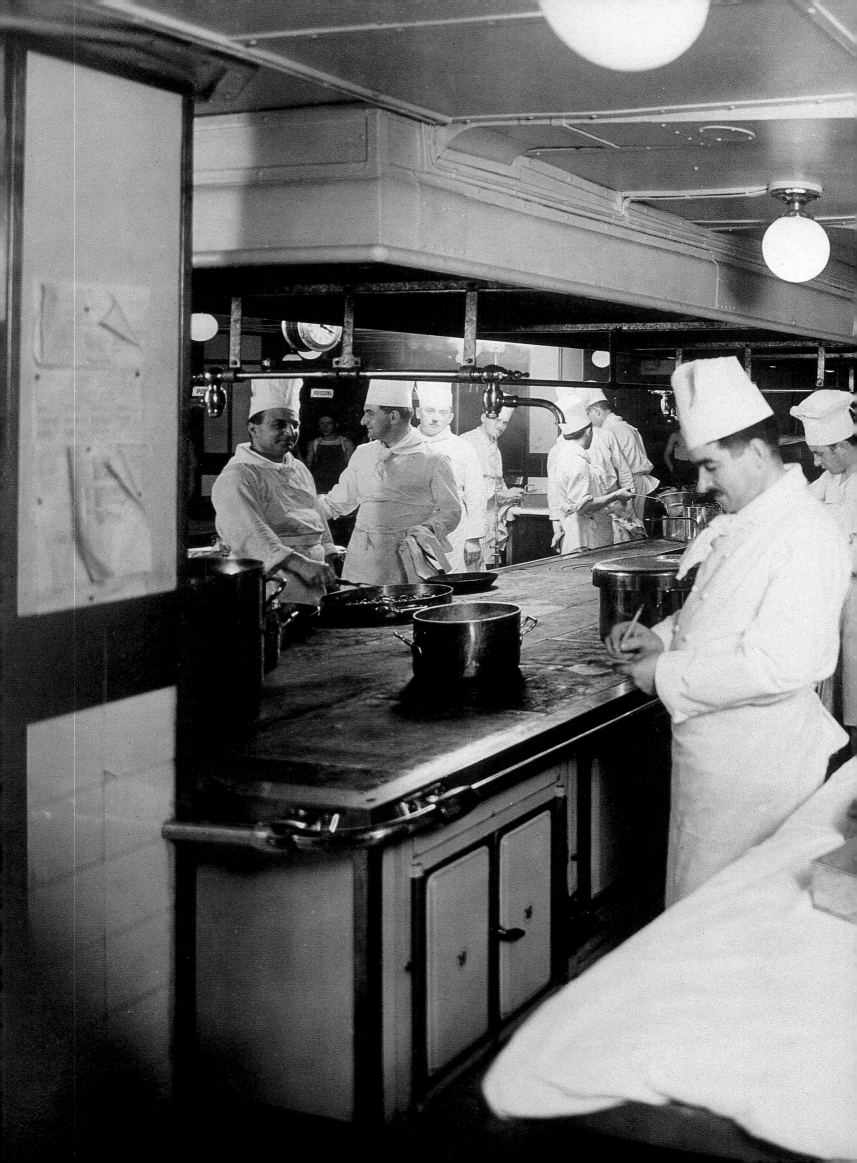

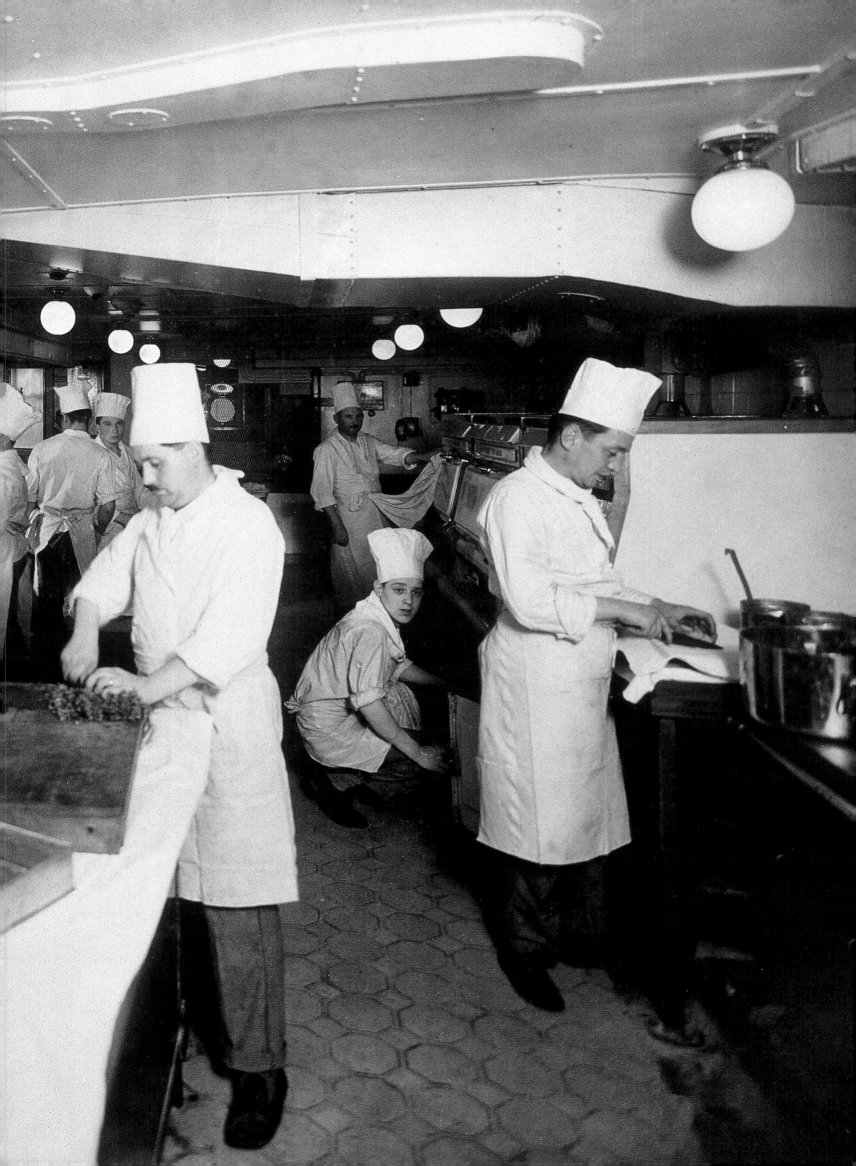

On these floating palaces the kitchens buzzed with dozens of hardworking staff. In 1924, the galleys of the *France* of 1912, for example, employed 25 chefs, 8 pastry chefs, 8 bakers, and 6 butchers; this was nothing in comparison with the *Normandie* a quarter of a century later, however, where the *chef de cuisine* was responsible for no fewer than 243 staff. All appliances, surfaces, and equipment, including saucepans and baking trays, were of stainless steel. In a special issue of June 1, 1935 devoted to the *Normandie, L'Illustration* waxed lyrical: "Round pans, oval casseroles, vegetable dishes of all shapes and sizes, platters for eggs, gratins, and sautés, all bright and gleaming, so simple in their lines, so clean and elegant, and so convenient to use."

LEFT: No stainless steel yet, in this photograph of the kitchens on the German liner *Dresden* in 1927, but instead copper polished to a high sheen.
OPPOSITE: A view of the ultramodern kitchens of the last *France*, showing cups, bowls, and jugs hanging in endless rows from hooks attached to long poles: the traditional storage technique for crockery and pots at sea, designed to avoid clattering and breakages in heavy seas.
PRECEDING PAGES: The altogether more modest kitchens of another liner of the CGT fleet, the *Lafayette*, in the 1930s. The gold-and-silver plate on the *Lafayette* was designed by Christofle.
BELOW: The day's catch on the *Europa*, c. 1935.

femmes fatales, matinee idols, famous politicians, and leading figures in the worlds of finance, literature, or the arts. It was the French Line that had launched the notion of a grand, glamorous staircase on its ships, a technical tour de force that required its designers to hollow out a great, gaping hole in the main body of the vessel without in any way compromising its structural rigidity. One of the most breathtaking and celebrated of these enormous voids was on the *France* of 1912: a replica of the grand staircase in the *hôtel particulier* of the Comte de Toulouse, designed by Robert de Cotte, son-in-law of the great seventeenth-century architect François Mansart, it cut through three decks and rose to a height of over twenty-six feet. The *France* was also a pioneer in serving passengers at smaller tables, a more elegant and intimate arrangement than the long refectory table that had previously been the norm, which could still be found in the second- and third-class dining saloons.

The first-class dining saloons on ocean liners escalated in their grandeur as they developed. Seven hundred diners could be seated in the Art Deco dining saloon of the *Ile de France*, with its stairway in gray Lunel stone and yellow marble, with an upper floor measuring over thirty-two hundred square feet, and a floor-to-ceiling height of thirty-five feet. On the *Normandie*, the dining saloon could accommodate a thousand diners at four hundred tables. And the dining saloon on the *Queen Mary*, while it boasted no grand staircase like those of the French liners, could serve eight hundred diners at once, in a space so vast that it could have held not only the first Cunard liner, *Britannia*, but also the entire fleet of Christopher Columbus: the *Niña*, the *Pinta*, and the *Santa Maria*. All this grandeur was set off with stylish details, including the use of three tones of wood and gilt bronze, and elegant dining chairs of sycamore upholstered in a charming shade of pink.

When the diners were all seated and served, it was the quality of background noise—the hum of hundreds of conversations and peals of laughter, and the chink of hundreds of glasses, forks, and plates—that told the chief steward whether or not the evening was a success. Either it was a good house, as they say in the theater, or else, on a bad night, the atmosphere was as chilly as the champagne buckets streaming with condensation at every table. Had the purser shown his usual light touch in drawing up a skillful seating plan, taking into account everybody's wishes while also

OVERLEAF: Silver plate made by Christofle for two great shipping lines, the CGT and HAPAG. The sauceboat, dish, and fish platter (left) are from the Empire service made for the *Kaiserin Auguste Victoria*, 1905. The sauceboat sports the German imperial eagle on its handle. In order to appeal to a cosmopolitan clientele, the public rooms of this sumptuously appointed liner included a Liberty-style winter garden and music room *à la française*. The "Albatros" tea and coffee service (right) was designed by Luc Lanel for the *Ile de France* in 1926; sugar tongs and a soup tureen exhibited at the Exposition des Arts Décoratifs complete the ensemble.

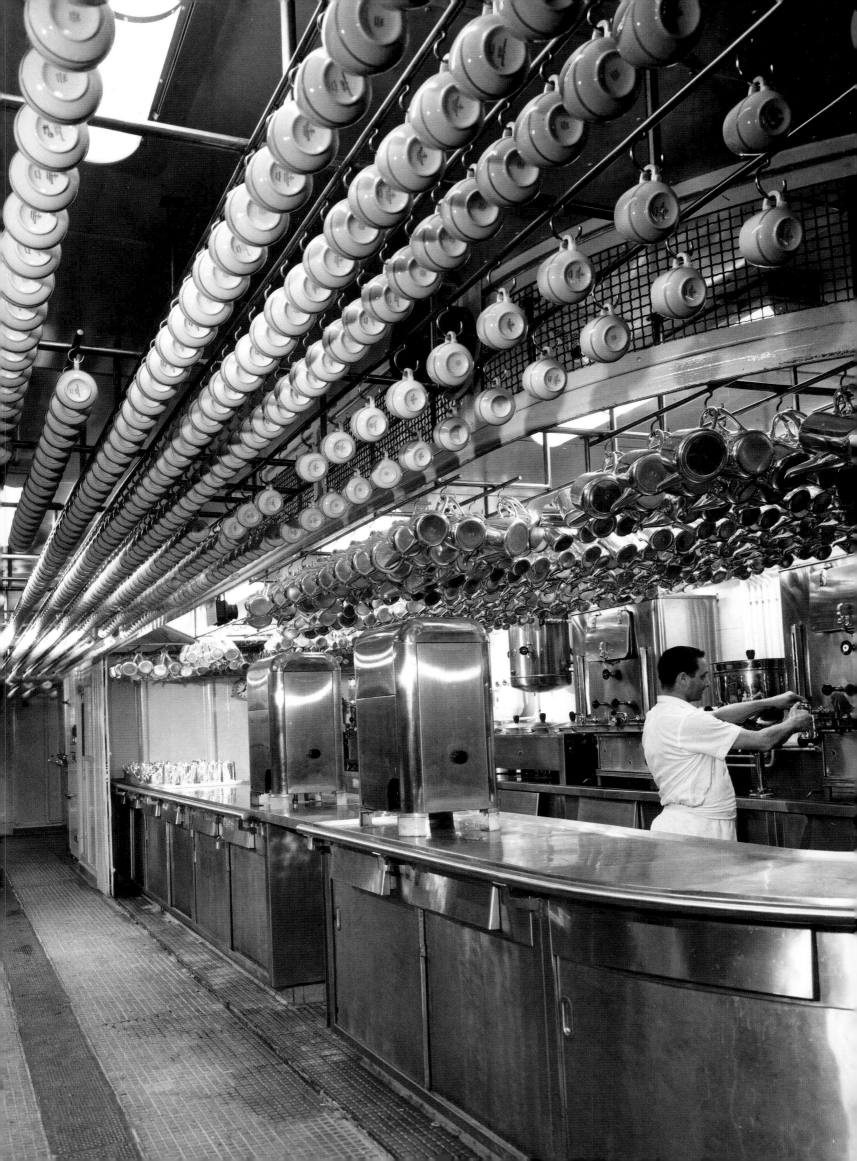

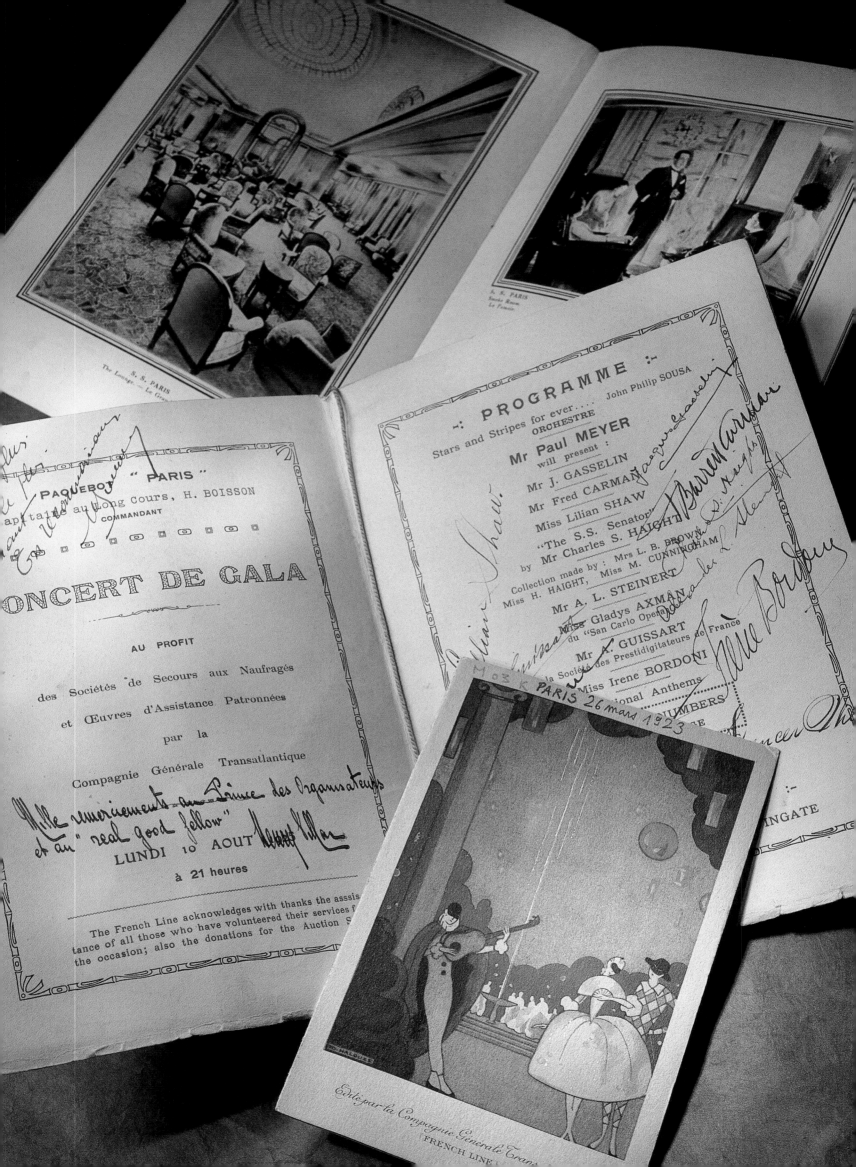

Dances, musical recitals, theatrical performances, charity galas, and games: evenings during the voyage were rarely without some form of entertainment, all organized by the purser and his team. Passengers were thus constantly flowing through the public rooms in one direction or another, and great care was taken by ever-vigilant stewards to ensure that they should feel relaxed and able to indulge their mood or whim at any particular time. It also fell to the stewards to discreetly but firmly escort back to their cabins passengers who had lingered too long in the bar.

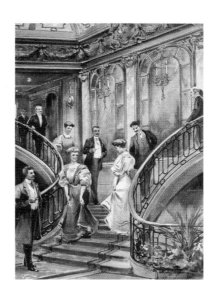

ensuring an even distribution of the sexes and different ages, of those who were good mixers (and universally sought after) and those who were crushing bores (and universally avoided), and of eligible bachelors, starlets, and young heiresses? It either worked or it did not, but that was impossible to predict. Strategically placed in a conspicuous position was the captain's table, where the master of the ship dined with his guests. Each evening on the *France* (1962), thirteen passengers enjoyed the privilege of dining at the captain's table—a fiercely coveted invitation for which some passengers would have moved heaven and earth. But most had to be content with the "captain's dinner" to which all were invited, generally at the end of the voyage. On the French Line, passengers were given keepsakes of ribbons embroidered with the ship's name, which were used on these occasions to tie the illustrated menus or serviettes.

Always noted for their fine cuisine, the French ships prided themselves on gala evenings such as the captain's dinner, producing menus that were the epitome of epicurean extravagance. At a fabulous banquet served during the "Imperial Cruise" of the *France* in April of 1969, after a port of call at Ajaccio, Corsica, the caviar, according to head chef Henri Le Huédé, "was served on dishes of ice carved in the form of imperial eagles, while the foie gras was presented in the form of a cushion decorated with a large cross of the Légion d'honneur, done entirely in a julienne of truffles. The parfaits were served in beehives made of spun sugar, decorated with bees also in sugar."

Clearly it would be impossible to overstate the magnificence of the cuisine aboard ships of the French Line. Indeed it was their chief selling point, as stated with admirable clarity by Jules Charles-Roux, company president, just before the First World War. "It is not the Gobelins tapestries that will attract American passengers on board our ships; rather it is the luxuries of life, immaculate service and good food, complemented by a good wine cellar." To judge by a dinner menu offered on board the *Normandie* in December of 1936 (and bearing in mind that this represented standard fare for passengers in first class), the ship's chefs rose to this challenge in impressive fashion. A tempting choice of hors d'oeuvres was followed by appetizers of five different soups, two fish courses, and calves' sweetbreads; the main course consisted of a regional speciality (on this occasion duck with orange), three different fresh green vegetables, potatoes

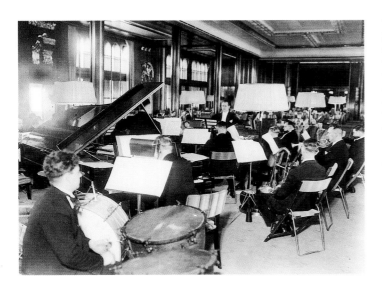

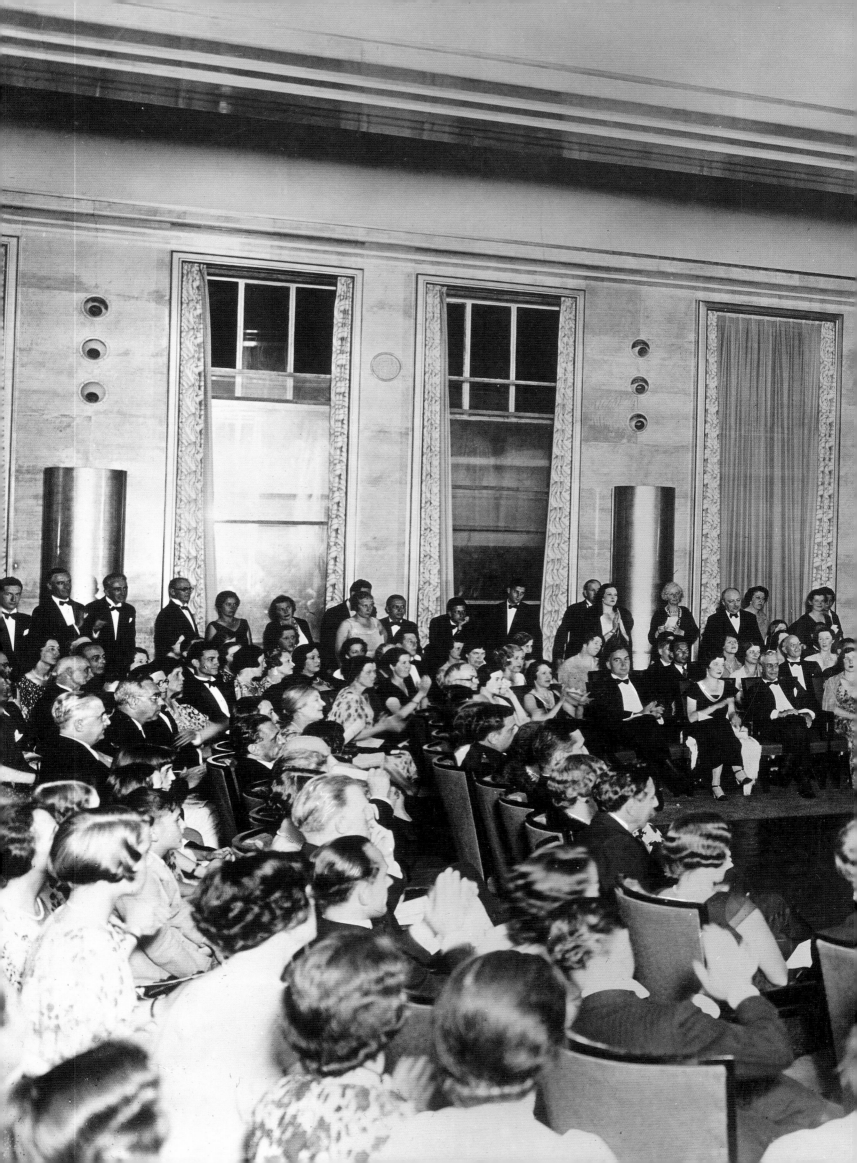

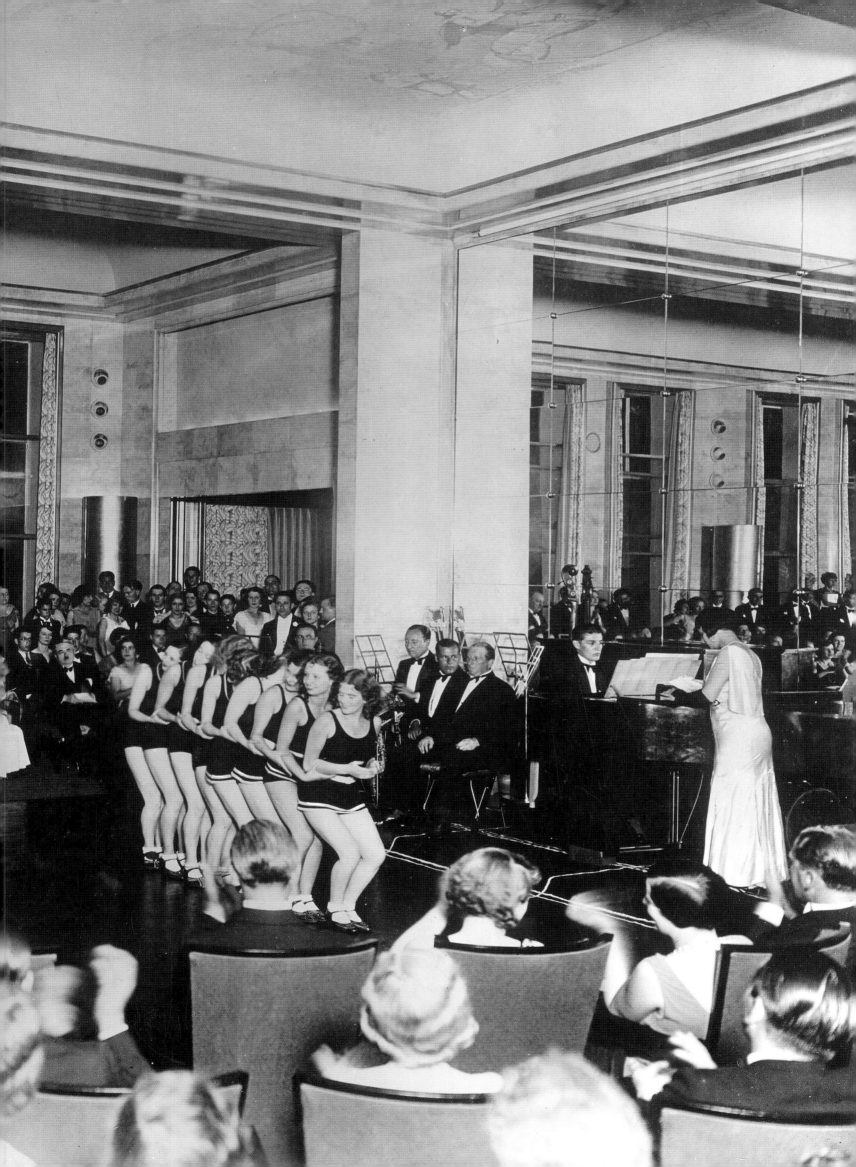

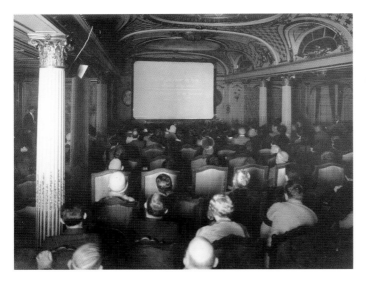

prepared in five different ways (puréed, roast, boiled, in their jackets, or sprinkled with parsley), pasta (with a ten-minute wait for macaroni and cheese), plain or curried rice, and roast chicken or rib of Charolais beef; a sumptuous buffet featuring six different types of ham, jellied beef, chicken, pork tenderloin, saddle of lamb with mint sauce, terrine of foie gras from Strasbourg, lobster mayonnaise, and brill with sauce gribiche; six different sorts of green salad; cheese, pastries, desserts, ice creams and sorbets, and fresh fruit and compotes. This was all accompanied by a wide selection of wine, red, white, and rosé in unlimited quantities, and followed by a variety of teas, coffees, and tisanes. Passengers were free to try every dish if they wished, and to have as many servings as they could eat, washing it all down with as much as they could drink, all meals and wine being included in the price of their ticket. It hardly needs saying that all special dietary needs were catered to as well. In 1933, the French Line introduced a kosher service across the board— for all its ships and all classes of passenger—under the supervision of a rabbi, with a trained staff and dedicated preparation areas and equipment, which included separate kitchens for meat and dairy, and thousands of utensils, sets

of cutlery, and crockery stamped *kosher*. In short, there was no requirement that could not (to varying degrees in the different classes) be accommodated, even to the point of absurdity: no fewer than five different menus were proposed for "Madam's little pooch" and "Sir's faithful friend."

But during the Prohibition era in the United States, from 1919 to 1933, the most persuasive marketing ploy available to the European lines, alongside the excellence of their service and cuisine, was the availability of wines and spirits on board. This was a delicate matter to administer, however. Until ships entered American territorial waters there was no problem, but as soon as they crossed that line even foreign liners came under U.S. jurisdiction, and all forms of alcoholic drink were banned. There thus ensued a frantic rush to round up anything even vaguely alcoholic and to stow it away under lock and key, padlocking, boarding up, and guarding the doors for good measure. None of this was sufficient to withstand the strong-arm tactics of flying squads of U.S. government agents, however, who would pick or smash locks, jimmy off nailed boards, and hack through door panels to get at the forbidden fruit within, before drawing up inventories, confiscating at will, and imposing colossal fines, for—

ABOVE LEFT: A cinema screening in the Louis XIV salon of the *France*, with the screen placed in front of a copy of Hyacinthe Rigaud's famous portrait of the Sun King.
ABOVE RIGHT: Scene from a mime show on board the *Conte Rosso* (1922).
RIGHT: An invitation and program for the inaugural performance of the theater on the *Ile de France*, on July 18, 1949. On the program were a "nautical extravaganza" by Georges Bacqué, aptly entitled *Appareillons!* (Anchors aweigh!), with Jean Piat and Françoise Engel "of the Comédie française" in the principal roles; and a ballet, *L'Ile aux oiseaux*, featuring Serge Lifar.

OPPOSITE: Musical interlude in the lounge of one of the deluxe suites on the *Normandie*, Caen, decorated by Pierre-Paul Montagnac.
OVERLEAF: The ballroom on the *Saturnia*, an Italian liner of the Cosulich Line (1927). While the elaborately fussy baroque decorative scheme of this imposing room still betrays the influence of the Coppedè brothers, the decoration of the vessel's other public rooms was entrusted to British and Austrian designers working in the modern style, and even to avant-garde artists such as Gustavo Pulitzer Finali— his debut as a nautical designer.

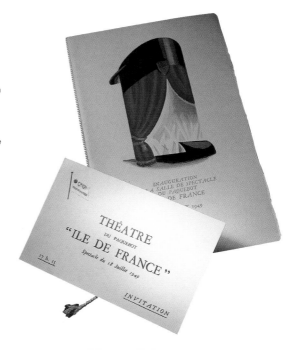

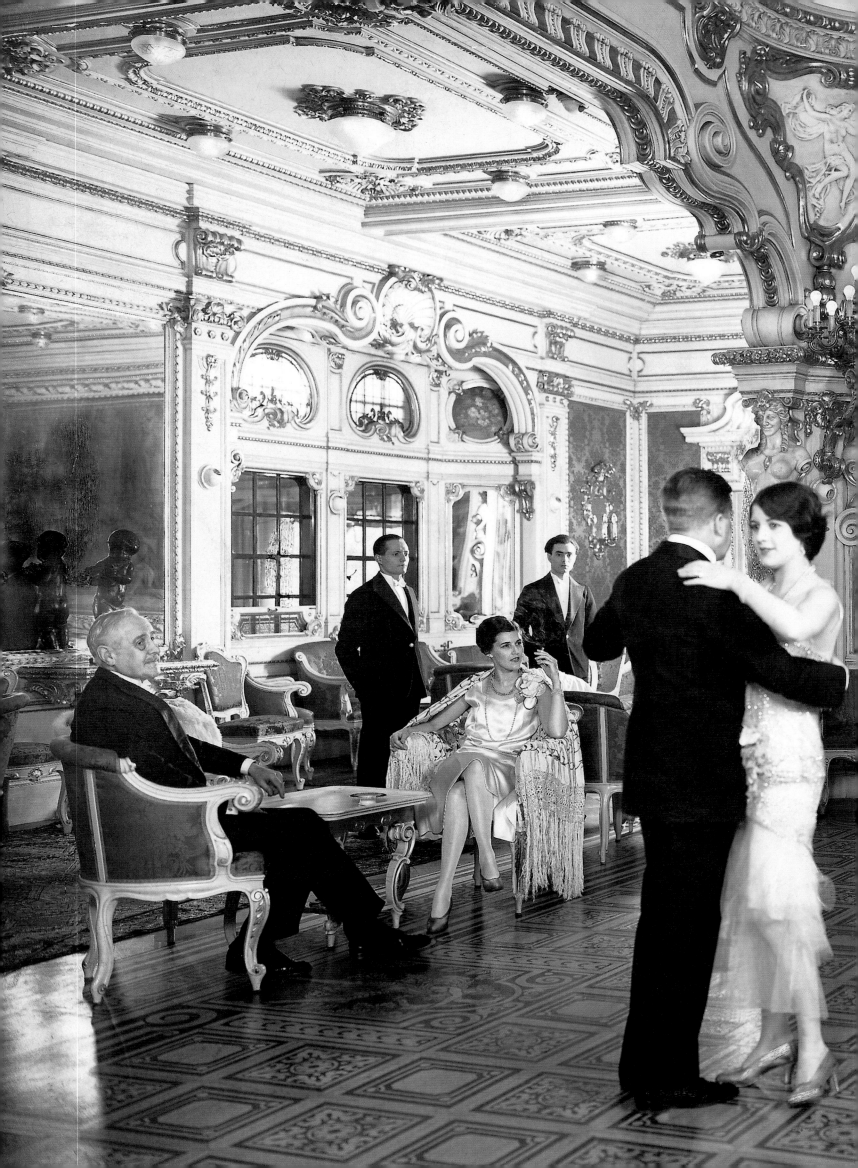

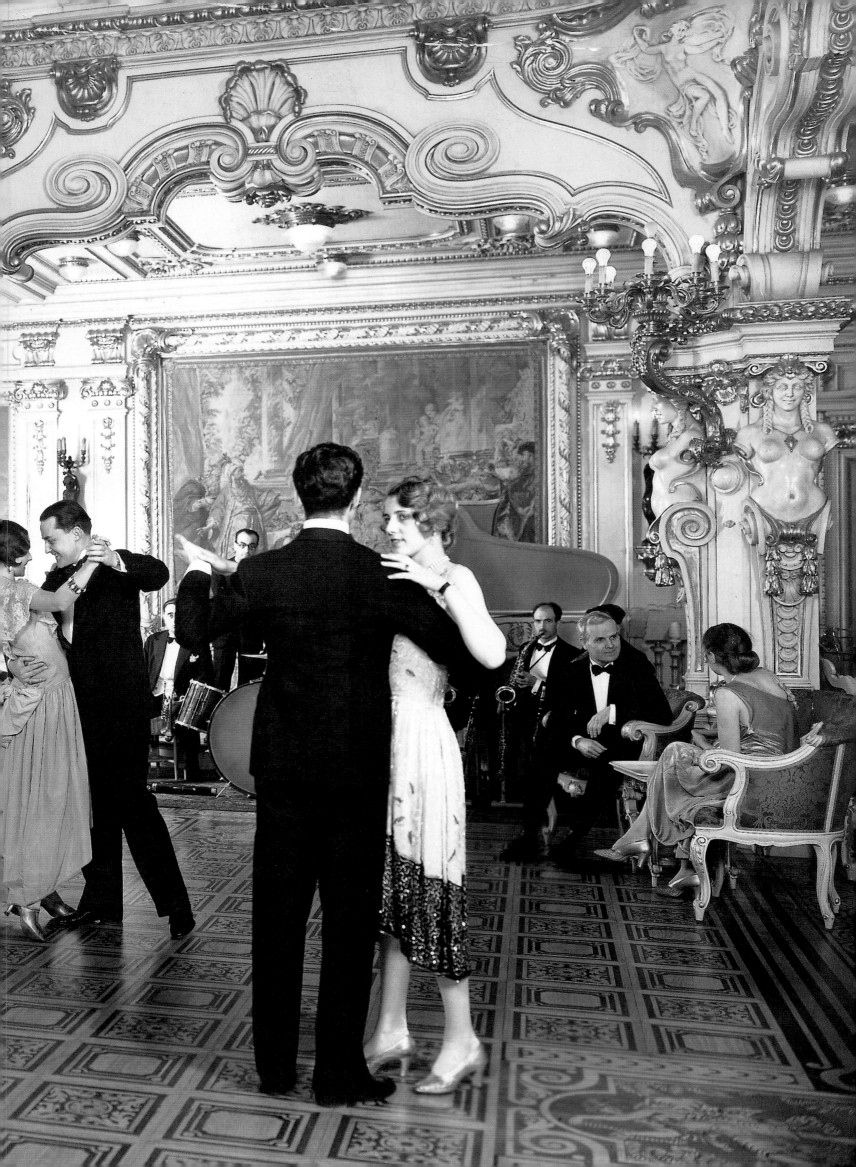

164

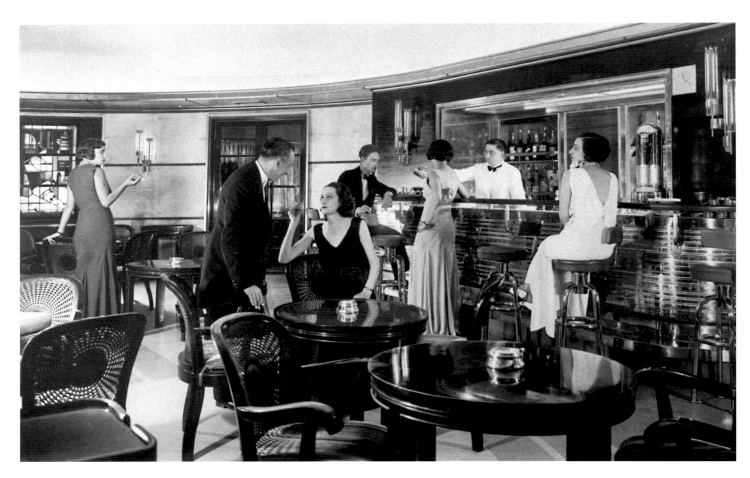

Evenings on board tended to finish, naturally, with a nightcap at the bar, a last glass of champagne or a cocktail before going back to one's cabin.
ABOVE: The elegantly restrained décor of the bar on the *Victoria*, the "white arrow of the Mediterranean," of the Italian SAN line, 1932.
TOP LEFT: An evening gown and fur stole on a HAPAG steamer in the 1930s.
TOP RIGHT: The Riviera first-class smoking room on the *France* of 1962; designed by André Arbus on two levels, it opened onto an outside terrace from the upper level and on to the covered promenade deck from the lower one.

OPPOSITE: Drawing by Ternat of the tourist-class smoking room on the *Normandie*, with the bar in the foreground. The silver champagne bucket, made by Christofle to a design by Luc Lanel, bears the CGT monogram, and is taken from a photograph of a table laid for dinner on the *Normandie*.
OVERLEAF: A fancy-dress ball on board the *Lafayette*, with (inset) the menu for a fancy-dress dinner on board the P&O liner *Strathaird*, July 29, 1932.

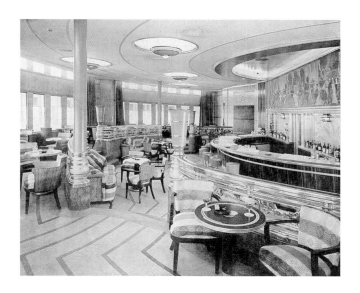

The *Queen Mary*, dubbed by the *Times* "an Art Deco masterpiece," made her maiden voyage to New York on May 27, 1936. On May 30, the French magazine *L'Illustration* reported on the launch and produced images of her interiors, including this photograph (right) of the first-class observation lounge, with its cocktail bar by the London designers Waring & Gillow. The semi-circular raised part of the lounge follows the curve of the deck, onto which open large plate-glass windows. The extremities of the balustrade that divides the bar from the lounge are marked by four uplights, and the eye is drawn naturally to the macassar ebony paneling of the bar, which gleams softly under the indirect lighting. Above the bar is an upbeat fresco by A. R. Thomson depicting the celebrations for the Silver Jubilee of George V in 1935. The columns, chairs, and bar stools punctuated this magnificent space with touches of red.

inevitably, and despite the thorough checks carried out at Southampton and Le Havre—they always managed to find some smuggled bottles squirrelled away in lifeboats, down hidden passageways, or elsewhere. But in defiance of all this, and even on theoretically "dry" American liners, passengers continued to drink unperturbed, with a bottle of mineral water on the table and a bottle of Bordeaux beneath it. And on the great liners, wine (and spirits) did indeed flow like water. Drinking was part of the culture, from the Blue Riband cocktail (made with blue curaçao, naturally) that traditionally toasted a new speed record to the drinks that invariably accompanied dances and all the other festivities that punctuated the voyage.

On liners that plied the South Atlantic, the Pacific, and the waters of the Far East, it was customarily the passengers themselves who organized the entertainments on board, including amateur dramatics and musical recitals. If there happened to be no professionals on board, the quality of these performances could be decidedly patchy. Fortunately there often were: French boats to Indochina, for example, often included on their passenger lists opera companies on their way to perform in Saigon or Hanoi. But whatever the

circumstances, passengers always seemed willing to learn their lines, and to perform in plays, or to try their hand at an instrument. Everyone, actors and audience alike, found it hugely entertaining, and these distractions culminated in the most important event of all: the gala entertainment in aid of seafaring charities. On board the *Sphinx*, Father Bulteau duly noted his observations on all the festivities that formed part of this entertainment that went on for two entire nights, from a tennis tournament to tombola, via a dinner concert and a fancy-dress ball. All this took place in first class, although it was generally the custom to invite passengers form second and third class to the ball, if only as spectators. Some, however, according to Father Bulteau, were not content merely to watch, as became evident from the injuries of two second-class passengers the following day. "One sported a seriously blackened eye, another the evidence of a well-aimed slap in the face." On the Atlantic superliners the festivities followed similar lines, with pride of place invariably going to the sacrosanct charity ball, but, as fitted their stature, these were the height of elegance and ingenuity. On the *Normandie*, for instance, a program illustrated by Bérard announced a parade of haute-couture fashion, and a

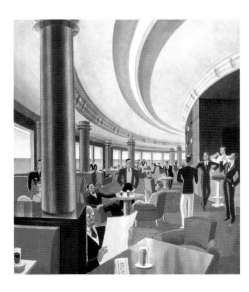

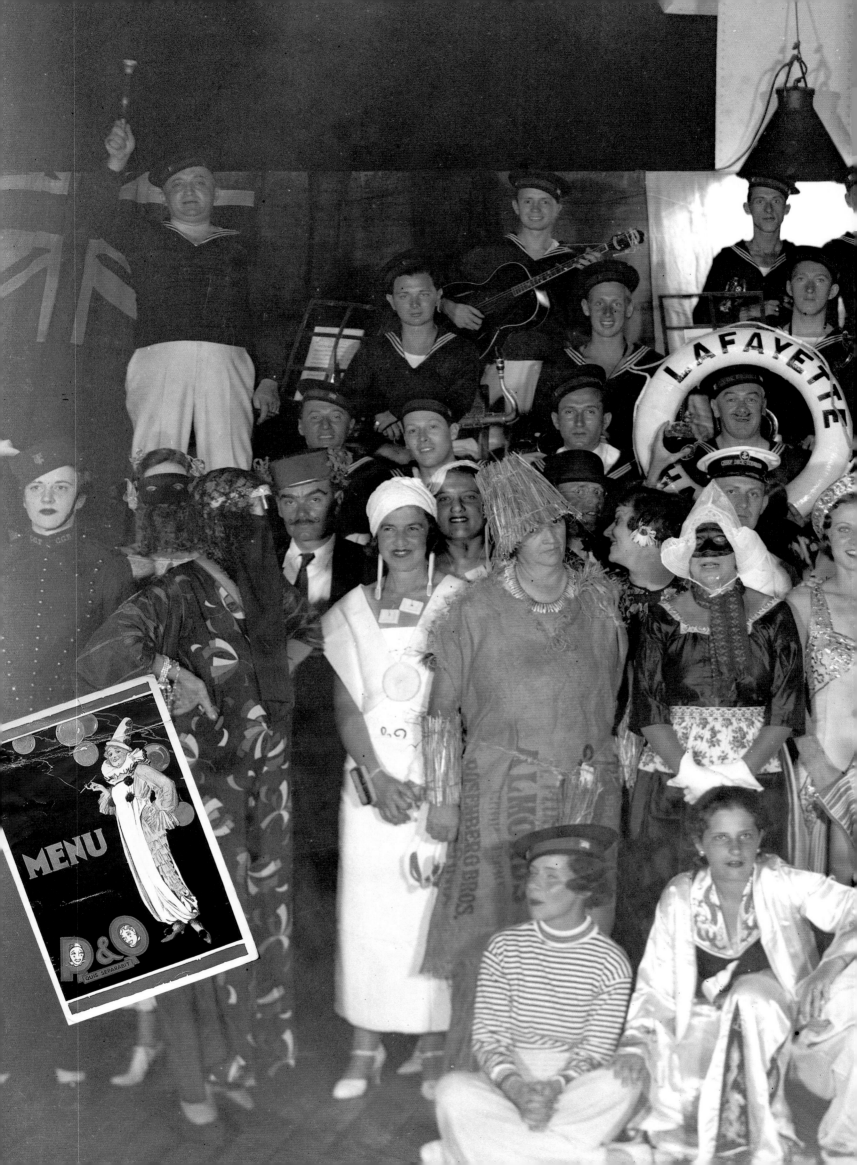

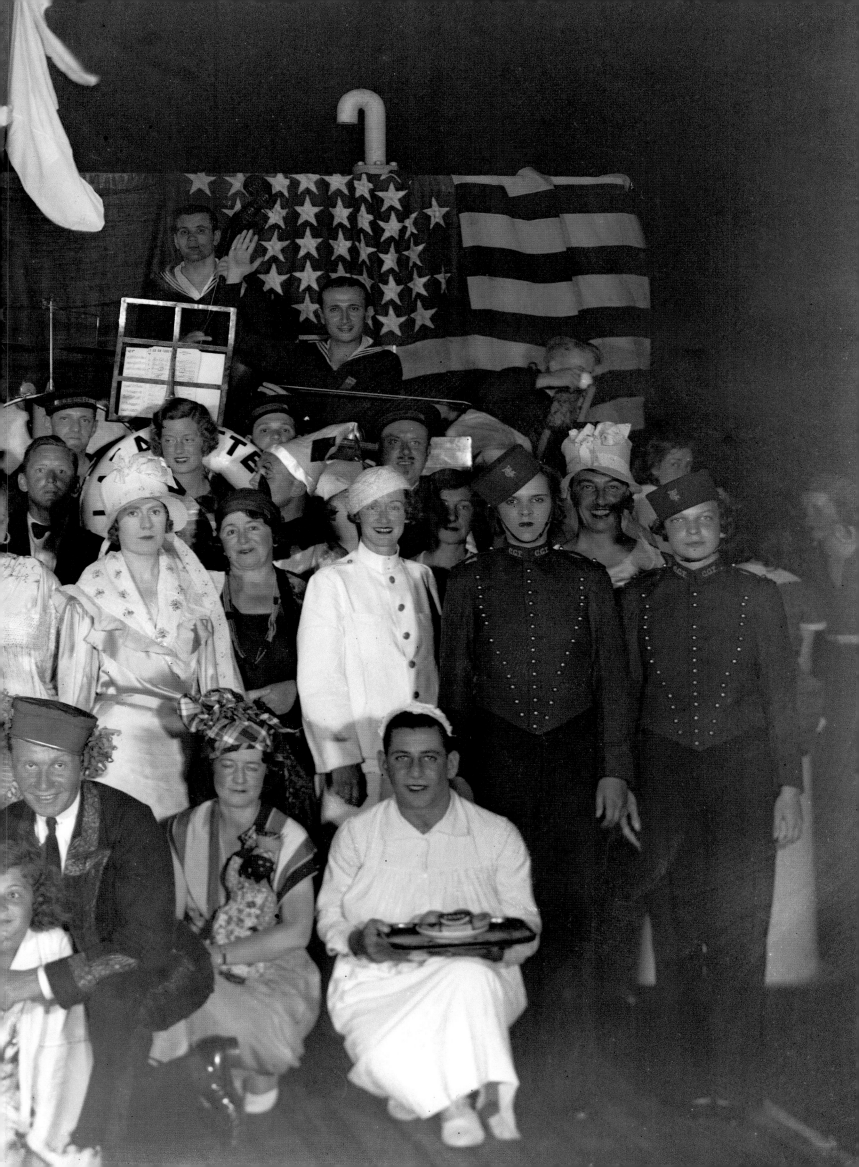

Paquebot "ILE DE FRANCE". — Salon de Correspondance des 2ᵉ classes. — 2 nd Class Writing Room.

troupe of performing seals took over the dance floor. And of course the tombolas and auctions were on a different scale altogether, with Napoleon's hat going under the hammer on the *France*, for instance, for the sum of one hundred forty thousand francs. But whatever the fleet and whatever the ship, all these events shared the same atmosphere of good-natured, unpretentious, and eminently well-intentioned fun. Once on the *Normandie*, Henry Fonda agreed off the cuff to referee a boxing match between two cabin boys; the famous music hall singer Mistinguett, though by no means young anymore, agreed to sing her famous song "Mon homme"; and the world-renowned Hungarian violinist Jascha Heifetz gave an evening concert purely for the pleasure of Chief Purser Villar, who in order to avoid any inopportune vibrations asked the captain to reduce the vessel's speed.

So between balls and concerts, plays and sporting tournaments, the voyage passed quickly, and soon the ship would be reaching its destination. Once more there was frantic activity in the passageways, with uniformed cabin boys dashing in all directions, and chambermaids packing trunks and boxes. On board the *Armand Béhic*, about to berth at Colombo where he would transfer to another vessel, Joseph Tremble hurriedly finished his letter to his parents. "This letter will leave in four or five days, so it should be with you by the 10th, or at the latest the 15th, of next month. It seems an awfully long time, all the same." After the introduction of wireless telegraphy, news traveled faster, but it was not the same thing. A letter written at sea, on creamy laid paper embossed with the coat of arms of an ocean liner, made an incomparable souvenir for the recipient. The *Ile de France* even boasted its own light aircraft, ready to take off when the ship was eight hundred kilometers from land, so that the mail could begin its journey that same evening. On board, their correspondence written and dispatched, passengers gradually fell to wondering what lay in store for them on this new continent. On that last day of the voyage, mail and dreams flew on ahead, while the great ship plowed on, far behind them.

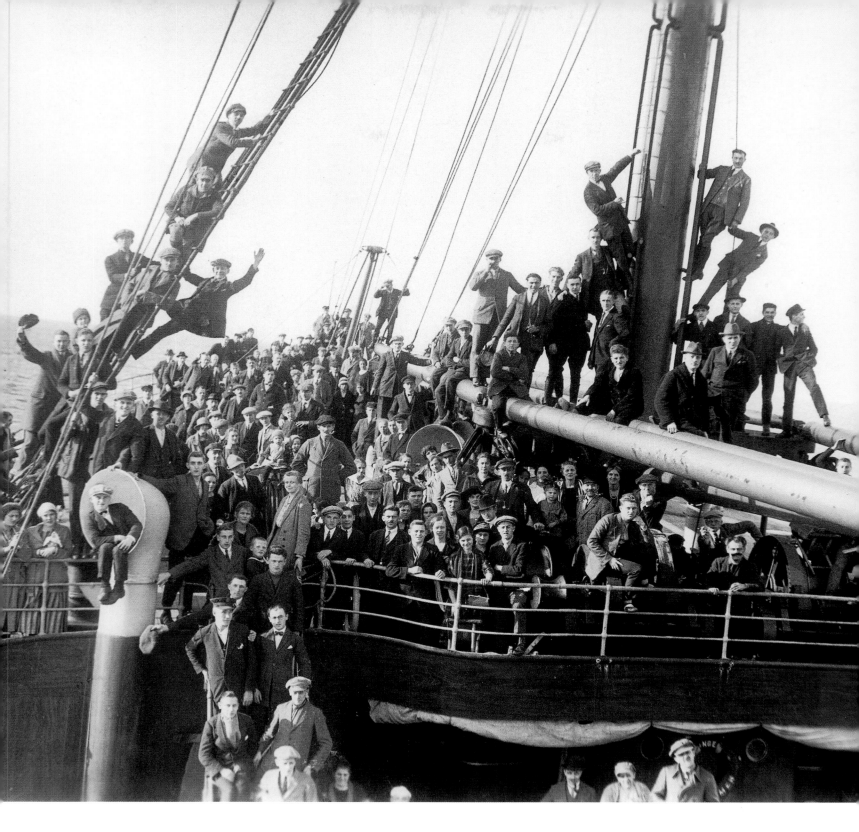

"*The voyage is over; we sleep, we wake, and, as though we are emerging from a dream, it is everyday life that awaits us.*"

Roland Dorgelès, *Partir...*

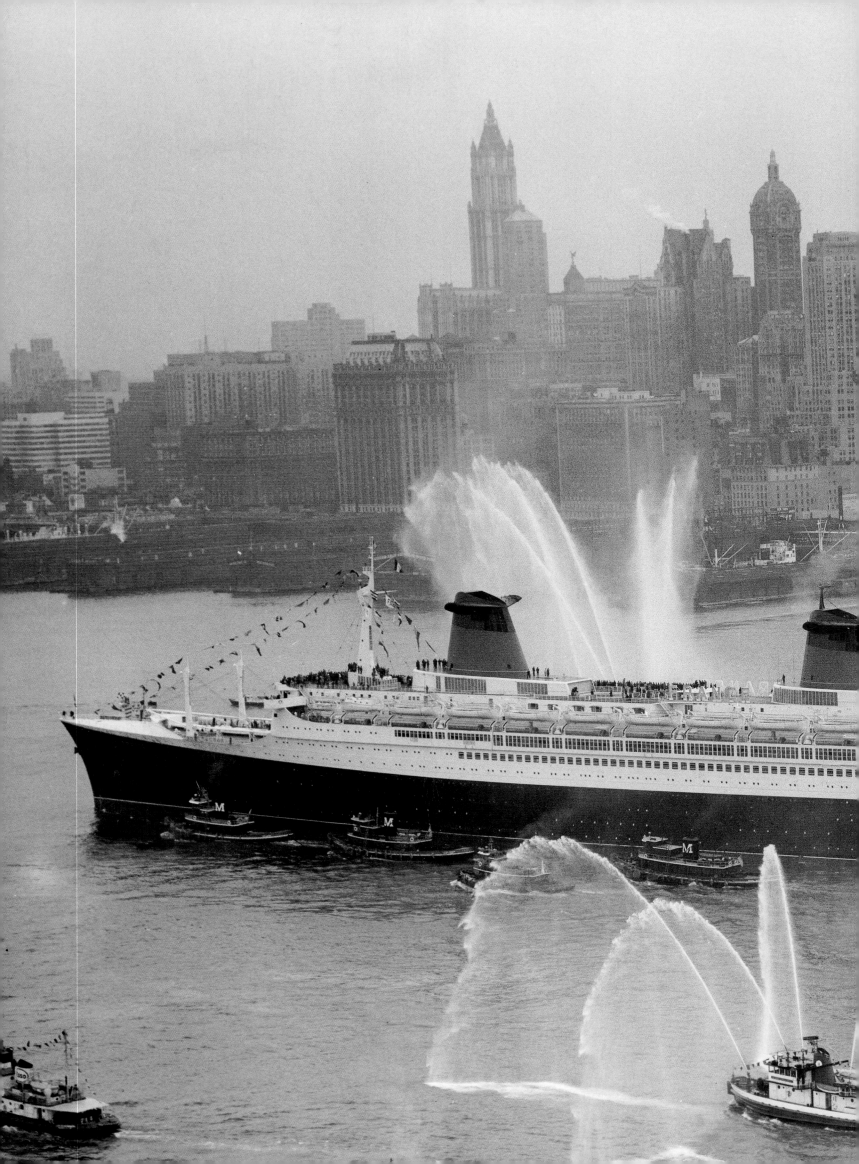

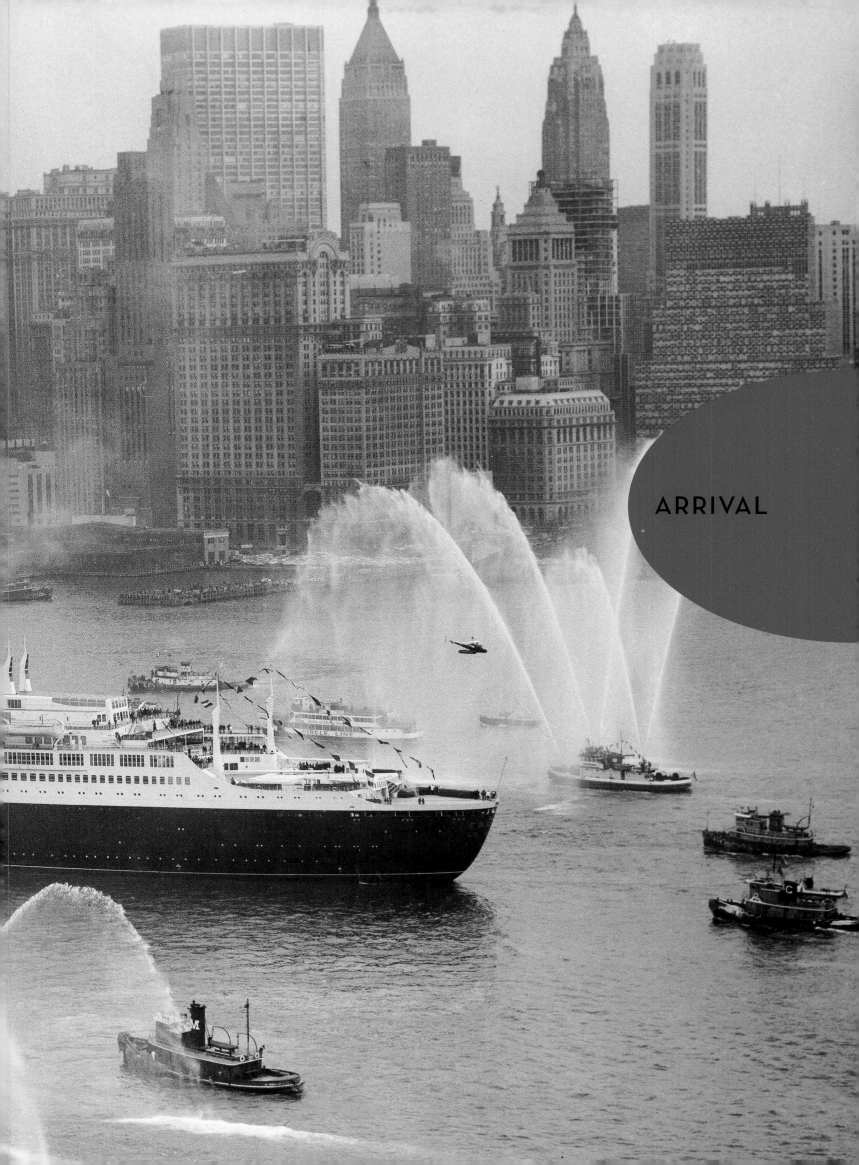

ARRIVAL

"*Then there came a morning when I saw far away a city rising from the waters like a mirage, and hope set my heart pounding.*"

Julien Green, *Mille chemins ouverts* **(The War at Sixteen)**

A FEW HOURS BEFORE a ship arrived in port, the order would be given to open up the engines and steam ahead at full throttle. The sooner she could dock, the better, for a whole variety of reasons. Vessels returning to France from the South Atlantic route raced to catch the high tide necessary to navigate the Gironde estuary, since if they failed to catch it they would have to wait twelve hours until the next one. For liners approaching New York, it was a race against the clock for different reasons. Following the American clampdown on immigration in the 1920s, competition among the shipping companies had grown even more cutthroat. It was imperative to arrive before the monthly quotas imposed by the U.S. government were filled. To stand the best chance of being allowed in, you really needed to disembark at one minute past midnight on the first day of the month. Five minutes later, and a superliner might have put its huge numbers of emigrants ashore, thus scooping up the entire month's quota in one fell swoop. When this happened, the unfortunate vessel bringing up the rear had no choice but to return to her port of departure, taking with her all the would-be immigrants on board, who would merely have snatched a tanta-

lizing glimpse of the promised land, without even setting foot on its soil. Meanwhile, stiff competition continued for the transatlantic speed record and the coveted Blue Riband. Bets continued to be placed until July 3, 1952, when the American liner the *United States* set a new—and still unbeaten—record for the eastbound journey (New York–Le Havre–Southampton) of three days, ten hours, and forty minutes. In accomplishing this, the line delivered a terrible blow to the pride of the previous holder, the *Queen Mary*. Only too well aware of this, the captain of the *United States* rubbed salt in the wound by maintaining (quite truthfully) that his vessel had scooped the Blue Riband without even going above her cruising speed. Rankled by this shocking example of brazen one-upmanship, British journalists retaliated by dubbing him the Yankee Braggart.

On June 2, seventeen years earlier, the *Normandie* was a day away from New York on her maiden voyage, sailing at full speed and virtually certain to win the Blue Riband. In confident anticipation, her passengers were dressed in blue, the ship was festooned with blue decorations, and work had begun on making the long blue flag that would soon be fluttering from the mast: thirty-three yards of it, or about three feet

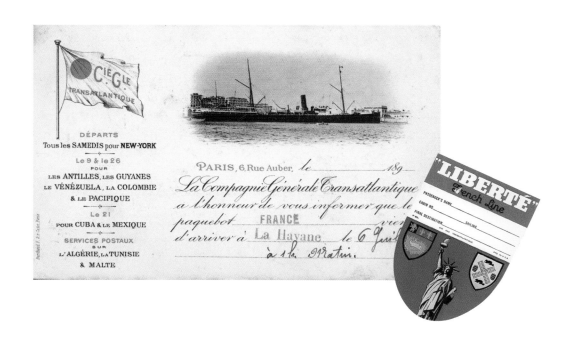

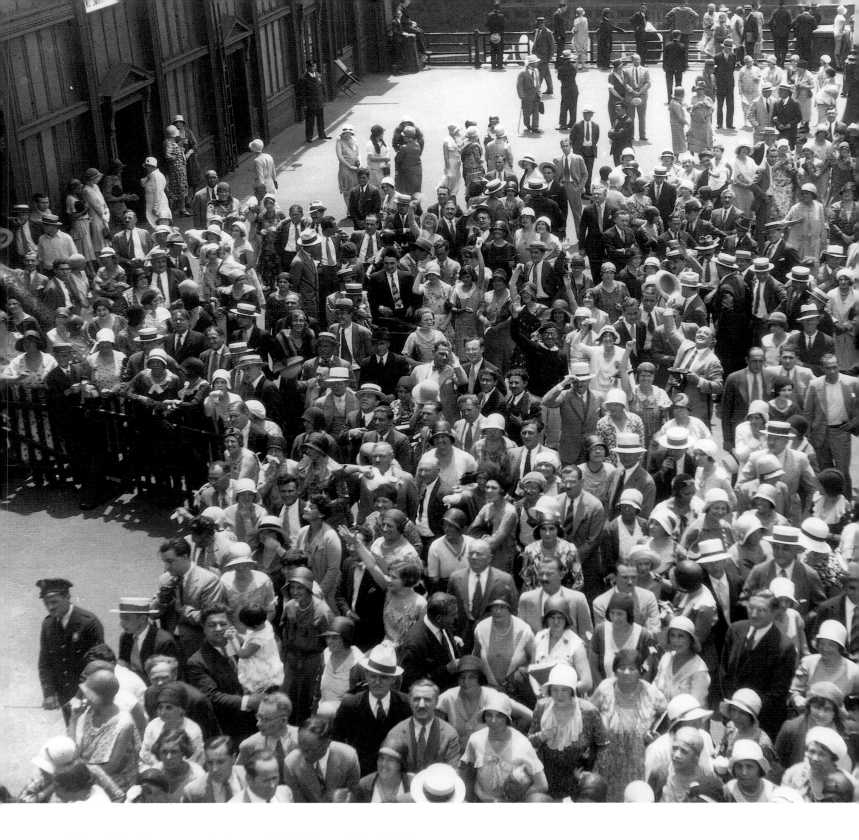

"You walk down the gangway and set foot on American soil, which turns out to be the concrete floor of the immense French Line hangar, amid heaps of cabin trunks, cases, and bags opened up for the inspection of customs officials. The grimy brick apartment blocks of New York, draped with washing hung out to dry from their windows, are silhouetted against the cloudless New York sky. It is at this point that you remember, as you are overwhelmed by the humid heat that is no longer tempered by the sea breeze, that New York lies at the same latitude as Naples." Michel Mohrt's description of his arrival in New York in 1949 would surely strike a note of recognition with all those who, after days at sea, disembarked in an unknown land.

ABOVE: Relatives and friends in their Sunday best throng New York's famous Pier 57 in the summer of 1930, waiting to meet French Line passengers from Le Havre.
OPPOSITE: The steamer *France* arriving in Havana, c. 1912–15.
INSET: Luggage label from the *Liberté*, c. 1955.
PRECEDING PAGES: The triumphant arrival of the *France* in New York in 1962.

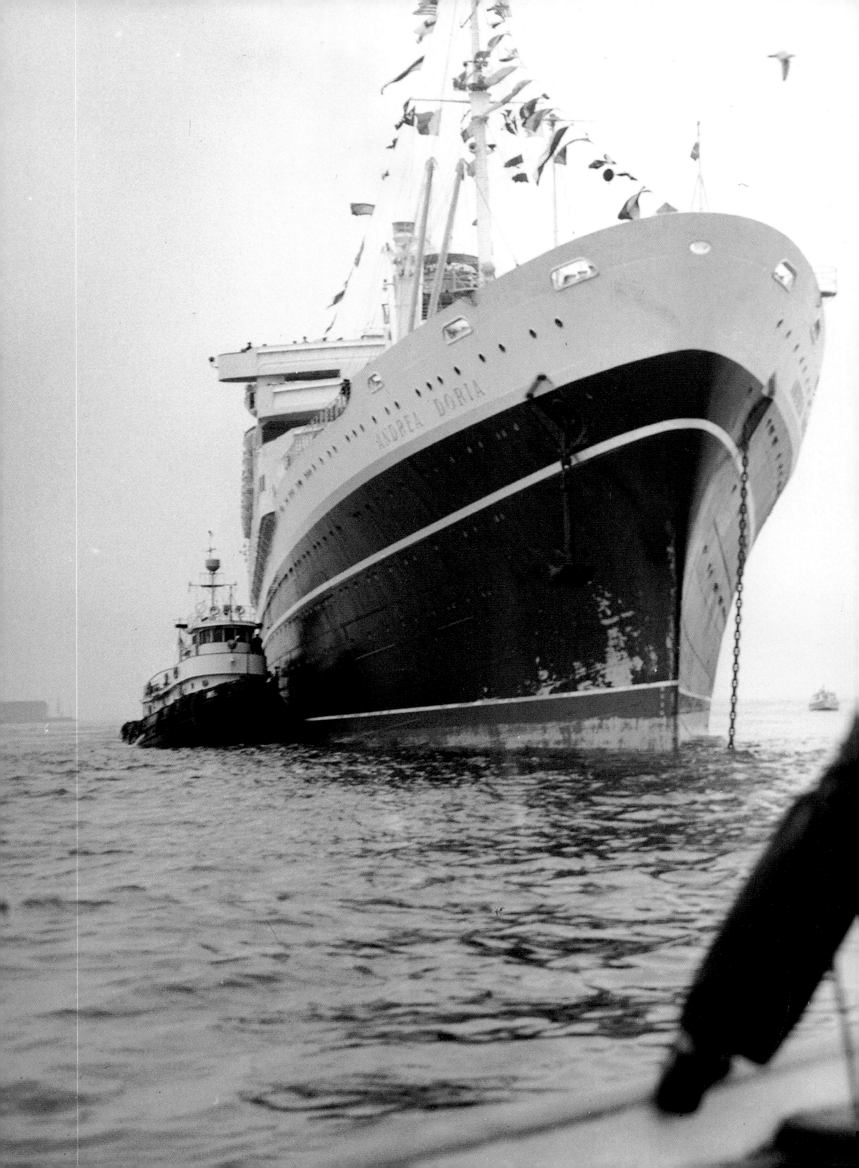

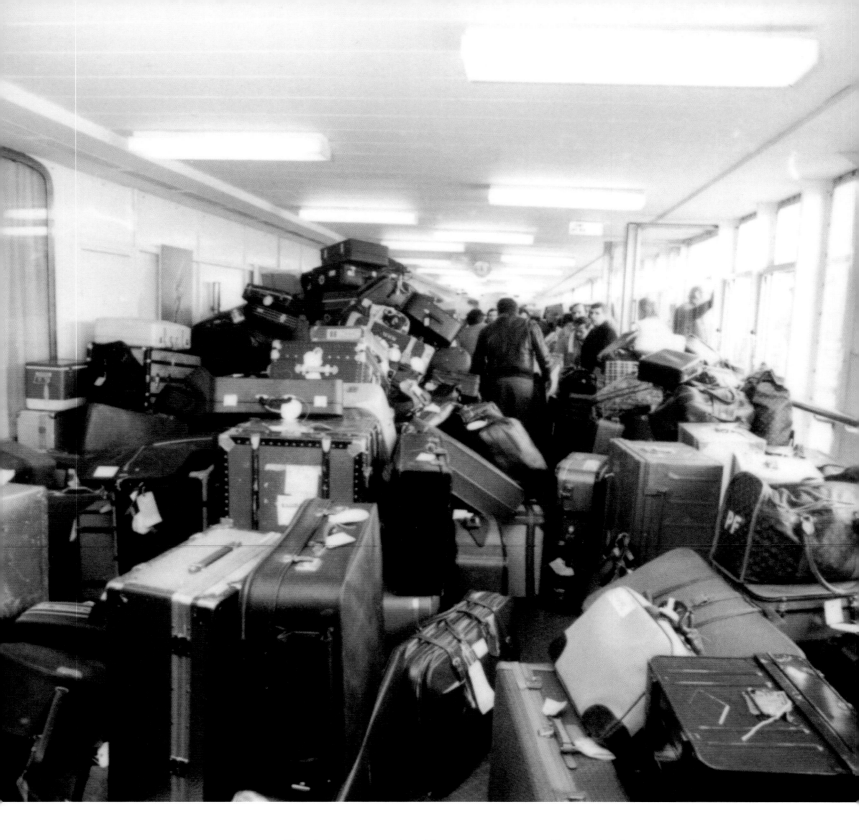

The arrival announcement invariably plunged passenger liners into a turmoil of excitement, starting several hours before the vessel moored. While on board passengers made frantic preparations for going ashore. On land, preparations were now being finalized for their disembarkation arrangements, for customs formalities and public-health inspections, for unloading the luggage and emptying the holds and refrigerated compartments, and for carrying out any necessary repairs and maintenance to the ship's fabric, with all the necessary technical staff at hand.

PREVIOUS PAGES: The second *Andrea Doria* arriving in New York on January 23, 1953. This was the first Italian liner to moor on American soil since the triumph of the great *Rex*, winner of the Blue Riband twenty years earlier, and the mayor of New York, Vincente Impelliteri—himself the son of Italian immigrants—gave it a warm welcome accompanied by a prestigious reception.
OPPOSITE: Souvenir insignia of the SS *Nevasa*, a P&O liner launched in 1956, the company's centenary year.
OVERLEAF: A puzzling photograph from the early twentieth century: this family of German emigrants, just arrived from Bremerhaven on the *Prinz Sigismund* and photographed here on the quayside at Brisbane in Australia, look improbably fresh and full of vim and vigor after nearly two months at sea. Their groomed appearance and broad smiles, together with the impromptu appearance (on the left) of a crew member brandishing a letter card, suggest that this is all rather posed. Could it be that the immigration services of the brand-new Australian state "encouraged" this family to pose for the camera, in the hope of attracting the immigrants it needed for the development of this vast continent?

Before the 1930s, the great ocean liners could not moor at quayside berths. Too large to enter shallow harbor waters, the early leviathans of the sea had to drop anchor outside the bar, while tenders ferried passengers to land.

RIGHT: On October 13, 1964, Richard Burton and Elizabeth Taylor arrived at Cherbourg aboard the *Queen Mary*. Because she was late and needed to make a rapid departure, the vessel exceptionally did not enter the harbor that day. Here her passengers are seen boarding the tender *Nomadic* to take them to shore.

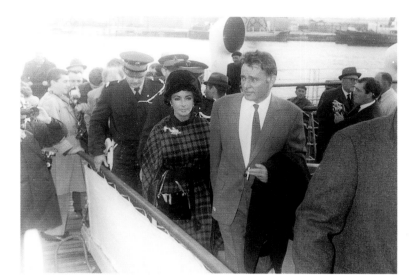

for every knot of the vessel's average speed during the crossing. That evening was one of wild celebration, in eager anticipation of the great liner's triumphant arrival the following day.

For the crew the moment of docking could not come too soon either: for the army of cabin boys, stewards, chambermaids, and other crew, each voyage was an exhausting affair. And the last evening, when everyone was on edge, or had drunk rather too much in order to steady their nerves, was the worst of all. By this time in the voyage the infirmary reserved for them was constantly full of members of crew suffering from "nervous exhaustion." The same conditions applied on the *Queen Mary* as on all the other superliners: a gruelling eighteen-hour work day, and a pampered, demanding clientele who were impossible to please. Mr. Bruschi, cruise manager of the *France* summed it up by saying, "on board ship . . . everything that is perfect, unique or exceptional is taken for granted as normal by the great majority of passengers . . . If their breakfast were wafted to them by a miniature helicopter they would probably not be particularly impressed. . . . The slightest imperfection, by contrast, is taken as a personal insult, an intolerable omission." Yet every year on the *Normandie* the crew received a total of fifteen million

francs in tips—the equivalent of the annual budget of a small French département. A good deck steward on the *Queen Mary* could earn as much as three hundred pounds per crossing in tips: a powerful inducement to endure whatever came their way with the most exquisite courtesy.

At dawn on June 3, 1935, the *Normandie* sailed into view off the coast of America. At three minutes past eleven she passed the Ambrose lighthouse, which marked not only the entrance to New York harbor but also the finishing line of the Blue Riband race. Calculations were made and the new victor was announced. An airplane flew over the liner trailing a banner bearing the inscription "New York welcomes *Normandie*." The skyscrapers of Manhattan came into view, and the great ship edged forward. A "quarantine" stop to take on board contingents of police, customs agents, public health officials, and the pilot, and then on to that most magical arrival of all: Staten Island to port, Brooklyn to starboard, and the Statue of Liberty and Ellis Island. Here the immigrants would disembark, to face either a long period of quarantine or enforced repatriation. Then it was up the Hudson River to the harbor railway station. On that June day, the *Normandie* glided majestically past

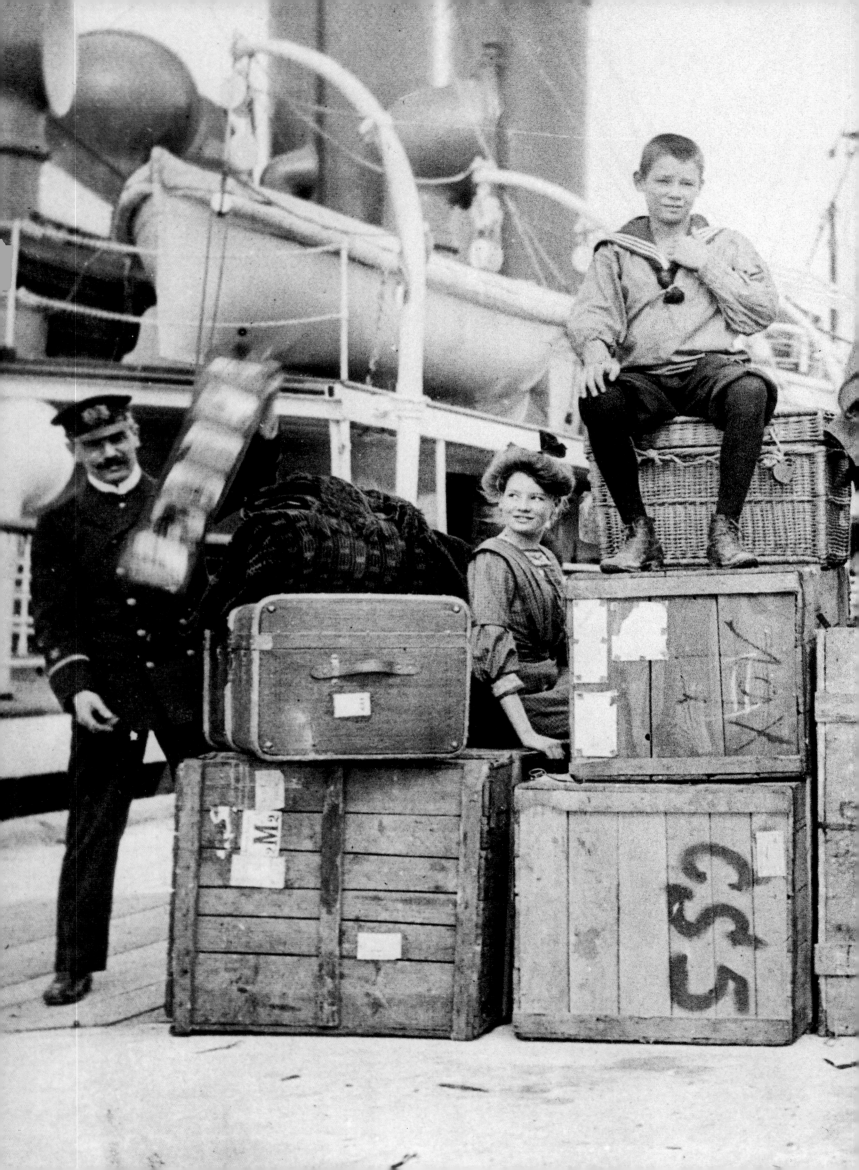

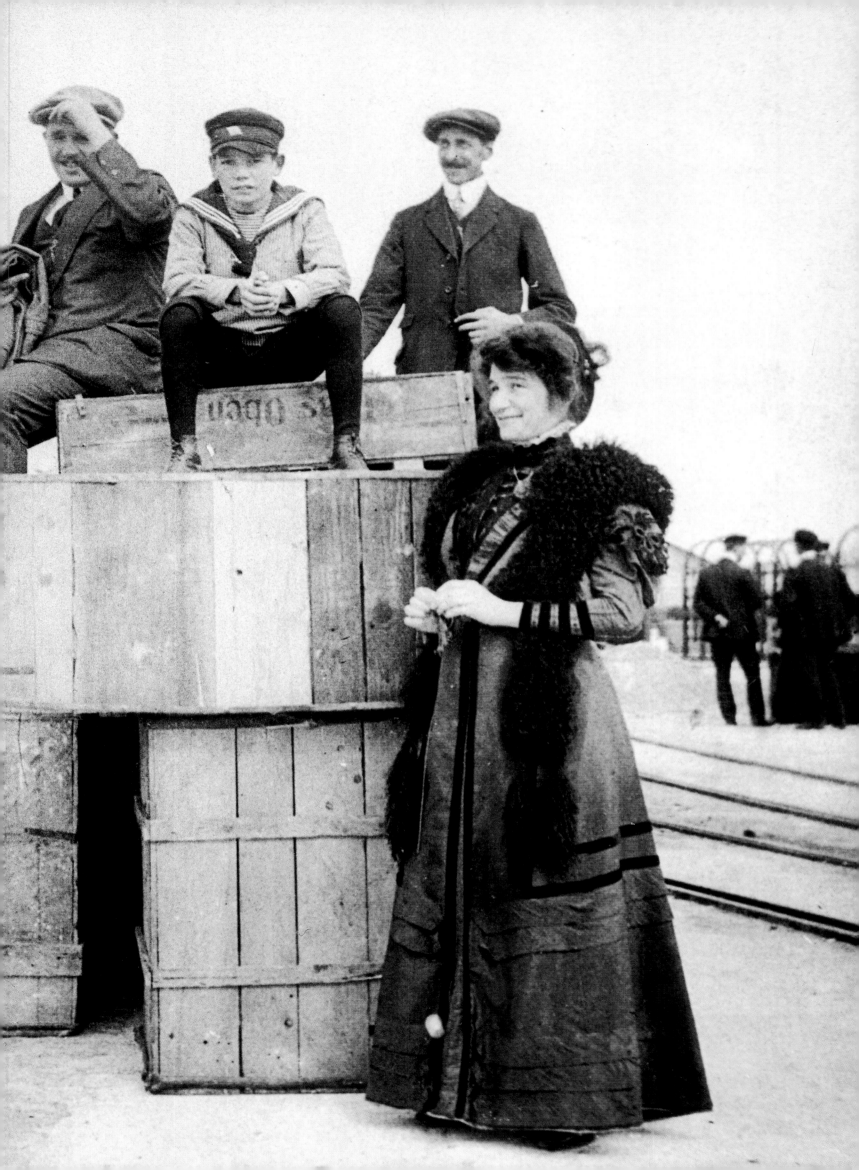

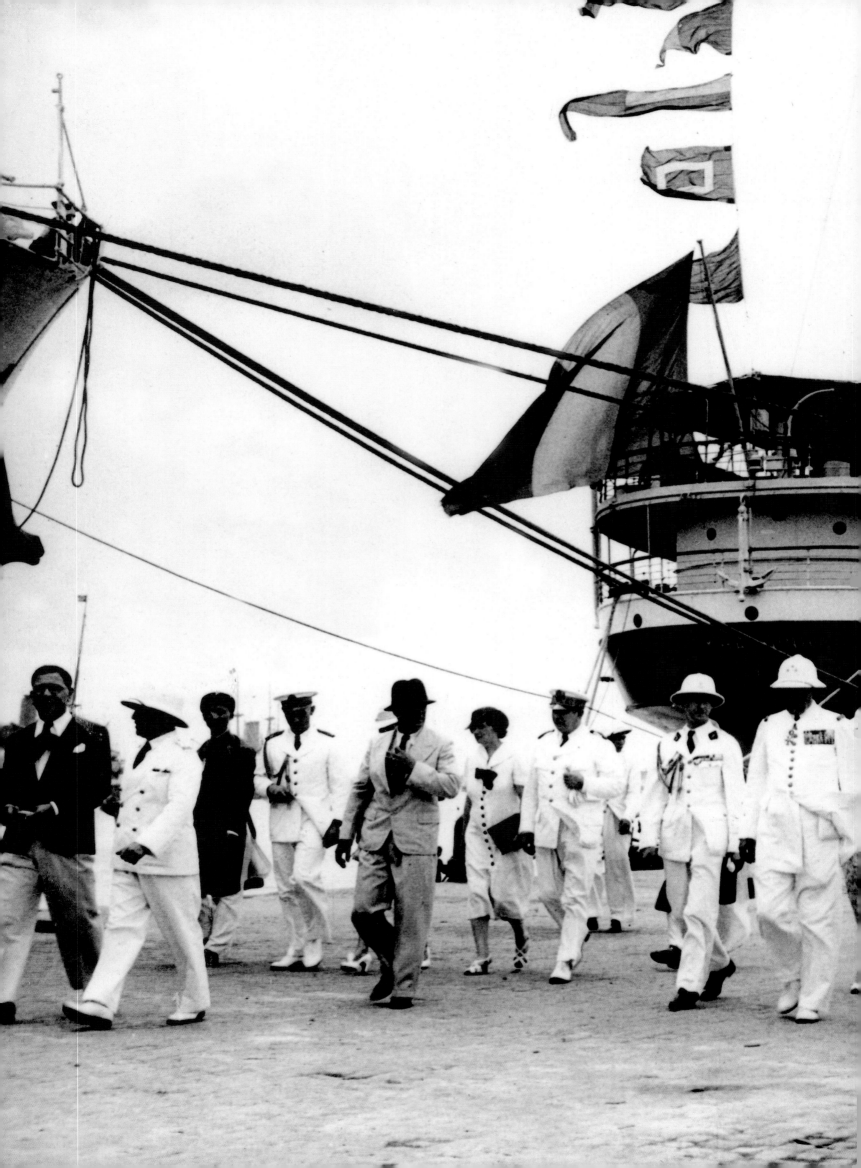

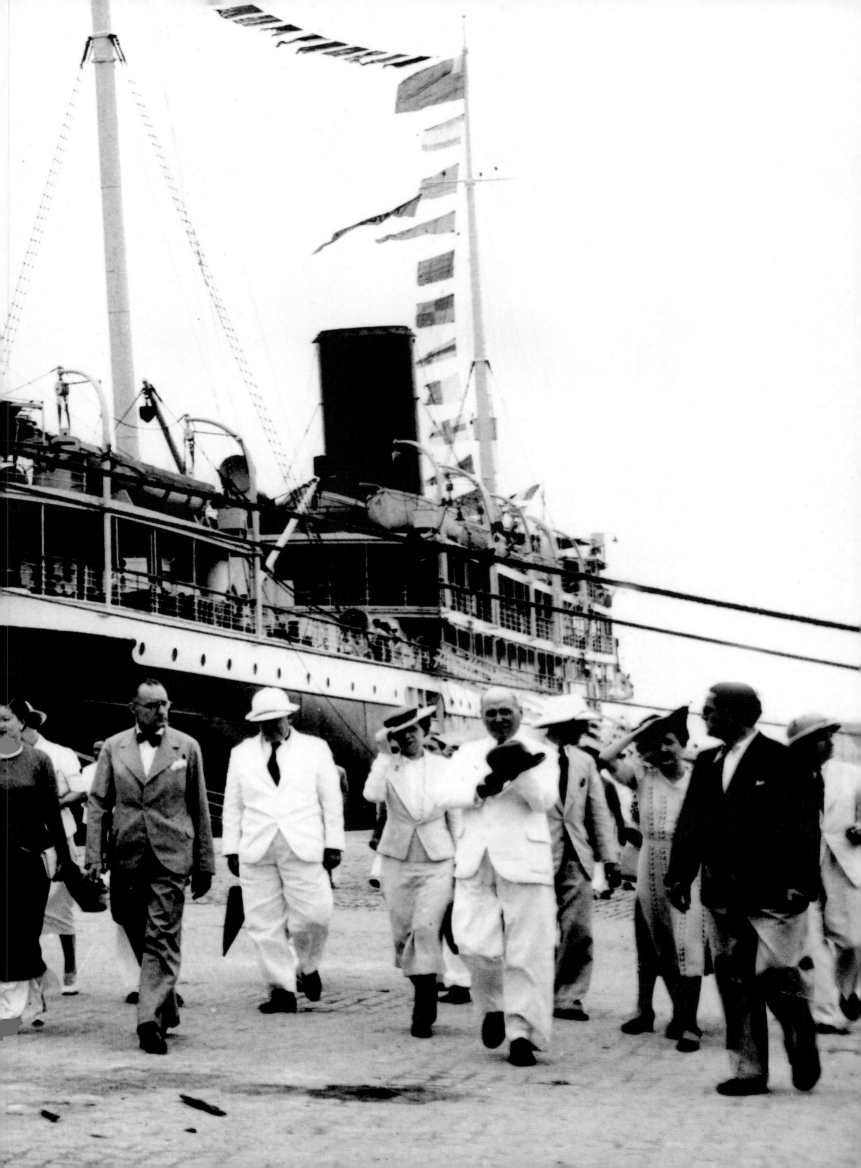

LEFT: The American liner the *United States*, from New York, moored at Cherbourg in April of 1961—an unaccustomed port of call necessitated by strikes that had paralyzed Le Havre.
PRECEDING PAGES: Arrival of an official delegation in French Indochina in 1940–41. The liner on which these VIPs arrived was the *Khai Din*, formerly the *Lamartine* of the Messageries Maritimes fleet.

under a snowstorm of tricolor tickertape cascading down from the tops of the skyscrapers, and the fireboats gave their traditional salute, playing hundreds of graceful arcs of water from their hoses. After her maiden voyage in 1912, the *France* had added to the romance of her entry into New York by arriving when the city was blanketed in snow.

The arrival of one of these great passenger liners was always an occasion for drama and ceremony. In Ceylon, a wreath of palm fronds would be cast into the sea. In Saigon, the bushes on the river banks flanking the ship's arrival were lined with flowering shrubs and the plumes of areca palms, with the steeples of French colonial churches rising above them. And Hong Kong harbor was a glorious and bustling kaleidoscope of junks and a flotilla of boats of every nationality among its picturesque rocky outcrops.

Landfall was at hand, but there were yet more delays before passengers could disembark. Public-health officials had to visit the ship and pronounce their verdict. Often the passengers had to wait for a tender to take them to shore, since many harbors were not equipped to dock such huge liners. Then, as on the ship's departure, the cabin boys and stewards lined up at the entrance to the gangway, and it was time to disembark: first class in the lead, followed by second and third, all amid a stampede of porters and luggage, and to the accompaniment of cries of greeting from friends waiting on the quayside. And so it was back to the daily routine. Josephine Baker, who in October of 1935 had boarded the *Normandie* as a star, arrived in New York to general indifference. Mrs. Carter never joined her husband in Indonesia; she left him for a ship's officer at Penang. Herbert Carter vowed never again to travel by P&O. Joseph Tremble arrived in Japan in October 1901: "We have arrived at last!" but not for long. He celebrated the following new year in Hong Kong, with a group of British officers in their scarlet mess jackets. Edmond Garnier, who sailed from Bordeaux on January 15, 1909, arrived on February 6 in Buenos Aires, where he complained of being charged an excessive amount in customs duties. Father Joseph Bulteau, meanwhile, who embarked on the *Sphinx* in September of 1927, disembarked at Kobe, the port of Honshu, on November 8 with his "eleven trunks, boxes, cases, and parcels," his bicycle, and his case of wine. But to reach his mission in Korea he needed to catch a train and another boat. The journey was not yet over . . .

"On the station platform at Le Havre, where the train stood that was to take passengers to the Gare Saint-Lazare, I can still see an aged professor from the Sorbonne arguing with customs officials who wanted to confiscate the numerous radios and other gadgets he had brought back in his luggage" (Michel Mohrt).
RIGHT: Just disembarked from the second *Queen Elizabeth* in July of 1973, Burt Lancaster indicates to a porter the railway compartment he is to share with Liv Ullmann for the journey to Paris.
OPPOSITE: Against a backdrop of the *Queen Mary*, moored at Cherbourg in 1973, Charlton Heston gives a smile for the camera of French regional press photographer Jean-Marie Lezec.

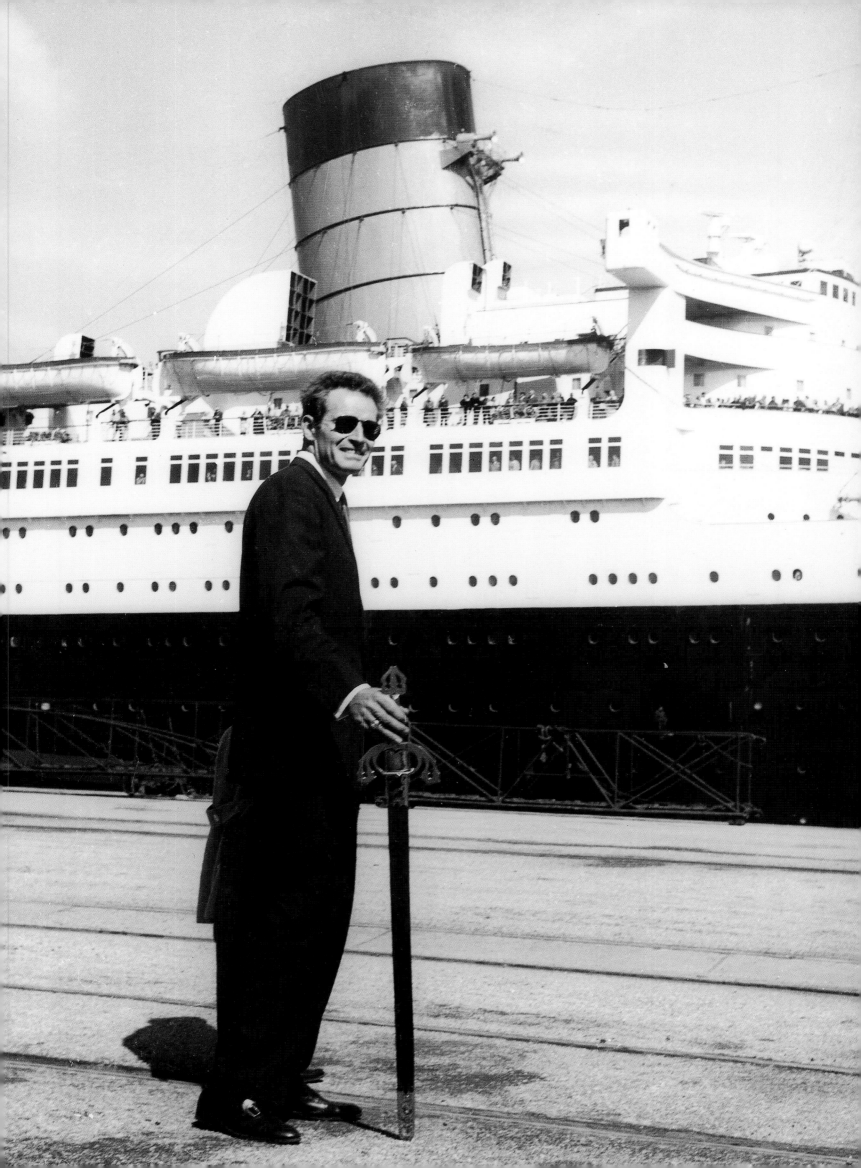

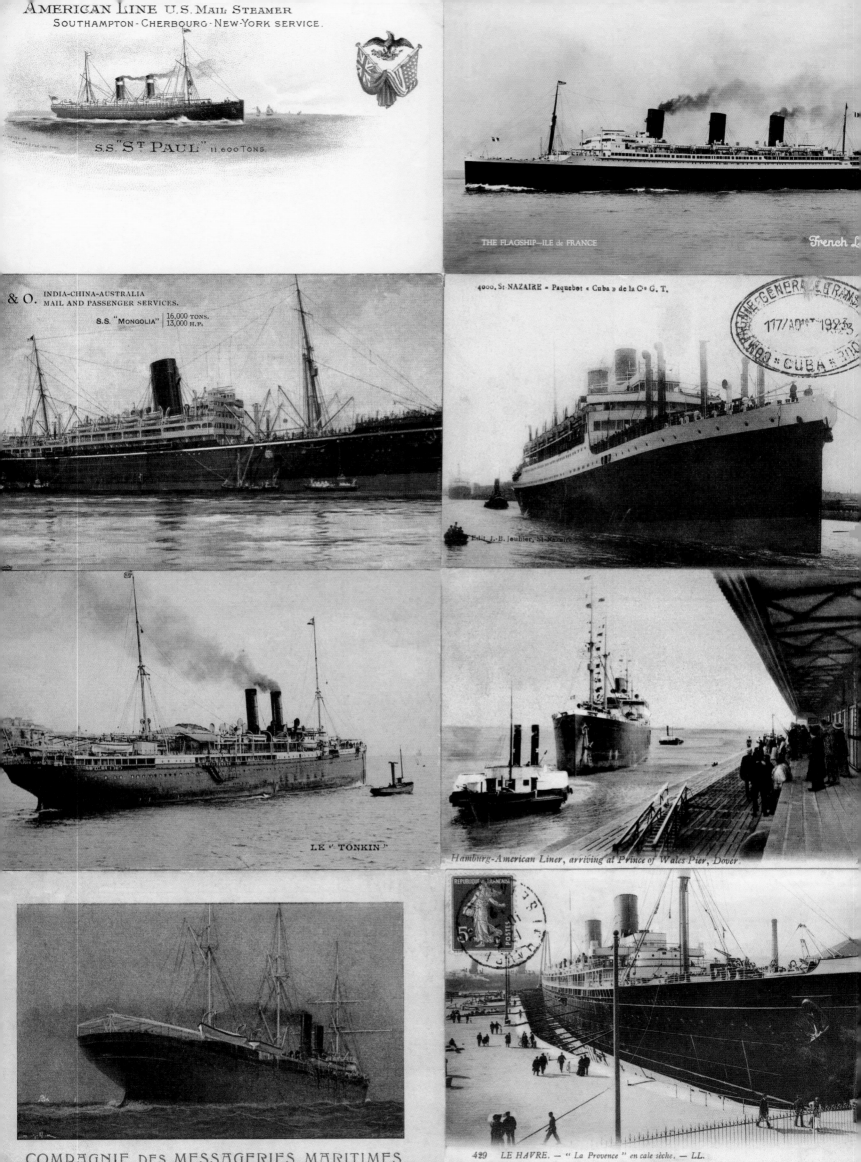

AMERICAN LINE U.S. MAIL STEAMER
SOUTHAMPTON-CHERBOURG-NEW-YORK SERVICE.

S.S. "ST PAUL" 11.600 TONS.

THE FLAGSHIP—ILE de FRANCE

French L

& O. INDIA-CHINA-AUSTRALIA
MAIL AND PASSENGER SERVICES.

S.S. "MONGOLIA" 16,000 TONS.
13,000 H.P.

4000. St NAZAIRE = Paquebot « Cuba » de la Cⁱᵉ G. T.

Edit. J.-B. Joubier, St-Nazaire

LE "TONKIN"

Hamburg-American Liner, arriving at Prince of Wales Pier, Dover.

COMPAGNIE DES MESSAGERIES MARITIMES

429 LE HAVRE. — "La Provence" en cale sèche. — LL.

INDEX OF OCEAN LINERS

Opposite, from left to right and top to
bottom: SS *Saint Paul, Ile de France,
Mongolia, Cuba,* and *Tonkin,* a HAPAG
liner docking at Dover, a liner on
Messageries Maritimes' Egypt route,
and *La Provence* in dry dock at Le
Havre.

186

Launch: 1912
End of service: 1934
L: 218.83 m (718 ft.) W: 23.08 m (76 ft.)
Gross tonnage: 23,666
Service speed: 22.8 knots
Route: Le Havre–New York
Passengers: 535 first class, 442 second
class, 908 third class

FRANCE (1962; later NORWAY)

Pages: *1, 4, 16, 32–33, 34, 40, 41, 54, 64,*
66–67, 74, 75, 96, 108–109, 112, 114,
117, 127, 137, 152, 153, 157, 164, 168,
170–171, 173, 177, 182
Compagnie Générale Transatlantique
Launch: 1962
End of service: 1976 (became
NORWAY)
L: 315.66 m (1036 ft.) W: 33.70 m (111 ft.)
Gross tonnage: 66,347
Service speed: 30/31 knots
Route: Le Havre–New York and cruises
Passengers: 407–590 first class,
1271–1637 tourist class

FURST BISMARCK

Page: *140*
Hamburg Amerikanische Packetfahrt
Actien Gesellschaft (HAPAG)
Launch: 1890
End of service: 1924
L: 158 m (518 ft.) W: 17 m (56 ft.)
Gross tonnage: 8874
Service speed: 19 knots
Route: Hamburg–New York
Passengers: 420 first class, 172 second
class, 700 third class

GEORGE WASHINGTON

Page: *147*
Compagnie Générale Transatlantique
Launch: 1864
End of service: 1899
L: 97.95 m (321 ft.) W: 12 m (39 ft.)
Gross tonnage: 3204
Service speed: 10/12 knots
Route: Le Havre–New York
Passengers: 315 couchettes

GEORGES PHILIPPAR

Pages: *28, 29,* 118
Messageries Maritimes
Launch: 1930
End of service: 1932 (fire)
L: 171 m (561 ft.) W: 20.80 m (68 ft.)
Gross tonnage: 16,674
Service speed: 16/17 knots
Route: Far East
Passengers: 196 first class, 110 second
class, 90 third class, 1200 steerage

GIULIO CESARE

Pages: *34, 35*
NGI, Italia SAN (1932), later Lloyd

Triestino (1937)
Launch: 1922
End of service: 1943
L: 193 m (633 ft.) W: 23 m (75 ft.)
Gross tonnage: 21,658
Service speed: 20 knots
Route: New York, South America,
later South Africa
Passengers: 243 first class, 306 second
class, 1791 third class

GREAT EASTERN

Pages: 50, 73
Cunard
Launch: 1858
End of service: 1888
L: 210 m (689 ft.) W: 36 m (118 ft.)
Gross tonnage: 23,800
Service speed: 14 knots
Route: Southampton–New York
Passengers: 800 first class, 2000
second class, 1200 third class,
1000 steerage

GREAT WESTERN

Pages: 25, 73
Great Western Steamship Company
Launch: 1838
End of service: 1856
L: 72 m (236 ft.) W: 11 m (36 ft.)
Gross tonnage: 1775
Service speed: 8/9 knots
Route: Bristol/Liverpool–New York
Passengers: 111

GRIPSHOLM (later BERLIN)

Page: *54*
Swedish American Line, later
Norddeutscher Lloyd
Launch: 1925, 1954
End of service: 1949, 1966
L: 175 m (574 ft.) W: 23 m (75 ft.)
Gross tonnage: 17,993
Service speed: 16/17 knots
Route: Göteborg–New York, later
Bremen–New York and cruises
Passengers: 127 first class, 482 second
class, 948 third class

ILE DE FRANCE

Pages: 16, 43, 46, 47, 50, 51, 64, 65, 72,
73, *74, 79,* 84, 85, 93, 96, 96, 100,
102–103, 104, *113,* 114, *128–129,* 130,
133, 140, *142–143, 147,* 152, 155, 160,
168, *184*
Compagnie Générale Transatlantique
Launch: 1927
End of service: 1959
L: 241 m (791 ft.) W: 28.09 m (92 ft.)
Gross tonnage: 43,153
Service speed: 23/24 knots
Route: Le Havre–New York
Passengers: 537 first class, 603 second
class, 646 third class

IMPERATOR (later BERENGARIA)

Pages: 11, *54,* 84, 93, 104, 105
Hamburg Amerikanische Packetfahrt
Actien Gesellschaft (HAPAG), later
Cunard
Launch: 1913, 1921
End of service: 1938 (fire)
L: 277 m (909 ft.) W: 30 m (98 ft.)
Gross tonnage: 52,117
Service speed: 23 knots
Route: North Atlantic
Passengers: 908 first class, 972 second
class, 942 third class, 1772 steerage

JULES CESAR (see GIULIO CESARE)

KAISER WILHELM DER GROSSE

Pages: *12, 13,* 88, *147*
Norddeutscher Lloyd
Launch: 1897
End of service: 1914 (act of war)
L: 199 m (653 ft.) W: 20 m (66 ft.)
Gross tonnage: 14,349
Service speed: 22 knots
Route: Bremen–New York
Passengers: 558 first class, 338 second
class, 1074 third class

KAISERIN AUGUSTE VICTORIA

Pages: 152, *154*
Hamburg Amerikanische Packetfahrt
Actien Gesellschaft (HAPAG), later
Canadian Pacific Line
Launch: 1906
End of service: 1919 (became
EMPRESS OF SCOTLAND
in 1921)
L: 214 m (702 ft.) W: 23 m (75 ft.)
Gross tonnage: 24,581
Service speed: 17.5 knots
Route: Hamburg–New York
Passengers: 652 first class, 286 second
class, 216 third class, 1842 steerage

KARNAK (formerly TOURANE, 1904)

Page: 130
Messageries Maritimes
Launch: 1912
End of service: 1916 (act of war)
L: 141.95 m (466 ft.) W: 15.5 m (51 ft.)
Gross tonnage: 6822
Service speed: 19.05 knots
Route: Egypt
Passengers: 192 first class, 110 second
class, 92 third class

KHAI DIN (formerly LAMARTINE)

Pages: *180–181,* 182
Messageries Maritimes
Launch: 1939
End of service: 1942
L: 120 m (394 ft.) W: 15 m (49 ft.)
Gross tonnage: 5110

Service speed: 13.5 knots
Route: Indochina coast
Passengers: no information available

KOREA

Pages: *2–3, 4*
Pacific Mail Line, later Dollar Line
Launch: 1902
End of service: 1916
L: unknown W: unknown
Gross tonnage: unknown
Service speed: unknown
Route: San Francisco–Kobe–Manila
Passengers: unknown

LA BRETAGNE

Page: 92, 95
Compagnie Générale Transatlantique
Launch: 1886
End of service: 1912
L: 150 m (492 ft.) W: 15.76 m (52 ft.)
Gross tonnage: 6754
Service speed: 17.5 knots
Route: Le Havre–New York
Passengers: 225 first class, 68 second
class, 603 third class

LA LORRAINE

Pages: 43, 84
Compagnie Générale Transatlantique
Launch: 1900
End of service: 1922
L: 170 m (558 ft.) W: 18.26 m (60 ft.)
Gross tonnage: 11,168
Service speed: 20 knots
Route: Le Havre–New York
Passengers: 228 first class, 116 second
class, 552 third class

LA MARSEILLAISE

Pages: *120–121,* 122
Messageries Maritimes
Launch: 1949
End of service: 1957
L: 181 m (594 ft.) W: 23 m (75 ft.)
Gross tonnage: 17, 408
Service speed: 20.5 knots
Route: Far East, later Mediterranean
Passengers: 279 first class, 76 second
class, 318 steerage

LA PROVENCE

Pages: *62–63,* 64, *81,* 137, *139, 184*
Compagnie Générale Transatlantique
Launch: 1906
End of service: 1916 (act of war)
L: 190.67 m (626 ft.) W: 19.78 m (65 ft.)
Gross tonnage: 13,752
Service speed: 21.5 knots
Route: Le Havre–New York
Passengers: 422 first class, 132 second
class, 808 third class

188

PHOTOGRAPHIC RESOURCES

(b: bottom, c: center; l: left, r: right, t: top)

Archives Association French Lines, Le Havre, all rights reserved, French Lines Diffusion: pp. 6-7, 10, 13 (t and bl), 17 (photo Marc Walter), 25 (b), 28 (b), 29 (photo Marc Walter), 32, 33, 34 (t), 38 (tr and bl), 40 (photo Marc Walter), 43, 44, 45 (photo Marc Walter), 46, 47, 50 (t), 51, 58 (tl), 62-3, 64 (b), 65, 66, 67 (photo Marc Walter), 68, 72, 74, 75 (bl), 80 (photo Marc Walter), 81 (b), 81 (t and c, photos Marc Walter), 85 (b), 86-7 (photo Marc Walter), 89 (photo Marc Walter), 90-1 (photo Marc Walter), 92, 93 (br), 94, 95 (photo Marc Walter), 96, 97, 100 (t), 101 (photo Marc Walter), 102-3, 104 (t), 106-7, 108 (tl and b), 109 (tl and tr), 110-11, 112 (b), 113, 114 (t), 114 (b, photo Marc Walter) 115 (photo Marc Walter), 116, 117 (photo Marc Walter), 119 (photo Marc Walter), 120-1, 122 (t, photo Marc Walter), 122 (b), 123 (photo Marc Walter), 124-5 (photo Marc Walter), 126 (photo Marc Walter), 128-9, 130 (tr and b), 131 (photo Marc Walter), 132 (photo Marc Walter), 133 (t), 134-5 (photo Marc Walter), 136 (b, photo Marc Walter), 137 (t), 139, 141 (photo Marc Walter), 142-3, 144 (photo Marc Walter), 145, 147 (tr), 148, 149, 150-1, 153, 156 (photo Marc Walter), 157 (t), 158-9, 160 (tl), 160 (b, photo Marc Walter), 161, 164 (tr), 165 (b), 166-7, 173, 176, 180-1; Chambre de Commerce et d'Industrie de Cherbourg Cotentin/photos Marc Walter: pp. 10, 21 (t), 22-3, 24 (t), 25 (t), 26-7, 36-7, 41 (t); Musée Christofle/photos Marc Walter: pp. 154, 155; Corbis/Bettmann: p. 55; Deutsches Schiffahrtsmuseum, Bremerhaven: pp. 12 (bl), 52-3, 54 (t), 59 (t), 75 (br), 76-7, 84 (t), 100 (b), 105, 112 (t and c), 140 (tc and tr), 152 (t and b), 157 (b), 164 (tl), 169, 178-9; Getty Images/Hulton: front cover, pp. 18-19, 56-7; Jean-Marie Lezec: pp. 70-1 (t and b, photo Marc Walter), 177 (t), 182 (t and b), 183; P&O Group: pp. 21 (bl and br), 42 (photo Marc Walter), 43 (bl), 58 (tr), 64 (t), 69 (photo Marc Walter), 118 (t), 127 (b), 132 (b), 137 (b, photo Marc Walter), 138 (photo Marc Walter), 140 (tl, photo Marc Walter), 168 (b, photo Marc Walter), 177 (b, photo Marc Walter); The Queen Mary RMS Foundation, Long Beach, CA: p. 78 (t); Roger-Viollet (coll. Alinari): pp. 98-9, 109 (c), 120 (t), 136 (t), 162-3, 164 (c); Rue des Archives: pp. 48-9; San Francisco Maritime National Historical Park: pp. 2-3, 14-15, 20, 30-1; SVT Bild, Stockholm: 54 (b), 174-5; Collection Walter: pp. 1, 4, 5, 8-9, 11, 12 (t and br), 13 (br), 16, 24 (b), 28 (t), 34 (b), 38 (tl and br), 39, 41 (b), 43 (br), 50 (b), 54 (b), 58 (b), 59 (b), 60-1, 68 (b), 70-1 (photo Marc Walter), 72 (b), 73 (tl), 73 (tr ©P&O), 78 (b), 79 (b), 79 (t ©P&O), 84 (b), 84 (t), 85 (t), 88 (t), 88 (b ©P&O), 92 (b), 104 (b), 118 (b), 127 (t), 130 (t), 140 (b), 146, 147 (tl and b), 160 (tr), 168 (t), 170-1, 172 (b), 184; Archivio Cara, The Michael Wolfson Jr Collection, Fondazione Regionale Cristoforo Colombo, Genoa, Italy: pp. 35, 82-3.

BIBLIOGRAPHY AND OTHER SOURCES

The individuals mentioned in the text are historical characters who actually undertook the voyages described. The only exceptions are Mr. and Mrs. Herbert Carter, who were inspired by characters in *La Dame de Malacca*, a novel by Francis de Croisset published in 1935 (Editions Grasset).

FIRST-HAND ACCOUNTS AND SHIPBOARD JOURNALS

Titanic and *Histoire de la White Star Line*, http://perso.wanadoo.fr/titanic/

Voyage de Alphonse Renkin, missionaire belge, de Marseille à Manille, à bord du paquebot Saghalien, 1885: passages from letters from Alphonse Renkin to his family, ©Philippe Ramona, *"La vie quotidienne à bord des paquebots des Messageries Maritimes,"* http://www.es-conseil.fr/pramona/saghalien2.html

Voyage de Edmond Garnier de Bordeaux à Buenos Ayres, à bord du paquebot Chili, 1909: passages from Edmond Garnier's account, published in 1933 by Editions Figuière, ©Philippe Ramona, op. cit., http://www.es-conseil.fr/pramona/chili2.htm

Voyage de Henri Inard de Marseille à Shanghai, à bord du paquebot Tourane, 1907: passages from the diaries of Henri Hinard, preserved and published by Michel Inard, ©Philippe Ramona, op. cit., http://www.es-conseil.fr/pramona/tourane2.html

Voyage de Joseph Tremble en Extrême-Orient, à bord du paquebot Armand Béhic, 1901: passages from the letters from Joseph Tremble to his family, ©Philippe Ramona, op. cit., http://dtriaud.free.fr/1901-09-08.htm

Voyage du Père Joseph Bulteau de Marseille à Kobé, à bord du paquebot Sphinx, 1927: passages from the diaries of Joseph Bulteau, ©Marie-Jo Rivet, 2001, *"La vie quotidienne à bord des paquebots des Messageries Maritimes,"* http://www.es-conseil.fr/pramona/sphinx2.htm

NOVELS AND TRAVELERS' TALES

Cocteau, Jean, *Tour du monde en 80 jours (mon premier voyage)*, Idées/Editions Gallimard, Paris, 1983

Croisset, Francis de, *Nous avons fait un beau voyage*, Le livre Moderne Illustré, Editions J. Ferenczi et fils, Paris, 1932

Dorgelès, Roland, *Entre le ciel et l'eau*, Les editions G. Crès et Cie, Paris, 1930

Dorgelès, Roland, *Partir...*, Le Livre de Poche/Albin Michel, Paris, 1966

Farrère, Claude, *Extême-Orient*, Editions Flammarion, Paris, 1924

Morand, Paul, *New York* (1930), in *Voyages*, Bouquins, Editions Laffont, 2001

Verne, Jules, *Une Ville Flottante*, Editions Fernand Nathan, Paris, 1984

PERIODICALS

Publications of the Association French Lines, Le Havre, http//www.frenchlines.com

"Paquebots de légende," in *Historia* no.541, Paris, January 1992

"Régates des grands paquebots—Ruban bleu," in *Miroir de l'Histoire*, no.B281 *"L'appel de la mer,"* Paris, 1974

MONOGRAPHS AND SPECIALIST WORKS

Barbance, Marthe, *Histoire de la Compagnie Générale Transatlantique*, Arts et Métiers graphiques, ©Compagnie Générale Transatlantique, 1955

Bonnett, Wayne, *A Pacific Legacy: A century of Maritime Photography, 1850-1950*, Chronicle Books, 1991

Brouard, Jean-Yves, *Paquebots de chez nous*, Editions E.T.A.L./M.D.M.

France, l'album souvenir, with prefaces by Charles Offrey and Louis Morin, Editions M.D.V., 2003

Grand Luxe: The Transatlantic Style, John Malcolm Brinnin, Kenneth Gaulin, Henry Holt and Company, 1988

Kjellberg, Pierre, *Art deco, "le décor des paquebots,"* Les Editions de l'Amateur, 1990

Lagier, Roselyne, *Il y a un siècle ... les paquebots transatlantiques*, Editions Ouest-France, 2002

La Grande Cuisine du France, Editions Mengès, Paris, 1980

Lost Liners: from the Titanic to the Andrea Doria, Robert D. Ballard, Rick Archbold, Ken Marschall, ©Odyssey Corporation 1997/Hyperion/Madison Press Books

Liners: The Golden Age, Robert Fox, Clive Harvey, Alex Linghorn, The Hulton Getty Picture Collection, Könemann Editions, 1999

Marin, Pierre-Henri, *Les paquebots, ambassadeurs des mers*, Découvertes Editions Gallimard-Techniques no.75, Paris, 1991

Mars, Christian, *Paquebots de légende*, Editions Flammarion, 2003

Maxtone Graham, John, *The North Atlantic Run (The Only Way to Cross)*, Cassell & Co. Ltd, London, 1972

Miller, William H., with the assistance of the Museum of the City of New York, *The Fabulous Interiors of the Great Ocean Liners in Historic Photographs*, Dover Publications, 1985

Mohrt, Michel, Feinstein, Guy, *Paquebots, le temps des traverses*, Editions EMOM, 1980

Molteni de Villermont, Claude, *Un siècle de paquebots du monde par la carte postale*, Editions M.D.V., 2000

Normandie, l'épopée du géant des mers, Bruno Foucart, Charles Ofrey, François Robichon, Claude Villers, Editions Herscher, 1985

Steele, James, *Queen Mary*, Phaidon, 1995/2001

Trogoff, Jean, *La course au Ruban bleu, cent ans de lutte dans l'Atlantique, 1838-1939*, Société d'Editions géographiques, maritimes et colonials, Paris, 1945

Voyages en mer, paquebots et cargos, trésors photographiques de French Lines, Aymeric Perroy and Didier Mouchel, Editiond du Chêne, 2000

ACKNOWLEDGMENTS

We owe a special debt of gratitude to the Association French Lines, and especially to Mr. Aymeric Perroy and Ms. Armelle Ollivier, not only for their unflagging support, assistance, and patience, but also for their warm and hospitable enthusiasm throughout the research period for this book and photographic shoots at Le Havre. We would also like to express our thanks to Mr. Jean Meillassoux for ensuring the best possible conditions were always available for these photographic sessions.

We are extremely grateful to the following individuals and organizations for providing us with access to their collections and allowing us to photograph certain documents: Mr. Stephen Rabson and Ms. Suzie Cox of the P&O Group, London; Ms. Anne Gros, Curator of the Musée Christofle; Mr. Jean-Marie Lezec, who received us with such warmth; and Ms. Giot of the Chambre de Commerce et d'Industrie de Cherbourg-Cotentin.

We would also like to thank all those who have generously furnished us with images, documents, and information, notably: Mr. Klaus Fuest/Deutsches Schiffahrt Museum, Bremerhaven; Ms. Mary Jo Pugh/San Francisco Maritime National Historical Park; Ms. Silvia Barisione/The Mitchell Wolfson Collection/Fondazione Regionale Cristoforo Colombo, Genoa; Mr. Will Kaynes/The Queen Mary Foundation, Long Beach. Finally, our thanks are also due to Kerstin Alfredsson and Nadja Klich (SVT Bild, Stockholm), Catherine Terk (Rue des Archives), and Barbara Mazza (Alinari/Roger Viollet).

PICTURE SOURCES

Archive documents have been photographed and reproduced by kind permission of the following: Association French Lines; P&O Group; Chambre de Commerce et d'Industrie de Cherbourg-Cotentin; Collection Lezec; Collection Walter; Musée Christofle; San Francisco Maritime National Historical Park; archives of HAPAG and Norddeutscher Lloyd/Deutsches Schiffahrtsmuseum (Bremerhaven); archives of the Italian Touring Club; SVT Bild/Stockholm; Fonazione Regionale Cristoforo Colombo, Genoa; The Queen Mary RMS Foundation, Long Beach.

First published in the United States of America in 2006 by
The Vendome Press
1334 York Avenue
New York, N.Y. 10021

Originally published by Editions Solar, Paris as *Paquebots*
Copyright © 2005 Editions Solar, Paris
English translation copyright © 2006 The Vendome Press

ISBN-10: 0-86565-173-6
ISBN-13: 978-0-86565-173-9

Design and layout: Marc Walter
Picture research and captions: Sabine Arqué
Managing editor, French language edition: Dominique Raynal
Senior editor, French language edition: Suyapa Granda Bonilla
Art director: Marc Walter/Studio Chine
Editor, French language edition: Sabine Arqué/Studio Chine
Photogravure: Quat'coul/Studio Chine

Managing editor, English language edition: Sarah Davis
Type design, English language edition: Patricia Fabricant
Translator, English language edition: Barbara Mellor

Library of Congress Cataloging-in-Publication Data

Donzel, Catherine.
 [Paquebots, la vie à bord. English.]
 Luxury liners, life on board / Catherine Donzel.
 p. cm.
 Summary: "An illustrated history of ocean liners of the twentieth century and the passengers' experiences onboard"—Provided by publisher.
 ISBN-13: 978-0-86565-173-9 (hardcover : alk. paper)
 ISBN-10: 0-86565-173-6 (hardcover : alk. paper)
 1. Ocean travel. 2. Ocean liners. 3. Ocean travel—Pictorial works. 4. Ocean liners—Pictorial works. I. Title.
 G550.D6413 2006
 387.5'42—dc22

 2006010184

Printed in Singapore